Dürer Jeffrey Chipps Smith

ART&IDEAS

Φ

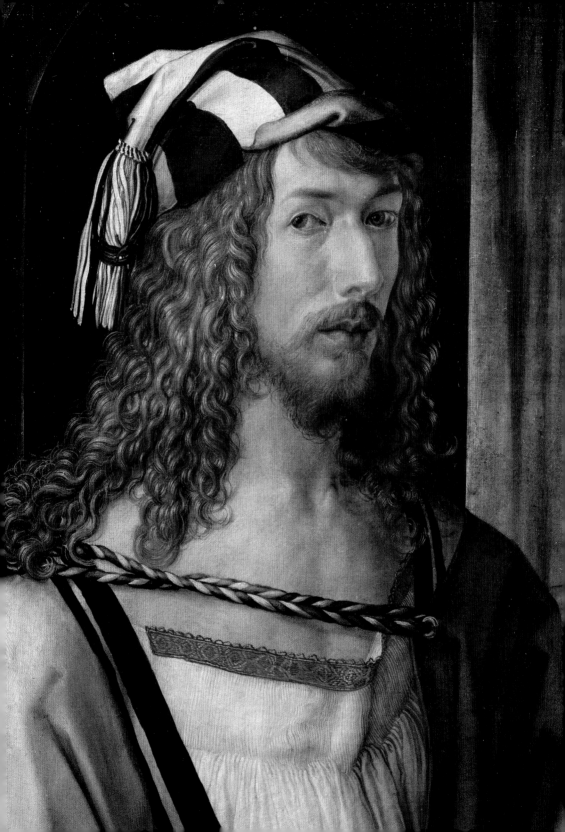

Dürer

Opposite
Detail of
(40) *Self-
Portrait*, 1498
Oil on
lindenwood;
52 × 41 cm
(20¹/₂ × 16¹/₈ in)
Museo
Nacional del
Prado, Madrid

Introduction

Albrecht Dürer (1471–1528) literally stands on a pedestal (1) in his native city of Nuremberg. The over-life-size bronze by Christian Daniel Rauch (1777–1857) has dominated the Albrecht-Dürer-Platz, formerly the Milk Market, since its placement there in 1840 (see page 389). Conceived in conjunction with the elaborate tercentenary celebrations that drew artists from across Germany to Nuremberg on Easter Sunday in 1828, this is Europe's oldest public statue honouring an artist. In life Dürer's fame, along with his art, stretched across the continent. In death the cult of Dürer continues to unfold. He is a mythic figure whose legacy is often shaped to fit the prevailing cultural aesthetics of each new era.

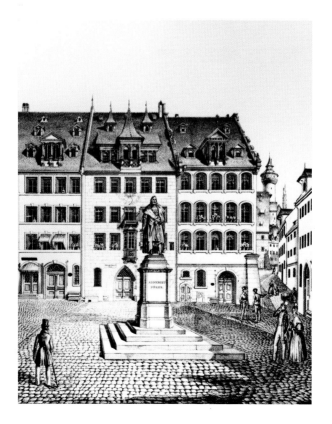

1
Nineteenth-century engraving of the Albrecht-Dürer-Platz, Nuremberg, including Christian Daniel Rauch, *Albrecht Dürer Monument*, 1828–40
Bronze cast by Jacob Daniel Burgschmiet; figure height: 295 cm (116⅛ in)

For some, Dürer is divine or, at least, often Christ-like; he is the melancholic genius; he is the pious, hard-working craftsman; he is the Teutonic hero claimed (and often misrepresented) by many different groups across the centuries; and he is a postmodern icon plastered on T-shirts, tourist trinkets and, formerly, German currency. Most viewers need no explanation when Dürer's *Self-Portrait* of 1500 (see 75) is used to advertise *The Gospel According to the Son*, Norman Mailer's book on Jesus, or when in August 2003 Ottmar Hörl (b. 1950) filled the Hauptmarkt in Nuremberg with 7,000 identical plastic sculptures to commemorate the 500th anniversary of Dürer's *Hare* watercolour (see 65).[1] For centuries Dürer's work, much like this animal famed for its reproductive abilities, has filled the artistic landscape. It has served as a collective visual and intellectual resource for over a half millennium.

This book seeks to demystify Dürer – somewhat – by considering his life and his art within the context of his fascinating and often tumultuous age. More is known about him than about any other Northern European Renaissance artist. This fact both aids and complicates our task. His signed, documented and attributed *oeuvre* is immense. In their respective catalogues Erwin Panofsky gives a handlist of works containing 1,725 objects, Friedrich Winkler records 949 drawings, Fedja Anzelewsky includes 189 paintings and Joseph Meder tallies 294 prints, excluding separate book illustrations.[2] Scholarly differences of opinion doom a definitive count. In addition, Dürer penned letters, composed poems, wrote a family history, kept an insightful journal while travelling in the Netherlands, authored three published treatises and prepared extensive notes for other literary projects.[3] Often with great intimacy and wit he tells us what he thought, felt and saw. His anguish over reports of Luther's seizure and possible murder and his awe at beholding objects brought from New Spain (Mexico) to Brussels offer vivid insights into his eventful period. This highly personal look at himself and his world is unique. Furthermore, Dürer's contemporaries mentioned him frequently

in their correspondence and publications. By contrast, when historians write about Albrecht Altdorfer (c.1480–1538), Hans Baldung Grien (1484/5–1545), Hans Burgkmair (1473–1531), Lucas Cranach the Elder (1472–1553), Matthias Grünewald (Matthias Gothart called Nithart, c.1475/80–1528), Hans Holbein the Younger (1497/8–1543), Tilman Riemenschneider (c.1460–1531) or Veit Stoss (c.1445/50–1533), among other peers, they are not over-burdened by primary literary records. Virtually no documents reveal these artists' private thoughts.

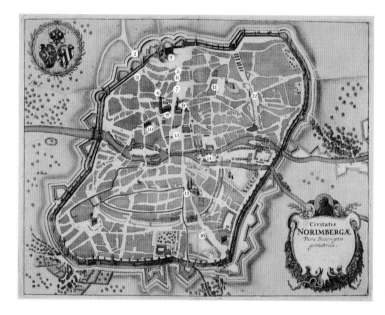

2
Wenceslaus Hollar,
Plan of Nuremberg,
c.1657
Etching;
35 × 45.8 cm
(13⅞ × 18 in)

1 Burg (castle)
2 Tiergärtnertor
3 Dürer's house (from 1509)
4 Albrecht-Dürer-Platz
5 Albrecht Dürer the Elder's house
6 Michael Wolgemut's house
7 Burgstrasse
8 Church of Saint Sebaldus
9 Rathaus (City Hall)
10 Augustinian monastery
11 Anton Koberger's publishing house
12 Landauer Zwölfbrüder-haus and chapel
13 Hauptmarkt (main market)
14 Heilig-Geist-Spital and Church
15 Church of Saint Lorenz
16 Convent of Saint Klara

Dürer was born, lived and died in Nuremberg, a wealthy Franconian city of about 40,000 inhabitants situated at the heart of the Holy Roman Empire (2).[4] It was one of Europe's leading trade and manufacturing centres.[5] Silver and copper mined in Saxony, Bohemia and the Tyrol were transformed by the city's goldsmiths and metalworkers into high-quality luxury and utilitarian wares. Nuremberg attracted talent, including Albrecht Dürer the Elder (1427–1502), an ambitious ethnic Hungarian goldsmith and father of our artist. Nuremberg presented opportunities that most other

German cities could not. Although it is intriguing to speculate what Albrecht the Younger's career might have been like if he had grown up in a smaller, less politically powerful town, one should also keep in mind that many other artists lived in Nuremberg without achieving his level of fame.

In 1493 Michael Wolgemut (1434/7–1519), Dürer's teacher, and Wilhelm Pleydenwurff (1458/60–1494) portrayed Nuremberg in a two-page woodcut in Hartmann Schedel's *Liber Chronicarum*, better known as the *Nuremberg Chronicle* (3). This, the earliest

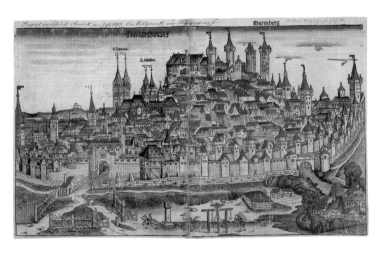

3
Michael
Wolgemut
and Wilhelm
Pleydenwurff,
Nuremberg
Woodcut in
Hartmann
Schedel, *Liber*
Chronicarum
(Nuremberg,
1493), folios
99v–100;
39.1 × 56 cm
(15⅜ × 22 in)

published view, shows a densely built town ringed by impressive fortified walls and watchtowers. The imperial castle and civic towers dominate the northern ridge. The River Pegnitz bisects the town originally into the southern parish of Saint Lorenz and the northern parish of Saint Sebaldus. The spires of these churches, proudly labelled here, soar about the rooftops of the many other religious establishments, stone houses and public buildings. The double-headed eagle painted on the Frauentor, or gate, identifies Nuremberg as an imperial free city, a special legal status that permitted its government much greater local autonomy and

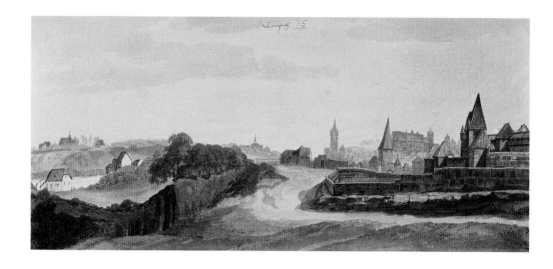

political independence than in most German cities. Nuremberg often functioned as the *de facto* capital in an age where there was not yet a permanent imperial residence. From 1356 newly elected emperors held their first diet or assembly here. In the woodcut a pedlar passes three crosses and, a few paces ahead, a stone monument with a crucifixion. This alludes to Nuremberg's role, starting in 1423/4, as the official guardian of the imperial relics and regalia, which include the lance that pierced Christ's side and a piece of the True Cross. For a contemporary viewer Nuremberg is prosperous, pious and politically well connected.

About three years later Dürer sketched a revolutionary view of Nuremberg (4).[6] Instead of opting for the woodcut's bird's-eye vantage point, he situates himself and his viewer on the grass outside the Spittlertor, the gate at the southwest corner of the city. Looking north along the western wall, Dürer depicts the imperial castle and, closer to the centre, the tall tower of the Tiergärtnertor in the distance. On the low hill at the far left are the church and cemetery of Saint Johannis, where the artist would be buried in 1528. This drawing is one of several that Dürer made in and around Nuremberg. As will be discussed in Chapter 3, there is little precedent in German art for the sense of immediacy, atmospheric mood and pictorial breadth of this vista. Dürer probably learned

to draw with watercolours in Wolgemut's workshop, yet it is characteristic of his singular creativity that he transformed both the medium and its use.

Sometimes Dürer's innovations are simultaneously exquisite and awkward as he explores a new idea. Consider his *Paumgartner Altarpiece* (5).[7] Large-scale winged altarpieces were prized as the most prestigious and lucrative commissions available to painters, as Dürer learned from Wolgemut, whose workshop was renowned for its retables. The patrons, members of an important Nuremberg patrician family, determined the subjects: the Nativity flanked by saints George and Eustace. In keeping with prevailing visual conventions, Dürer includes diminutive portraits of the donors kneeling beside Joseph and Mary. A hierarchy of scale distinguishes the patrons from the narrative's protagonists. Their coats of arms remind contemporary viewers of the Paumgartners' local social status, and the altar advertises their piety. Dürer patterns the sharply tilted ground plane with its vertical stacking of features on sculpture, which around 1500 still dominated the central panel of most retables (see 14). While operating within these pictorial formulas, the artist introduces a complex architectural setting based on a coherent perspective scheme. Most of the orthogonal lines meet at a point just above the heads of the two approaching shepherds. The figures' poses and glances draw attention to the Christ Child, who is located on the central vertical axis. This scene displays the artist's ambition as well as his struggles in setting his figures within a logical spatial stage.

The inclusion of standing saints flanking a central scene is quite common in carved altarpieces. Nevertheless, Dürer links the saints through their shared setting of a bare rocky ground and a black backdrop. This contrasts with the expansive space and naturalistic landscape of the central panel. Such sharp distinctions have caused some scholars to speculate that the central panel must date from several years later; however, an old document states that the

4
View of Nuremberg from the West, c.1496 (inscribed 'nörnperg') Watercolour and body-colour; 16.3 × 34.4 cm (6⅜ × 13½ in) Kunsthalle, Bremen (currently held by the Russian Federation in Moscow)

5
*Paumgartner
Altarpiece,*
c.1498
Oil on
lindenwood;
centre:
155 × 125 cm
(61 × 49¼ in),
wings each:
157 × 61 cm
(61⅞ × 24 in)
Alte
Pinakothek,
Munich

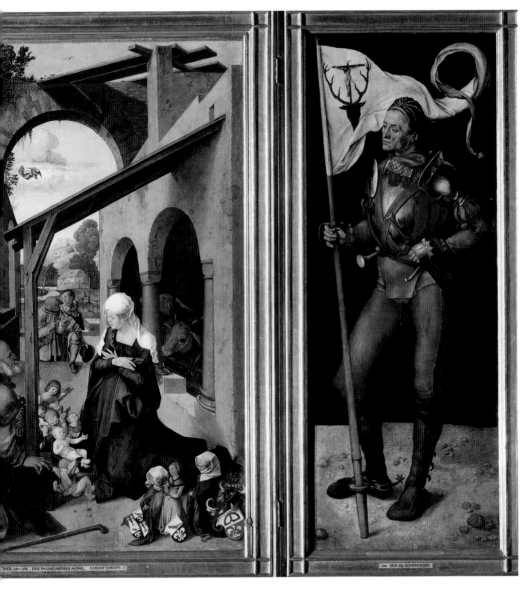

DÜRER, 1471–1528 DER PAUMGARTNER ALTAR. GEBURT CHRISTI

DER HL. EUSTACHIUS

altarpiece was given to the Dominican convent of Saint Katharina in Nuremberg in 1498. While Dürer's solution initially appears awkward, his arrangement highlights the two men's imposing physical presence, the detail of their attire, including their reflective armour, and their individualized features. As already recognized in the seventeenth century, Stephan Paumgartner, one

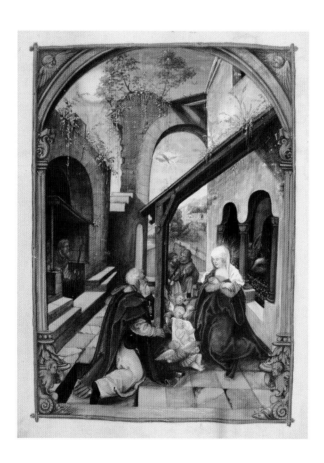

6
Nikolaus Glockendon, *Nativity, Horae beatae Mariae virginis* (Ms. 9, folio 25 recto), 1530–1 Manuscript illumination on parchment; 23 × 17.5 cm (9 × 6⅞ in) Hofbibliothek, Aschaffenburg

of Dürer's closest friends, and his brother Lukas are portrayed as saints George and Eustace respectively. The *Paumgartner Altarpiece* exemplifies how Dürer adopted and adapted contemporary pictorial conventions. No earlier Nuremberg painter can match either Dürer's spatial experimentation or the monumentality and realism of these two saints.

The altarpiece's subsequent history as model, collector's object and symbol typifies the engagement of Dürer's art with later audiences. Nikolaus Glockendon (d. 1534), the talented local miniaturist, copied the central panel, among other designs by Dürer, in the *Horae beatae Mariae virginis* illuminated in 1530–1 for Cardinal Albrecht von Brandenburg, archbishop of Mainz (r. 1514–46; 6).[8] When Duke and later Elector Maximilian I of Bavaria (r. 1597–1651) purchased the *Paumgartner Altarpiece* in 1613, the Nuremberg city council stipulated that a full-size replica should be painted for the former nuns' convent.[9] Maximilian also ordered one of his artists in Munich to paint over the donor figures in the central panel. George and Eustace, in turn, were given new helmets, lances rather than standards, powerful horses and landscape backgrounds (7).[10] These alterations were only removed in 1902–3. Unfortunately Dürer's enduring fame has prompted unwanted attention. Acid was senselessly tossed on this altarpiece in 1988. The resulting damage, especially to the central panel, required considerable restoration. Both incidents, however jolting to our modern sensibilities, remind us that works of art exist in a constant and continually shifting dialogue with audiences over time. The *Paumgartner Altarpiece* survives, albeit with its original function and setting altered. The loss of some paintings and drawings during the intervening centuries must be borne in mind when writing any account of the artist.

7
Paumgartner Altarpiece with seventeenth-century alterations prior to 1902–3 restoration

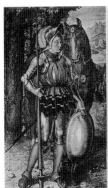
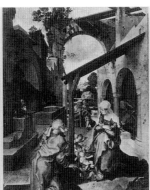
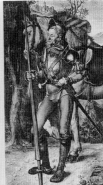

Throughout his career Dürer remained an integral participant in Nuremberg's community of artists. He was a frequent collaborator and a sought-after mentor. Other artists often used his drawings as models. Hans Frey (1450–1523), his father-in-law, fabricated elaborate table fountains populated with small male and female figures fashioned from copper.[11] He ingeniously used air pressure to lift and circulate the wine or water. Around 1500 Dürer created several drawings for table fountains, perhaps for Frey. The 1:1-scale design in London (8), the most ambitious, combines natural forms and artistic artifice.[12] The sixteen-sided base is populated by a hunter running with his hounds, a bagpipe-playing shepherd, peasants with their harvesting tools, soldiers marching to drum and fife, and a robber, all set within a rocky landscape. A giant tree trunk entwined with thick grapevines rises up to support the large embossed bowl. Amid the grape clusters and leaves is a blank pair of shields for the eventual owner's coat of arms. The architectonic superstructure consists of intricate Gothic-style tracery bearing a second, shallow bowl and, at the apex, a soldier in armour. Liquids, coloured red and blue probably for red and white wine, shoot upwards and downwards from the various figures. Two hands holding wine beakers allude to the fountain's primary function. It would have been placed in a wide basin to capture and recycle the liquid. The fountain could be lifted using its three handles, each in the form of two intertwined snakes. Frey or someone else penned practical notations about scale on the verso. One reads: 'The mechanism which is silver and rises from the basin is equal in height to the length or height as in the design.' The craftsmanship and expense involved in producing such a table decoration assured its rarity as well as its utility as a conversation piece.

The chapters that follow track the significant transformations in Dürer's art over the course of his career. Consider his *Design for a Double Cup* (9), made in 1526, just two years before his death.[13] Even accounting for the practical needs of each goldsmith model, the exuberant complexity of the table fountain now yields to the

8
Design for a Large Table Fountain,
c.1500
Pen and brown ink with watercolour;
56 × 35.8 cm (22 × 14⅛ in)
British Museum, London

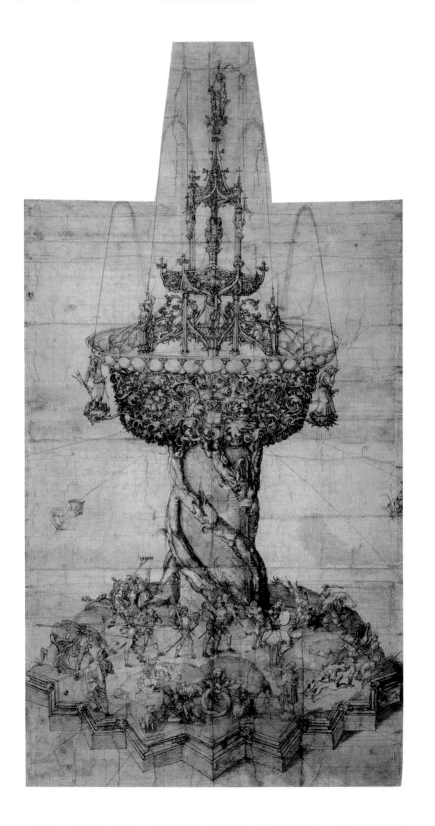

taut linear precision and ornamental discipline of this cup. The freely drawn figures and foliage of the former contrast with the absolute clarity and perfect symmetry of the drinking vessel. In the latter a faint vertical line bisects the composition. Several tiny holes indicate Dürer used a compass. This drawing's cool monumentality, indeed its sculpturesque plasticity of form, recalls other late works (see 169, 170).

Heinrich Conrad Arend's *Das Gedächtnis der Ehren Albrecht Dürers*, composed in 1728, was the first book on the artist. The steady stream of subsequent publications has turned recently into a torrent. When Matthias Mende's *Dürer-Bibliographie* appeared in 1971 in conjunction with the last *Dürer-Jahr*, or jubilee year, he listed 10,271 entries. I suspect that the number of citations has doubled in the intervening decades.[14] Viewed historiographically, this literature reveals the interests and methodological approaches of every generation. Erwin Panofsky's *The Life and Art of Albrecht Dürer*, published in 1943, challenged the prevailing preoccupations with biography, attribution and style.[15] Panofsky delved into the iconography or meaning of Dürer's art by investigating the humanistic interests of the artist and his friends, notably Willibald Pirckheimer. Subsequent scholars have poked and prodded Dürer and his *oeuvre* in many creative ways, including careful technical examinations. They have explored the profound impact of Dürer's art. My text benefits from and seeks to incorporate this stimulating new research. My book has two main objectives. First, I offer what I hope is a compelling narrative about the famed Nuremberg master and his career. To this end the chapters, organized chronologically, include often detailed discussions of individual works of art or significant moments in his career. Second, writing history is a process of inclusion, exclusion and honest differences of opinion. Therefore I try to explain interpretative problems and methodological issues as these arise. Dürer's art dazzled and challenged his contemporaries. I trust this short book will demonstrate some of the reasons for its enduring appeal.

9
Design for a Double Cup, 1526
Pen and black ink with ochre yellow wash; 42.2 × 28.8 cm (16⅝ × 11³/₈ in)
Albertina, Vienna

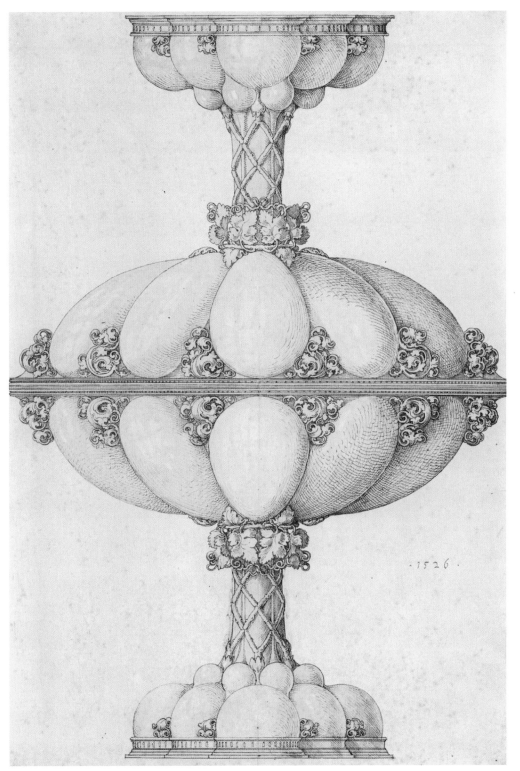

·1526·

In 1489–90 Albrecht Dürer portrayed his parents, Barbara Holper
(1451–1514) and Albrecht Dürer the Elder (10, 11).[1] These
pendants, the oldest secure paintings by the young artist, show the
couple in half-length facing each other. Both are neatly if soberly

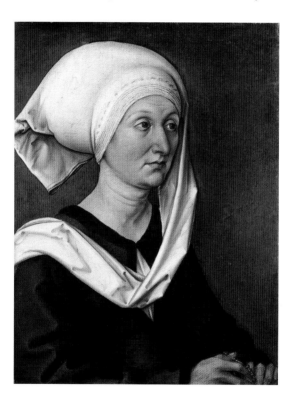

10
*Barbara
Holper*,
c.1489–90
Oil on
pinewood;
55.3 × 44.1 cm
(21¾ × 17⅜ in)
Germanisches
National-
museum,
Nuremberg

dressed. Neither wears any jewellery. Only Albrecht the Elder's
fur-trimmed jacket and Barbara's highly starched linen headdress
hint at their middle-class status. Each sitter fingers a strand of
rosary beads, signs of their piety. Dürer's later comments about
his parents, written on the occasion of their respective deaths
and in a brief *Family Chronicle* of 1524, stress their devoutness.
He describes his father as stern and hard-working. 'But he won

just praise from all who knew him, for he lived an honourable, Christian life, was a man patient of spirit, mild and peaceable to all, and very thankful towards God. For himself he had little need of company and worldly pleasures; he was also of few words and was a God-fearing man.'[2]

Albrecht the Elder hailed from Ajtós, near Gyula, today in southeastern Hungary near the Romanian border. The family

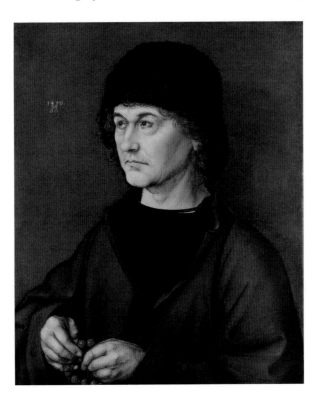

11
Albrecht Dürer the Elder, 1490
Oil on wood;
47.5 × 39.5 cm
(18¾ × 15½ in)
Galleria degli Uffizi, Florence

name Dürer, first used during his apprenticeship by Anton, Albrecht the Elder's father, derives from the name of this village. The Hungarian word *ajtó*, meaning 'door', became *tür* or *dür* in German.[3] In the family's heraldry, including the coat of arms painted on the reverse of Albrecht the Elder's portrait, this is rendered as a portal with two open door panels (see 188). After his initial training with his father, Albrecht the Elder was a highly

skilled goldsmith who headed northwest, perhaps directly to Nuremberg, in whose militia he served in 1444. In the *Family Chronicle* Dürer records that his father 'had been a long time with the great artists in the Netherlands'. Unfortunately nothing is known about this period in the elder Dürer's life. Like many foreign artists he was drawn to the commercial opportunities of Bruges, then Northern Europe's leading port, or Brussels, the favourite residence of Philip the Good, duke of Burgundy (r. 1419–67), Europe's wealthiest noble.

Albrecht the Elder arrived back in Nuremberg on 11 March 1455, the feast day of Saint Eligius (Eloy), the patron saint of goldsmiths. He soon found employment with Hieronymus Holper (d. 1476), one of the city's most prominent goldsmiths. In 1467 Albrecht the Elder married Barbara, Holper's fifteen-year-old daughter, and acquired local citizenship. On 7 July 1468 he became a master goldsmith and succeeded his father-in-law as civic gold assayer. Although no known works by Albrecht the Elder survive, he must have been successful since in 1475 he was able to purchase for 200 florins his own house on Gasse Unter der Veste (today Burgstrasse 27), a prominent address on Nuremberg's main north–south street. He and Hans Krug (d. 1519) crafted a drinking vessel for Emperor Friedrich III (r. 1440–93) in 1489. In a letter to his wife in 1492 Albrecht the Elder recounts that he and his drawings, presumably goldsmith designs, were well received by the emperor during his trip to Linz.

Barbara, not Albrecht the Elder, is situated in the heraldic right panel (on the left from the viewer's standpoint). Traditionally the position of honour was reserved for the husband. Does the position acknowledge Barbara's more privileged status as the daughter of a prominent local artist? Albrecht the Elder was a new immigrant in a town whose complex social organization institutionalized the power of the old established families. Alternatively, perhaps Barbara's portrait was painted first as an independent picture. Its

quality is lower than the more confidently conceived and spatially convincing portrait of Albrecht the Elder. The latter may have been painted a bit later, though completed before their son departed on his *wanderjahre*, or journeyman's trip, in April 1490.

Albrecht the Younger, henceforth referred to as Dürer to avoid confusion with his father, was born on 21 May 1471 in Nuremberg. Dürer was the third of eighteen children, but only he and his younger brothers Endres (1484–1555) and Hans (1490–1534) lived to adulthood. The family's child mortality rate exceeded the standard for the age, when it is estimated that one-third of children died before the age of ten and only five to ten per cent of the population lived to sixty.[4]

In the *Family Chronicle* Dürer observes:

> And my Father took special pleasure in me because he saw that I was diligent in striving to learn. So he sent me to the school, and when I had learnt to read and write he took me away from it, and taught me the goldsmith's craft. But when I could work neatly my liking drew me rather to painting than to the goldsmith's work, so I laid it before my father; but he was not well pleased, regretting the time lost while I had been learning to be a goldsmith. Still he let it be as I wished, and in 1486 (reckoned from the birth of Christ) on Saint Andrew's day (30 November) my Father bound me apprentice to Michael Wolgemut, to serve him three years long. During that time God gave me diligence so that I learned well, but I had much to suffer from his lads.[5]

This is a remarkable statement both for its author's intentions and its contents. Writing in 1524, Dürer recorded some of the major events in his and his family's lives. Did he compose his account for family, friends or some broader audience? Here and on other occasions Dürer's self-fashioning was done with an eye to posterity.

Albrecht the Elder played a formative role in Dürer's early education. His son received a few years of formal schooling, where he learned to read and write. Nuremberg had different types of schools. Some small private ones taught the rudiments of reading and writing German as well as of arithmetic.[6] This provided a sufficient basis for most urban youths before they began their specific training to be an artisan or merchant. As an adult, Dürer knew some Latin. It is unclear whether he gained this as a boy, perhaps in the nearby Saint Sebaldus parish school or later on his own.

Sons customarily followed their father's trade. Dürer's father and grandfather were goldsmiths, so his career path seemed obvious. Albrecht the Elder removed his son from school to start his apprenticeship. Typically, a new apprentice began his four to six years of training around the age of twelve. In exchange for a fee he would live and work with his master. This was not an issue when a son studied with his father. The art of the goldsmith, especially in Nuremberg, one of the foremost centres in Europe, was quite demanding.[7] Besides learning how to draw and create designs, Dürer would have been taught how to work with silver, gold and other metals. He needed to master techniques such as casting, embossing or hammering from the inner side, chasing for shaping the metal from the front, and decorating the surfaces using engraving, chiselling and punch work, as well as gilding. Although not recorded before 1515, the tests to become a master goldsmith in Nuremberg required the candidate to fashion a chased columbine-shaped drinking cup, a ring set with a precious stone and an engraved document seal.[8]

About mid-way through his goldsmith training Dürer drew a remarkable *Self-Portrait* (12).[9] The inscription, added in the 1520s, reads: 'This I fashioned after myself out of a mirror in the year 1484, when I was still a child. Albrecht Dürer.' Dürer was about thirteen years old when he depicted himself in half-length. Using a small convex mirror, he carefully studied his own features,

12
Self-Portrait,
1484
Silverpoint;
27.3 × 19.5 cm
(10¾ × 7⅝ in)
Albertina,
Vienna

especially how light plays across the contours of his face. He reinforced the lines of his chin and his nose. The latter serves as a divide from the broadly illuminated right cheek to the heavily shaded side of his head. Dürer looks away from the viewer as though to mask his dependence on the mirror. The drawing shows few of the optical distortions one would experience when staring into a convex mirror. The pointing right hand is the reflected image of his left hand. He conveniently hides his right or drawing hand behind the folds of the sleeves. As he sketched, Dürer made repeated adjustments. Faint lines indicate that his cap was initially set a bit higher and his right sleeve slightly lower. He changed the length and position of his index finger. As a novice artist, young Dürer struggled. The clarity of the hair and drapery evident on the left side of the drawing disappears on the right. Is the mass of broad vertical lines to our right of his face to be read as hair or cloth attached to the cap? The fabric of the sleeve is flat and awkwardly defined.

In spite of these problems, the products of inexperience, this drawing tells much about the ambition and skill of the young Dürer. Although this is the oldest surviving sketch, it was certainly not his first, since he probably drew often during his training and on his own. Instead of pen and ink, pencil or charcoal, Dürer chose silverpoint. The lines that result from running the silver stylus across the burnished prepared ground that coats the sheet of paper are light and rather feathery. Because these derive from the chemical reaction of the stylus contacting the prepared coating, silverpoint lines, which darken slightly with age, cannot be erased. This explains some of the stray trial lines produced when blocking in the initial composition. His choice reveals his confidence and, I think, the importance he placed on this particular drawing.

From our modern vantage point Dürer's decision to depict himself may seem unexceptional since we are accustomed to the self-portraits of Rembrandt, Van Gogh and so many other masters.[10]

In 1484 there were virtually no self-portraits by German artists, excluding a few busts of master builders adorning the walls of their churches and the rare inclusion of a painter's face amid a crowd in an altarpiece scene. Unlike these, Dürer's sketch has no religious context. It stands out as one of the earliest (one hesitates to say the first) known independent self-portraits by a German artist. Sometimes it is compared with the *Self-Portrait of Albrecht Dürer the Elder* (Albertina, Vienna), also done in silverpoint.[11] Based on an inscription on an old copy, the latter probably dates to 1486 and was perhaps done as an exercise in response to his son's sketch. The issue of primacy does not concern me here. Rather, I see this as an indication of Albrecht the Elder's own skills as a draughtsman and his encouragement of his son.

The 1484 drawing, as Joseph Koerner observes, 'inaugurates his artistic biography as we know it'.[12] It opens our visual dialogue with Dürer as it is the first of a varied corpus of self-portraits made over four decades. Although conceived as an early demonstration of his skill, the drawing, through the later addition of the date and inscription, becomes a record of Dürer's precocious talent. Perhaps this is why he kept the drawing. He presented himself as a prodigy to family, friends and future viewers. The sketch later passed to his heirs and eventually to Willibald Imhoff, the grandson of Willibald Pirckheimer, his best friend. When painstakingly copied in 1576 by Hans Hoffmann (c.1545/50–1591/2), the portrait was no longer a simple drawing.[13] Rather, it had become an historic artefact by the century's leading German artist and a coveted treasure that Emperor Rudolf II (r. 1576–1612) acquired in 1588.

Drawings such as this eventually convinced Albrecht the Elder that his teenage son's talents made him better suited to be a painter. This certainly was not an easy decision, because in Nuremberg goldsmiths were more esteemed than painters. Unlike most German cities, Nuremberg had no guilds. After suppressing a craftsmen's revolt in 1348/9, the patrician government assumed

control of the city's trades.[14] Over time these were grouped into the sworn crafts and the free arts. The council tightly regulated the former, including goldsmiths, because of their economic importance. Members swore an annual oath of allegiance not to reveal trade secrets and not to leave Nuremberg without the government's permission. The council's rules for painters and sculptors, who belonged in the second group, covered the training of apprentices and the use of journeymen but otherwise encouraged rather open competition.

Although Dürer states in the *Family Chronicle* that his father felt their time together had been wasted since he switched careers, this stage of his education ultimately proved invaluable. His practice using such metal-cutting tools as a lozenge-tipped burin prepared him to make copper engravings a few years later. The experience also taught Dürer to think three-dimensionally. In his art and later theoretical writings he was intrigued by the challenge of how to convey space and the volumetric properties of objects using two-dimensional techniques such as perspective.

On 30 November 1486 Dürer began his three-year apprenticeship with Michael Wolgemut (13). Albrecht the Elder's choice was fortunate. Wolgemut, who lived just a few doors away at Burgstrasse 21, was Nuremberg's most successful painter.[15] He and other members of his shop, including Wilhelm Pleydenwurff, his stepson and partner, instructed Dürer in the mechanics of drawing, painting and composition. He learned by copying drawings and prints before eventually tackling three-dimensional models and portraiture. Like any young pupil, he ground colours, mixed and blended paints, prepared panels and canvases for use, added under-drawings to block out the composition and indicate shading patterns, and, finally, applied the different layers of paint and varnish. The portraits of his parents, created within only a few years, reveal how well and how quickly Dürer mastered these skills.

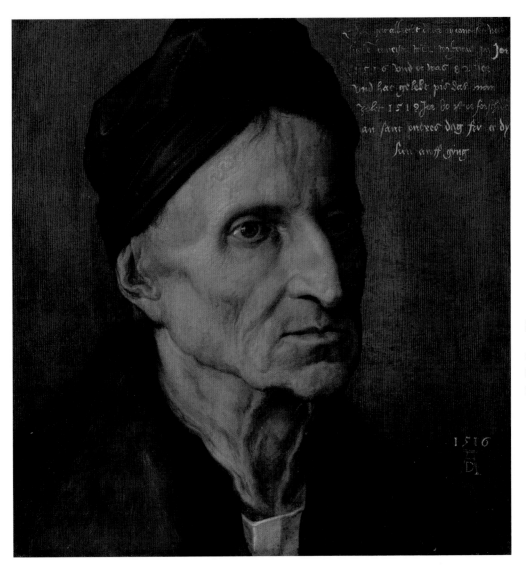

13
*Portrait
of Michael
Wolgemut,*
1516
Oil on
lindenwood;
29 × 27 cm
(11⅛ × 10⅝ in)
Germanisches
National-
museum,
Nuremberg

Wolgemut ran an integrated workshop employing painters, sculptors and, from at least 1482, carpenters. The atelier specialized in creating large-scale carved and painted retables, such as the *Peringsdörffer Altarpiece* (14), commissioned in 1486 for the Chapel of Saint George in Nuremberg's newly rebuilt Augustinian Cloister.[16] The basic configuration, quite common in south German retables, comprises: a predella housing a lindenwood statue of the recumbent dead Christ and painted shutters; a carved Lamentation in the shrine; three sets of folding wings with paintings of Christ's Passion (inner), the Nativity (middle) and Mary's life (exterior or closed setting); and an ornamental wooden superstructure with a sculpted Crucifixion group and, at the apex, a *Schutzmantelmadonna* (Virgin of Mercy). The individual panels reflect Wolgemut's style, if not always his own hand. He crowds his figures in the foreground, where they stand on a sharply tilted ground plane. Buildings and landscapes serve as mere backdrops for the narrative. This arrangement emulates relief sculpture, which emphasizes complex surface patterns of gesture and clothing rather than spatial articulation.

The seeds of Dürer's future artistic and financial success were nurtured during his years with Wolgemut, although he chose not to make sculpted altarpieces and he never employed many assistants. The 1,400 guilder payment that Wolgemut received in 1479 for his high altar in Zwickau's Marienkirche was almost three times more than Dürer ever received for a painting. Nevertheless, he learned the arts of painting and printmaking. During the 1480s and 1490s Wolgemut's shop produced high-quality woodcuts, most of which illustrated books published by Anton Koberger (1440–1513), who just happened to be Dürer's godfather and neighbour. For many years he lived at Burgstrasse 3. Koberger rented and, in 1489, purchased a large house for his business on the Egidienplatz across from the Benedictine monastery and school. According to Johann Neudörfer, another Burgstrasse (no. 16) resident who authored an invaluable account about Nuremberg's artists in 1547,

Koberger possessed twenty-four presses and employed one hundred workers.[17] He published around 250 titles, mostly illustrated, and established an efficient Europe-wide distribution system.

Two grand collaborations between printer and painter were conceived and initiated during Dürer's apprenticeship. Wolgemut's shop created ninety-six illustrations for Stephan Fridolin's *Schatzbehalter* (1491), a collection of edifying devotional texts, and 645 different blocks yielding a total of 1,809 woodcuts for the *Liber Chronicarum* (1493), or *Nuremberg Chronicle*.[18] The latter, mentioned in our Introduction, is a history of the world

14
Michael
Wolgemut
and workshop,
Peringsdörffer
Altarpiece,
c.1486
Sculpture and
painting, oil on
lindenwood.
Friedenskirche,
Nuremberg

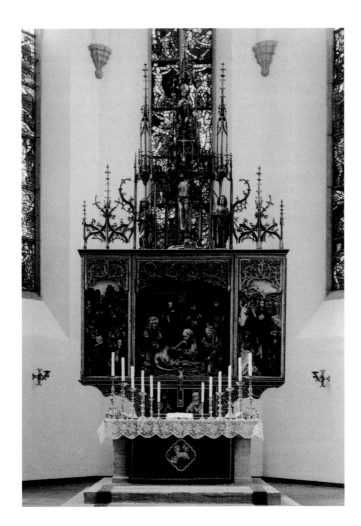

from its divine creation to 1493. The author was the physician Dr Hartmann Schedel, Wolgemut's neighbour at Burgstrasse 19. After Johann Gutenberg's forty-two-line Bible (Mainz, 1456), the first printed book using movable type, the *Nuremberg Chronicle* was the century's most ambitious publishing project. Documents indicate that in late 1487 or early 1488 an agreement existed between Schedel, Wolgemut and Pleydenwurff, Koberger and the two financial backers, Sebald Schreyer and his brother-in-law Sebastian Kammermeister. Schreyer, who lived at Burgstrasse 7, was the superintendent of Saint Sebaldus. Koberger published 1,500 Latin and 1,000 German copies. Its folio scale and sumptuous design intentionally rivalled illuminated manuscripts. The book could be purchased printed on parchment or on paper, either unbound or bound, and, at an additional cost, with colours added to the black-and-white illustrations.

Ultimately, it was the visual appeal of the woodcuts by Wolgemut and his shop that made the *Nuremberg Chronicle* so memorable. Besides the biblical and narrative scenes, the volume contained innumerable 'portraits' of historical figures from patriarchs to popes and emperors, as well as dozens of views of different cities from Europe to Asia Minor. Wolgemut and his collaborators pioneered a new type of civic imaging, since their woodcuts provided the earliest known views of most of these cities. While many town prospects were fanciful and sometimes a single view was reused for different cities, thirty-two of the depictions were fairly accurate. Their prospect of Nuremberg seen from the south (see 3) spreads impressively across two pages. Someone in the workshop developed an expertise in drawing outdoors, an ability that young Dürer soon would exploit for his own needs.

The opening woodcut shows God the Father enthroned (15). His raised right hand blesses and seemingly points the viewer to the pages that follow. Wolgemut, whose drawing for this page, dated 1490, is in the British Museum in London, exhibits his abilities as

a woodcut designer. The billowing contour lines of God's mantle and the crisp folds of his robe energize the figure. The highlighted passages contrast with the varied hatched and cross-hatched shadows. Their relative simplicity is juxtaposed with the details of the head and beard. Wolgemut surrounds God with scalloped clouds and an energetic frame consisting of flanking columns topped by infants climbing amid the plant tendrils. At the bottom two wildmen hold blank coats of arms on to which a future owner

15
Michael Wolgemut,
God the Father
Woodcut in
Hartmann
Schedel, *Liber Chronicarum*
(Nuremberg,
1493), folio 1
verso;
47 × 32.5 cm
(18½ × 12¾ in)

could add his or her own heraldry. This large image represented the apex of the art of the woodcut in Europe – at least until Dürer revolutionized the medium a few years later.

Identifying Dürer's specific participation in this project is problematic. Several woodcuts, notably the *Dance of the Resurrected Skeletons* (fol. 264 in the Latin edition), have been ascribed to the young pupil. At the very least, during his

apprenticeship with Wolgemut, Dürer learned to design and make woodcuts. He witnessed how a composition is either drawn on or transferred to the surface of a woodblock (see 19). Scholars have vigorously debated whether Dürer cut some of his own pearwood blocks for woodcuts, such as that of *Samson and the Lion* (see 45), during the 1490s. Unfortunately this cannot be proved. Wolgemut, and later Dürer, hired specially trained woodworkers, known as *formschneider*, to cut their blocks. As a pupil he probably wielded the knife, if for no better reason than to master the technical process. This knowledge would be vital as he started designing his own prints and instructing his assistants in how to cut the blocks in order to achieve specific visual effects. While in Wolgemut's studio or during his visits to Koberger's shop Dürer studied inks, paper and the printing process. From his mentors he glimpsed the artistic and economic possibilities of the print. A few years later Dürer took full advantage of Koberger's network of agents for distributing his own prints and books.

Dürer admired his teacher. Perhaps Wolgemut first recognized the youth's drawing skills and convinced Albrecht the Elder that his son's talents were better suited for a career as a painter. In 1516 Dürer portrayed Wolgemut (see 13) for his own collection.[19] Three years later he added an inscription recording the latter's death on Saint Andrew's day at the age of eighty-two. Dürer was doubtless struck by the coincidence that Wolgemut died on the same day, 30 November, as he had begun his apprenticeship in 1486. Not all memories of his training were positive. In the *Family Chronicle*, quoted above, he recalls the harsh treatment he experienced at the hands of some of Wolgemut's other apprentices and assistants. *The Cavalcade* (16) is one of three related drawings that Dürer made during his final year with Wolgemut.[20] A group of riders bunched in the foreground prepare to head down a path perhaps *en route* to the sketchy castle at the back left. Dürer's interest was not their destination but their varied poses. Horses and riders are presented from the front, the side, the rear and at a diagonal. The

16
The Cavalcade, Dürer dated it 1489
Pen and ink; 20.9 × 30.1 cm (8¼ × 11⅞ in) Kunsthalle, Bremen (currently held by the Russian Federation in Moscow)

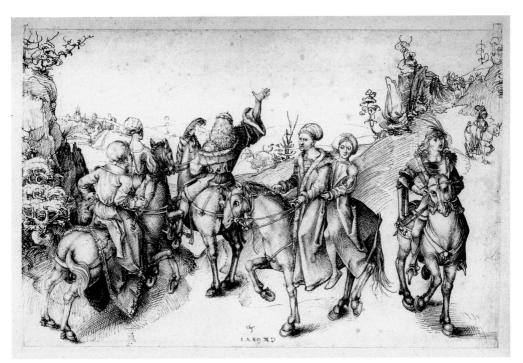

two galloping horses at the left threaten to crash into the central
rider. The riders at the right are awkwardly integrated into the
composition. Dürer has not yet mastered how to draw a horse
in motion, as evidenced by the oddly curved front right leg of
the frontally foreshortened horse at right. One can also fault the
inconsistent modelling. Such carping about his youthful failings,
however, misses the point. Dürer is clearly ambitious. His complex,
multi-figure scene reveals too his growing familiarity with
the drypoints of the Housebook Master (c.1470–1500) and the
engravings of Martin Schongauer (c.1435/50–1491; see 18).
Dürer finished his apprenticeship with Wolgemut in late 1489.
Presumably he completed the portraits of his parents, especially
his father's, in early 1490 before departing on his *wanderjahre*
around Easter.

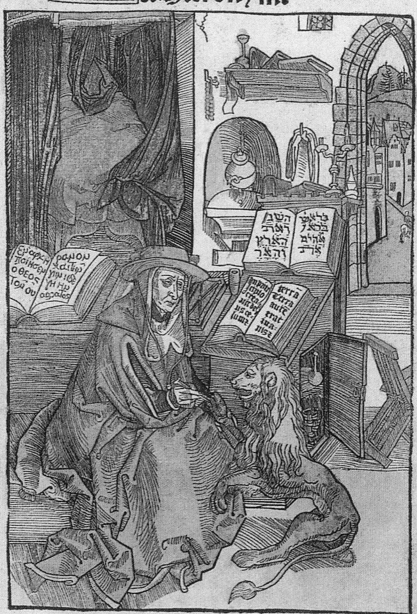

In Basel's Kunstmuseum is a woodblock depicting Saint Jerome in his study extracting a thorn from a lion's paw. The resulting woodcut (17) serves as the title page of the *Epistolare beati Hieronymi*, or *Letters of Saint Jerome*, published by Nikolaus Kessler on 8 August 1492 in Basel.[1] The reverse of the woodblock is prominently inscribed 'Albrecht Dürer von nörmergk'. If the handwriting is Dürer's own, then this is his first known signed and datable print, one executed not in Nuremberg but in Basel, where Dürer lived while a journeyman. However, if the signature was penned by someone else, the prevailing theories about his activities in Basel are open to reconsideration. Before examining this woodcut further, let us consider the evidence for Dürer's *wanderjahre*.

Writing in his *Family Chronicle* in 1524, Dürer remarks: 'When I had finished my service, my father sent me off, and I stayed away four years till he called me back again. As I had gone away in the year 1490 after Easter, then I came back again in 1494, as it is reckoned, after Whitsuntide.'[2] Most cities required a period of travel following the completion of an artist's apprenticeship. This entailed working as a bachelor journeyman in another city for a year or so. The laudable practical intention was to broaden one's artistic horizons. The young man would return home with new expertise that, ideally, would enrich the local artistic community. Dürer's wanderings lasted longer than those of most artists. He left Nuremberg shortly after Easter, on 11 April 1490, and did not return until just after Pentecost, 18 May 1494. In the autumn, just months after marrying Agnes Frey, he left Nuremberg again for Venice, where he stayed until some time the following spring.

The *Family Chronicle* tells us when Dürer left and returned to Nuremberg, but not where he travelled. The humanist Jakob

Wimpheling observes in his *Epithoma rerum Germanicarum*, published in Strasbourg in 1505 but written three years earlier, that Dürer was a disciple of Martin Schongauer in Colmar.[3] This claim is clarified by Christoph Scheurl, one of Dürer's friends and Burgstrasse neighbours (no. 10), in 1515. Scheurl remarks:

> Then, when he had travelled to and fro in Germany he came to Colmar in the year 1492, and there Caspar and Paulus, goldsmiths, and the painter Ludwig, and similarly in Basel, Georg, all four of whom were brothers of 'Schön Merten', kept him good company. But, not only did he not study with [Martin Schongauer], he never saw him in all his life, although he had greatly wished to do so.[4]

In 1547 Johann Neudörfer states that Albrecht the Elder sent his son, then thirteen, to study with Schongauer, but the latter's death prompted the youth to return to learn from Wolgemut instead.[5] Neudörfer muddles this point but correctly mentions that Dürer spent three years with Wolgemut before travelling across Germany.

These and other sources inform us that Dürer arrived in Colmar some time after Schongauer's death on 1 February 1491 in nearby Breisach. Schongauer's brothers, who were goldsmiths and painters, welcomed him. They probably sent Dürer to their brother Georg, a successful goldsmith and since 1485 a resident of Basel, where there were more opportunities for the young Nuremberger. If the *Saint Jerome* is by Dürer, then he must have been active in Basel by early 1492.

Martin Schongauer was Germany's foremost engraver. He monogrammed 116 known engravings, all of which survive in multiple copies. Numerous replicas by other printmakers, such as Israhel van Meckenem (c.1440/50–1503) of Bocholt, and compositional reproductions in other media, from painting and sculpture to furniture and ceramics, attest to his art's broad geographical reach. Taught to use the burin by his father and to make woodcuts by Wolgemut, Dürer's interest in learning the

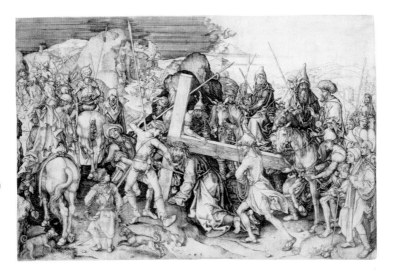

18
Martin
Schongauer,
*Christ
Carrying
the Cross,*
c.1475–80
Engraving;
28.6 × 43 cm
(11¼ × 16⅞ in)

art of engraving is hardly surprising. Around 1490 Nuremberg
possessed no significant engraver, and practitioners in Bamberg
and Würzburg were second-rate. Most early German engravers,
including Master E. S. (fl. 1450–67), were trained goldsmiths.
Schongauer, the son and brother of goldsmiths, was an accomplished
painter. This shows in his engravings, which are often richly pictorial.
Had Dürer travelled straight to Colmar in 1490, he would have
been directed to nearby Breisach, where Schongauer was painting
the colossal *Last Judgment* mural in Saint Stephan's Church.

Consider the appeal to young Dürer of Schongauer's *Christ
Carrying the Cross* (18).[6] In size and ambition this engraving rivals
a painting but, of course, with the benefit that it can be replicated.
Over fifty figures progress through a sweeping landscape that
extends clockwise from still sunny Jerusalem on the right to the
darkening gloom of Golgotha opposite. In the centre Christ falls
under the weight of the cross. He looks sadly not at his frenzied
tormentors but at the viewer, who by implication stands just
outside the picture plane. Much like the child at lower left, we
stare in morbid fascination. Christ's head is located before the
intersection of the arms of the cross, which is the dominant stable
feature within the busy composition. Schongauer's epic scene

employs simultaneous narrative. Time is frozen. This permits the viewer to scrutinize every figure. Some soldiers curse and beat Christ; the leaders converse on horseback at right; other soldiers escorting the two thieves walk ahead of Christ; a solitary woman, Saint Veronica, patiently waits for Christ to pass by; Mary and John the Evangelist join other grieving figures slightly removed from the road. Dürer, who had already signalled his equine interest in *The Cavalcade* (see 16), carefully studied the foreshortened horses receding on the left and the trio appearing out of the crowd at right. Schongauer's familiarity with Netherlandish art, especially the paintings of Rogier van der Weyden (c.1399–1464), affected the composition's unity, its accomplished spatial recession and the integration of the narrative into a convincing continuous landscape. The traditional Netherlandish fascination with naturalistic details is fully evident in Schongauer's costumes and in such painstaking features as the wood graining of the cross.

Schongauer's engraving revealed the medium's pictorial potential to Dürer. The simple contour and shading lines of Wolgemut's *God the Father* woodcut (see 15) are now replaced by a myriad of lines capable of differentiating textures, such as the firmness of the wooden cross or the supple fabric of Christ's robe. This robe consists of long, flowing contours; short curved marks to indicate three-dimensionally how fabric bunches at the folds; small marks formed by making little nicks in the copper plate, to suggest surfaces even in highlighted areas; and a wealth of hatching and cross-hatching. These shading lines vary from a few parallel or concentric strokes to dense webs implying deep shadows and, importantly, convincing spatial recession. Schongauer imposed consistent lighting throughout. The shadows cast by the raised horses' hoofs, participants' feet and even the running dog in the foreground subtly reveal his virtuosity.

It is unknown how long Dürer remained in Colmar, where he had access to Schongauer's paintings in local churches and, perhaps, to

his drawings. Dürer owned a drawing of *Christ Blessing*, on which he inscribed, 'This was made by handsome Martin in the year 1469.'[7] Another Schongauer drawing may have been a model for Dürer's *Self-Portrait* of 1500 (see 75, 76). Although Dürer's first known engraving, *The Ravisher* (see 52), dates to around 1495, he may have experimented informally with this technique during his *wanderjahre*. Engraving quickly became an integral part of his creative arsenal.

Where was Dürer between the time of his departure from Nuremberg in 1490 and his arrival in Colmar in late 1491 or early 1492? Scheurl and Neudörfer say he wandered around Germany but offer no details. Some scholars propose that he first travelled to the Netherlands.[8] After all, Albrecht the Elder had worked there for many years. In their biographies of Dürer, Karel van Mander (1604) and Joachim von Sandrart (1675) claim he visited Haarlem. Unfortunately, suggestions that he was influenced by Hans Memling (c.1440–1494) in Bruges or Geertgen tot Sint Jans (fl. 1475–95) in Haarlem have no secure basis in Dürer's own art. Furthermore, there are no references indicating past familiarity with this region and its cities in his detailed *Netherlandish Journal* of 1520–1. Given his interest in prints, he would more probably have been attracted to the Swabian publishing centres of Augsburg and Ulm or to Mainz on the middle Rhine, where the Dutch woodcut designer Erhard Reuwich (c.1455–c.1490) resided, or, a bit further south, Heidelberg, the likely abode of the influential Housebook Master.

The *Saint Jerome* woodcut is the linchpin for all of the various Basel book illustrations attributed to Dürer. The signature on the woodblock has been challenged on the grounds of its odd spelling of Nuremberg ('nörmergk'), its calligraphy and handwriting, and the lack of similar signatures on any of his other autograph woodblocks.[9] If the writing is not Dürer's, was it penned by someone who knew his authorship or, less honestly, by someone

hoping to enhance its value? Dürer's oldest monogrammed woodcuts (see 42), independent prints dating to around 1496, offer little help since they are far larger and more ambitious. *Saint Jerome* is more pictorially complex than any earlier Basel woodcut. Its artist either moved to Basel or sent his design from another town. Based on some stylistic similarities with woodcuts by Wolgemut's atelier, I favour an attribution to Dürer. Jerome interrupts his writing to aid the injured lion. Like his teachers, the young artist employs bold contour lines coupled with a system of rather schematized shading lines. Some curve concentrically, suggesting the rounding of Jerome's body beneath the cloak, yet the figures still read as rather flat. The bedroom and townscape visible through the window exhibit conflicting perspectival recessions. In spite of the obvious awkwardness of its parts, some of which may be blamed on an inexpert *formschneider*, the overall scene conveys an appealing intimacy.

Dürer focused on book illustrations while in Basel.[10] He was aided by Anton Koberger, his godfather, who certainly put him in touch with Johannes Amerbach (c.1445–1513), his partner in Basel and one of its foremost publishers.[11] Years later, on 20 October 1507, Dürer wrote a short letter asking Amerbach what new books he had printed. The warm tone and personal content of the letter suggest a long-term friendship with Amerbach and his wife. Their association began in 1492, when Amerbach commissioned Dürer to design woodcuts for a new edition of the comedies of Terence (c.190–159 BC).[12] The ancient Roman author's text enjoyed renewed popularity, especially among Latin teachers and students, during the later fifteenth and sixteenth century. The edition was to contain at least 147 woodcuts. Before its completion, however, it was trumped by the publication of the comedies by Johann Trechsel in Lyon in 1493. Amerbach abandoned the project but retained the pearwood blocks. Most of the 132 blocks, still in Basel (Kunstmuseum), are uncut. Each has a simple pen-and-ink scene drawn on the white-grounded surface. Some of the compositions are attributed

to Dürer because of their style or the reappearance of certain
gestures, costumes or details in other works from the 1490s. Most
are by weaker artists who patterned their scenes after Dürer's.

The title design (19) depicts the poet Terence writing outdoors.
Dürer makes no effort to dress Terence in Classical attire other
than the poet's laurel wreath. The handling of the drapery and
shading is akin to the Basel *Saint Jerome*, although simpler
because of the differences in scale. The Roman poet's profile pose,
his extended right foot, the linear interplay of his drapery and
his placement before a broad vista were inspired by Schongauer's
Saint John the Evangelist on Patmos (see 46). Dürer opted for
a horizontal format to accentuate Terence's concentration. The
attributions to Dürer of the woodcuts in Geoffroy de la Tour
Landry's *Der Ritter vom Turn* (1493) and Sebastian Brant's *Das
Narrenschiff* (*The Ship of Fools,* 1494), both published by Johann
Bergmann von Olpe, are doubtful.[13]

Some time in 1493 Dürer moved down the Rhine to Strasbourg.
Although he may have worked for local publishers, his focus
shifted to drawing and painting. The 1573/4 inventory of Willibald
Imhoff's collection in Nuremberg includes two relevant entries:
a parchment portrait of an old man, who was Dürer's master in

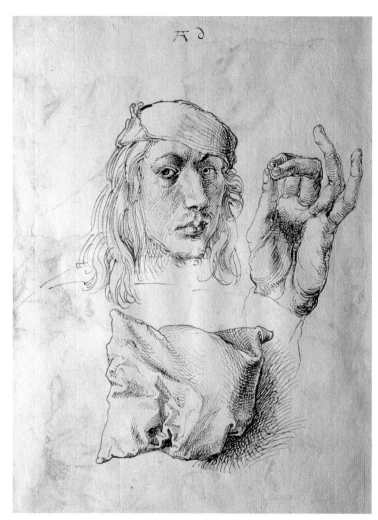

20
Self-Portrait and Pillow Study, 1493
Pen and brown ink; 27.8 × 20.2 cm (11 × 8 in)
Metropolitan Museum of Art (The Robert Lehman Collection), New York

21
Self-Portrait, 1493
Oil on parchment mounted to panel; 56.5 × 44.5 cm (22¼ × 17½ in)
Musée du Louvre, Paris

Strasbourg, and its pendant, a small portrait in oils of a woman, painted in Strasbourg in 1494.[14] These portraits, which could be rolled up for easy transportation, apparently remained in Dürer's possession until his death. The identity and even the profession of the Strasbourg artist are unknown.

His activities become clearer in 1493, when he began monogramming and/or dating some works.[15] These include a two-sided drawing of a simple pillow (20).[16] On one side of the sheet he sketched six studies of this pillow, which he punched and pushed into different shapes so that he could explore how light played across the

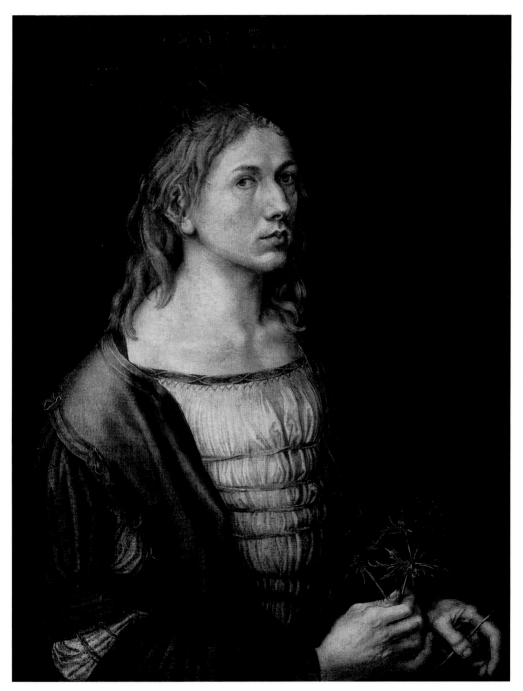

crumpled surfaces. After drawing one more pillow on the verso, he added a quick self-portrait and a separate rendering of his left hand with the index and middle finger bent touching the thumb. He wears a standard journeyman's cap and the start of a wispy beard. Unlike the self-portrait of 1484 (see 12) or his slightly bewildered-looking likeness in Erlangen, done around 1491, Dürer now exudes confidence.[17] With a minimum of lines the head seems solidly three-dimensional and the lighting is coherent.

In the same year Dürer produced his first known painted *Self-Portrait* (21).[18] The New York drawing was probably one of several preparatory studies for this. Like the portraits of the Strasbourg artist and his wife, this was done in oils on parchment. In about 1840 a restorer transferred it to canvas. Dürer, softly illuminated, seems to emerge from the black background. He is seated with his hands resting on the edge of a table or ledge. The artist clearly delights in his own appearance, including his long reddish-blond locks and handsome face. As in the drawing, his nascent beard is limited to a few strands of hair. The red trim of his robe and the twisted red strands across his shirt animate the otherwise still figure. He sports a stylish red beret with a somewhat foppish tassel.

Dürer's picture recalls Wolgemut's *Portrait of a Young Man* (22).[19] The young man's pose, general clothing style, placement against a dark neutral ground and even the inclusion of an inscribed date at the top of the composition anticipate Dürer's Strasbourg likeness. This comparison, however, stunningly illustrates how quickly Dürer surpassed his master and how far he had progressed since painting his parents in 1489–90. Wolgemut's portrait appears flat. Its slightly too large head and shoulders fit awkwardly on the body. Wolgemut's lighting is very generalized, whereas Dürer already excels in chiaroscuro modelling. Compare how differently the two artists treat the sitters' right shoulders. Wolgemut used unmodulated patches of black, grey and flesh tones. Dürer

highlighted the shoulder by varying the colours of the robe, adding slight folds to the fabric and exploiting the lively curving movement of the red trim. These plausibly imply the physical structure of his shoulder and arm. Much as Dürer did in his 1484 drawing, Wolgemut applied a clear bold stroke of black paint to accentuate the contour of the man's nose and to separate the two halves of his face. Dürer softened this line, employed light to modulate the colouring of the exposed side of the nose and cast a faint shadow just above the mouth. His powers of naturalistic observation greatly exceed those of his master.

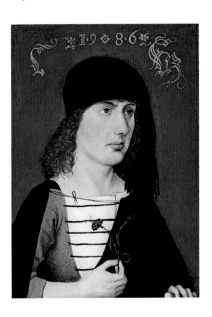

22
Michael
Wolgemut,
Portrait of a
Young Man,
1486
Oil on wood;
33.4 × 23 cm
(13⅛ × 9 in)
Detroit
Institute
of Arts

In his hands Dürer holds a thistle sprig identified as eryngium or, more recently, sternkraut (Aster Atticus)[20]. Peter Strieder cites its possible devotional meaning, since the spiky leaves recall Christ's crown of thorns.[21] More commonly, it is read autobiographically. Wolgemut's gentleman carries a red carnation, a flower often represented in betrothal portraits. While Dürer was in Strasbourg, his parents negotiated his marriage to Agnes (1475–1539), Hans Frey's daughter. The inscription at the top of his picture reads: 'My affairs will go [or fare] as ordained from above' ('My sach die gat / Als oben schtat'). Was Dürer referring to God's direction,

or astrological effects, or to fickle Fortune's influence, or, perhaps with a hint of resignation, to the wishes of his parents? If he made his self-portrait as a gift to his future bride, then eryngium, the powdered roots of which were an aphrodisiac, may convey a wish for success in love. Although this is the most probable reading, it has been suggested that the rootless plant alludes to the artist's current itinerant life and uncertainties.[22]

Dürer was back in Nuremberg shortly after Pentecost, 18 May 1494. Thirty years later in the *Family Chronicle* he wrote: 'And when I returned home, Hans Frey made a deal with my father and gave me his daughter, Miss Agnes by name, and with her he gave me 200 florins, and held the wedding – it was on Monday before Margaret's Day [7 July] in the year 1494.'[23] During this period, parents arranged most marriages. Besides his skills as a metalworker, Hans Frey was 'a clever and charming man and the best harp player in town as well as a good singer'.[24] His wife, Anna Rummel (d. 1521), belonged to one of Nuremberg's oldest and once wealthiest families. Probably that summer Dürer sketched 'mein Agnes' seated at a table resting her chin on the back of her right hand (23).[25] One can imagine Dürer catching her in an unguarded moment or telling her to hold this particular pose. Rapid pen stokes deftly capture her salient features. The informality of Agnes's portrait is unprecedented in surviving European art of the period. Indeed, the drawing anticipates the intimate sketches that Rembrandt (1606–1669) made of his wife, Saskia, in the later 1630s.

Efforts to see Agnes here as sullen miss the mark. It is but a simple study on which the artist proudly, it seems, wrote 'mein Agnes'. This raises the issue of how much scholars should rely on the incomplete textual and visual evidence to make judgments about Agnes and about their marriage. This is not an exercise commonly practised with other German artists of this period. In his classic monograph on Dürer, Erwin Panofsky weaves a highly

unflattering 'portrait' of Agnes, one that persisted through most of the twentieth century.[26] According to his view, she evolved from being 'fairly good-looking and harmless' as a young woman into a 'forbidding lady', 'a real termagant who did everything in her power to make his [Dürer's] life miserable and practically brought about his death by forcing him to work incessantly to increase their income'. Panofsky concludes that theirs was a loveless

23
*My Agnes
(mein Agnes),*
c.1494
Pen and
black ink;
15.7 × 9.8 cm
(6⅛ × 3⅞ in)
Albertina,
Vienna

marriage. 'Agnes Frey thought that the man she had married was a painter in the late medieval sense, an honest craftsman …; but to her misfortune her husband discovered that art was both a divine gift and an intellectual achievement requiring humanistic learning, a knowledge of mathematics and the general attainments of a "liberal culture". Dürer simply outgrew the intellectual level and social sphere of his wife, and neither of them can be blamed

for feeling uncomfortable. … He lived in a world apart from hers which filled her with misgivings, resentment and jealousy.' Panofsky based his remarks on the information that Dürer normally travelled alone, including soon after their marriage, that when Agnes accompanied him to the Netherlands in 1520–1 they rarely ate dinner together, that the artist's private letters to Willibald Pirckheimer, penned in Venice in 1506, include a few joking references to his wife, that the couple was childless, and that in November 1530, just months before his own death, Pirckheimer wrote but never sent a long letter to Johann Tschertte, an imperial architect, that included disparaging comments about Agnes, 'the enemy of all who were kindly disposed to her husband'.[27]

This litany of opinions can be criticized item by item, as Corine Schleif has done insightfully.[28] The surviving evidence shows that Agnes was very much Albrecht's partner throughout their life together. The letters between Albrecht and Agnes, written during his second trip to Italy in 1506–7, are documented but do not survive. These demonstrate that Agnes was literate, even if the lost letters cannot serve as a counter-balance to the artist's correspondence with Pirckheimer. For our purposes it is more relevant to consider Agnes's role as an artist's wife. As Dürer's career blossomed, so did Agnes's responsibilities. When Albrecht the Elder wrote to Barbara from Linz in 1492, he addressed her as a 'Goldschmidin' (or female goldsmith), his dear housewife.[29] Barbara was not actually a goldsmith, since Nuremberg's craft regulations precluded women from being masters in most trades. Rather, this alludes to her full participation in managing various aspects of the family workshop. Agnes was responsible for a household. This entailed feeding and often housing other family members, who in later years included Barbara, Dürer's brother Hans, apprentices, journeymen, maids and the occasional visiting patron or friend. Agnes, sometimes helped by her mother-in-law, sold her husband's art, especially prints, at their home workshop and elsewhere, including the Frankfurt fair in the autumn of 1505

and Easter 1506.[30] In a letter of 2 April 1506 to Pirckheimer from
Venice, Dürer remarked: 'Tell my mother to be ready to sell at the
Crown-Fair [*Heiltumsfest*]. I am arranging for my wife to have
come home by then; I have written to her about everything.'[31]
Agnes was away from Nuremberg selling his prints but would
soon be back to help his mother during the town's spring festival,
which was always a time of good business. The letter expressed full
confidence in Agnes's professionalism. Such trips were probably
common. When she and Albrecht travelled to the Netherlands
in late July 1520, the toll-taker at Lahnstein, which is on the east
bank of the Rhine just south of Koblenz, 'gave me also a tankard
of wine, for he knew my wife well and was glad to see me'.[32] This
suggests that Agnes journeyed frequently, perhaps even as far
as Cologne or the book fairs in Leipzig or Strasbourg, to sell her
husband's wares. Unlike Albrecht the Elder, who from 1486 rented
a shop near Nuremberg's city hall, his son was content to limit
his retail sales to his house. Agnes guarded her husband's ideas
and art after his death in 1528. As noted in the second Latin
edition of the *Art of Measurement* (1538), Agnes initiated the
project to have Albrecht's German treatise translated into Latin.[33]
Parsing out their private interactions descends into the realm of
mere speculation.

Following their marriage, where did the young couple live? The
Freys owned a double house on the Hauptmarkt, a prime address
for any artist. Dürer enjoyed cordial relations with his in-laws.
After Hans Frey's death in 1523, which Dürer noted with sadness
in the *Family Chronicle*, Agnes received only about half the
inheritance awarded to her sister Katharina Zinner, since at an
earlier date or dates her father had given her money.[34] Agnes's
dowry provided Dürer with enough seed money to establish his
own workshop and, perhaps, to rent a house. In all likelihood,
however, Dürer resided and worked in his father's house on
Burgstrasse until he acquired his own residence in June 1509. In
describing Albrecht the Elder's death in 1502, Dürer mentioned that

a maid ran up to his room to tell him of the change in his father's condition but that the old man died before he could reach him.[35] He lived either upstairs or in a rear section of his father's house.

Within two or three months of his wedding Dürer headed for Italy. There is no firm textual record for this trip beyond two brief references. Writing to Pirckheimer from Venice on 7 February 1506, Dürer remarks that 'those things [artists or works of art] which so pleased me eleven years ago please me no longer'.[36] In 1508 Christoph Scheurl of Nuremberg notes that 'not long ago, when he [Dürer] travelled once again to Italy, he was greeted in Venice and in Bologna as a second Apelles; at which occasions I often served him as an interpreter'.[37] The very lack of a documentary trail and the uncertain dating of several works prompted Katherine Luber to renew the thesis that Dürer went only once to Italy, from late 1505 to early 1507.[38] Nonetheless, I am inclined to accept the validity of Dürer's statement since his art opened up thematically and stylistically in ways that are difficult to explain if he had remained in Nuremberg. Numerous drawings (see 31) certainly done in Italy are dated 1495. The immediate catalyst was the plague, which reportedly killed 805 residents of Nuremberg in September and October 1494.[39] Neighbours, including Hartmann Schedel and Anton Koberger, briefly left town. Dürer may have taken Agnes with him as far as Innsbruck, where she had relatives.

Earlier German artists rarely travelled to northern Italy; however, Dürer's choice is not surprising. During his *wanderjahre* he had already journeyed to the Rhine. The lure of Italy may have been stoked by his contact with prints by Andrea Mantegna (1431–1506; see 33), among others, circulating in Basel or Nuremberg. On returning to Nuremberg in 1494, Dürer found Wolgemut engaged on a new project, the *Archetypus triumphantis Romae*.[40] Sebald Schreyer, the financial backer of the *Nuremberg Chronicle*, commissioned Peter Danhauser, a local lawyer and astrologer, to

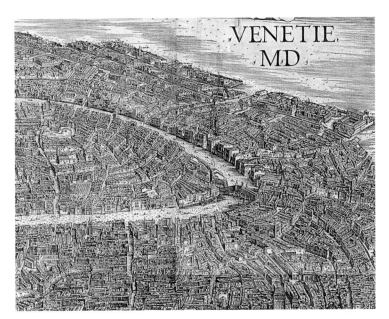

24
Jacopo de' Barbari(?), *View of Venice* (detail with the Rialto bridge, Fondaco dei Tedeschi, and church of San Bartolomeo), 1500. Woodcut; whole: 139 × 282 cm (54¼ × 111 in)

gather a compendium of Classical texts and Wolgemut to prepare the accompanying illustrations. The project was never finished, since Danhauser moved to Vienna in 1497. Wolgemut's extant drawings and woodcuts reveal that his designs for the nine Muses, among others, were modelled on Ferrarese engraved *tarocchi*, or tarot cards, of about 1465–70. Dürer copied several. These same Italian prints may have inspired the designs for Schreyer's *stube* or meeting room of his house. In 1495 he had an artist, probably from Wolgemut's workshop, paint the walls with a scene of Apollo surrounded by the nine Muses, seven ancient wise men and half-length portraits of Schreyer, Danhauser, Conrad Celtis and Petrus Schoberlein.[41]

Nuremberg enjoyed well-established business ties with Venice, a city with over 100,000 residents. Its merchants comprised the largest contingent of the Fondaco dei Tedeschi, the trading centre of the German 'nation' adjacent to the Rialto bridge in the heart of Venice (24).[42] They stayed in hostels or took up residence in the neighbourhood surrounding the Fondaco and the Campo San Bartolomeo, the location of the German church. During

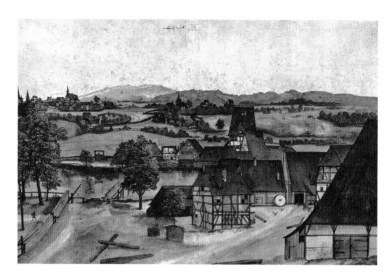

25
*Wire-Drawing
Mill*, c.1494
Watercolour
and body-
colour;
28.6 × 42.6 cm
(11¼ × 16¼ in)
Kupferstich-
kabinett, Berlin

26
*View of
Innsbruck*,
1494–5 (or
1496[?])
Inscribed
'Isprug'
Watercolour
on paper;
12.7 × 18.7 cm
(5 × 7⅜ in)
Albertina,
Vienna

Dürer's lifetime Venice remained Europe's gateway to the eastern Mediterranean and Asia. Most German merchants engaged in exporting luxury wares, including silks and other fine fabrics, jewellery, spices, wine and Venetian glass. The large, semi-permanent German community included printers, metalworkers, jewellery makers, musical instrument makers and a host of other trades. Anton Koberger may have encouraged his godson to travel to Venice. He enjoyed a virtual monopoly on the German distribution of Classical and humanistic texts printed in Venice, especially those of Aldus Manutius, Italy's leading publisher.[43] His agent was Anton Kolb, who in 1500 published the monumental bird's-eye *View of Venice* attributed, uncritically, to Jacopo de' Barbari (fl. 1497–1516).[44]

Given the rigours of transalpine travel, Dürer probably accompanied one of the frequent armed merchant convoys that journeyed between the two cities. Although the 700-kilometre (435 mile) trip could be covered in about five days under extreme circumstances, eight to about fourteen days was normal, depending on the route, weather and travellers' inclinations. After passing through Augsburg, Mittenwald and Innsbruck, one crossed the Tyrolean Alps using the Brenner Pass and slowly descended southward. Travellers

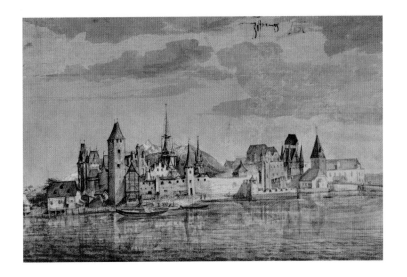

then had several options. A longer but easier route went through
Trent to Verona and then eastwards through flatter landscape to
Padua and Venice. At Trent one could also follow the Val Sugana
southeast towards Treviso to Venice. A third choice involved taking
the road from Fortezza (Franzensfeste), just south of the pass,
eastwards through Brunico (Bruneck) and Dobbiaco (Toblach)
before turning south to Conegliano, Treviso and Venice.

Dürer's itinerary is the subject of unusual debate since he made
watercolours of some of the towns and country views along his
route.[45] At least thirteen of these, all undated, survive. Questions
about their order, the maturation of his drawing skills and his
intentions in making them remain partially unresolved. Dürer's
interest in landscapes and cityscapes was stimulated as an
apprentice in Wolgemut's shop, where he witnessed the creation
of the *vedute* or city scenes illustrating the *Nuremberg Chronicle*
(see 3). There was already an existing tradition in Franconian
painting of including detailed city views in the backgrounds of
religious scenes, as may be observed in the pictures by Hans
Pleydenwurff (fl. 1457–72), Wolgemut's wife's first husband,
and in the Master of the Krell Altar's *Saint Bartholomew
Altarpiece* (c.1480) in Saint Lorenz in Nuremberg.[46] Neudörfer

notes that Dürer made portraits of people, landscapes and cities ('Conterfetten der Leute, Landschaften und Städte') during his *wanderjahre*.[47] Gauging the accuracy of this remark is difficult, but it is at least plausible since Dürer apparently drew a group of four watercolours of Nuremberg's environs, including the *Wire-Drawing Mill*, during his brief return home in 1494 (25).[48]

Seated on the north bank of the River Inn, Dürer sketched the Tyrolean capital of Innsbruck with the snow-topped peaks of the Waldrast visible to the south (26).[49] Other than his own Nuremberg watercolours, there is no obvious Northern European precedent for this exquisite scene. Dürer probably learned watercolour from a *Briefmaler*, one of the specialists Wolgemut employed to paint single woodcuts and book illustrations. This was a practical technique for Dürer as he travelled, since the materials (paper, pigments mixed with gum arabic, an adhesive binder and water) are lightweight, readily portable, easy to use and quick-drying. Yet no earlier artist is known to have sketched outdoors with watercolours. Dürer carefully records the city's profile with its conglomeration of towers and roofs of varying shapes bound together by the fortified walls. The Kräuterturm with its red roof stands in the left foreground before the original stepped façade of Saint Jakob's. The tall tower of the Wappenturm is covered with scaffolding. On the right is the castle precinct, of which Dürer made two separate watercolours, and finally the Inn bridge.

Dürer here sought much fuller pictorial effects than for the city views in the *Nuremberg Chronicle*, which were probably sketched in pen and ink. Varied horizontal brushstrokes mimic the swift current and shifting surface lighting of the river. The reflections of the buildings and walls reach almost across the water to the place where the artist and viewer look on. The density of naturalistic detail in the lower half of the composition is then beautifully juxtaposed with the light, breezy openness of the sky. Dürer exploited the way his brushstrokes leave varying wavy patterns

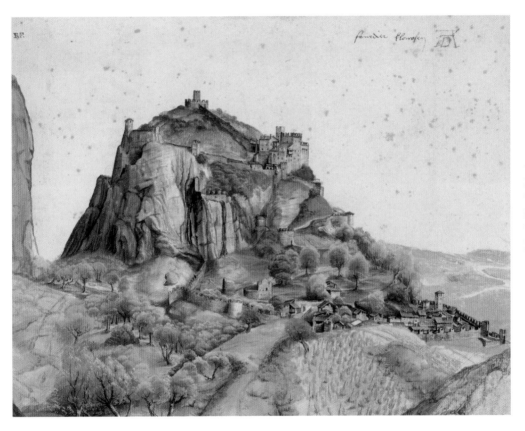

27
View of Arco,
1494–5
Watercolour
and body-
colour;
22.3 × 22.2 cm
(8¼ × 8¼ in)
Musée du
Louvre, Paris

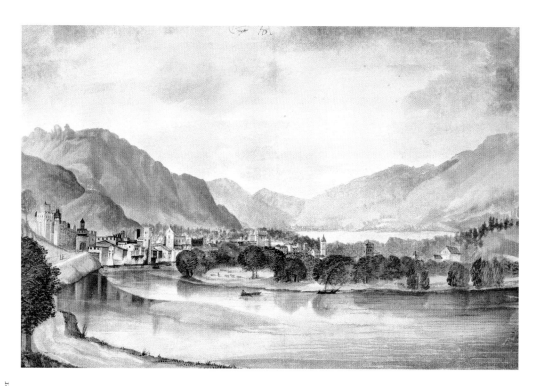

and intensities of blue as he dragged the bristles over the surface of the white paper. The lighter tones just above the city and mountains imply recession. Darker clouds, strokes of grey applied over the blue, sweep slowly through the valley. The handling of the washes gives the sky a convincing insubstantiality as the clouds will seemingly soon change their positions and shapes. The artist fully understood how the atmospherics of sky and water transform this scene from being a mere view into a believable record of an instant in time.

During his journeys to and from Venice the Nuremberg master sketched Chiusa (Klausen), Arco (27), Trent (28) and Segonzano as well as ruined huts, watermills, Alpine paths and cliffs along his route. Only rarely did these drawings serve as models for future works, such as the lost watercolour of Chiusa that he repeated in the *Nemesis* (see 72). His approach to these landscapes changed according to his interests and, quite conceivably, the amount of

28
View of Trent,
1494–5
Watercolour
and body-
colour;
23.8 × 35.6 cm
(9¼ × 14 in)
Kunsthalle,
Bremen
(currently held
by the Russian
Federation in
Moscow)

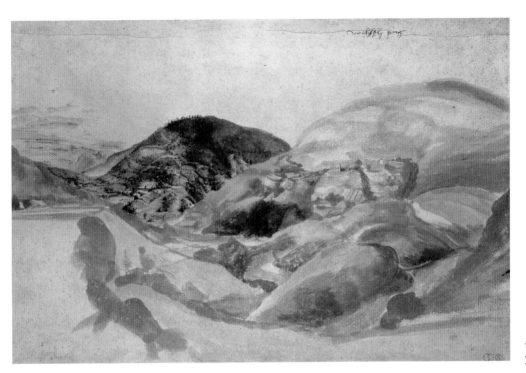

29
*Alpine
Landscape,*
1494–5
Inscribed
'*Wehlsch
pirg*' ('Italian
mountain')
Watercolour;
21 × 31.2 cm
(8¼ × 12¼ in)
Ashmolean
Museum,
Oxford

time available before he and his party moved on. One particularly
impressive watercolour is labelled simply '*Wehlsch pirg*' ('Italian
mountain'; 29).[50] It has been identified as being near Segonzano
in the Cembra Valley, just northeast of Trent. The localization
concerns me less than Dürer's radically novel conception of the
landscape. The highly descriptive style of the topographic view
of Innsbruck yields here to a panoramic vista. The foreground
is scarcely defined as Dürer used the shorthand of a few strokes
of blue and green against the white paper to imply the viewer's
elevated position, one that descends quickly into a winding valley.
Against the tall hill on the right, which is brushed in thinly, fields,
groups of trees and a small village surrounding its church stand
out. Only the next hill, set in the far middle ground, is provided
with a modicum of detail. The viewer, much like Dürer himself,
must strain to see its features. At left the valley stretches towards
the distant blue hills and a few clouds illuminated by the setting
sun. The *plein-air* effects and the incompleteness of Dürer's

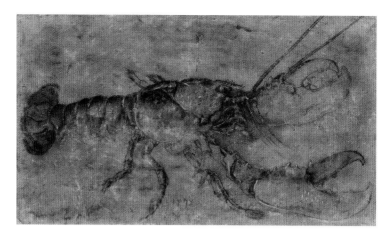

30
Lobster, 1495
Pen and
brown ink
with black and
brown washes,
heightened
with white;
24.7 × 42.9 cm
(9¼ × 16⅞ in)
Kupferstich-
kabinett, Berlin

landscape appeal to modern aesthetics since the artist powerfully
evokes the momentary experience of visiting this valley. This
unprecedented type of drawing, alas, had minimal impact on his
contemporaries and few heirs before Claude Lorrain (1600–1682)
or Rembrandt.

To Dürer's eyes Venice was exotic. If he sketched its canals
and lagoons, these are lost. He drew a lobster (30) and a sea
crab, creatures that he had probably never seen in landlocked
Nuremberg.[51] Equally fascinating were the fashions worn by
Venetian ladies. One two-sided drawing of 1495 (31) provides
three views of a woman who posed for him.[52] Shortly after
returning to Nuremberg he modelled the Whore of Babylon
in his *Apocalypse* series on her. Her dress is cut low in front
and back and she has bare shoulders. Jewels, or Venetian glass
imitations of them, ornament her bodice and sleeves. She lifts up
her high-waisted dress to reveal her underskirt, decorated with
a pomegranate design. The woman, perhaps a courtesan, wears
zoccoli, thick-soled slippers that make her appear taller and more
graceful. The reverse of the drawing includes a separate sketch of
one shoe. She sports a rich necklace and a jewelled band on her
carefully coiffed hair. Another sketch made in Italy contrasts a
young Venetian woman, with her loose dress and hair veil, and
a Nuremberg *hausfrau*, with her pointed shoes, pinched-bodiced

31
*Venetian
Woman*, 1495
Pen and
ink with
watercolour
and grey wash;
trimmed at top:
29 × 17.3 cm
(11⅛ × 6¾ in)
Albertina,
Vienna

dress and covered hair.[53] Dürer's interest in regional costumes would persist throughout his career.

In Venice, Dürer encountered Ottoman Turks and traders from the eastern Mediterranean. He recorded their appearance in several drawings although most, if not all, of these are based on earlier models by Gentile Bellini (c.1435–1507; 32). In 1479 a peace treaty was negotiated between Venice and Sultan Mehmed II (r. 1444–6, 1451–1481), who requested that an artist be sent to Constantinople, which he had captured in 1453. Gentile lived and worked at the sultan's court from 1479 to 1481.[54] He returned with innumerable sketches, which he mined in later paintings. Somehow Dürer gained access to Gentile's studio, where he copied images of Turkish horsemen, archers, Mehmed and a Circassian slave girl.[55] Three walking men wearing Ottoman turbans and robes, one of whom Dürer changed to be a black Moor, derive from a preparatory design that Gentile made for a detail at the right rear of his *Procession in the Piazza San Marco* of 1496 (Gallerie dell'Accademia, Venice).[56] Stylized images of Turks had long existed in German art. Back in Nuremberg, Dürer's depictions of Ottomans would be more accurate, even if, in accordance with then current political sentiments, most were still portrayed as tormentors of Christ and his saints (see 78).

Little is known about Dürer's contacts with other artists in Venice. During his second Venetian trip he wrote to Pirckheimer about his admiration for Giovanni Bellini (c.1431/6–1516), Gentile's half-brother. Giovanni's influence would prove formative, although not until this later journey. The circumstances surrounding Dürer's arrival in the Adriatic port as a young unknown artist were very different from when he returned as Europe's most famous printmaker. He may have met the Bellinis through one of the German merchants at the Fondaco dei Tedeschi, where each brother owned a broker's patent.[57] It was their brother-in-law Andrea Mantegna, active in Mantua, who most influenced the

32
Three Orientals, c.1494–5 Pen and ink with watercolour; 30.6 × 19.7 cm (12 × 7¼ in) British Museum, London

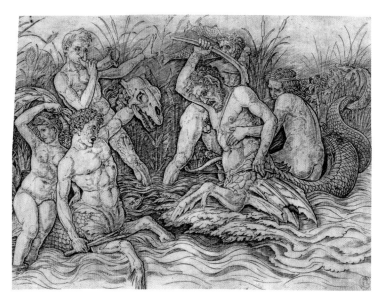

33
Andrea
Mantegna,
*Battle of the
Sea Gods,*
c.1470–5
Engraving:
right half:
28.8 × 38.1 cm
(11⅜ × 15 in)

Nuremberg artist. In 1494 Dürer made painstaking pen-and-ink
copies of Mantegna's *Bacchanal with Silenus* and the right half
of the *Battle of the Sea Gods* (33, 34).[58] Given the date, he could
have encountered and duplicated Mantegna's prints while still
in Germany. It is more likely that he first saw the engravings
in Venice, perhaps even in one of the Bellinis' workshops. Both
drawings are virtually identical in scale to the engravings. There
are no indentations visible on the surface of the two sheets of
paper, so Dürer replicated his models free-hand rather than by
resorting to tracing. Writing in about 1508–9, Dürer recommended
that in order to become a great painter, the young artist 'must copy
much of the work of good artists until he attains a free hand'.[59]

Mantegna's Classical themes and figures were unlike anything
that Dürer had seen before. His scenes recall ancient Roman
sculptural friezes and sarcophagi. In the *Battle of the Sea Gods*
the male and female nudes are respectively muscular or sinuous.
Their energetic poses, often with strong contrapposto, convey richly
varied emotions. The anger of the merman at right is expressed
equally in the tension of his body and the concentrated expression

34
*Battle of the
Sea Gods* after
Mantegna, 1494
Pen and
brown ink;
29.2 × 38 cm
(11½ × 15 in)
Albertina,
Vienna

of his face. His companion's fear is evident in her face and how she raises her left shoulder to shield herself. The man's forwards diagonal movement is answered by the more defensive backwards tilt of the other merman and horn-blower at left. Mantegna rhythmically balances the two women, one seen frontally and one observed from the rear, while also stressing their physical beauty. Dürer replicated the contours of these figures but replaced Mantegna's somewhat harsh shading with a subtler, more effective system of hatchings and cross-hatchings. He also simplified the background plants and surface of the water.

In the same year Dürer created the *Death of Orpheus* (35).[60] Although the general poses of the four figures were inspired by a Ferrarese engraving, the Nuremberg artist switched to a vertical format and brought the action closer to the front. The added cluster of trees focuses attention on the figures. Orpheus is being beaten to death for the sin of pederasty by the two stick-wielding women. The banderole fluttering in the tree reads, 'Orpheus, the first lover of boys'. Dürer imbued the figures with a pathos and sense of volume reminiscent of Mantegna's art. Orpheus looks extracted directly from a Classical relief of a dying warrior. This, however, was not Dürer's usual practice. Orpheus is one of the artist's first *all'antica* figures. Normally Dürer did not sketch original examples of ancient art. Rather, he derived inspiration from intermediary sources, especially from prints by Mantegna, Antonio Pollaiuolo (c.1432–1498) or, later, Jacopo de' Barbari. In these early drawings Dürer was entranced by the physical power and emotional charge of such models.

Mantegna's nudes exerted particular appeal. Already in 1493, probably while in Strasbourg, Dürer had first drawn a female nude (36).[61] Judging by her slippers, she was a bath-house attendant. She is posed standing with her arms raised. While there are a few stray lines, Dürer's handling seems sure, as though he had practised this exercise before. She is slightly pear-shaped, a

36
Nude Woman,
c.1493
Pen and ink;
27.2 × 14.7 cm
(10¾ × 5¼ in)
Musée Bonnat,
Bayonne

37
*Abduction of
the Sabine
Women*
after Antonio
Pollaiuolo,
1495
Pen and ink;
28.3 × 43.2 cm
(11⅛ × 17 in)
Musée Bonnat,
Bayonne

38
*Rape of Europa
and Apollo
Stringing His
Bow,* 1494–5
Pen and brown
and black ink;
28.9 × 41.7 cm
(11⅜ × 16⅜ in)
Albertina,
Vienna

common convention to express a woman's fecundity and her cold-wet humoural attributes. In 1494–5 Dürer sketched four nudes from an *Abduction of the Sabine Women* after Pollaiuolo (37), a sheet with seven dancing nude putti, a nude *Christ Child* after Lorenzo di Credi (1456–1536) and a marvellous study sheet of the *Rape of Europa* and *Apollo Stringing His Bow* (38).[62] The latter includes an oriental man pondering a skull that may be based on Gentile Bellini. Each in its own way is derivative. Of greater significance is his *Nude Woman with a Staff* of 1495 (39), a life study.[63] The model, seen from the rear, rests her right arm on a tall staff. After completing the figure Dürer added the drapery that sweeps over her left shoulder and across her body; the final

flourish at left is invented, not observed. Unlike in the 1493 nude, here Dürer grappled with the curving lines of her body. Quick strokes reinforce some contours and change others. He explored how rounded forms, such as a shoulder, a hip or a thigh, appear when lit from the upper left. Her legs cast shadows on the floor. In short, her sculpturesque figure is more solid and more convincing than the woman in the earlier drawing. On the reverse of the Paris drawing Dürer included the barest outlines of the same model holding the same pose seen from the front. It is impossible to determine whether this sheet was executed in Venice or shortly after his return to Nuremberg in the spring of 1495. Together these drawings represent the first stirrings of Dürer's career-long fascination with the human body, an investigation that will evolve from sketching actual models to theoretically analysing their proportions.

Dürer's post-apprenticeship training was unusually long (1489/90–5) and varied. He wandered through southern Germany to the Rhine. Extended stays in Basel and Strasbourg are secure, something that cannot be said about a hypothetical journey to the Low Countries before 1492. After being recalled to Nuremberg for a few months Dürer continued his training in northern Italy and Venice. During these years he studied German engravings, especially Schongauer's, designed woodcuts for book publishers, portrayed himself and his Strasbourg teacher, among others, and honed his skills as a draughtsman and watercolourist. His nascent interest in mythological themes and Classical forms may have started within Nuremberg's humanist circles, but it emerged more fully while in Italy. Mantegna's evocative art offered a formal language, with its antique reception and powerful plastic forms, unlike any that Dürer had encountered in Germany. The impact of his contacts with the Bellinis and other Venetian artists would surface gradually over the next few years. The trip to Venice broadened his artistic and intellectual horizons. It also inspired his quest to become a knowledgeable artist, a passion that ultimately prompted his return to Italy in 1505–7.

39
Nude Woman with a Staff, 1495
Pen and ink with wash;
32 × 21 cm (12⅝ × 8¼ in)
Musée du Louvre, Paris

1495

73 Dürer's 'Wanderjahre'

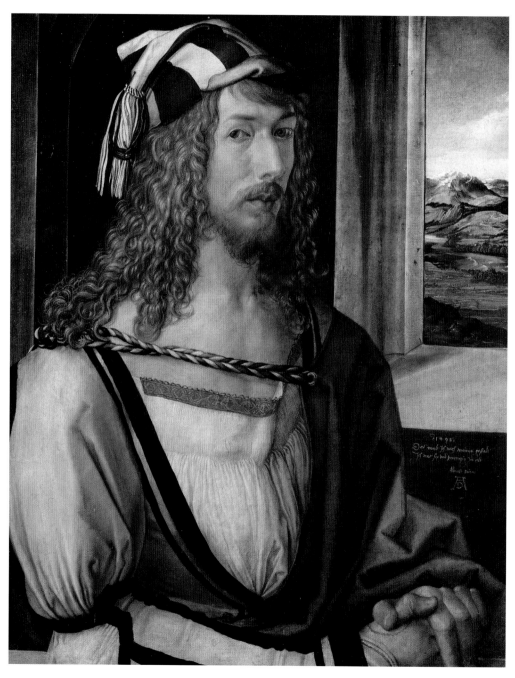

Dürer painted a second *Self-Portrait* (40) in 1498.[1] The half-length pose loosely echoes that of the 1493 likeness (see 21). Conceptually, however, it depicts a very different person. In the intervening five years Dürer married, travelled to Venice, returned to set up his own workshop in Nuremberg and started painting portraits and religious pictures for the city's elite and for Friedrich the Wise, elector of Saxony (r. 1486–1525), one of the Holy Roman Empire's most powerful nobles and discerning patrons. He was in the midst of what Erwin Panofsky would later call a 'maximum phase' – a period of remarkable graphic production.[2] Dürer's fame, built on the visual appeal and technical virtuosity of his woodcuts and engravings, spread well beyond Nuremberg. Meanwhile, copies of the *Apocalypse*, his first illustrated book, were rolling off his godfather's presses. These would soon secure his reputation as Europe's foremost printmaker. No other Renaissance artist would match this remarkable trajectory of achievement and recognition in so short a span of time.

Dürer showed himself as a well-dressed gentleman. Nothing ostensibly conveys his vocation as an artist. He wields neither brushes nor palette. Still this picture is very much a statement of his skill as a painter and his sense of self-worth. Dürer wears festive, not everyday, attire. The white shirt is edged with a gold thread band at the neck. Over this he sports a long-sleeved white doublet bordered with black strands and a brown mantle secured on his shoulders by entwined blue and white cords. His black and white cap matches his doublet. Its tassels are now bound, unlike in the 1493 portrait. In German *minne* or courtly love tradition, the binding of the tassels, especially with a ring known as a *schnürlein*, signified the man's fidelity.[3] Perhaps Dürer alludes to his own marital state. His hands, the creative hands of an artisan, are

40
Self-Portrait,
1498
Oil on
lindenwood;
52 × 41 cm
(20¹/₂ × 16¹/₈ in)
Museo
Nacional del
Prado, Madrid

masked within doeskin gloves. His sartorial elegance complements Dürer's attention to his own features. The few furtive chin hairs of the 1493 portrait have grown into a carefully trimmed moustache and beard. Long strands of curly light-brown hair catch the light as they fall to his shoulders. The decorative interplay of hair and clothing draws attention to the exposed skin of his upper body: in later years friends would tease him about his vanity.

In the 1493 portrait Dürer looks towards the viewer. Five years later he returns our stares with his own. Dürer intensified the gaze. The small strokes of white paint indicating light striking the surface of the eyes now cohere into the reflections of a double window with a central mullion. This links the fictive Dürer with the imagined physical space of the viewer, establishing a visual dialogue between the viewer and the viewed. It also alludes to the notion that the eyes are the windows of the soul or the light of the body, specifically that the eyes tell something about one's character.[4] Dürer continued to use this pictorial device throughout his subsequent career.

The artist situated himself within a clearly defined room. His arms rest on the foreground parapet, the physical barrier separating him from the realm of the viewer. The L-shape of his right arm is rhythmically repeated in the frame of the window behind. Similarly, the lines of the tasselled cap are reiterated in the vertical planes of the wall and the curves of the springing vaults. Dürer takes great care in harmoniously balancing the composition and further unifying it through the subtle lighting scheme. Earlier Netherlandish and German portraitists, including Wolgemut, located their sitters in a room with a rear or side window.[5] Dürer thus merely refines an existing portrait type.

Much has been made of the snow-capped mountainous landscape behind Dürer. Is this an autobiographical allusion to his recent trip over the Alps to Italy? Can the depiction of himself as a

gentleman, rather than the son of a goldsmith, be linked with
the higher social status that noted artists such as the Bellinis or
Mantegna enjoyed in Italy? While both suggestions are possible,
especially from our privileged twenty-first-century vantage point,
it is necessary to recall that mountains glimpsed through windows
can be observed in earlier Nuremberg portraits as well as in an
example by Hans Schäufelein (1480/5–1540), one of Dürer's first
assistants.[6] Furthermore, Dürer included windows with mountain
views in his *Portrait of a Young Fürlegerin Woman* (1497) and the
pendant *Portraits of Hans and Felicitas Tucher* (c.1499).[7] Although
Dürer incorporates more personal references into his art than any
other German master, these other paintings serve as a necessary
caution against wishful interpretations. An allusion to his Italian
trip remains plausible but cannot be taken as a certainty.

Inscribed on the wall beneath the window is the text, '1498 /
This I painted after my own image / I was twenty-six years old /
Albrecht Dürer', as well as his monogram. In keeping with the
naturalism of the composition, he anchored these words to the wall
rather than floating them above his head as in the 1493 likeness.
In both cases Dürer meticulously recorded how he looked (or
wanted to look) at a specific moment in time. In the case of the
1498 portrait the information that he was twenty-six pinpoints
its execution to before his twenty-seventh birthday on 21 May.
He also included his full name for the first time and what would
be the definitive form of his AD monogram. When Dürer began
making engravings, he placed his monogram on the copper plates,
much as Schongauer and other German engravers had done
before him. He briefly experimented with other arrangements of
the two letters before settling on a large capital A with a smaller
capital D set beneath the crossbar. Dürer took the unusual step of
monogramming woodcuts and many drawings, which he desired to
be recognized as the products of his hand and mind.

This practice was more than a clever marketing ploy. Dürer wanted

to exert whatever controls he could over his art, even if it meant going to court, as it would in the future.[8] The Nuremberg artist's self-awareness soon became conscious self-fashioning without parallel. One searches in vain in contemporary German literature for writers who sought a comparable text–author association. In the *Ship of Fools* (1494) Sebastian Brant mentions himself at the beginning and end of his book and occasionally for moral emphasis with the words, 'Thus speaks Sebastianus Brant' (Chapter 111).[9] Conrad Celtis (1459–1508), the arch-humanist, and Hans Sachs (1494–1576), Nuremberg's famed Meistersinger and cobbler, sometimes identified themselves within the body of their texts. Sachs even made himself a participant ('One morning I was going through a wood; it had snowed and was horribly cold. Next to the road I heard a whispering').[10] Sachs used this ploy to establish himself solely as the informed narrator.

What, then, motivated Dürer? The answer to this question is complex and will be explored throughout this study. His recognition that some Italian artists enjoyed a higher social status than their German counterparts was certainly a factor. So was his new friendship with Willibald Pirckheimer (see 175).[11] Through Pirckheimer and his circle of humanist friends Dürer learned about fame that outlasted one's mortal existence. While Dürer initially may have gauged his success against that of Wolgemut and the deceased Schongauer, he grew conscious of the honour accorded, for instance, to Apelles (fl. before 336–after 301 BC) and Zeuxis (fl. late fifth and early fourth centuries BC) of ancient Greece. During Dürer's lifetime no works by these artists were known to survive, yet their fame lived on in the descriptions in Pliny the Elder's *Natural History* or in the writings of Strabo, Plutarch, Quintilian, Lucian and other Classical authors. Dürer became aware that art had a past and present history, one that accorded canonical status only to the truly exceptional artist. Perhaps it is not coincidental that Apelles, the court painter of Alexander the Great, is known to have written a lost treatise on painting and that Dürer was

German art's first theoretician. Comparisons of Lucas Cranach the Elder and other contemporary artists besides Dürer with Apelles or another ancient master became increasingly common in the early sixteenth century. Already in 1499 or early 1500 Conrad Celtis, the imperial poet laureate (shown standing with Dürer in the *Martyrdom of the Ten Thousand*; see 78), wrote an epigram lauding Dürer. It begins:

> To the Painter Albrecht Dürer from Nuremberg.
> Albrecht, most famous painter in German lands
> Where the Frankish town raises its lofty head up to the stars,
> You represent to us a second Phidias, a second Apelles
> And others whom ancient Greece admires for their sovereign hand.
> Neither Italy nor versatile France has seen his equal
> Nor will anyone find him in the Spanish domain.[12]

Later Erasmus dubbed Dürer the 'Apelles of black lines' as a way of pronouncing the Nuremberg master's superiority to the Greek painter. Such humanistic conceits, while diminished in impact by their growing frequency of application, were central to Pirckheimer, the German Xenophon, and his friends. Their use reflected the humanists' desire to link the glories of antiquity with their present world. Pirckheimer's profound knowledge and linguistic skills expanded Dürer's intellectual horizons.

Some time soon after returning to Nuremberg in 1495, the young artist became friends with Pirckheimer. Panofsky succinctly describes the latter as 'one of the most learned men in an extremely learned period, he was a huge man of enormous vitality and violent temper, witty, superior and far from virtuous'.[13] There is no record that these men met, or at least fraternized, until 1495 or so. Willibald, born in Eichstätt, where his father Johannes was the legal counsel to Bishop Wilhelm von Reichenau (r. 1464–96), was only rarely in Nuremberg. Between 1488 and 1495 he studied law, the humanities and Greek at the universities of Padua and

Pavia. That summer he came back to Nuremberg for his sister's wedding. Perhaps it was their recent Italian experiences, inherent curiosity and compatible personalities that first brought the men together. Contemporary in age, both were newly married.[14] In the stratified social hierarchy of Nuremberg, Pirckheimer belonged to one of the city's oldest, most influential and wealthiest families. He was first elected to the powerful Inner Council in 1496 and would direct Nuremberg's troops during the Swiss War of 1499. As their friendship blossomed and then deepened over the decades, Pirckheimer provided Dürer access to Nuremberg's elite and, critically, to an international community of scholars.

41
Attributed to Dürer, *Landscape,* c.1502
In Theocritus, *Idyllia* (*Idylls*; Venice, 1496)
Gouache heightened with gold on laid paper, irregularly cut from and pasted back on to page 1; page size: 31 × 20.3 cm (12¼ × 8 in)
Ian Woodner Collection, National Gallery of Art, Washington, DC

Pirckheimer was an avid bibliophile. His library in his house on the Hauptmarkt was noted for its manuscripts and new published editions of Classical authors. Writing from Venice in October 1506, Dürer, acting as a supplier, informed Pirckheimer, 'I cannot anywhere hear of any Greek books recently published'.[15] Renowned for his Latin and German translations of ancient Greek authors, Pirckheimer particularly coveted the editions of Aldus Manutius. Pirckheimer's *Idyllia* or *Idylls* by Theocritus (c.320–260 BC), which the Venetian publisher's Aldine Press issued in February 1496, contains an opening illumination (41) attributed to Dürer.[16] Unable to read Greek, Dürer relied on Pirckheimer's description of the contents. The countryside's bucolic mood, which looks wholly unlike any landscape produced in Germany, matches the pastoral evocations of the text. Neither the quietly grazing sheep nor the butting rams disturb the panpipe-playing shepherd with his dog or Thyrsis playing his viola da braccio. The shields of Pirckheimer (a birch tree) and his wife, Crescentia (a double-tailed siren), hang on the sides. The miniature probably pre-dates her death, from complications during childbirth, on 17 May 1504.[17] Thereafter Pirckheimer stopped including her shield. Regardless of the precise date of the illumination, it is emblematic of the unique talents and interests that each brought to their relationship.

Dürer's fascination with the human body, both as object of study and narrative theme, increased significantly during the later 1490s. In his *Women's Bath* (42) he explored the nude and the issue of viewer reception.[18] Dürer depicted six women and two small male children within a private room of a bath-house. The low ceiling and sharp perspectival recession give the wood-panelled chamber an intimate, if cramped, feeling. These are not the classicizing nudes of Mantegna but local women posed washing themselves, combing their hair or switching themselves to promote circulation. The banal subject obscures the artist's virtuosity as he displayed the women from the front, back, side and in a serpentine contrapposto. Except for the corpulent older woman seated with

her feet in the pool of water, they are young and physically appealing. Their seeming innocent preoccupation with their cleansing is perhaps not so innocent after all. At the back left a wooden shutter opens slightly as an older bearded male quietly peers into the chamber. His gaze introduces a sexual tension: these women are the objects of his voyeuristic gaze and, presumably, physical desire.[19] This shatters the privacy of the moment, even if the women are not yet aware of his presence.

Two of the women acknowledge the viewer's stare. The figure in the foreground turns her eyes and body towards the viewer. The woman behind her looks coyly at us as she combs her hair. When examining Dürer's self-portraits of 1493 and 1498, the viewer is confronted with the naturalistically rendered artist, set close to the foreground picture plane, returning our attention. In Schongauer's *Christ Carrying the Cross*, Jesus fixes his eyes (and perhaps his silent accusations) on the viewer. They and other contemporary artists were aware of the tensions inherent when the pictorial barrier separating the fictive realm and the real world is breached.[20] While Dürer never imbued his works with the sexual and psychological stress that carries some of the scenes of Hans Baldung Grien (see 92), in the *Women's Bath* he challenges the viewer's self-awareness and physical proximity.[21] Assuming that his audience was primarily male, he humorously scattered phallic-looking spouts on the steaming water cauldron and over the pool on the right. Dürer may have intended this drawing as a model for a print. Crude woodcuts based on this design were made later by others.[22]

He may have created it as the counterpart to the *Men's Bath* woodcut of 1496–7 (43).[23] Six largely nude men occupy an open-air bath. Behind a dressed figure peers at the gathering. None, however, stares knowingly out of the composition at the viewer. Unlike the women in the drawing, they are not actively grooming themselves. Only the figure in the left foreground holds a cleaning

scraper. Rather, the men talk, drink and play music. The bearded man (Dürer himself?) leaning on the wooden post quietly observes the others. The strategically situated water spout with its cock valve is a bawdy pun.[24] The setting is fanciful. Although complex iconographic readings have been offered, its meaning may be no more complicated than a group of men enjoying each other's company. Social gatherings, even meals, occurred in public and private bath-houses. There was an open-air bath on Schütt Island in Nuremberg. Private baths became more common as larger houses with gardens were constructed in the city and surrounding countryside. Roughly contemporary with this print, a new scourge – syphilis – first appeared in Nuremberg.[25] In 1496 the council banned the sick from public baths. As in the *Women's Bath*, Dürer varied the men's poses. Their muscular bodies more readily recall Mantegna's figures than any of Dürer's life studies.

Dürer harboured radically different ambitions for his woodcuts, much as Schongauer had for his best engravings (see 18). Because he used a large woodblock, the resulting compositional field rivalled that of a painting or small relief sculpture. In the *Men's Bath* his complex design takes advantage of the space. The background is full of rich topographical features as one descends from the fortified upper gate to the lower town with its river. Dürer carefully varied his textures to define the foreground. Consider the stone blocks at front. These convey a hardness that contrasts immediately with the woodgrain of the post and its metallic spout. The top surface of the block is simply the whiteness of the paper. The artist added a few strokes to suggest the edges of the block, the metal pin linking two stones, the chip in the rock and the shadows of the scraper and two men. If seen alone, this section seems rather flat. To prevent this Dürer mimicked the shaded edges of chisel marks on the perpendicular or side face of the stone. Each block's pattern varies from the next. He then filled the ground before the wall with a plant, drinking cup, pear and undulating surface to distract from his simple artifice.

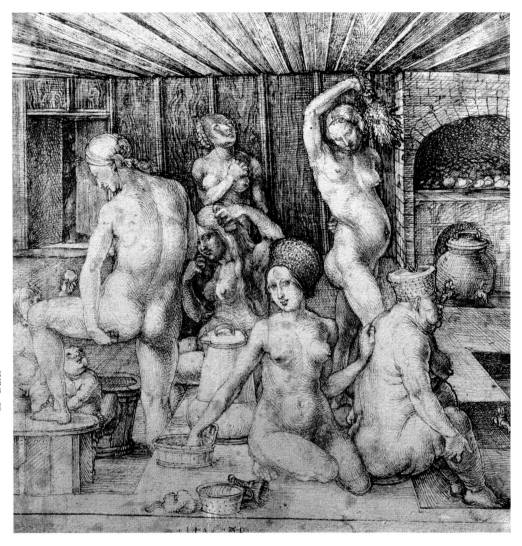

42
*Women's
Bath*, 1496
Pen and
black ink;
23.1 × 23 cm
(9 × 9⅛ in)
Kunsthalle,
Bremen

43
Men's Bath,
c.1496–7
Woodcut;
39.4 × 28.4 cm
(15½ × 11⅛ in)

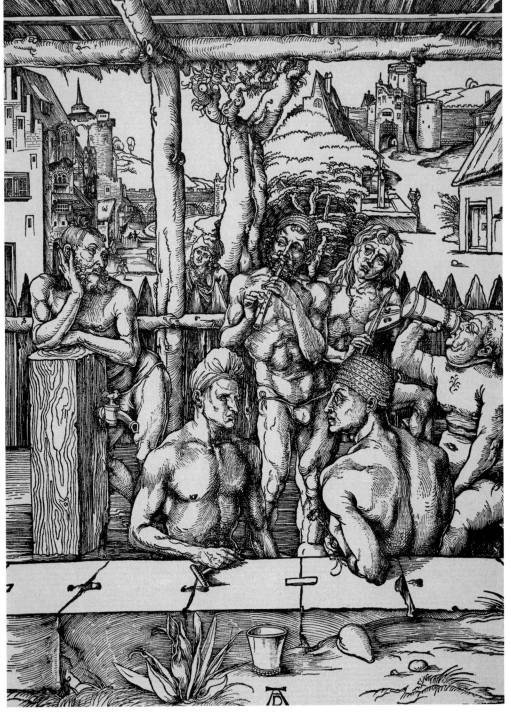

The solidity of the foreground, however, has another purpose. Its hardness, coupled with all of the verticals of the rest of the bath-house structure, serves as a visual foil to the supple curving lines of the men's bodies. His system of shading, with its hatchings and cross-hatchings, observed already in the *Women's Bath*, greatly surpasses even the best efforts of his teacher or any other contemporary woodcut designer. He is able to describe forms plausibly. As his style was still developing, he had occasional problems, as can be observed in the muddle of lines on the shaded left shoulder of the man holding the scraper.

All twenty-six of Dürer's best early woodcuts, including the *Men's Bath* and the *Apocalypse*, are printed on a whole sheet of paper, which when uncut measures 45 by 32 cm (17³/₄ × 12⁵/₈ in). Few fifteenth-century woodcuts, other than the full-page images of the *Nuremberg Chronicle* (see 15), were as large. He selected exceptionally high-quality paper for his prints. Nuremberg, the home of Germany's first paper mill, produced paper of varying quality.[26] For his woodcuts Dürer favoured a paper handmade from linen rags that 'was strong and durable; had a pleasing, warm, ivory or cream white colour; and possessed a lively resilience and rich surface texture'.[27] Such care was unusual since most woodcuts, used for utilitarian or devotional purposes, were discarded when worn.[28]

44
*Samson and
the Lion,*
c.1497–8
Woodcut;
38.2 × 27.8 cm
(15 × 11 in)

A year or so later Dürer completed *Samson and the Lion* (44), a woodcut of much greater visual complexity.[29] The deep peaceful landscape belies the violence unfolding in the foreground. According to Judges 14:5–6, a young lion suddenly confronted Samson as he walked in the vineyards of Timnah. 'The spirit of the Lord rushed on him and he tore the lion apart barehanded as one might tear apart a kid.' Dürer borrowed Samson's pose bestride the lion with his right foot pinning the beast's neck from an engraving by Israhel van Meckenem.[30] Yet he greatly surpassed his model by the sheer tension and physical presence of his two protagonists. Samson grabs the lion's jaw and sharply wrenches its head. The

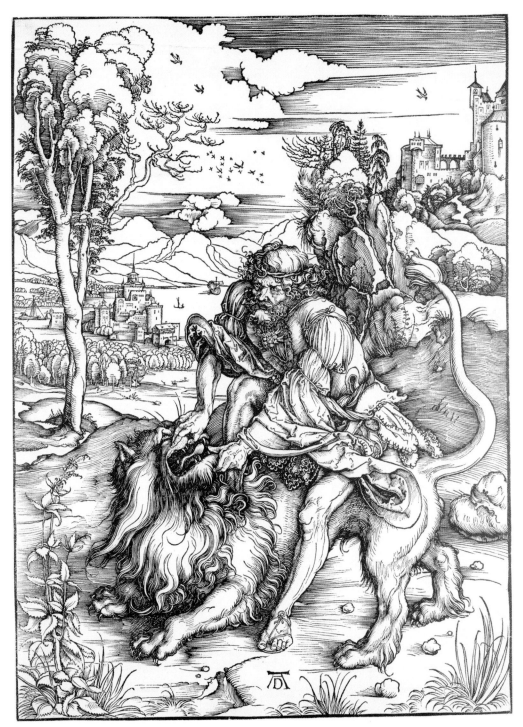

intensity of their struggle is evident in the agitated swishing of the lion's tail and in the flexing of Samson's muscular arms and legs. Only Samson's detached gaze seems a bit incongruous. With his wild, strength-giving hair and curly beard Samson looks brutish, much like a biblical Hercules. But the real story here is neither the narrative nor the popular typology comparing Samson's battle with Christ's victory over the devil; rather, it is the dynamic use of line. The long, flame-like lines of the lion's mane flare outwards while the shorter fur of the rest of the body is handled with small concentric strokes. The bold contours of Samson's straining limbs contrast marvellously with the energy of his clothing. This is nicely seen in the right arm, where the physical tension of the forearm releases explosively in the fluttering sleeve. When looking closely at this area, the descriptive and shading lines are carefully defined. Most of his black lines, including contours, add gradations of shading against the luminosity of the white paper. Dürer adjusted the chiaroscuro values by varying the width and character of the lines. He was probably the first to apply tapering and swelling of lines, a method adopted from engraving, to his woodcuts. Samson and the lion stand out clearly from and logically within the landscape. Their monumentality, unrivalled in any earlier German print, is matched only in some of Mantegna's engravings (see 33).

Dürer's surviving woodblocks exhibit a remarkable conceptual and technical complexity.[31] At first glance *Samson and the Lion* (45) looks chaotic. Soon one discerns that the lines and gouges yield a reversed image of the composition. The *formschneider* removed a bit of wood from either side of most lines. This is clearest perhaps in the horizontal striations of the sky. The print's large open patches of white, such as the puffy clouds, the mountains, the sea or the highlights in the branches of the tree in the middle ground, are achieved by cutting away the original surfaces in those areas. The rough knife and chisel marks, visible on the block, are recessed and so do not appear when printed. Dürer added a few

45
Samson and the Lion,
c.1497–8
Pearwood woodblock;
38.2 × 27.8 cm (15 × 11 in)
Metropolitan Museum of Art, New York

birds winging through the sky to suggest spatial recession. When looking at these on the block, they seem like atolls rising out of the surrounding wooden surface. The *formschneider* faced the dual challenges of keeping all of the forms clearly separate while also transcribing the visual impact of Dürer's varied lines.

This particular woodblock exhibits damage especially along its edges. Beyond the perils, such as rot or insect damage, faced by any 500-year-old piece of wood, the block's condition was affected by its continuous use during Dürer's life and long after his death. This was a common fate for many of the woodblocks, owing to the continued popularity of Dürer's prints. The artist continually

replenished his stock of woodcuts and engravings by printing new impressions even of his early works such as *Samson and the Lion.* A woodblock can yield hundreds of good impressions and a couple of thousand legible ones. Precise figures are often difficult to come by. Dürer's *Triumphal Arch of Emperor Maximilian I* (see 135) is recorded being printed in about 700 copies in 1517–18, another 300 or so in 1526–8, a third edition of unspecified size in 1559 and a final edition in 1799.[32] Damage occurs first to the black border of a woodcut. Small holes or gaps appear as the edges of the woodblock chip from rough handling, inexpert storage or, more commonly, simple fatigue from repeated printings. Breaks or gaps in the simple contours of the mountains behind Samson occurred before 1600. Some time in the seventeenth century this particular woodblock was recut in a few places to repair worn lines. In the case of Dürer's *Rhinoceros* of 1515 (see 131), the degradation of the block prompted Willem Janssen, a Dutch publisher, to reissue it as a chiaroscuro print after 1620.[33] He used a newly made tone block inked in green or brown to produce coloured versions of the print that partially masked the original block's damaged lines.[34]

Inspired by the success of the *Nuremberg Chronicle,* Dürer created the *Apocalypse,* his own illustrated book.[35] In Schedel's tome the woodcuts merely illustrate the text. Dürer desired conceptual parity between image and text. Unlike the *Nuremberg Chronicle,* with its many partners, Dürer was both artist and publisher. The book's colophon reads: 'Printed at Nuremberg by Albrecht Dürer, painter, after Christ's birth the year 1498.' This is the oldest known book printed by an artist at his own initiative. While Wolgemut started illustrating books as a mature artist, Dürer was at the beginning of his career. The choice of project, its imposing physical scale, complex mechanical execution and, above all, its pictorial daring mark Dürer's confidence in his own abilities.

The text of the *Apocalypse* dates to the late first century. Throughout the Middle Ages it was revered as a divine revelation

46
Martin
Schongauer,
Saint John the
Evangelist on
Patmos, c.1480
Engraving;
16 × 11.4 cm
(6¼ × 4½ in)

given to Saint John the Evangelist, who, as in Schongauer's
engraving (46), is customarily shown writing his text on the
island of Patmos.[36] The *Apocalypse* describes the calamitous
events signalling Christ's impending second coming for the
faithful, the start of Christ's thousand-year kingdom. In a
world where wars, famine, sickness and social upheavals were
stubbornly common, millenarian thoughts were endemic. The
year 1500, a half-millennium, was approaching, and the signs
were not encouraging.[37] Constantinople fell to the Turks in 1453;
syphilis, believed to have been brought from the Americas, was a
growing scourge, a deadly sibling to the recurrent plague. German
discontent with the increasingly corrupt and distant Roman
Church pre-dated Martin Luther and the Reformation. Foes
derided popes as the anti-Christ. Social, political and economic
problems bedevilled German society. Regardless of his motives,
Dürer's creation of a visually breathtaking new edition of the
Apocalypse on the eve of 1500 was a savvy business decision.
In 1498 Dürer published separate German and Latin editions,

each sixteen folios long. The *Vulgate*, Saint Jerome's translation from Hebrew and Greek, was used for the Latin version. Anton Koberger's vernacular bible of 1483, with its translation from the *Vulgate*, was the source for the German text. Both editions open with a title page (folio 1 recto), a brief biographical prologue of Saint John the Evangelist written by Saint Jerome (folio 1 verso) and the full-page woodcut of the *Martyrdom of Saint John* (folio 2) where the Emperor Domitian, dressed as an Ottoman sultan, tries unsuccessfully to kill the saint by boiling him in oil. Thereafter the text begins. Dürer placed the text on the verso and the image on the facing recto (47). The separate forms holding the text and the woodblock were joined and printed together on a single sheet.[38] Text and image run independently, so that after the first couple of folios there is no direct correlation between the woodcut and the facing chapters. By structuring the volume in this manner, Dürer forced his reader/viewer to acknowledge the text and image cycles as distinct and co-equal.

Koberger's assistance must have been invaluable during the design and production of the book. The size of the *Apocalypse* matches that of the *Nuremberg Chronicle*. The Latin and German texts respectively used Rotunda and Schwabacher type faces, the same that Koberger made for printing the chronicle. The technique of printing of text and woodcut simultaneously was mastered earlier in Koberger's edition of the *Schatzbehalter*. Did Koberger also let Dürer use his presses and workmen? At some point the artist acquired his own platen press, but whether he had sufficient capital to make such an expensive purchase in about 1496 is unlikely. Dürer possessed (or borrowed) a copy of Koberger's German Bible of 1483. Its simple Apocalypse woodcuts, which first appeared in a Bible published in Cologne in 1479, were one source of inspiration for Dürer's prints.

The *Seven Trumpeting Angels* (folio 8 recto; 48), the sixth figure excluding the initial *Martyrdom of Saint John*, is uncomfortably

crowded.[39] It was among the cycle's first images and probably pre-dates *Samson and the Lion*. The density of the composition, however, brilliantly befits the violence of the text (Revelation 8:1–13, 9:1–12) and Dürer's combining different events into a single image. The text begins, 'When the Lamb opened the seventh seal, there was silence in heaven for about half an hour. And I saw the seven angels who stand before God, and seven trumpets were given to them.' God, set against the radiant luminosity of heaven, hands out the horns. Another angel, positioned behind the ornate Gothic-style altar, fills his censer with fire and casts it towards earth. This causes 'peals of thunder, rumblings, flashes of lightning, and an earthquake'. Each trumpet blast proves deadly. The first hurls hail and fire, mixed with blood, which burns up a third of the earth. As the second angel blows its horn, 'something like a great mountain, burning with fire, was thrown into the sea. A third of the sea became blood, a third of the living creatures in the sea died, and a third of the ships were destroyed.' The third angel causes a falling star to poison a third of the water. The fourth darkens a third of the light of the sun, moon and stars. 'Then I looked, and I heard an eagle crying with a loud voice as it flew in mid-heaven, "Woe, woe, woe to the inhabitants of the earth …."'. A plague of biting locusts tortures 'those people who do not have the seal of God on their foreheads'.

Unlike the corresponding illustration from the Cologne Bible, most of the woodcuts from which were reprinted in Koberger's German Bible (49), Dürer's woodcut is terrifying. As the first four angels blow their horns, cities and countryside are in flames. Two great hands thrust a fiery mountain into the sea, causing huge waves that swamp nearby ships. Locusts rain down on the right. A shooting star pollutes the well. While these disasters occur, the sky behind perceptibly darkens, the closely spaced horizontal lines contrasting vividly with the roiling clouds of heaven above. The eagle with its message of doom knifes through heaven to earth. Translating Saint John's visionary language into memorable

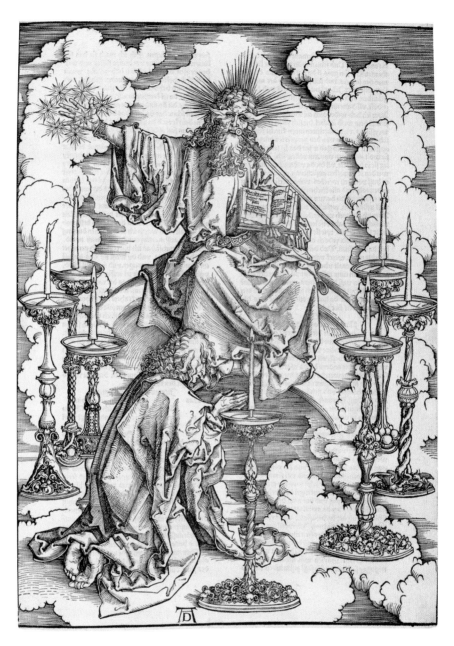

47
*Saint John's
Vision of God
and the Seven
Candlesticks,*
1496–8
Woodcut in
The Apocalypse
(Nuremberg,
1498), figure 1;
39.6 × 28.5 cm
(15⅝ × 11¼ in)

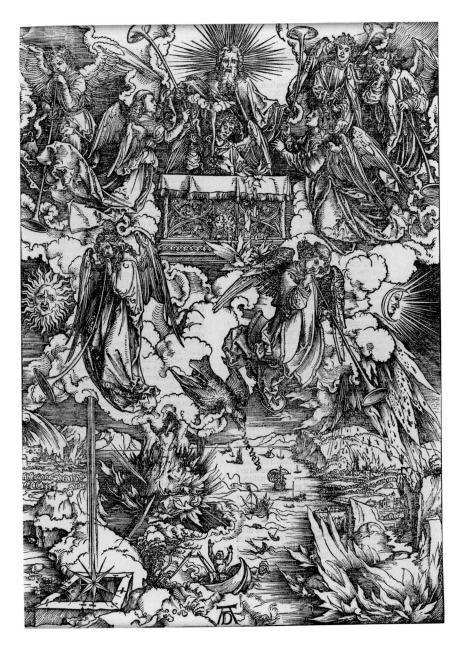

48
The Seven
Trumpeting
Angels, 1496–7
Woodcut in
The Apocalypse
(Nuremberg,
1498), figure 6;
39.3 × 28.3 cm
(15½ × 11⅛ in)

pictures challenged Dürer. Although familiar with earlier Apocalypse images, including fifteenth-century German block books, he redefined virtually every episode.[40] Nowhere is this more evident than in the *Four Horsemen* (Revelation 6:1–8; 50).[41] At the opening of one of the seven seals four riders appear. The first, holding a bow, is War, who comes to conquer; the second is Strife or Pestilence, who with his sword takes peace from the world; next appears Famine, holding a balance or scales; finally Death rides forth on a pale horse and is followed by Hell. Working in black and white, Dürer cannot present the white, red, black and green horses

49
The Seven Trumpeting Angels, 1483
Woodcut in German Bible (Cologne, c.1479) (unnumbered leaf 539)

described by the text. Instead he combines them into a cavalry of horror. With the blessing of the angel above, the riders relentlessly pass over the earth. Humanity succumbs beneath the horses' hoofs. Only the single figure on the lower left turns defensively to await his fate. He stands as the pictorial counterpart to the viewer, who is alive, but for how long? He falls partially outside of the frame of the composition. Dürer conceived this scene as one of unfettered movement from left to right through space. As the riders sweep through the world, the head of War's horse and the flank of Death's steed breach the edges of the composition. The

frame cannot contain their movement and their devastation. The upper three horses and riders gallop in perfect rhythmic unison. Wild-eyed Death and his emaciated horse trample all in their path. The dead are swallowed up by the accompanying beast-snouted hell-mouth. Every facet of the upper four-fifths of this scene seems in motion. Lightning from heaven at the upper left is met by churning clouds. The darkness behind signals the abject despair felt by humanity and, one suspects, by Dürer's viewers. Neither king nor monk nor burgher is spared.

Very different in spirit is the eighth image, *Saint John the Evangelist Devouring the Book*, also known as *The Strong Angel* (Revelation 10:1–10; 51).[42] The text begins, 'And I saw another mighty angel come down from heaven, clothed with a cloud: and a rainbow was upon his head, and his face was as it were the sun, and his feet as pillars of fire: And he had in his hand a little book open: and he set his right foot upon the sea, and his left foot on the earth.' In medieval exegesis this Strong Angel mediating between heaven and earth is identified as Christ. Dürer presented the scene literally. The legs are burning columns. The head is enveloped in a rainbow. The right hand, in a blessing gesture, points towards the heavenly altar, while the left gives John the book. The angel says to John, 'Take it, and eat it up; and it shall make thy belly bitter, but it shall be in thy mouth sweet as honey.' John consumes and digests God's revelation before he transcribes its message into his own book.

The Strong Angel is among Dürer's most memorable figures. The artist captured his simultaneous materiality and insubstantiality. Notice how the smoke emanating from the two solid columns diffuses. It loosely coalesces as though to define where the angel's torso would be. The single curly strokes at the top of the angel's right leg form wisps of smoke that intensify to produce animated clouds. In spite of the moderately detailed spatial recession defined by the land and sea, the Strong Angel's 'body' defies logic, as it is

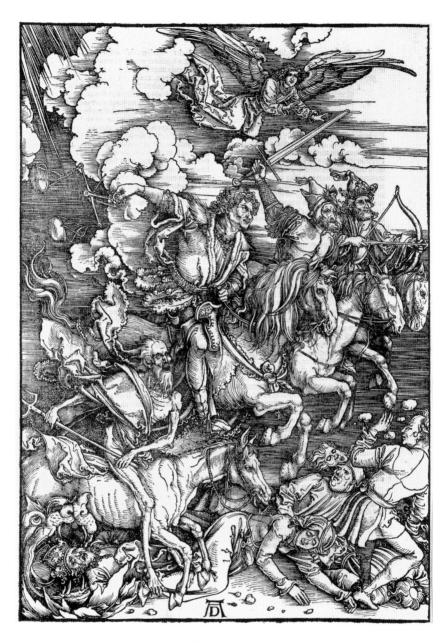

50
*Four
Horsemen,*
c.1497–8
Woodcut in
The Apocalypse
(Nuremberg,
1498), figure 3;
39.6 × 28.3 cm
(15⅝ × 11⅛ in)

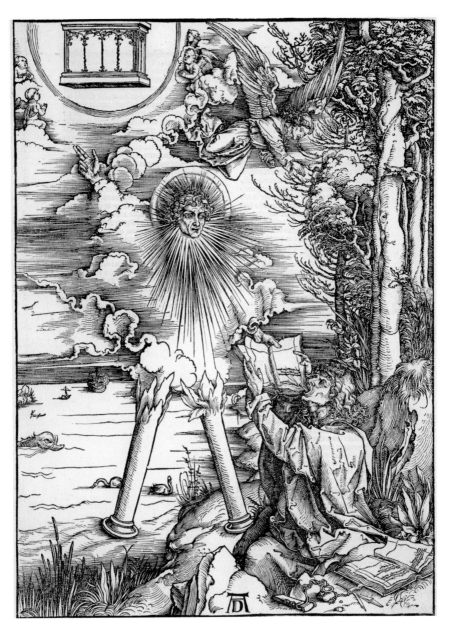

51
*Saint John
the Evangelist
Devouring
the Book* (*The
Strong Angel*),
c.1498
Woodcut in
The Apocalypse
(Nuremberg,
1498), figure 8;
39.3 × 28.6 cm
(15½ × 11¼ in)

at once anchored in the foreground and dissipated throughout the rest of the composition. Divine revelations, Dürer suggests, do not obey the laws of nature. The flatter figure of Saint John and the vaporous angel contrast sharply with Samson's raw physicality (see 44). One scene unfolds in Saint John's mystical imagination, the other in the material world.

Dürer's fourteen *Apocalypse* woodcuts radically recast the familiar. The text of Revelation, the source of endless sermons and homilies, was ingrained from youth in the minds of his contemporaries. The artist transformed the visual imagery into scenes of great majesty, as when John kneels humbly before God in the first figure, and of palpable anxiety, as ever-new misfortunes befall the world. The monumental scale of each woodcut, the intensity of rich black lines coursing with energy that in the best impressions seem to leap off the luminous white paper, and the sheer beauty of the prints, unlike those of any other artist, ensured the project's success. As copies of the book spread across the Holy Roman Empire and beyond, Dürer's fame was likewise assured. His monogram adorns every print. His name, his role as publisher, and his city are listed in the colophon on the verso of the last folio. Already by 1502 full-scale pirated editions in German and Latin were published by Johann Prüss the Elder in Strasbourg. For these Hieronymus Greff (c.1460–after 1507) copied Dürer's woodcuts, substituted his own monogram and replaced the original colophon with a new one crediting himself ('Iheronismus Greff den maler, genant von Franckfurt').[43] In Venice, Zoan Andrea made an unauthorized copy of the 1511 edition. Although such episodes of intellectual theft bedevilled Dürer, these demonstrate the appeal of his prints. In 1511 Dürer reissued the Latin edition of his *Apocalypse*, which appealed to an international audience, with a new illustrated title page.[44] Together with the *Large Passion* (see 110, 172) and the *Life of the Virgin* (see 107–8, 196), the *Apocalypse* constitutes one of the three Great Books ('Drei Grossen Bücher'), as he referred to them.

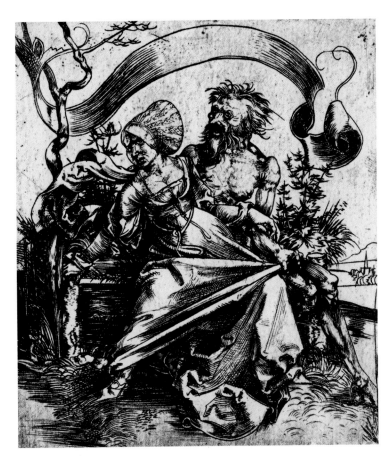

52
The Ravisher,
c.1495
Engraving;
11.1 × 10.1 cm
(4⅜ × 4 in)

During this period Dürer started engraving. About twenty-five
engravings pre-date 1500, although the precise number and
sequence are debated since he began systematically dating his
prints only in 1503.[45] The *Ravisher* (52), perhaps his first intaglio
print, portrays Death as an unwanted lover.[46] He and the young
maiden sit on a grassy bench. Shoots of eryngium, the plant
that Dürer holds in his 1493 *Self-Portrait* (see 21), sprout up
on both sides. She suddenly realizes her misfortune: instead of
the caresses of a handsome young man, she is embraced by the
cadaverous figure of Death. Grabbing her dress and her waist,
he thwarts her attempt to flee. The woman's face and taut body
express her growing terror. The crowded foreground heightens the
psychological intensity. The fluttering banderole's blankness allows

53
*Virgin and
Child with a
Monkey*, c.1498
Engraving;
18.9 × 12.2 cm
(7½ × 4¼ in)

the viewer to append his or her own moral or commentary. The *Ravisher* is a juvenile work. Dürer's ability to tell a story exceeds his technical facility at this moment. The handling of the lines is tentative and, as in the lower left, often ineffective in conveying forms and shading effects. The maiden's dress, in spite of the calligraphic flourish of the bunched drapery by her left foot, reads flat. This lack of depth marks the two figures, their bench and the twisted tree to the side. Dürer even neglected to extend the simple contour lines of the background all the way to the right border. Some of the roughness, reminiscent of the scratchy lines of a drypoint (see 118), may have been intentional, to enhance the anxiety of this couple's encounter.

Dürer quickly realized how his engraved lines, cut into the surface of the copper plate, could be varied to achieve even the most complicated pictorial effects. His *Virgin and Child with a Monkey* (53) dates from about three years later.[47] Mary sits securely on another grassy bench. The grain of its wooden supports reveals knots and rotten spots, naturalistic details that bolster the overall feeling of solidity. Mary is particularly sculpturesque as her knees jut forwards clearly in a different plane from the rest of her body. Dürer painstakingly laboured on the hatching and cross-hatching of her dress as light moves subtly across the different surfaces. Notice the slight undulation of the fabric of Mary's right leg. Its highlighting is achieved by linking only some, not all, of the downwards-curving cross-hatchings on either side. With fewer and more widely spaced lines this passage pushes gently forwards. It is pure yet effective illusion. Dürer learned how to cut deeper, stronger and richer-looking lines during the years since *The Ravisher*. The attractive landscape includes a narrow, half-timbered fisherman's house. This derives from Dürer's *Pond House* (54), one of the watercolours he sketched in the countryside around Nuremberg after returning from Italy.[48] He copied the house, which still existed a century later, and its reflection but not the setting sun or the marvellous sense of quietude.

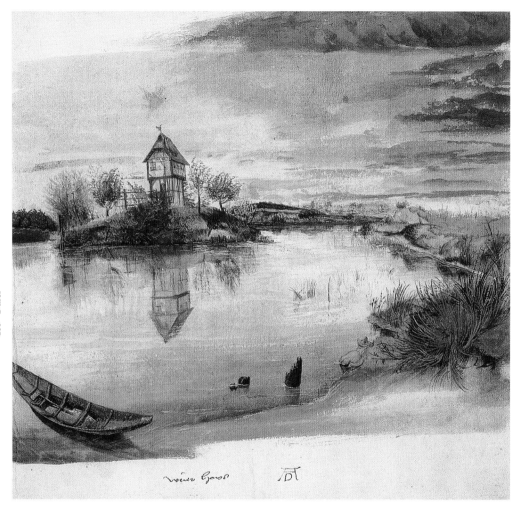

54
Pond House,
c.1496
Inscribed
'weier Haws'
Brush
drawing with
watercolour
and body-
colour;
21.3 × 22.5 cm
(8⅜ × 8⅞ in)
British
Museum,
London

Dürer's engravings illustrate both traditional and newly popular themes. Besides images of saints and other religious topics he represented peasants, witches, a monstrous sow, an unequal couple and other lovers, various nude females, soldiers and exotic Turks. His novel *Sea Monster* (55) defies simple explanation.[49] Scholars have proposed esoteric myths, obscure stories from ancient Lombard history and mariners' tales of seaside abductions as its source. Giorgio Vasari (1511–1574) describes it simply as 'a nymph being carried away by a sea monster'.[50] *Das Meerwunder*, Dürer's own title, may allude to its inherent lack of thematic specificity.[51] Each viewer could devise his or her own story. A bizarre horned sea creature, half-fish and half-man, swims rapidly away from the far shore. In his left arm he holds a turtle-shell shield and jaw bone. His right steadily, if rather gently, grasps a beautiful nude woman, whose jewelled head-dress conveys her high-born status. She is abducted while swimming with her companions. The other women and the turbaned Turk (her father?) are far more agitated than she. Dürer stressed the sensuous lines of her body, here turned for the viewer's delectation much as in the *Women's Bath* (see 42). Her pose may have been inspired by Dürer's copy of Mantegna's *Battle of the Sea Gods* (see 34) or by an Italian niello print of Triton swimming with a Nereid on his back.[52] Her left arm, shining brightly against the sea monster's darker body and placed next to his genitals, hints at the sexual outcome of the abduction. The highly detailed landscape behind, one of Dürer's most beautiful, recalls the precision of some of his watercolours (see 27). The setting cannot be localized in spite of claims that the castle is Nuremberg's Burg.

Virtually the same woman appears in *Hercules at the Crossroads* (56), Dürer's most ambitious mythological engraving from these years.[53] She is not the only familiar figure. The club-wielding woman and the fleeing child, although reversed, derive from his *Death of Orpheus* drawing (see 35), as does the idea of setting figures against a stand of trees. Her head covering is based on a

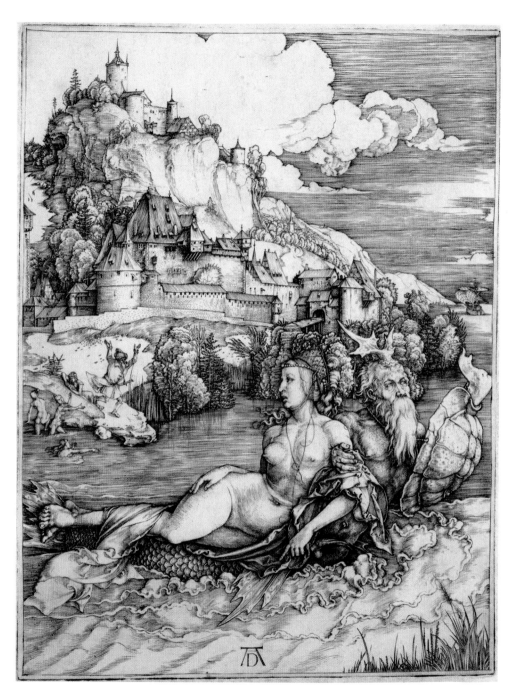

55
Sea Monster,
c.1498
Engraving;
25.5 × 19.2 cm
(10 × 7½ in)

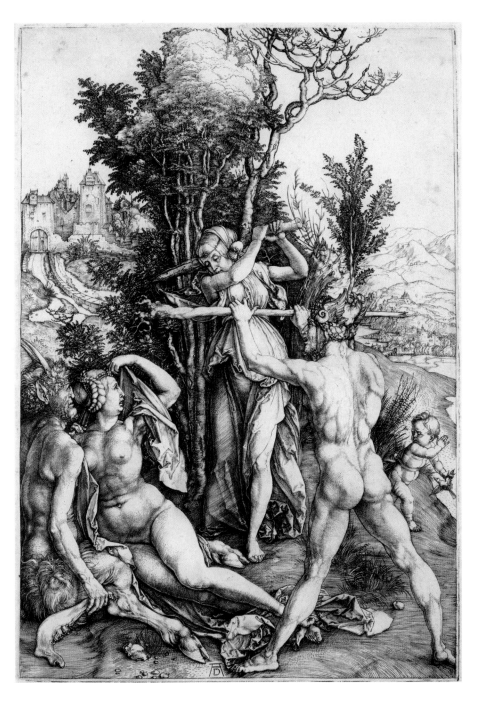

56
Hercules at the
Crossroads,
c.1498
Engraving;
32 × 22.5 cm
(12⅝ × 8⅞ in)

sketch of a woman, in the guise of the Wise Virgin, which Dürer produced while in Venice.[54] Other poses, including Hercules' back, recall the artist's drawings after Mantegna and Pollaiuolo. While these features are patched together from different sources, the result is a compelling scene of impending violence and a virtuoso display of Dürer's skill at rendering the human body, especially the classicized body. Such figures have no precedent in German art. The subtle manipulations of line and light to create forms, as nicely observed in Hercules' left buttock and leg or in the body of the reclining woman, are unmatched by any printmaker. Dürer's finesse almost makes us forget that we see lines and not palpable flesh. The engraving's composition and careful execution demonstrate its importance to the artist. Was this a *summa* of what he had learned in Italy and his recent technical mastery of the medium? Most contemporary viewers would not have recognized the subject – at least not without assistance. If this was the print that Dürer gave the Portuguese factor in Antwerp on 20 August 1520, he calls it simply 'den Herculem'.[55] Panofsky plausibly proposes it illustrates *Hercules at the Crossroads*.[56] Xenophon relates how the young Hercules, uncertain about his future path in life, encountered two beautiful women. Pleasure, dressed lasciviously, 'tried to lure him into a life of luxury and self-indulgence'. Virtue, simply clad, 'described the moral satisfaction to be gained by hardships and gallantry'. Dürer's reclining nude woman personifies pleasure. The attack by Virtue and Hercules derives from other sources perhaps suggested by Pirckheimer. For humanists, who mined Classical literature for edifying tales, Hercules' choice of Virtue's harder path was morally uplifting. Even though not initially as marketable as his themes from religious and popular culture, the print's iconographic novelty and style appealed to discerning collectors.

Information about how many impressions Dürer made of any engraving is scarce. Useful in this regard are the two portrait engravings commissioned by Cardinal Albrecht von Brandenburg, archbishop of Mainz (r. 1514–45).[57] Dürer supplied at least two

hundred impressions of the so-called *Small Cardinal* (1519) and five hundred of the *Large Cardinal* (1523) plus the two copper plates so that Albrecht could have more printed. After the first hundred or so impressions, the quality gradually decreases. It is reasonable to assume an average edition of two to three hundred impressions during Dürer's lifetime and many more thereafter. Obviously the demand was stronger for certain prints than for others. The scale of his overall production becomes apparent when we recall that he created 102 intaglio prints and around 350 woodcuts (or about 158 if book illustrations are excluded). Even by the lowest estimates, tens of thousands of high-quality impressions issued from Dürer's workshop. This was a lot for his wife and mother to sell.[58] Nuremberg's enterprising merchants occasionally included his prints among their wares for sale abroad. Dürer probably benefited from Anton Koberger's distribution network for vending the *Apocalypse* and his prints across Europe.[59] At least early in his career he hired agents, each with his own sales territory. On 7 July 1497 Dürer employed Contz Switzer (Schweitzer), and on 26 July, Jörg Coler. Switzer received a weekly wage of half a florin plus an additional three pounds for expenses when travelling outside Nuremberg.[60] These vendors, who had to be knowledgeable about Dürer's art, were charged with travelling 'from one land to another and from one city to another', where they were to seek the highest possible prices, send the income to Dürer in a timely manner and avoid idleness, especially in places where no new sales were possible.[61] This implies that Dürer had a basic price list based on the medium and scale. Woodcuts were cheaper than engravings. In 1500 he engaged Jakob Arnold, the brother of Nuremberg painter Hans Arnold, who vouched for his character.[62] Perhaps as the result of a bad experience Dürer included a provision that he must be compensated if prints were damaged through Arnold's carelessness. Years later, in his *Family Chronicle*, Dürer remarks that while he was in Venice in 1506–7 one agent's death in Rome resulted in considerable losses, probably both financial and in the theft of his print stock.[63]

Between 1495 and 1499, Dürer built a reputation as a superb painter. Among the finest pictures is the *Haller Madonna* (57), which was first attributed to Giovanni Bellini when it appeared on the art market in 1932.[64] The painting is in excellent condition, except for the repainting of the coat of arms in the lower right. While the shield opposite belongs to a member of the Haller family of Nuremberg, a more precise identification was impossible until recently. Using infrared reflectography, an imaging technique

57
Haller Madonna, 1496–8
Oil on wood (double-sided); 52.4 × 42.2 cm (20⅝ × 16⅝ in)
Samuel H. Kress Collection, National Gallery of Art, Washington, DC

58
Giovanni Bellini, *Madonna of the Little Trees*, 1487
Oil on panel; 74 × 58 cm (29⅛ × 22⅞ in)
Gallerie dell'Accademia, Venice

employing an infrared vidicon camera, it is possible to view under-drawings done in black chalk, charcoal or dark inks and, sometimes, the under-layers of paint. The arms of the Koberger family are faintly but clearly discernible beneath the over-painting. Bertold Freiherr von Haller recognized the patrons as Wolf III Haller zu Kalchreuth, who in 1491 married Ursula Koberger, Anton's eldest child. Dürer had known Ursula since childhood; both were born in 1471. Haller lived at Burgstrasse 12, just a few houses away from

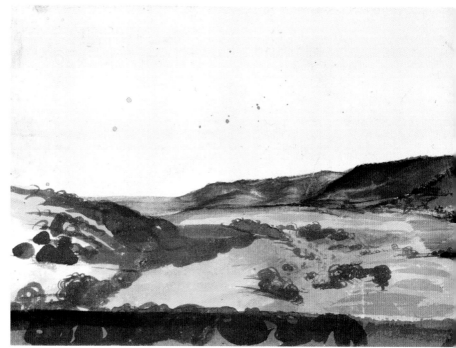

59
*Valley near
Kalchreuth,*
c.1498–1500
Watercolour
and body-
colour
(gouache);
10.3 × 31.6 cm
(4 × 12½ in)
Kupferstich-
kabinett, Berlin

Albrecht the Elder's residence. Although undated, the painting
was created during the first few years after the initial Italian trip.
Haller, a difficult individual, quarrelled with his father-in-law, was
arrested by the city in 1503, fled a year later to the margrave of
Brandenburg-Kulmbach, one of Nuremberg's adversaries, and was
excommunicated by the Catholic Church before his death in 1508.
Mary and Christ stand in a space conceptually akin to Dürer's 1498
Self-Portrait (see 40), although the stone is now veined marble.
Unlike the tender Maries of some earlier paintings or the *Virgin
and Child with a Monkey* engraving (see 53), she stares solemnly
at or past the viewer.[65] Her reserved expression, enhanced by the
passive blue of her attire, contrasts with her animated son. Christ
lifts his right leg and fingers a strand of his mother's golden hair.
His nude body, an allusion to the maleness of the God made flesh,
stands out vividly against the dominant blues, greens and bright
reds. While in Venice, Dürer certainly admired Giovanni Bellini's
small hieratic Marian pictures, such as the *Madonna of the Little
Trees* (58).[66] From these he adopted such features as the solemn

Virgin, the solid-coloured cloth backdrop, aspects of Christ's pose and the foreground parapet. Above all, Dürer emulated Bellini's sense of balance and colour harmonies. Christ, however, is closer to his engraved counterparts than to Bellini's restrained *bambini*. Painted on the reverse of the *Haller Madonna* is the unusual subject of *Lot and His Daughters*, done in a much looser style. This may have served as the exterior of a diptych with a pendant portraying one or both donors. Alternatively, perhaps the panel slid into a slotted frame with the Virgin and Child facing inward for protection (see also 178). Based on its scale, this small devotional picture could easily be transported between the Hallers' house in Nuremberg and the family's castle near Kalchreuth.

Dürer's association with this couple helps date two of his most beautiful watercolours, showing the *Village of Kalchreuth* and the *Valley near Kalchreuth* (59).[67] It may have been during a visit to the Hallers' country residence before 1503 that the artist sketched the village, which is about 14 kilometres (8.7 miles) north of

Nuremberg, and the view with the Honigs plateau farther north. Scholars generally consider these the last watercolours before Dürer suddenly stopped making landscapes in this medium. Dates up to 1514 have been suggested, although this seems much too late on stylistic grounds. The sheet used for the valley view has a watermark that appears elsewhere on paper datable from 1492 to 1495.[68] Like the *Haller Madonna*, this drawing was probably created during the three or four years immediately after Dürer's return to Nuremberg. The horizontal format and the rapid blocking in of the foreground with broad brushstrokes suggest the artist drew the valley *in situ* in one sitting. With a tremendous economy of technique and only a modicum of detail in the centre, Dürer convincingly conveyed the expansive sweep and recession of the valley, its topographic features (the hills are known as the Hetzles) and its momentary atmospherics. Dürer accidentally dripped or splattered small dots of colour in the sky. Earlier sketches, such as the *View of Innsbruck* (see 26), express a precision or factuality achieved by joining together lots of details. The *Valley near Kalchreuth*, on the other hand, imparts an experience of the whole – a fleeting, unified glimpse of the humble beauty of the countryside.

During the later 1490s Dürer painted the *Paumgartner Altarpiece* (see 5) and a now lost *Altar of Saint John the Baptist* (c.1498), commissioned by Sebald Bamberger, the new abbot of the Cistercian monastery at nearby Heilsbronn.[69] He also authored several portraits, the most notable of which is Oswolt Krel's (60). Krel, a native of Lindau, worked in Nuremberg between 1495 and 1503 as the branch head of the Great Ravensburg Trading Company.[70] In conception, the picture recalls Dürer's *Self-Portrait* of 1498 (see 40) as the highly plastic figure, rendered in careful detail, is pushed up to the very front of the picture plane. His right hand rests on an unseen ledge. Krel looks intently outwards but not at the viewer. Instead of placing him in a room, Dürer sets Krel against a bright red cloth and a forest road. The wings show wildmen holding the coats of arms of Krel and his wife Agathe von Esendorf.

60
Oswolt Krel,
1499
Oil on
lindenwood;
including
open wings:
49.7 × 70.8 cm
(19¹/₂ × 27⁷/₈ in)
Alte
Pinakothek,
Munich

The artist also began working for Friedrich the Wise, elector of
Saxony. Besides founding the University of Wittenberg in 1502
and hiring a young monk named Martin Luther as a professor,
Friedrich was one of the great Renaissance art patrons.[71] In mid-
April 1496 he and his brother Johann the Steadfast (r. 1525–32)
attended the imperial diet in Nuremberg, where he met Dürer.
Their encounter inaugurated a professional relationship that
lasted until the elector's death in 1525. The deeply pious Friedrich
made the dangerous pilgrimage to Jerusalem in 1493. After
returning safely, he initiated the rebuilding and decorating of
Wittenberg's Schlosskirche. Friedrich commissioned Dürer's *Mary
Altarpiece* (1496) and *Dresden Altarpiece* (1497) for this church.[72]

Subsequently the artist produced the *Adoration of the Magi* (1504; see 99) and the *Martyrdom of the Ten Thousand* (1508; see 78), among other projects (see 174), for the prince.[73]

Dürer's now lost sketch served as the model for the life-size, bust-length portrait of *Friedrich the Wise* (61).[74] One is immediately struck by its dark and rather subdued coloration. Using a finely woven canvas, Dürer painted the portrait in distemper (pigments mixed with size and thinned with water). The choice of materials may have been dictated by expediency if the elector wanted to take the finished picture with him. The water-based pigments dry very quickly, and the canvas can be rolled for easy transportation. This was also a matter of taste since, unlike oils with their bright glossiness, distemper on canvas has a matt appearance. The pigments soak into the fabric, so they do not have the same luminous characteristics of oils. Dürer placed Friedrich against a muted green background. The warp and weft of the canvas threads are readily visible as the green was brushed on rather thinly. The elector's black beret and clothing, while fashionable with the slit sleeves and decorative gold bands, heighten the sitter's sense of sober restraint. He turns his head slightly and stares attentively at the viewer. With his left eye cast in partial shadow, Friedrich seems to see us better than we can see him. This detachment, coupled with his sureness of pose, lends him an air of authority that differs from the self-consciousness of Dürer's self-portraits of 1493 and 1498 (see 21 and 40), in spite of their compositional similarities. Dürer's *Hercules Killing the Stymphalian Birds* (62) employs the same technique.[75] Trimmed at the top and right sides, the picture was also damaged by over-painting and the application of a dark varnish. It depicts the sixth labour of Hercules, in which King Eurystheus orders him to disperse a large flock of birds gathered by a lake near the Greek town of Stymphalos. Dürer set the story in a magnificently evocative landscape. Using a pair of divinely forged noise-makers (*krotala*) hanging by his left leg, Hercules startles the birds. As they fly into the air, he shoots them.

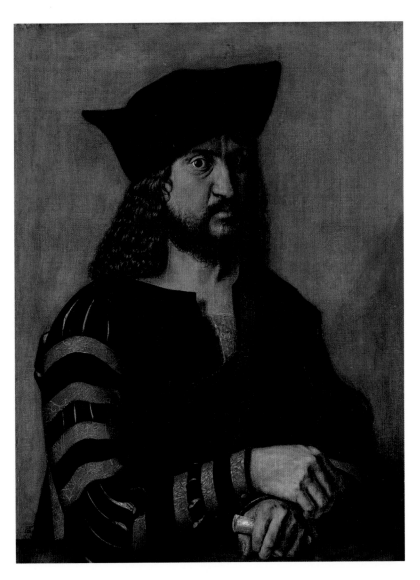

61
*Friedrich the
Wise*, c.1496
Distemper
on canvas;
76 × 57 cm
(29⅞ × 22½ in)
Gemälde-
galerie, Berlin

According to Pausanius' description of ancient Greece, these birds, believed to be man-eating, were rendered as maidens with bird legs on the temple at Stymphalos. Dürer picked the moment of greatest violence, as the muscular hero aims his bow at the harpy-like creatures. His stance recalls the artist's drawings after Mantegna and Pollaiuolo, with their vivid expressions and dynamic poses. In all likelihood Dürer sought Pirckheimer's advice for relevant textual sources, including Ovid, or how to represent *krotala*, hollow blocks of wood hinged together with leather that were much smaller than seen here.

Surprisingly, this is Dürer's only known, or at least extant, mythological painting. Around 1500 most German patrons commissioned religious art and, with increasing frequency, portraits. Unlike the later pin-up-like nude goddesses peddled by Lucas Cranach the Elder, Dürer strove for a feeling of authenticity.[76] Memories of Classical art in Italy, albeit through the filter of such contemporary masters as Mantegna, still affected him. Even in its present damaged state, *Hercules Killing the Stymphalian Birds* nicely embodies many of the artistic lessons Dürer learned in the 1490s. When viewed within the context of contemporary German art Dürer's vision and style were unique. Was this painting ordered by Elector Friedrich? In 1508 Andreas Meinhardi, a student at the University of Wittenberg, published a fictitious account describing the interior decorations of Friedrich's palace.[77] One heated ground-floor chamber was adorned with four paintings of Hercules, including his shooting the Stymphalian birds. Unresolved, however, is whether this painting could be Dürer's, or if this cycle ever existed. The author may have invented the entire programme as an exercise displaying his Classical erudition. Such an unusual theme would have appealed to Friedrich. The actual patron, alas, remains unknown. Dürer's interest in Classical subjects, though not in the human body, soon waned and disappeared completely after he returned from his second trip to Italy in 1507.[78] His ambitions took him in a different direction.

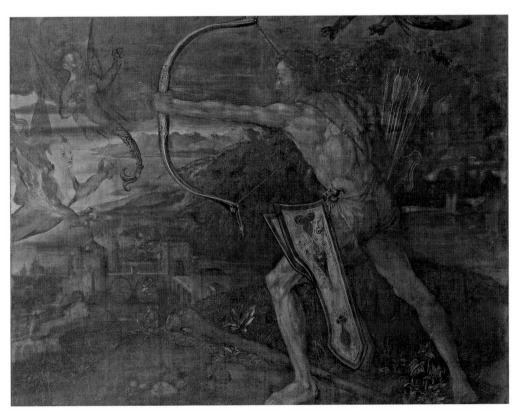

62
*Hercules
Killing the
Stymphalian
Birds*, 1500
Distemper
on canvas;
87 × 110 cm
(34¼ × 43¼ in)
Germanisches
National-
museum,
Nuremberg
(on loan from
the Bayerische
Staatsgemälde-
sammlungen,
Munich)

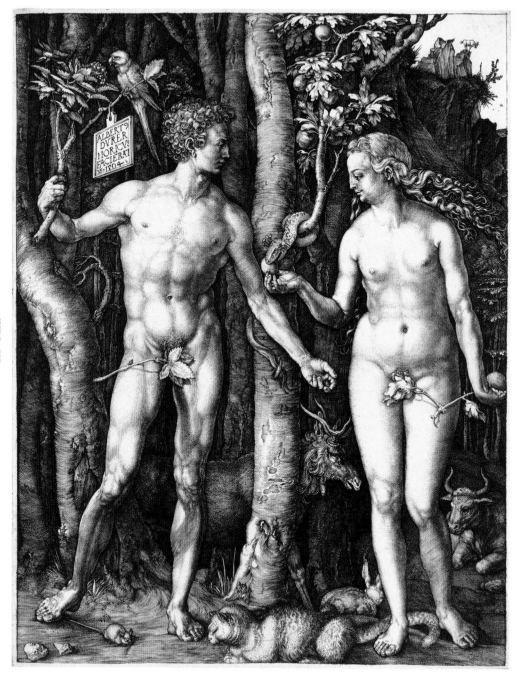

In 1504 Dürer completed his *Adam and Eve (The Fall of Man)* engraving (63).[1] Although he could not foresee that this would become the most influential image of his career, he conceived it differently from any earlier print. *Adam and Eve* narrates, in Judaeo-Christian thinking, the earliest human story. It also articulates a new artistic vision, one based on diverse types of knowledge skilfully melded together into a perfect whole. In 1512 Dürer wrote a partial book draft, alas unpublished, entitled 'Speis der Malerknaben (Nourishment for Young Painters)'.[2] In the introduction he uses the term 'artful painter' ('ein künstreicher moler') and notes that the world often goes two or three hundred years without the appearance of such a master.[3] He blames the rarity of such masters on artists themselves, specifically on those who possess great talent but do not study other branches of learning. As developed here and in his published treatises, Dürer's concept of *kunst*, the word he coined and which is used today in German to mean art, encompasses both the verbs *können* (to understand or to be capable of) and *kennen* (to know).[4] By these terms Dürer meant respectively practical understanding (being a skilled artist) and theoretical knowing (being an educated artist). The first type of artist has formidable talents based on his inherent skills and learned craft. The second type of artist, the true 'artistic painter', combines craft with a theoretical knowledge that includes human proportions, geometry and perspective, among other things. This allows the artist to work at a much higher level. Dürer's engraving embodies his creative quest and personal ambitions at the advent of the new century.

Adam and Eve stand at the edge of a dense, dark forest. They are nude but not yet naked, since they have yet to gain a shameful or sinful awareness of their bodies (see also 92). Adam grasps the

63
*Adam and Eve
(The Fall of
Man)*, 1504
Engraving;
25.2 × 19.5 cm
(9⅞ × 7⅝ in)

branch of a mountain ash tree, a symbol of the tree of life. Coiled around a fig tree, here standing for the tree of knowledge of good and evil, a serpent hands Eve the forbidden fruit (a fig or an apple). The first human pair is accompanied by a parrot, cat, mouse, elk, rabbit, ox and, standing precariously on the cliff at the upper right, a mountain goat. Genesis 2:15–17 and 3:1–7 describe Adam naming the animals but mention specifically only the serpent that tempted Eve. Their inclusion, like the inscribed *cartellino*, is highly unusual in traditional scenes of the fall of man.

Dürer's pictorial invention and technical virtuosity almost make the viewer forget that he or she is looking at hundreds of black marks printed on the thin white sheet of paper. Adam and Eve stand believably within the Garden of Eden. The implication of motion, specifically the shifting of weight in their legs, is augmented by light. Adam's raised right foot shades the ground below. The shadow of his right leg deftly plays across his left leg as it gently curves in unison with the contours of the thigh, knee and calf. One can even see how the tree branch faintly darkens his right shoulder and armpit. The exquisite modulations of light and shadow throughout the composition are matched by (and essential to) Dürer's mastery of line to convey texture. The couple's supple flesh and Adam's wiry hair contrast with the rough tree trunks, the crafted surfaces of the *cartellino* and the fur or feathers of the other creatures.

To gauge his progress Dürer inked and printed the unfinished plate twice.[5] These trial proofs are invaluable records for understanding his working method. In the first state (64) he completed much of the background before starting on Adam and Eve. As the print is a reverse or mirror image of the plate, Dürer worked his plate from right to left. He either drew directly on the copper with a pencil or pen or traced a carbon-backed sketch on to the plate. With the burin Dürer lightly incised the contours of his figures as observed in Eve's legs and the left side of her body. The forest

64
Adam and Eve,
trial proof, 1st
state, 1504
Engraving;
sheet trimmed:
24.9 × 18.6 cm
(9¼ × 7⅛ in)
British
Museum,
London

provides a dark backdrop for the lighter figures. By doing the figures last, he could adjust their surface values. In the second state Dürer completed Adam's left leg.[6] He focused on the arms and torso before attempting the head. The artist left small blank spaces around the heads, a transitional zone that he filled in last. He kept a few proofs, which were typically discarded, for reference or teaching purposes or maybe as gifts. These also document his exceptional creativity, and thus were saved for many of the same reasons that he kept his early *Self-Portrait* (see 12).

Dürer devoted two or three years to this project. The trajectory of his thinking may be tracked in numerous drawings and engravings, ranging from exquisite nature studies to constructed (mathematically conceived) figures and classicizing prototypes. Not all are directly linked to Adam and Eve, yet these illustrate his current creative interests. Art begins by studying nature. In the aesthetic excursus of the Latin translation of the *Four Books on Human Proportions* (1528) Dürer writes:

> But life in nature manifests the truth of these things. Therefore observe it diligently, go by it and do not depart from nature arbitrarily, imagining to find the better by thyself, for thou wouldst be misled. For, verily, 'art' [that is, knowledge] is embedded in nature; he who can extract it has it. If thou acquirest it, it will save thee from much error in thy work. … Therefore, never put it in thy head that thou couldst or wouldst make something better than God has empowered His created nature to produce. For thy might is powerless against the creation of God. Hence it follows that no man can ever make a beautiful image out of his private [*eigen*] imagination unless he have replenished his mind by much painting from life.[7]

Drawings and watercolours survive for the parrot, elk, rabbit and bull.[8] Dürer adjusted the angle of the elk's front leg slightly, as reversed in the print; otherwise it would have been obscured by the tree. The elk's stiffness prompts speculation that Dürer drew

65
The Hare, 1502
Watercolour
and body-
colour,
heightened
with white;
25 × 22.5 cm
(9⅞ × 8⅞ in)
Albertina,
Vienna

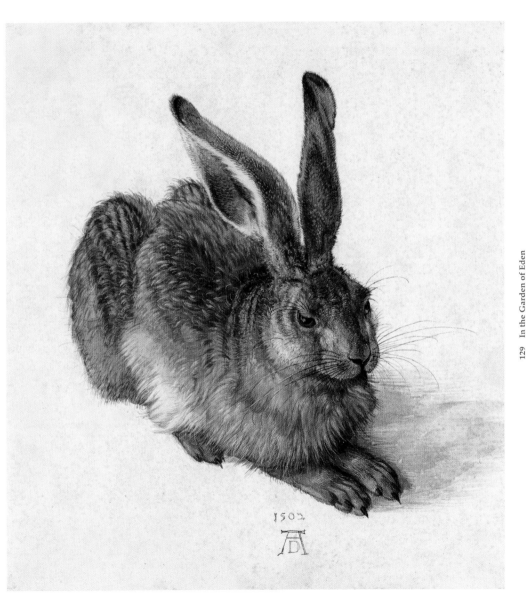

from a stuffed specimen, although this form of taxidermy was not practised in the early sixteenth century. These animals lack the vivacity of *The Hare* (65), his most famous (and widely copied) nature study.[9] Here the erect ears, raised head, alert sitting posture and the cast shadow mimic a living creature, one that Dürer placed (repeatedly?) on a table. The right eye reflects the light of a nearby window. He carefully replicated the different types of fur, from short hairs on top of the nose to the long whiskers to the thick coat of its breast. The hare's tactility resonates with our own experiences of such creatures. Dürer used a simpler drawing of a hare for the engraving.

His *Large Piece of Turf* (66), made concurrently with his designs for *Adam and Eve*, celebrates in microcosm the abundance of a Franconian meadow in May.[10] Dürer's accurate rendering of a cluster of grasses and flowers permits botanists to identify daisy, dandelion, yarrow, plantain, cock's foot and speedwell, among other species. Earlier artists, such as Schongauer, portrayed individual flowers, yet their conceptual vision was wholly unlike Dürer's.[11] He shaped the plants, without sacrificing their specificity, into a unified scene. The close-up focus, life-size scale of the plants and careful lighting throughout create a palpable monumentality. Furthermore, the edges of the sheet frame but do not limit the natural growth, which extends, at least in one's imagination, in all four directions.[12]

Dürer was, above all, preoccupied with the body, especially the nude body. In the 1490s he sketched from life (see 36, 39) and emulated the classicizing figures of Mantegna (see 34) and Pollaiuolo (see 37). *Adam and Eve*, achieved only after considerable intellectual struggle, is the result of Dürer's quest for physical perfection. Nothing like these figures exist in earlier German art, and they reflect a direct Italian influence. Jacopo de' Barbari, whom Dürer met during his first Venetian trip, lived in Nuremberg in 1500–1 while in the employment of Emperor Maximilian I

66
Large Piece of Turf, 1503
Watercolour and body-colour on paper with brush, pen, heightened with white; 40.3 × 31.1 cm (15⅞ × 12¼ in) Albertina, Vienna

(r. 1493–1519). Years later, Dürer wrote, Jacopo once

> showed me the figures of a man and a woman, which he
> had drawn according to a canon of proportions; and now
> I would rather be shown what he meant … than behold
> a new kingdom. If I had it [his canon], I would put it into
> print in his honour, for the use of all men. Then, however,
> I was still young and had not heard of such things
> before. Howbeit I was very fond of art, so I set myself to
> discover how such a canon might be wrought out. For this
> aforesaid Jacopo, as I clearly saw, would not explain to
> me the principles upon which he went. Accordingly I set
> to work on my own idea and read Vitruvius, who writes
> somewhat about the human figure. Thus it was from, or
> out of, these two men aforesaid that I took my start, and
> thence, from day to day, have I followed up my search
> according to my own notions.[13]

This incident, which occurred either in Venice or Nuremberg,
inspired Dürer's years of careful study of human proportions
and culminated in his treatise of 1528 (see 186, 187). Adam and
Eve embody what he truly meant by the term *kunst*. De' Barbari
may have advised Dürer to study mathematics and geometry. In
a letter to Friedrich the Wise, his patron, between 1500 and 1502,
the Italian master stressed that artists must be knowledgeable in
these disciplines.[14]

While much of this story post-dates *Adam and Eve*, the artist
prepared constructed proportional drawings by 1500. In these he
sought to understand the human body in terms of the ideal ratios
of the parts to the whole. Manuscript copies of the ancient Roman
architect Vitruvius' *De architectura libri decem* (*Ten Books on
Architecture*) stimulated debate among architects and humanists
in the fifteenth century.[15] The text was first published in Rome
around 1486, with other editions appearing in Florence (1496)
and Venice (1497). Dürer possessed a copy or borrowed one from
Pirckheimer. Book 3 begins with a discussion of symmetry in

67
Adam (recto),
c.1504
Pen and ink;
26.2 × 16.6 cm
(10⅛ × 6½ in)
Albertina,
Vienna

68
Adam (verso),
c.1504
Pen and ink
with brown
wash;
26.2 × 16.6 cm
(10⅛ × 6½ in)
Albertina,
Vienna

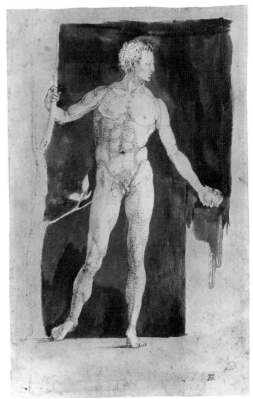

temples and its relation to the human body. Chapter 1 contains the
author's theory on the ideally proportioned body, subsequently
known as Vitruvian Man. The idea that there might be a rational
mathematical basis for defining the human body fascinated
Dürer during the early 1500s, even though he soon recognized the
theory's inherent limitations in the face of humanity's
infinite variability.

One preparatory drawing for Adam (67, 68) applies the Vitruvian
scheme.[16] A vertical line defines the figure's central axis.
Numerous prick marks indicate that Dürer employed a compass
to determine forms, as in the resulting circles circumscribing
the shoulders and abdomen with the hips. Adam is marked with
proportional measurements. Vitruvius states that the head should
be equal to one-eighth of the body's total length; the face from

the chin to the hairline is one-tenth; the width of the square that defines the chest (and this construction is visible in the drawing) is one-sixth; the length of the foot is one-sixth; the forearm is a quarter; and so on. Dürer made the genitals rather than the navel, as suggested by Vitruvius, the centre point of the body. The inscribed circles, square and triangle reflect Dürer's belief in the underlying geometric foundation of the body.

In 1500 Dürer began using a recto–verso transcribing technique.[17] He turned this sheet over and traced the constructed figure on the verso.[18] Dürer then added the tree, Adam's apple, shading and body details, and the dark-brown background. The male figure is now clearly Adam. His raised arm grasps the tree branch, and he carries an apple in the other hand. In a separate life study (69) Dürer experimented with different poses for the left arm, which is critical to the print's meaning.[19] Should Adam hold the apple? Or, if the hand is empty, how should the fingers be positioned? At the lower left he drew a variant of the cliff at the upper right of the print. Above, he was concerned with the position and shading of Adam's other arm.

By the time Dürer made these drawings, he had settled on the fundamental poses of the couple. Both are based on Classical sculptures.[20] Adam derives from the *Apollo Belvedere* (70). The Roman copy of the lost Hellenistic bronze was unearthed in Italy and by the late 1490s was displayed in the garden of Cardinal Giuliano delle Rovere, the future Pope Julius II (r. 1503–13), in Rome. Eve emulates the *Venus Pudica,* or modest Venus, devised by Praxiteles in the fourth century BC. Dürer knew these prototypes only through Italian intermediaries, such as Jacopo de' Barbari's *Apollo and Diana* or Mantegna's *Bacchanal with the Wine Vat* engravings.[21] Adam's pose, however, first appears in reverse in Dürer's *Apollo and Diana* (71), a sketch done in preparation for a never completed print of the Sun (Sol/Apollo) and Moon (Luna/Diana).[22] The stance, when reversed, is quite

69
Studies for the Hand and Arm of Adam, 1504
Pen with brown and black ink;
21.6 × 27.5 cm
(8½ × 10⅞ in)
British Museum, London

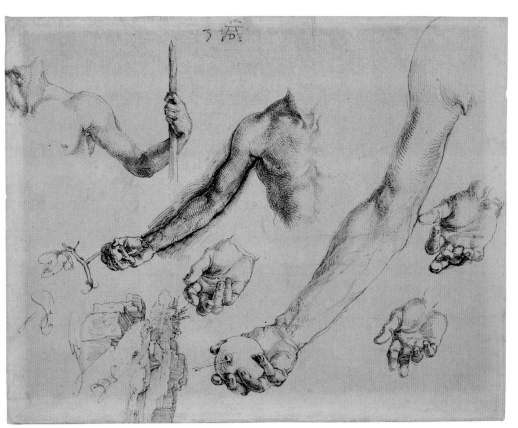

close to Adam's. Around 1510 Dürer explains his willingness to
emulate Classical sources: 'As they used the most beautiful human
proportions for their idol Apollo, so should we use those same
proportions for Christ the Lord, the most beautiful in the world.
And as they used Venus to express the most sublime beauty, we
should depict the same elegant and refined figure of the purest
Virgin Mary, the Mother of God. And out of Hercules we should
make Samson, and we should do the same with all the others.'[23]

Dürer conceived Adam and Eve, God's prototypical first humans,
as physically perfect before the fall. Two simple nudes would
fail to convey their divinely crafted forms. For this reason the
artist looked to Classical and Italian models. Then he subjected
these figures to Vitruvius' canon to ensure their mathematical

harmonies. In his *Nemesis* (or *Large Fortune*; 72) Dürer depicted the Classical goddess of retribution floating in the heavens above the mountainous town of Chiusa (Klausen), which he must have visited as he passed through the southern Tyrol in 1494–5.[24] One is struck by Dürer's careful attention to the landscape, Nemesis' wings, and her body. The wings recall the artist's remarkable *Dead*

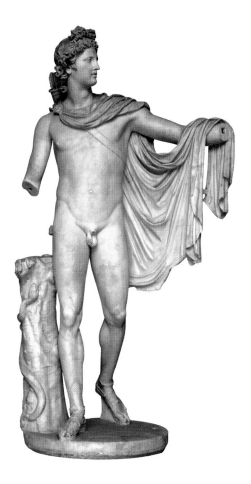

Blue Roller and *Wing of a Blue Roller* (73, 74), ornithological studies of true precision as apparent in the careful delineation of the colours and the forms of the different types of feathers of a *Coracias garrulus* L.[25] Although the dates of these watercolours are debated, since the inscriptions may not be contemporaneous, they reflect Dürer's scientific approach throughout this period. He chose

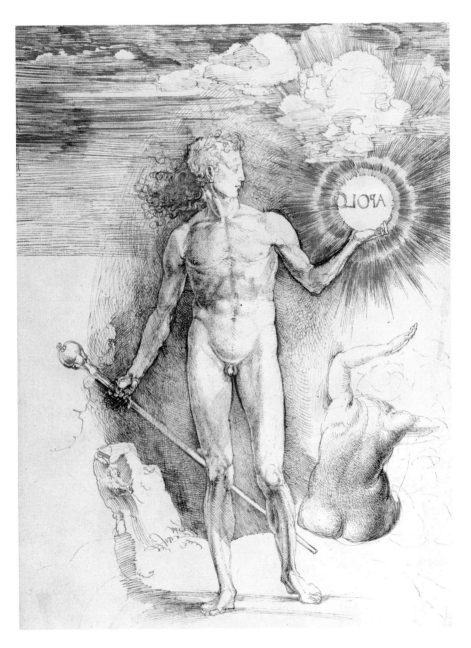

71
*Apollo and
Diana*, c.1501–4
Pen with brown
and black ink
with white
heightening;
28.3 × 20.5 cm
(11⅛ × 8⅛ in)
British Museum,
London

a Classical theme for his first exposition of a constructed figure based, imperfectly, on Vitruvius' theory of human proportions. Dürer must not have been satisfied, since she looks more like one of his nude life drawings than a goddess. The poses of Adam and Eve convey a greater sense of grace, balance and beauty. Although Adam's muscular body is minutely described, it is the delicately raised right foot and shifting of the weight, traits deriving from his Italian models, that animate the figure. Eve has exquisite poise.

This quest for perfection, grounded in nature, canonical mathematical ratios and Classical prototypes, had a purpose. Dürer sought to devise ideal figures based on his *kunst*, the skill and knowledge that he felt distinguished him from his contemporaries. If God created Adam and Eve in his image, Dürer bore the responsibility to invent figures more perfect than had ever been seen in German art. His understanding of Adam and Eve was grounded too in humoral theory, the foundation of Classical and medieval medicine.[26] It was believed that each person has four fundamental fluids or humours (black gall, choler, phlegm and blood) that determine his or her character. Adam and Eve, their fluids in perfect equilibrium, were immortal in the Garden of Eden before biting into the forbidden fruit. With their knowledge of good and evil and their expulsion from paradise, however, they became mortal. When one's fluids lose this balance, the body is subject to illness and the soul to sin. Dürer's couple is still in the prelapsarian state. Some of the surrounding animals embody the four humours: melancholic gloom (the elk), sanguine sensuality (the rabbit), choleric cruelty (the cat) and phlegmatic sluggishness (the ox). Their inclusion adds a deeper level of meaning to the print.[27] Even the body types of Adam and Eve refer to the physical distinctions between males and females. Men are hot and dry by nature, so the upper body is more developed. By contrast, women are cold and wet. Their lower body, specifically the abdomen as the seat of childbirth, is accented. Dürer never quite overcame the artistic custom of showing a woman's abdomen as pear-shaped.

72
Nemesis (Large Fortune),
c.1501–2
Engraving;
33.5 × 26 cm
(13¼ × 10¼ in)

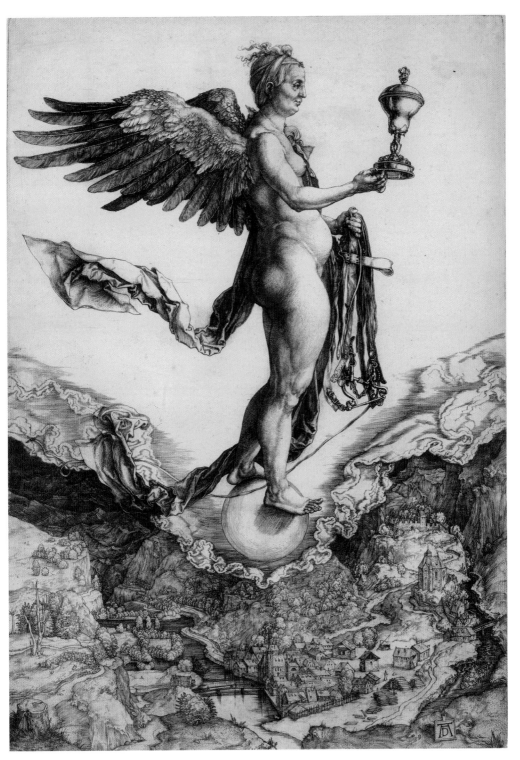

73
*Dead Blue
Roller*, c.1500
or 1512
Watercolour
and gouache
on parchment;
27.4 × 19.8 cm
(10¾ × 7¾ in)
Albertina,
Vienna

74
*Wing of a Blue
Roller*, c.1500
or 1512
Watercolour
and gouache
on parchment;
19.7 × 20 cm
(7¾ × 7⅞ in)
Albertina,
Vienna

One antidote to the impending human fall appears on the branch above Adam's head. The parrot, with its waterproof feathers, was often a symbol for the Virgin Mary, who as the second Eve bears Christ to redeem mankind from original sin. The goat, linked with witches and the devil, has more negative connotations (see 81).

Amid the natural abundance of Eden is a single man-made object: the *cartellino* inscribed 'ALBERT[US] DVRER NORICVS FACIEBAT 1504' ('Albrecht Dürer of Nuremberg made this 1504'), plus his AD monogram. Dürer's choice of Latin, the international language of the educated, is deliberate, as is the decision to give his full name and city. He informed his viewers that it was a German, not an Italian or Netherlandish, artist who devised this complex image. He is celebrating his *inventio*, or inventiveness. Wittily, he suspended the *cartellino* from the Tree of Life. Unlike Adam and Eve or even Dürer the man, his art is immortal. God, the first artist, formed Adam and Eve from base material before breathing life into them. Dürer used copper, ink and paper, equally humble matter. Both God and Dürer are cast in the role of creators. The latter, because of his *kunst,* breathes life into his anatomically perfect first couple. Dürer's *cartellino* signals that he too walked through the Garden of Eden before the fall. Does this make his art sinless or faultless? Similarly, his art mimics nature just as the parrot mimics human speech. Furthermore, in 1504 Dürer was thirty-three, Christ's age when he died. Saint Augustine claimed that Christian souls would be this age when they entered heaven.[28] Perhaps this offers another reason for Dürer's lingering in paradise. One can easily imagine Dürer and Pirckheimer chuckling over the possible ways one might interpret the artist's signature.

Adam and Eve is a public declaration of self. As a reproducible print, it carries its messages of creative thought and pictorial fulfilment wherever it travels. The engraving is conceptually a self-portrait, even though it lacks the requisite physical likeness of the artist. The autobiographical characters of his 1493 and 1498

75
Self-Portrait,
1500
Oil on
lindenwood;
67 × 48.8 cm
(26⅛ × 19¼ in)
Alte
Pinakothek,
Munich

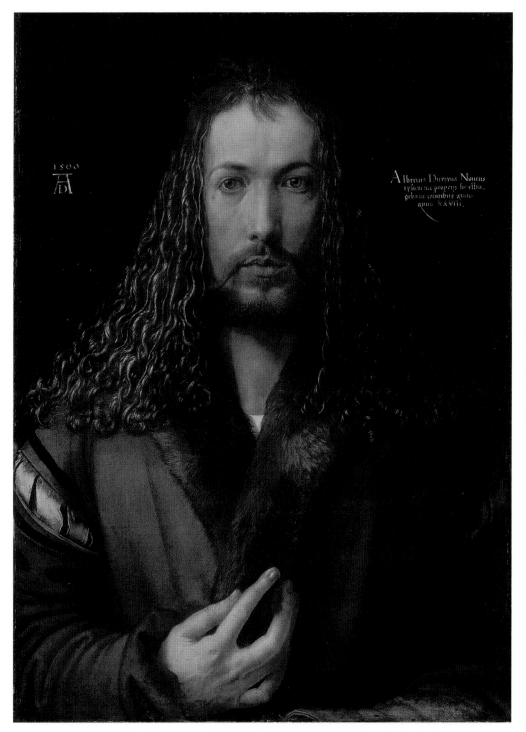

1500

Albertus Durerus Noricus
ipfum me proprijs fic effin-
gebam coloribus ætatis
anno XXVIII.

paintings (see 21, 40) are the preliminary chapters of a lifelong process of self-fashioning. Sometimes Dürer offers us his face; at other times the revelation occurs in his writings, in his signatures or in works such as *Adam and Eve* or *Melencolia I* (see 122), where the iconographic message is but part of the broader story.

Nowhere is Dürer's intentionality better articulated than in his *Self-Portrait* of 1500 (75).[29] The painting was well known to his acquaintances, including Conrad Celtis, who composed three epigrams in its honour in 1500. The portrait hung in Dürer's house, although at some time between the 1520s and 1555 the picture migrated to the city hall, where Van Mander saw it in 1577.[30] Dürer's *Self-Portrait* confronts the viewer with an unblushing directness not found in earlier Renaissance portraiture. The artist positions himself parallel to and immediately behind the frontal picture plane. The space is tight as his body pushes, fictively at least, past the limits of the frame on three sides and perhaps slightly too close to the front for the viewer's comfort. Only the sleeve of his left arm is visible, as it appears to be resting on a table or ledge just beneath the lower edge of the painting. His raised right hand fingers the fur trim of his expensive coat. The black background withholds any information about his setting; however, it presents a vivid contrast to the radiantly illuminated face and lustrous hair. Dürer again incorporated a window reflected in his moist eyes. The viewer naturally reads this as a source of illumination shining from the upper left behind him or her. This, coupled with the close proximity of the sitter and his unflinching stare, establishes Dürer's almost disconcertingly believable physical presence.

Dürer modelled his frontal pose, hair and beard on images of Christ as the *Salvator Mundi*, such as Schongauer's drawing (76).[31] Christ gazes rigidly forwards as he raises his right hand in blessing. Dürer equally emphasized his own right hand, although for different reasons, as we shall see shortly. Such images derive

from Byzantine art, which increasingly found its way into Northern Europe in the fifteenth century.

The iconic figure of Christ as saviour is timeless. Dürer too craved immortality. The painting is inscribed with his monogram and the year 1500 at left, and, opposite, the text 'I, Albrecht Dürer of Nuremberg, painted myself thus, with undying colours [or, with my own colours], at the age of twenty-eight years'

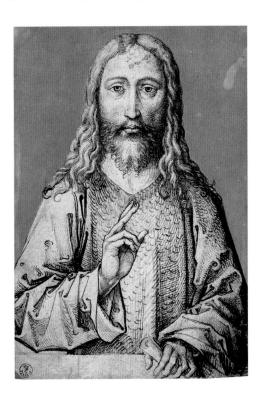

76
Martin Schongauer,
Salvator Mundi, c.1467–early 1470s(?) Pen and ink drawing; 21.3 × 14.5 cm (8⅜ × 5¼ in) Galleria degli Uffizi, Florence

('Albertus Durerus Noricus / ipsum me proprijs sic effin- / gebam coloribus aetatis / anno XXVIII').[32] As Goldberg, Heimberg and Schawe observe, 'proprius' can carry a double sense of 'own' and 'immortal'. Dürer alluded to the durable quality of his colours and of his enduring image, both markers of lasting fame. In 1500 the year that many thought would bring the Apocalypse, the artist announced that he was twenty-eight. While this sets the date of completion early in the year before his next birthday on 21 May,

twenty-eight was considered the age when one reaches the peak of greatest attractiveness and strength (in the sense of ability). The portrait testifies to his physical prime and artistic skills. Even seemingly small choices reveal Dürer's changing vision. Unlike in the 1498 *Self-Portrait*, with its German inscription written in Gothic-style lettering, now the artist uses Latin and a script reminiscent of Roman (Italian *Antiqua*) book typeface. The prototype for the *Salvator Mundi* also conveys the image's essential truth. Waiting just behind Jesus in Schongauer's *Christ Carrying the Cross* (see 18) is Saint Veronica. When Jesus passes, she wipes his bloodied face with her veil. Miraculously, his portrait is imprinted on the cloth. This likeness, one made without human hands, is divinely given and therefore authentic. In both Byzantine and western European art, Veronica's veil (the *Sudarium* or *Vera Icon*) serves to sanction the use of religious art depicting Christ in his human manifestation.

The inscription rhetorically proclaims the truthfulness of the portrait.[33] Never mind that in reality Dürer's hair was a blondish brown, rather than the darker tones observed here. Christ is typically shown with dark-brown hair, so Dürer emulated his model.

The choice of Christ as a model for a portrait may from a modern perspective seem odd, indeed blasphemous. Yet by 1500 the concept of *imitatio Christi* was deeply ingrained in popular devotional practices. Nurtured by the mendicant orders, especially the Franciscans, and later by the Modern Devotion, a spiritual renewal movement, the individual sought to deepen his or her understanding of Christ's life and sacrifice by being imaginatively present. To comprehend Christ's crucifixion, it was necessary to put oneself at the foot of the cross in order to experience deeply, with all one's senses fully engaged, the moment. Schongauer's *Christ Carrying the Cross* implicates the viewer in this way. As the Dutch mystic Thomas à Kempis remarks in his highly influential treatise *The Imitation of Christ* (1427–41), 'Take up the Cross,

therefore, and follow Jesus, and go forward into eternal life. …
And if you share His sufferings, you will also share His glory.'[34]
Saint Paul writes in Galatians (2:20), 'and it is no longer I who
live, but it is Christ who lives in me. And the life I now live in
the flesh I live by faith in the son of God, who loved me and gave
himself for me.' A true Christian should emulate Christ. Dürer
took this to its pictorial extreme in his *Self-Portrait as the Man
of Sorrows* drawing (see 162) of 1522, where he showed his once
vigorous body now broken by malaria, which he contracted in the
Netherlands in late 1520. Based on his own writings, the artist was
devout. Thus his decision to pattern his portrait of 1500 on images
of Christ is understandable even if no other artist had taken this
man-in-God's image identification quite so literally. Later artists
transformed this portrait of Dürer-based-on-Christ into depictions
of Christ-based-on-Dürer (see 193).[35]

Dürer emphasized too his God-given talent in the 1500 portrait.
His ability to mimic nature down to the veins of his hands and the
nap of the fur is dazzling. Less apparent yet no less important is
the underlying geometry of the picture. Using a scheme developed
for iconic images of Christ, Dürer inscribes his bust, from the
shoulders to the top of his head, in an equilateral triangle, a square
and a circle that overlap and determine their relative positions.[36]
Soon afterwards, he would employ these three perfect geometric
shapes when fashioning Adam's torso.

The portrait's arrangement stresses the central vertical axis,
specifically Dürer's forehead, eyes and right hand. This is the
picture's axis of meaning. The high, broad forehead is the seat of
the intellect. The eyes, so critical to an artist, are the location for
sight, the strongest and most virtuous of the five bodily senses and
the prime catalyst for memory. The hand is the instrument with
which the right-handed Dürer created his art. The artist shows
off his long, graceful fingers (77). Much was made by others of
these hands. In his foreword to his Latin translation of Dürer's

Four Books on Human Proportions (1532) Joachim Camerarius describes the artist as follows: 'Nature gave him a build and a bodily development that, as is right and proper, fit supremely well with the magnificent spirit it encloses. … He has an expressive head, glittering eyes, an attractive nose, which the Greeks would call perfect, a somewhat long neck, a broad chest, a taut body, powerful thighs, firm legs; but a finer thing than his fingers no man has seen.'[37] Speaking more rhetorically on another occasion, Camerarius refers to the Nuremberg master's 'divine hand' ('Albrecht Dürer, the most accomplished artist, from whose divine hand many immortal works still exist').[38] Helius Eobanus Hessus's funerary poem composed shortly after Dürer's death laments the artist's once vital and creative hand now 'horribly discoloured' in the tomb. 'Nature itself, it seems, mourns your death, / Nature whom you were virtually able to renew with your learned hand!' As we shall see in Chapter 11, his friends exhumed his body to make casts of his hand and face. While such comments were made decades after his death, Dürer fully understood the meanings associated with the creative hand. In the opening woodcut in the *Nuremberg Chronicle* (see 15) God gestures with his right hand to create the heavens and the earth. In the following six images it is sufficient just to show his disembodied pointing hand.[39]

In this portrait Dürer is author and subject. He recorded his features while meditating on the nature of creativity and immortal fame. He is not the artist in the guise of Saint Luke, a common *topos* in Northern European art. Instead, Dürer is himself, the embodiment of the divinely inspired, knowledgeable artist. In 1508 Christoph Scheurl, the artist's close friend, recounted that one day while this painting was drying in the sun, Dürer's dog mistook the likeness for the master himself. The dog licked the portrait and 'one can still see marks on this, as I can prove'.[40] This amusing and doubtlessly apocryphal story about the imitative power of Dürer's art to trick even his own dog was first told by Conrad Celtis in one of his epigrams of 1500 on the artist.[41] Scheurl likely knew

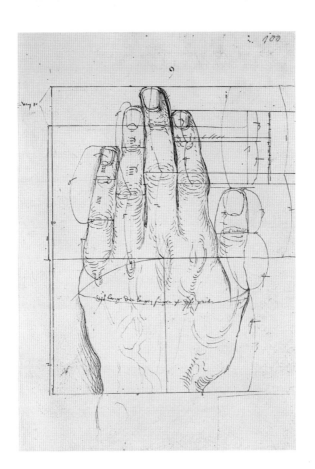

this unpublished poem. More significant is the story's circulation. It once again places Dürer in the company of Apelles, Zeuxis and other famous Classical artists who, Pliny and ancient writers report, made *trompe-l'oeil* paintings capable of deceiving insects, birds, animals and even fellow artists. Still in the early years of his post-*wanderjahre* career, Dürer boldly compared himself to antiquity's greatest artists.

Dürer's rise in prominence coincides with an emerging nationalism stoked by Celtis. Feeling the slights of his Italian counterparts, who considered the Germans barbarians, literally the descendants of the Gothic tribes that destroyed the Roman Empire, Celtis embarked on a concerted campaign to celebrate the German-ness of the German-speaking lands.[42] His creative and highly selective

readings of the newly discovered favourable comments in Tacitus'
Germania and Classical sources do not concern us for the moment.
But Dürer's timely appearance and obvious skills provided Celtis
with a German Apelles to laud. The artist was fully aware of
Celtis's flattering words, as well as their underlying motivation.
In 1508 he painted the *Martyrdom of the Ten Thousand* (78) for
Elector Friedrich the Wise.[43] Amid the Christian carnage stands
Dürer with the recently deceased Celtis. The artist holds up a small
text supported on a stick in which he signs himself 'Albertus Dürer
alemanus' ('the German').

Around 1500 Nuremberg was the home of the Sodalitas Celtica,
a society that supported Celtis. It was probably Pirckheimer who
first introduced Dürer to the poet. In 1502 the society published
Celtis's *Quattuor libri amorum* (*Four Books of Love*), an allegorical
description of the author's loves and the union of the German-
speaking lands.[44] Dürer supplied the unsigned frontispiece, in
which Celtis presents the book to Emperor Maximilian I, and the
monogrammed woodcut of *Philosophy* (79). The enthroned queen
of the muses is based on a description in the *De Consolatione
Philosophiae* (Book 1) of Boethius (c.480–524). Greek letters,
extending ladder-like from Philosophy's feet to her breast, refer
to the seven liberal arts and to the ascent from practice to theory.
The text at the bottom states that all human knowledge is based on
philosophy. Dürer positioned his monogram as the foundation for
the arts. It is linked, too, with ancient Roman poetry and rhetoric
in the accompanying roundel. Set within wreathes, signifying
seasons, this and the other roundels depict the four great world
cultures: Ptolemy (Egypt), Plato (Greece), Cicero and Virgil
(Rome) and Albertus Magnus (Germany). Celtis deliberately
excluded modern Italy. In each corner is one of the four winds
associated with an element, a humour and a season. For instance,
Boreas, the north wind at the lower left, is allied with the earth,
melancholy and winter, as signified by the ice-covered oak leaves
on the wreath.

78
*Martyrdom
of the Ten
Thousand,*
1508
Oil on canvas,
transferred
from wood;
99 × 87 cm
(39 × 34¼ in)
Kunsthistori-
sches Museum,
Vienna

Overleaf
Detail of
*Martyrdom
of the
Ten Thousand*
(78)

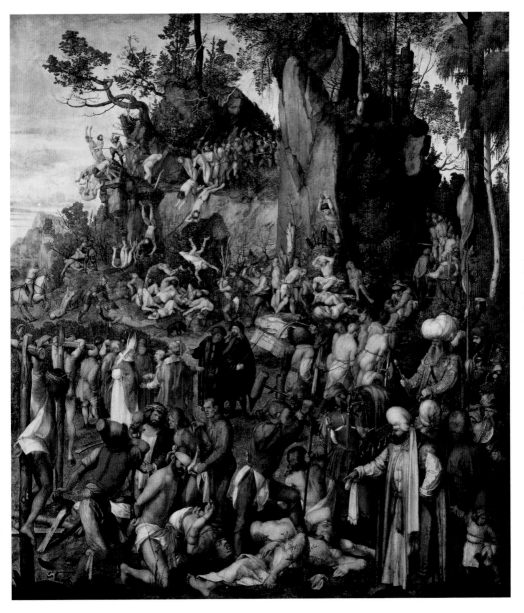

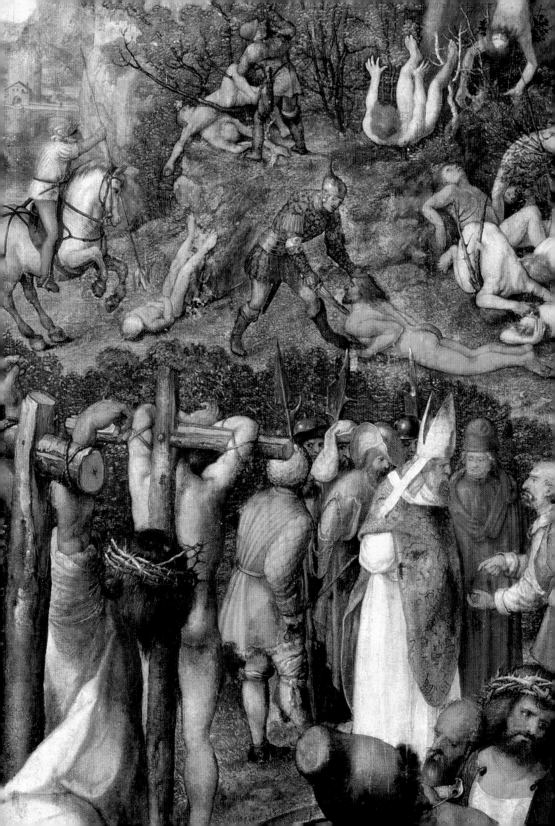

Please delete address *not* required before mailing

PHAIDON PRESS INC.

180 Varick Street

New York

NY 10014

PHAIDON PRESS LIMITED

Regent's Wharf

All Saints Street

London N1 9PA

Return address for USA and Canada only

Return address for UK and countries
outside the USA and Canada only

Affix
stamp
here

Thank you for purchasing a Phaidon book

Sign up online today at **phaidon.com/news** to receive information about the latest new releases, special offers and exclusive events, or fill in your details below and return this card to the adldress overleaf.

I am interested in the following subjects:

☐ Architecture ☐ Art ☐ Children's ☐ Collector's Editions
☐ Decorative Arts ☐ Design ☐ Fashion ☐ Film
☐ Food ☐ Music ☐ Photography ☐ Travel

I would like to receive information about books in the following languages:

☐ English ☐ French ☐ Italian ☐ Spanish

First Name _____ Last Name _____

Town _____ State/Region _____ Country _____

Email address _____

Your occupation _____

Which book have you just bought? _____

Where did you buy this book? _____

☐ Tick here if you do not wish to receive regular updates on new releases, special offers and exclusive events from Phaidon

79
Philosophy,
1502
Woodcut in
Conrad Celtis,
*Quattuor libri
amorum* (*Four
Books of Love*;
Nuremberg,
1502), folio a
vi verso;
21.9 × 14.8 cm
(8⅝ × 5⅞ in)

80
*Nude Self-
Portrait*,
c.1500–5
Pen and brush,
heightened
with white,
on green-
grounded
paper;
29.1 × 15.3 cm
(11½ × 6 in)
Klassik
Stiftung
Weimar,
Graphische
Sammlungen,
Weimar

Celtis claimed here that these four cultures promote Philosophy. The cultural torch passed from Egypt to Greece to ancient Rome and now to Germany. Germany is represented by Albertus Magnus (1193/1200–1280), the famed philosopher, theologian and naturalist, and the words 'sapientes germanorvm' ('wise man of the Germans'). In another epigram honouring Dürer in 1500, Celtis links the two Albrechts/Albertuses together as a means of praising the artist's 'Symmetrie et Picture' (his *kunst*).[45] The poet acknowledged Dürer's unusual thirst for learning in order to improve his art. Through his mutually beneficial association with Pirckheimer and other humanists Dürer answered Celtis's clarion call to creative action in works such as *Adam and Eve* (see 63) and the *Self-Portrait* of 1500 (see 75).

Dürer's self-examination and his studies of the human body combined in the *Nude Self-Portrait* (80).[46] This is another absolutely novel image, since there are no surviving earlier full-length, nude self-studies by other artists. Dürer portrayed himself clad only in a hairnet or cap. His stare suggests that he looks at a small mirror propped on a nearby table at roughly the same

155 In the Garden of Eden

position as the viewer. This makes the intensity of his gaze and the frank representation of his body rather disconcerting. The genitals are just as carefully described as the face. There is speculation, much unfounded, about the artist's health, intentions and audience. Dürer was sick in 1503, as is known from the inscription ('during my illness') on his *The Head of Dead Christ* sketch (90).[47] Panofsky remarks: 'The convalescent painter looks at his emaciated body and still haggard face with the same mixture of fatigue, apprehension, and dispassionate curiosity with which a farmer might take stock of his crops after a bad storm.'[48] Is this judgment based truly on what the Weimar drawing conveys or on two later drawings (see 125, 162) linked with future illnesses? Dürer portrayed his body, especially the torso, as robust. Is his face gaunt or just summarily described? The artist who made punning references to the cock spout in the *Men's Bath* (see 43) may have been foregrounding his own manliness in this chiaroscuro drawing.[49] Rather than looking to Christological or Freudian interpretations, the sketch must be considered with his contemporary studies of the real and ideal human body. While making life drawings of models, constructing Vitruvian-proportioned figures and exploring ancient prototypes, contemplating his own body must have seemed like a logical exercise. The black backdrop and aspects of the pose recall his roughly contemporary drawing of *Adam* (see 68).

Dürer's pursuit of ideal forms did not prevent his occasional fascination with human deviancy. In the engraved *Witch Riding Backwards on a Goat* (81), he conjures a compelling vision of a wild, powerful woman whose nudity and actions flount social conventions.[50] Her unbound hair blows counter to the direction in which she flies. Mounted on a goat, often a symbol of the devil, she embodies lust and the inverted world where the laws of nature, including gender roles, are reversed. Occasionally during this era, widows, spinsters and cuckolded husbands were humiliated publicly by being forced to ride through town backwards on an animal. Here, however, Dürer's woman is in control as she firmly

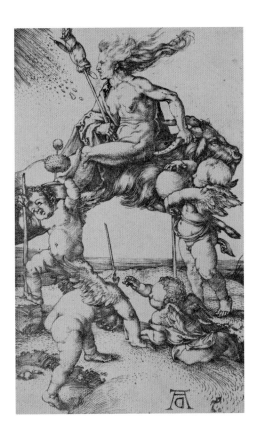

81
*Witch Riding
Backwards on a
Goat*, c.1500–3
Engraving;
11.5 × 7.2 cm
(4½ × 2¼ in)

grabs the phallic-like horn of the goat while holding the erect
distaff and spindle, traditional female symbols, between her legs.
She is a weather witch whose incantations prompt hail to fall
from the sky at the upper left and the four putti below to behave
most strangely. Like many Classical authors and contemporary
humanists, including Sebastian Brant, Dürer seemingly doubted
the existence of true witches. While his hag lacks the malevolence
of Hans Baldung Grien's witches, she whimsically causes the letter
D in the artist's monogram to reverse.

The Nuremberg master's education was hardly finished. In 1505 he
returned to Venice, but under very different circumstances and with
different ambitions from those of his initial visit. He sought further
tutelage especially in the secret art of perspective. Dürer's musing
on art, and on the delicate balance between the practical and the
theoretical, would preoccupy him for the rest of his career.

'Here I am a gentleman, at home only a parasite' A Return to Venice

5

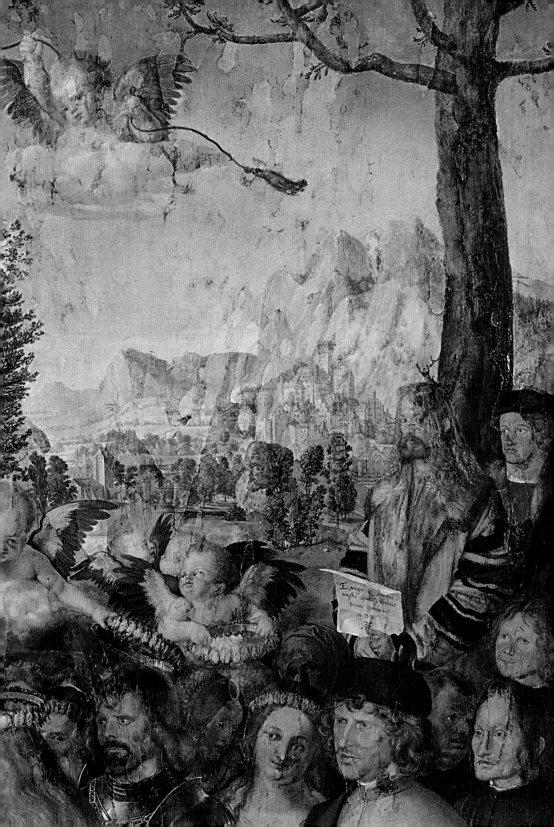

Among the Italians I have many good friends who warn
me not to eat and drink with their painters. Many of them
are enemies and they copy my work in the churches and
wherever they can find it; and then they revile it and
say that the style is not *antique* and so not good. But
Sambelling [Giovanni Bellini] has highly praised me
before many nobles. He wanted to have something of
mine, and himself came to me and asked me to paint him
something and he would pay well for it.[1]

Opposite
Detail of (82)
*Feast of the
Rose Garlands,*
1506
Oil on
poplar wood;
162 × 195 cm
(63¾ × 76¾ in)
Národní
Galerie, Prague

Writing to Pirckheimer (see 175) on 7 February 1506, Dürer
acknowledges the mixed response to his return to Venice.[2]
Admiration, jealousy, uncertainty and pride flow through this
and nine other surviving letters that he penned to his best friend
in Nuremberg that year.[3] Dürer never states his motives for
journeying back to the Adriatic port city, although his desire to see
Venice again and his interest in artistic theory were factors. His
financial prospects looked good, since he probably already had the
commission to paint an altarpiece for San Bartolomeo, the German
church near the Fondaco dei Tedeschi. Dürer travelled south in
December 1505 and returned to Nuremberg in February 1507.[4] His
personal copy of Euclid's *Geometry* contains the notation that he
purchased the book in Venice in 1507.[5] Unlike the trip of 1494–5,
when he was just beginning his independent career, Dürer now
returned to Venice as a famous artist, albeit one known in Italy
solely for his prints. This time he left his mark on Venice, just as
the city did on him.

Dürer corresponded with his mother, wife, father-in-law and
Nuremberg friends, including the Augustinian prior, Stephan
Paumgartner and the unidentifiable Mistress Dietrich. The

letters are unusual in that personal letters from this period rarely survive.[6] Pirckheimer, however, kept his letters from the artist. Humanists, notably Erasmus (see 114, 151), collected and published their correspondence. For Pirckheimer it was more a personal matter. Dürer wrote to him about once a month. The gap between letters 6 and 7 (25 April and 18 August) suggests that two or three of Dürer's notes are missing. Unfortunately, none of Pirckheimer's replies exists.

Posterity's picture of Dürer's personality is largely crafted from this correspondence. In his *Family Chronicle* and Netherlandish diary Dürer revealed insights into his character, business practices and ambitions. Yet the Venetian letters offer a glimpse into an easy and deepening friendship where the two men joke about their respective vanities, celebrate successes and share information, both mundane and significant. Wanting his friend to return to Nuremberg, Pirckheimer threatens to make love to Agnes if the artist does not start soon. Dürer replies, 'a ponderous fellow like you would be the death of her'.[7] At other times he teases Pirckheimer, whose wife died in 1504, about his many girlfriends, including the ones whom he merely indicates with pictures of a rose, a duster and a dog.[8] In his last letter Dürer states that if he were burgomaster, he would lock Pirckheimer in the city's prison with all of his women and let them 'deal with you'.[9]

Dürer borrowed money from Pirckheimer for the trip. This debt, promptly repaid in 1507, weighed on the artist, as did his worries about his wife and mother's finances and the idleness of his brother Hans. The women earned a steady stream of income from print sales, but this may have been insufficient to cover all of his, the family's and the workshop's expenses while he was abroad. He asked Pirckheimer to speak with his mother about sending Hans to Wolgemut's workshop. He had hoped that Hans would accompany him to Venice 'but my mother was afraid that the sky would fall on him'.[10] Dürer brought at least six small paintings for sale in

Venice. On Pirckheimer's behalf he acquired jewellery, books, paper, carpets, glass, feathers and other items that the Imhoff family's Venetian agents shipped to Nuremberg. Dürer's life in Venice was hardly Spartan, although he was money-conscious: 'My French mantle greets you and my Italian coat also.'[11] He was proud of his fine new clothing and upset when a store fire destroyed a woollen cloth that he had purchased the day before but not picked up. Dürer suffered through two expensive dance lessons and, on another occasion, the discovery of a grey hair. He requested Pirckheimer to ask the Augustinian prior 'to pray for me that I may be protected, and especially from the French sickness [syphilis]; I know of nothing that I now dread more than that, for well nigh everyone has got it. Many men are quite eaten up and die of it.'[12]

His relations with local artists were rocky. Some were envious because Dürer received the San Bartolomeo altarpiece commission. In Venice, as in other cities, artists worked within guilds or other professional organizations. In his letter of 2 April 1506 Dürer observes: '[T]he painters here, let me tell you, are very unfriendly to me. They have summoned me three times before the magistrates, and I have had to pay four florins to their school.'[13] He bristled at their insinuation that his paintings were insufficiently antique in style and, therefore, inferior. Others chided him for not being a good colourist. According to Dürer, even as the Venetian artists criticized his work, many avidly copied it.

Dürer mentions only two Italian artists by name. After relating that what pleased him eleven years earlier no longer did so, he wrote that 'there are many better painters here than Master Jacob [Jacopo de' Barbari who] is abroad yet Anton Kolb would swear an oath that no better painter lives than Jacob. Others sneer at him, saying if he were good he would stay here, and so forth.'[14] Dürer's praise of Giovanni Bellini, cited above, stands as a foil to the carping of the younger artists. Even in his seventies, he was still

the city's most respected painter. Dürer was not a threat to Bellini, who enjoyed a special status that included a state exemption from Venice's Painters' Guild since 1482.[15] He may have introduced Dürer to some of the city's elite. In his introduction to the Latin edition of Dürer's *Four Books on Human Proportions* Camerarius recounts a story of how the two artists admired each other.[16] One day Bellini asks Dürer 'to make me a present of one of the brushes with which you draw hairs', specifically the one in which he could sketch several hairs with a single stroke. After showing him a batch of regular brushes, Dürer finally satisfies Bellini's curiosity by using one of these to sketch a woman's wavy tresses. Pliny records a contest between Apelles and Protogenes of Rhodes, another painter, in which Apelles triumphs because of his ability to render the finest of lines. Like Apelles, Dürer visits the other artist and, from Camerarius's perspective, triumphs over the Venetian. The story, while apocryphal, perpetuates the flattering associations that some contemporaries made between Apelles and Dürer.

Six letters mention the *Feast of the Rose Garlands* (82). Dürer was just settling into Venice when he wrote on 6 January 1506 that 'I have a panel to paint for the Germans for which they are to pay me a hundred and ten Rhenish florins – it will not cost me as much as five. I shall have scraped it and laid on the ground and made it ready within eight days; then I shall at once begin to paint and, if God will, it shall be in its place above the altar a month after Easter.'[17] His progress was slowed by a bout of scabby hands (eczema), perhaps stress-induced, later in January and by the exceptional care he put into the picture's design and execution. While he told Pirckheimer on 28 February that he was 'doing well and working fast', he related on 2 April that 'there is much work in it'.[18] He complains about the high cost of living in Venice and that he could have earned more money if he had made other paintings rather than the altarpiece. When finished in September, Dürer's attitude changes.[19] He feels pride in his picture and vindicated as a painter.

Dürer created this wingless altarpiece, his largest painting, for
the German chapel located to the right of the high altar in San
Bartolomeo di Rialto (see 24). He refers to the painting as being
done for the Germans. This suggests that the leaders of the Scuola
dei Tedeschi, rather than a single patron, funded the project. In this
prominent location in the heart of the city the picture was seen
by an ever-renewing audience of Northern Europeans, Venetians
and other visitors. The earliest Italian reference to the altarpiece
in 1548/9 cites Dürer's painting as one of the artistic highlights
of Venice, along with the horses of Saint Mark's and pictures by
Giorgione and Titian.[20]

Today the altarpiece is a ruin, so a full appreciation of Dürer's
accomplishment is impossible.[21] Even before being purchased
in 1606 by Emperor Rudolf II and transported over the Alps to
Prague, the picture was in poor condition with flaking paint.
Further damage happened when the imperial art collection was
evacuated in 1631 before the Swedish army captured Prague.
The altarpiece returned from Austria four years later. The first of
several restorations occurred in 1663. Virtually the entire centre of
the composition is lost as Mary, Christ, the lute-playing angel and
the pope's head were wholly repainted in 1839–41.[22]

Seated in a landscape before a cloth of honour supported by two
angels, the Virgin Mary and Child bestow garlands of roses on
Emperor Maximilian I and a pope. Saint Dominic and angels
distribute these floral crowns to the clergy at left and the laity
opposite. The rosary as a form of religious devotion focusing
on the joys, sorrows and glory of the Virgin was instituted by
Dominic in 1213. In 1475 the Dominican Jacob Sprenger founded
the first brotherhood of the rosary in Cologne.[23] It was based on
the belief of a universal Christian sodality of clergy and laity
united by their common veneration of the Virgin Mary and Christ.
Local chapters of this brotherhood rapidly spread across Germany
and beyond. Johannes, a Dominican monk from Erfurt, established

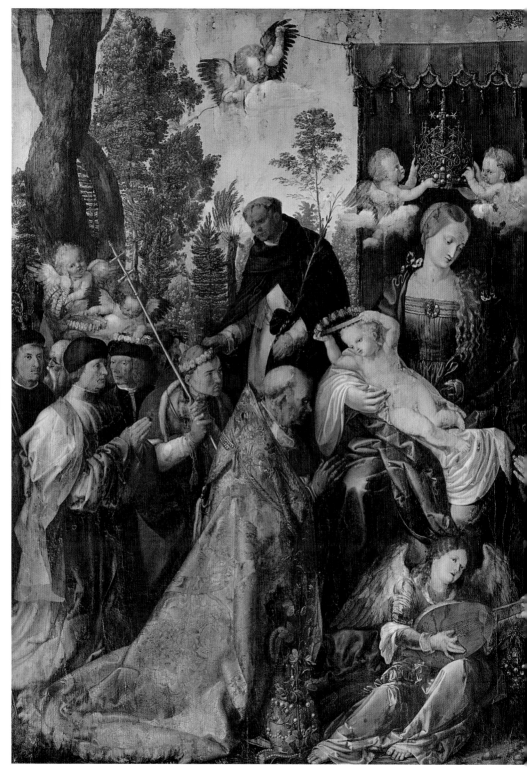

82
*Feast of
the Rose
Garlands,* 1506
Oil on
poplar wood;
162 × 195 cm
(63¾ × 76¼ in)
Národní
Galerie, Prague

Venice's chapter in 1480. In the Venetian statutes the last prayer following the Assumption is the Glory of Paradise, which Dürer portrayed as the Coronation of the Virgin with two angels crowning Mary. A crude woodcut in Sprenger's 1476 edition of the German statutes provided a partial model.[24]

Some of the figures crowded around Mary have a portrait-like quality. Other than Maximilian and Dürer, most of the proposed identifications cannot be verified. Based on the builder's square held in his hand, the man dressed in black at the far right may well be Master Hieronymus, the German architect who redesigned the Fondaco dei Tedeschi after its 1505 fire. The black-attired cleric on the other side, who turns to his right as he is crowned, reappears in a separate portrait, today in Windsor Castle, that Dürer painted in 1506; however, his identification as Burkhard von Speyer is problematic.[25] Did Dürer depict a specific pope? The original rather generalized face exists only in a preparatory drawing in Berlin.[26] Relations between Julius II and Venice were poor, and later in 1506 the pope and Maximilian would be at war. As has been suggested, Dürer gave a generic image to the pope or perhaps the face of Paul II (r. 1464–71), a Venetian pope. The specific naming of the figures is less significant than the recognition that the artist included local members of the brotherhood collectively venerating the Virgin and Child.

Dürer altered his technique perhaps with an eye to the picture's ultimate reception by local painters.[27] The wood for the panel is poplar, as was customary in Venice, rather than his normal lindenwood or pine. The panel, ordered and prepared in advance, was ready when the artist arrived. Strips of linen or canvas cloth were laid on the wood to give a strong, smooth working surface. This is an Italian rather than a German practice. In his letter of 6 January Dürer mentions being about to apply the preparatory ground. Normally he used chalk, but here gesso, Italian gypsum mixed with glue, is evident. The intense blue seen in the cloak of the man at right in the altarpiece is painted with expensive ultramarine

(pulverized lapis lazuli) rather than his customary azurite. This choice may have been a matter of local preference since Venice was the primary European importer of this precious pigment from Badakshan, today in Afghanistan, along the Silk Road.

Next, he designed the composition with a thoroughness never observed in his pre-Venetian paintings. Twenty-two preparatory drawings, including one copy, survive for this picture. No comparable sketches exist for his earlier paintings, although some are known for his engravings (see 69). All but one of these drawings are done on *carta azzurra*, a blue-dyed paper on which he applied ink and white highlights with a brush. This type of paper was newly popular in Venice with artists such as Giovanni Bellini and Cima da Conegliano (c.1460–1517/18). For the lute-playing angel's head (83) Dürer focused on chiaroscuro effects, especially the way light and shadow model surfaces.[28] He still employed his system of careful hatchings and cross-hatchings, although these are secondary to the broader, unifying lighting scheme. In contrast with the detailed under-drawings of the 1500 *Self-Portrait* (see 75), Dürer simply traced the basic contour lines of his drawings, which are done on exactly the same scale, directly on to the painting's surface (85).[29] He then referred to the individual drawings for details and shading information. Most drawings show only the relevant parts of the figures as they appear in the painting.

Dürer carefully studied Bellini's compositions and his application of colours. He derived such features as the floating putti and the pose of his kneeling pope from Bellini's *Votive Picture of Doge Agostino Barbarigo* of 1488 in Murano (San Pietro Martire), while his foreground angel comes from the *San Zaccaria Altarpiece* (86).[30] Less immediately obvious is his admiration for Bellini's skilful colour combinations in the latter picture. Saint Peter's lilac and salmon-orange robe inspired that of Dürer's kneeling cleric at the left. Saint Jerome's scarlet red robe with its grey accents influenced Maximilian's robe and the shading of the pope's pluvial.

83
*Head of the
Lute-Playing
Angel*, 1506
Brush and
ink with grey
wash and white
highlights on
blue prepared
paper;
27 × 20.8 cm
(10⅝ × 8¼ in)
Albertina,
Vienna

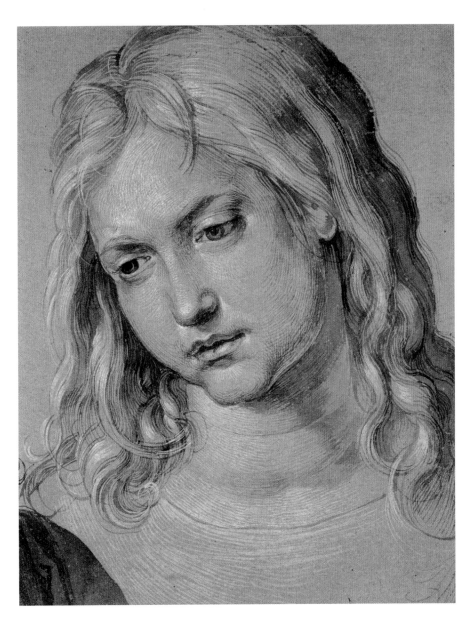

84
*Head of the
Young Christ,*
1506
Brush and
ink with grey
wash and white
highlights on
blue prepared
paper;
27.5 × 21.1 cm
(10⅞ × 8¼ in)
Albertina,
Vienna

(83 and 84
formed a
single sheet
until separated
around 1822.)

Dürer's pluvial watercolour (87), which differs somewhat from the finished painting, borrows its lilac and brown scheme and its textile patterns from Bellini's Saint Lucy.[31] He muted the base lilac and white by varying the intensities of his brown shading.

Stung by the persistent slights of many Venetian painters, Dürer determined the *Feast of the Rose Garlands* would be a statement about his powers as a painter and colourist. His conversations with Bellini, whom Dürer states was friendly, and his own careful scrutiny of the master's painting techniques allowed him to make a picture more in the Venetian mode. On 8 September he wrote to Pirckheimer: 'My picture … is well painted and beautifully coloured. I have earned much praise but little profit by it. … I have stopped the mouths of all the painters who used to say that I was good at engraving but, as to painting, I did not know how to handle my colours. Now everyone says that better colouring they have never seen.'[32] In his next letter he remarks that 'they [the Venetian nobles and painters] had never before seen such a sublime, lovely painting'.[33] This concept of sublime painting had a currency of meaning among contemporary Venetian artists. Dürer employed the word 'erhaben' at the beginning of his section on colour in the *Speiss für Malerknaben*: 'If you would like to paint in a sublime manner [*erhabn willt molen*], so that the eye is deceived and perceives relief, you must use your paint wisely and know how to distinguish one colour from another.'[34] Dürer's altarpiece demonstrates that he understood the painterly aesthetic that distinguished Venetian art from other Italian schools. Temporarily he replaced his normal graphic and highly mathematical approach with one stressing colour and value.

The Nuremberg master, like his humanist friends, considered imitation a virtue.[35] He copied Mantegna, the *Apollo Belvedere*, Bellini and Schongauer, among others. Imitation, however, is merely a stage in a creative process to make a better work of art. Believing that he had achieved his goal, Dürer inserted a bold

85
Salvator Mundi,
c.1503–4
Oil and tempera on lindenwood;
58.1 × 47 cm
(22⅞ × 8½ in)
Metropolitan Museum of Art, New York

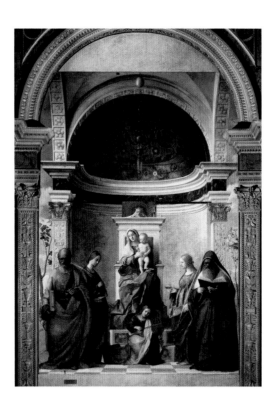

86
Giovanni Bellini,
San Zaccaria Altarpiece,
1505
Oil on canvas transferred from panel;
500 × 280 cm
(196⅞ × 110¼ in)
Church of San Zaccaria, Venice

87
Study for Pluvial of the Pope, 1506
Watercolour on paper;
42.7 × 28.8 cm
(16¾ × 11⅛ in)
Albertina, Vienna

statement of authorship into his picture (see page 159). His self-portrait appears at the upper right. As in the 1498 *Self-Portrait* (see 40), his hair is a blondish-brown colour. He wears an expensive robe, perhaps the French mantle or the Italian coat that twice offer their greetings to Pirckheimer in the artist's letters. Such an insertion of self into a religious composition is most unusual, although Dürer was to do it three more times within the next six years (see 78, 96, 102). Staring directly at the viewer, Dürer holds a slip of slightly curled paper, a motif common in Bellini's paintings. The inscription reads: 'Exegit quinque- / mestri spatio Albertus / Durer Germanus / M.D.VI. AD' ('Albrecht Dürer, a German, produced it within the span of five months. 1506'). He stresses that a German artist made this picture. The spirit relates to Celtis's nationalistic sentiments (see 79).

The text contains two other learned allusions that some viewers may have understood. The first word, 'exegit', links it to the

175 'Here I am a gentleman, at home only a parasite'

ancient Roman author Horace's *Odes* (III, 30), in which the poet states that his writings would bring him immortality.[36] Dürer next claims that he completed the painting in five months.[37] As his letters to Pirckheimer prove, he was busy for at least eight months, although the artist may not have factored in the weeks spent designing the composition. Quickness was considered a mark of the knowledgeable artist: Pliny, among others, celebrated Nichomachus and Aesclepiodorus as rapid painters. In his treatise *Della pittura* Alberti describes the superior artist's ability to think quickly and, because of practice, to transform thought rapidly into art.[38] In his *Four Books on Human Proportions* Dürer observes that a day's sketch by a 'powerful artist ... will be more artful and excellent than another man's large work, which he makes with great diligence in a whole year'.[39] Dürer boasts he painted *Christ among the Doctors* (88) in five days. Speed is a virtue prized by Titian and the next generation of Venetian artists. Finally, Dürer playfully inserted a life-size fly resting on the white cloth between Christ's foot and Maximilian's hands.[40] This feature, now obliterated but visible in later copies, alludes to ancient stories of illusionistic virtuosity, such as Pliny the Elder's account of the rivalry of the painters Zeuxis and Parrhasius.

Dürer judged the *Feast of the Rose Garlands* to be a tremendous success. He told Pirckheimer that Doge Leonardo Loredano (r. 1501–21) and Patriarch Antonius Surianus (r. 1504–8), who was also the patron of San Bartolomeo, admired the altarpiece.[41] In his last letter Dürer jokes: 'How pleased we both are when we fancy ourselves worth somewhat – I with my painting, and you with your wisdom. When anyone praises us, we hold up our heads and believe him.'[42] He adds that the world is full of false flatterers.

In the letter of 23 September Dürer mentions the completion of the altarpiece 'as well as another *quar* [*quadro*, or painting] the like of which I have never painted before'.[43] The artist is probably referring to his highly novel *Christ among the Doctors*.[44] As

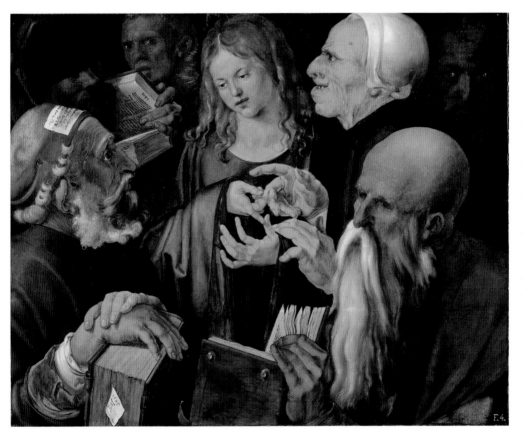

88
*Christ among
the Doctors,*
1506
Oil on poplar;
64.3 × 80.3 cm
(25¼ × 31⅝ in)
Museo
Thyssen-
Bornemisza,
Madrid

recounted in Luke (2:47–49), the twelve-year-old Jesus was lost for three days during his family's Passover visit to Jerusalem. When Mary and Joseph found him, he was debating with the scribes in the high temple. In his two earlier depictions of this story Dürer emphasized the parents' arrival, the architectural setting and Christ actively discoursing with the scribes.[45] The 1506 painting focuses solely on Christ. Six scribes uncomfortably surround him. Dürer may have been inspired by Mantegna's pioneering half-length compositions with dark backgrounds.[46]

Christ's innocent beauty contrasts sharply with the ageing men with their unsettling glances. Only the profiled figure with the white cap personifies malevolence as he pushes right up to Christ. His hands tap Christ's as he attempts to interrupt and refute the youth's answer. The brilliant dance of these four hands pulls the entire painting together. Dürer's drawing on Venetian blue paper (89) reveals the attention he devoted to Christ's hand gesture and its careful lighting, such as the shadow that the right index finger casts on the left thumb.[47] While stereotypical portrayals of certain figure and ethnic types occur in German art, this man's face closely recalls Leonardo's caricatures, which circulated through copies.[48] Years later Dürer experimented with different physiognomies; however, here the physical distortion signifies the man's inherent spiritual deformity. All seven figures, including Christ, are Jews. The artist studied Jews who worked around the Rialto bridge. Dürer singled out this one man as the bad Jew. As Margaret Carroll and David Price observe, Dürer shared in his period's dislike of Jews, who continued to be blamed for Christ's death.[49] Indeed, in 1499 Nuremberg expelled all Jews: Pirckheimer, a city councillor, justified this measure by claiming the Jews planned to poison Nuremberg's fountains. Not all of the other scribes, especially the two in the foreground, who recall prophets, are portrayed so negatively.

The inscription on the bookmark at the lower left reads, '1506 / AD / opus qui[n]que dierum' ('a work of five days'). As in the *Feast of*

89
Study for Christ's Hands, 1506
Brush in grey and ochre, heightened with white on blue-dyed paper;
20.7 × 18.5 cm (8⅛ × 7¼ in)
Germanisches National-museum, Nuremberg

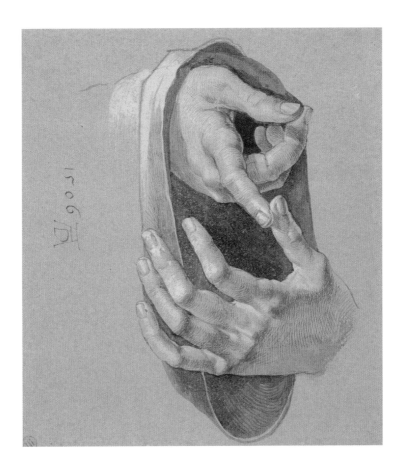

the Rose Garlands, the boast is about Dürer's speed of execution.[50]
The style of painting is indeed much looser than in the altarpiece.
Except for the green, the colours are not applied in multiple layers.
Details in the faces are done with hatching directly on top of the
base pigment. The overall palette is restricted, although there are
some beautiful iridescent passages in the sleeves of Christ and the
figure at the lower left. Regardless of how long it took him to paint
the picture, Dürer carefully planned the composition and sketched
major details. His study of Christ's head (see 84) was originally on the
same sheet of paper as the angel in the *Feast of the Rose Garlands*,
so he must have been thinking about *Christ among the Doctors*
early in the spring of 1506. Perhaps Dürer playfully decided on
five days since it made him quicker than God's six days for the
Creation. The artist's ability to work very rapidly is, however, not

an idle boast, since he painted the oil portrait of Christian II, king of Denmark (1481–1559; see 163), in about five days in July 1521.

Two later drawings after this painting add the words 'F[ecit]. Roma[e]' ('made in Rome') to the inscription at a point where the original is no longer legible.[51] The painting is documented in Rome from 1634, when it was listed in the Barberini family inventory. This information raises the tantalizing question: did Dürer travel to Rome? In his letter of about 13 October 1506 the artist mentions that 'I should like to ride to Bologna to learn the secrets of the art of perspective, which a man is willing to teach me. I should stay there eight or ten days and then return to Venice. After that I shall come with the next messenger.'[52] Actually he returned to Nuremberg only in February 1507. His trip to Bologna, substantiated by Christoph Scheurl in 1508, will be discussed in Chapter 10. Scholars speculate, wrongly I think, that Dürer went to Rome to settle the losses incurred because of his sales agent's death. Yet why would Dürer carry a painting finished in September to Rome before adding the final part of the inscription? The word choice is odd, as well, since *fecit* does not reappear elsewhere in Dürer's *oeuvre*.[53] More tellingly, there is no discernible impact of a Roman trip visible in Dürer's art during this period. In fact, his post-Venetian art becomes less and less Classical in its style and theme.

Dürer's Venetian trip was financially and artistically successful. He repaid his debt to Pirckheimer through the funds earned from his religious pictures, numerous portraits, which he mentions in his letter of about 13 October 1506, and, doubtlessly, the sale of his prints.[54] In the 1568 edition of his *Lives of the Artists*, Giorgio Vasari claims that Dürer travelled to Venice (from Flanders!) to stop Marcantonio Raimondi's unauthorized copying of his prints.[55] Since the Nuremberg master never mentions this matter in his letters beyond his comment cited at the outset of this chapter, this can hardly have been his prime motivation for travelling to Italy. This issue did vex him, as we shall see in Chapter 7.

In his letter of 18 August Dürer declares, 'I have become a gentleman in Venice.'[56] He makes this statement amid his complaint about having to acquire rings for Pirckheimer. Far better known is his lament at the end of his final letter: 'How I shall freeze after this sun! Here I am a gentleman, at home only a parasite [*ein schmarotzer*].'[57] While the comment about the weather, especially with late autumn and winter approaching in Nuremberg, is understandable, how should the second statement be interpreted? Dürer clearly enjoyed the recognition that he received in Venice. The doge, patriarch and local nobility admired his *Feast of the Rose Garlands*. Writing to the Nuremberg city council on 17 October 1524, Dürer recalled that, nineteen years earlier, the Venetian government had offered him a civic position as painter with an annual salary of 200 ducats.[58] Some of Venice's artists, besides Bellini, admired and were influenced by his work.[59] Although Dürer may have underestimated the many difficulties he would have faced had he settled in Venice, he was fully cognizant of the rigid hierarchy of Nuremberg's society, the upper levels of which he could never hope to crack in spite of his fame and growing circle of powerful friends. In his final letter to Pirckheimer he writes: 'Now, however, that you are thought so much of at home, you won't dare to talk to a poor painter in the street any more; to be seen with the painter varlet would be a great disgrace for you.'[60] While teasing the humanist about his inflated sense of his own importance, the comment also conveys the perception that artists remained mere craftsmen in the eyes of many Nuremberg patricians, although not, of course, Pirckheimer – at least as far as Dürer was concerned. He longed less for the sun than for the esteem Bellini enjoyed in Venice or that Mantegna, as a prized court artist, received in Mantua. Rather than fretting about the situation, the sentences immediately preceding the 'parasite' quip inform Pirckheimer that he was leaving soon for Bologna 'to learn the secrets of the art of perspective'. Dürer's intellectual curiosity ultimately trumped any self-pity.

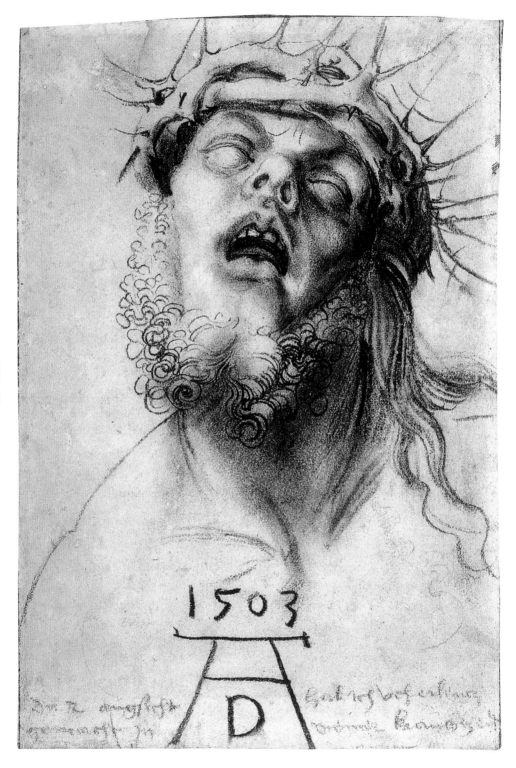

The *Head of the Dead Christ* (90) is disturbingly intimate.[1]
Christ's head tilts back. His eyes are closed. The mouth gapes open,
revealing his teeth and silenced tongue. Thick branches of the
crown of thorns weigh heavily and impress with a disconcerting
tactility on his now lifeless forehead. Several thorns rip the flesh.
The energetic curls of the beard, bearers of his recent vigour,
joltingly frame the face while death's pallor spreads. Dürer's
hand is present in every expressive stroke of the charcoal stick.
He smeared the dust with his fingers across Christ's left cheek
and neck. The drawing records Christ's death while pictorially
assuring his memory. His moving image appeals to the viewer's
morbid fascination and evokes empathy. Below, Dürer inscribed
his monogram and date directly over Christ's chest. The initials
can also be read as 'A[nno] D[omini]' ('the year of our Lord'), a
temporal marker of the world's ages that links artist and Christ
together. Much more faintly, Dürer writes on the drawing, 'I
produced these two countenances when I was ill'. He refers to a
pendant drawing of a sick man.[2] Dürer equated his illness in 1503
with Christ's physical torment. This is neither the first nor the last
time that he identifies himself with Christ for artistic, devotional
or physical reasons.

Dürer focused on religious themes for the first decade or so of
the new century. Needing to recount familiar biblical or saintly
stories compellingly, he experimented with novel narrative and
compositional strategies, as observed already in *Adam and Eve*
(see 63). Religion, practised privately and publicly, remained
central to one's personal life and communal identity. The ideal of
imitatio Christi on an individual level was balanced by one's ties
to a parish church, corporate group, such as the Brotherhood of
the Rosary in Venice, and town. Each spring Nuremberg hosted

90
*Head of the
Dead Christ,*
1503
Charcoal;
31 × 22.1 cm
(12¹⁄₄ × 8³⁄₄ in)
British
Museum,
London

a display of the imperial relics and regalia. Dürer sketched a
Venetian Corpus Christi procession (91) in which fifteen men
carry a bier displaying Christ seated on the edge of his tomb.[3]
Christ holds a chalice to catch the blood flowing from his chest
wound. Mary, John the Evangelist and lute-playing, dolphin-riding
angels accompany him. While in Antwerp on 26 May 1521, Dürer
described a great procession on the feast of the Holy Trinity.[4] The
staging of such devotional events occurred in towns across Europe
on special church holidays.

Once back in Nuremberg, Dürer received several painting
commissions. In 1508 Johann V Thurzo (Turzó), bishop of Breslau
(Wrocław; r. 1506–20), purchased the life-size *Adam and Eve*
pendants (93, 94) and an unidentified *Virgin and Child*.[5] *Adam
and Eve*, which hung in the bishop's library, permitted Dürer to
rethink his canonical engraved composition. He reduced the theme
to its essentials. The couple stands on rocky ground against a
dark background, a formula already observed in the *Paumgartner
Altarpiece* (see 5). The stark setting highlights Eve's sensual allure
and the awkwardness of Adam, who shyly opens his mouth to
speak. Responding to Venetian art, Dürer softened the bodies,
Eve's in particular. They appear natural rather than painstakingly

constructed. He elongated the proportions so the head is one-ninth, rather than one-eighth, the overall height. Even though Adam and Eve lean towards each other, they are not the intimate, sexually aroused couple portrayed in 1511 by Hans Baldung Grien, Dürer's associate (92).

Later in 1507 Dürer began the *Assumption and Coronation of the Virgin* (or *Heller Altarpiece*; 96) for Jakob Heller, a successful

91
Procession,
c.1506
Monogram
was added later
by another
hand
Pen and
brown ink;
21 × 32.2 cm
(8¼ × 12⅝ in)
Kupferstich-
kabinett, Berlin

92
**Hans Baldung
Grien**, *Fall of
Man*, 1511
Chiaroscuro
woodcut;
37.1 × 25.1 cm
(14⅝ × 9⅞ in)

LAPSVS HVMA-
NI GENERIS

Frankfurt businessman and town councillor.[6] It was designed for the Saint Thomas of Aquinas altar, before which Heller and Katharina von Melem were subsequently buried, in Frankfurt's Dominican church. The altar originally possessed double folding wings, the inner set painted by Dürer's assistants. Heller separately commissioned Matthias Grünewald's outer wings showing *Saint Lawrence* (95) and three other saints in grisaille as well as a lost *Transfiguration* for the altar's superstructure.[7] When Duke

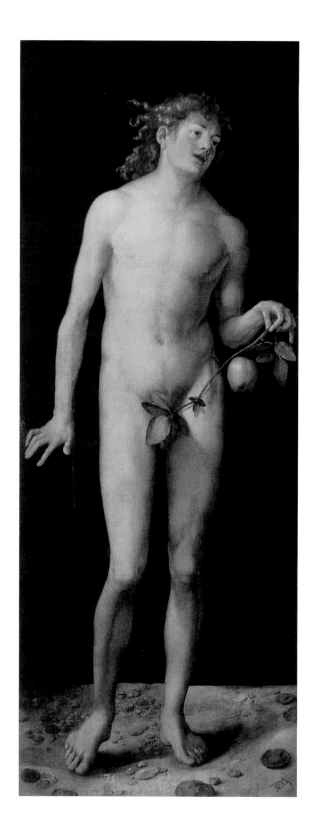

93
Adam, 1507
Oil on
pinewood;
209 × 81 cm
(82¼ × 31⅞ in)
Museo
Nacional del
Prado, Madrid

94
Eve, 1507
Oil on
pinewood;
209 × 83 cm
(82¼ × 32⅝ in)
Museo
Nacional del
Prado, Madrid

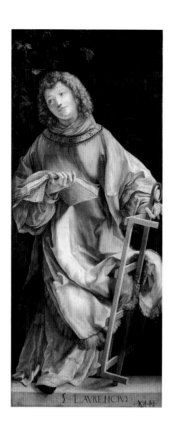

95
Matthias Gothart Nithart (called Grünewald), *Saint Lawrence* (from the *Heller Altarpiece*), c.1509–11
Oil on pinewood;
99.1 × 43.2 cm (39 × 17 in)
Städelsches Kunstinstitut, Frankfurt

96
Jobst Harrich, replica of the central panel of *Assumption and Coronation of the Virgin* (*Heller Altarpiece*; 1507–9), 1613–14
Oil on lindenwood;
189 × 138 cm (74⅜ × 54¼ in)
Historisches Museum, Frankfurt

Maximilian I of Bavaria (r. 1597–1651) purchased the central panel in 1614, he ordered Jobst Harrich (c.1580–1617) of Nuremberg to paint a full-scale replica for the church. Unfortunately, a fire in Munich's Residenz in 1729 destroyed Dürer's original central panel.

Influenced by his Venetian experience, Dürer prepared at least eighteen drawings done on green, blue or grey-green dyed paper, just for the central panel.[8] He composed whole figures as well as details of heads, hands, feet, drapery, and even a self-portrait. One sheet (97, 98), now divided, includes the upturned head and praying hands of the red-robed apostle on the right.[9] Characteristic is the careful attention to the physical details and exquisite shading of the hands. Centuries later the praying hands became an independent icon of Christian faith, one endlessly reproduced, often on a monumental scale, for churches and cemeteries.

97
*Upturned Head
of an Apostle,*
1508
Pencil in grey
and black with
grey wash
and white
highlights
on a green-
ground paper;
31.6 × 22.9 cm
(12½ × 9 in)
Albertina,
Vienna

98
Praying Hands,
1508
Pencil in grey
and black with
grey wash
and white
highlights
on a green-
ground paper;
31.7 × 19.8 cm
(12½ × 7¾ in)
Albertina,
Vienna

(97 and
98 originally
formed a
single sheet)

The space is divided into distinct heavenly and earthly zones. Amid an angelic chorus the Holy Trinity crowns Mary. Divine order, as seen in Christ and God's symmetrical placement and dignified gestures, contrasts with the chaotic, highly personal responses of the apostles surrounding the Virgin's empty tomb. Dürer endowed each with a different pose, as though showcasing his inventiveness. Some stare at the heavenly apparition; others converse. Saint John peers into the grave, while, on the right, another disciple looks directly at the viewer. The artist arranged the apostles into two groups of six around the painting's open central axis. Even in Harrich's copy Dürer's rich colour combinations and attention to subtle shifts in lighting are evident, as nicely observed in the standing and kneeling apostles in the extreme foreground. Dürer proudly placed himself alone just beneath Mary. His isolation before a deep landscape captures our attention. Beyond any religious association, he celebrates his creativity by holding a veritable shop sign. As in the 1507 *Adam and Eve*, the artist is identified as 'Albertus Dürer alemanus', a synonym of 'Germanus' that he inscribed on the Venetian pictures.

Dürer's maturation as a painter in just a few years is clearly seen if this picture is contrasted with the attractive *Adoration of the Magi* (99), made for Friedrich the Wise in 1504.[10] The latter's structure, with its careful perspective and repeated geometric forms, seems contrived. Incidental features, such as the riders by the rear arch or the servant fumbling in the bag, distract attention from the Christ Child. The crisp contours of the drapery and the somewhat unmodulated colours lack the grace of Dürer's post-Venetian style.

Nine surviving letters that Dürer wrote to Heller between 28 August 1507 and 12 October 1509 illuminate, sometimes unflatteringly, Dürer's badgering for a higher-than-contracted payment.[11] He describes his painting practice, including the fact that he employs a joiner to make the panel, a preparer to add the chalk ground and assistants to execute the wings and, probably,

the preliminary layering of colours throughout. Dürer promises
to paint the central panel himself. He complains about the high
price of the colours, especially ultramarine, which cost him 10 to
12 ducats per ounce. He remarks that if the painting is 'kept clean
I know it will remain bright and fresh 500 years, for it is not done
as men are wont to paint. So have it kept clean and don't let it
be touched or sprinkled with holy water.'[12] Dürer distinguishes
between ordinary paintings ('*gamine gmäll*') and painstakingly
detailed ones, such as the *Heller Altarpiece* (see 96). He brags that
he could paint a large 'pile' of these common paintings in a year.
Perhaps he was thinking about *Christ among the Doctors* (see
88) or a rapidly executed portrait. A laborious painting such as
Heller's, on which he worked for over a year, does not pay enough.
'So henceforth I shall stick to my engraving, and had I done so
before I should today have been a richer man by 1,000 florins.'
Dürer instructs Heller on how to display the picture: 'If anyone
wants to see it, let it hang forward two or three finger breadths, for
then the light is good to see it by.' The artist urges Heller not to let
anyone else varnish the painting once the oils are fully dry. Rather,
he would prefer to do it himself with his finest varnish, one that
lasts one hundred years, if he passes through Frankfurt in the next
two or three years. Heller was quite pleased with the altarpiece,
which Hans Imhoff, their middleman, shipped to Frankfurt in
September 1509. He gave *trinkgeld*, or tips, to Agnes and Hans,
Dürer's younger brother, who must have assisted. In his last letter
the artist sends a sketch for 'how the picture should be adorned',
presumably a frame design, which Heller could use if he wished.
The original frame disappeared around 1742, when the remaining
panels of the altarpiece were separated.

With the damage to the *Feast of the Rose Garlands* and the
destruction of the central panel of the *Heller Altarpiece* Dürer's
skills as a painter are best observed in the *Adoration of the
Holy Trinity* (or *Landauer Altarpiece*; 102).[13] The patron was
Matthäus Landauer, who earned a fortune by inventing a process

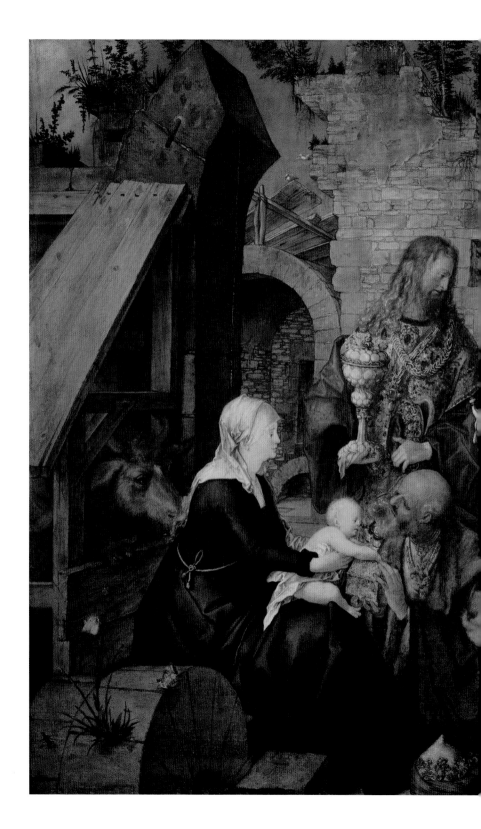

99
*Adoration of
the Magi,* 1504
Oil on panel;
100 × 114 cm
(39³/₈ in
× 44⁷/₈ in)
Galleria degli
Uffizi, Florence

100
Georg Christian Wilder, *Interior of the Zwölfbruder-haus Chapel,* 1836
Watercolour; 28.9 × 36 cm (11⅜ × 14⅛ in) Germanisches National-museum, Nuremberg

for extracting raw copper, a central commodity in Nuremberg's metalworking industry. His businesses extended to Thuringia, Bohemia, Krakow and Breslau. In 1501, the year his wife, Helena, died, he acquired a substantial plot of land adjoining the Inner Laufertor in Nuremberg. On this site Landauer, whose family had once been painters, erected the Zwölfbrüderhaus, a charitable home for twelve ageing craftsmen. The residents had to be destitute, single or widowed, and citizens of Nuremberg. The complex included a small chapel (100) housing Dürer's altarpiece and stained-glass windows after his designs.[14]

The altarpiece, completed in 1511, closely follows Dürer's detailed presentation drawing of 1508 (101).[15] Its wingless form was then a novelty in Germany. A sculptor, perhaps Ludwig Krug (1488/90–1532), and a joiner collaborated to create the intricate polychrome frame, which mixes classicizing elements, notably the columns with their composite capitals, foliate decorations and carvings. The sculptures illustrate the Last Judgement: Saint Peter greets the saved souls while on the opposite side of the lintel demons haul the damned into the gaping mouth of hell.

Dürer presented a vivid evocation of heaven's splendour as described in Saint Augustine's *City of God*. The elect perpetually adore the Holy Trinity. Dürer again constructed his composition symmetrically around the central vertical axis. Cherubs and other angels, some of them holding instruments of the Passion, extend back infinitely through the upper reaches of the celestial realm. The strong V-pattern of the clouds separates the angels, God, Christ and the Holy Spirit from the worshippers. The Virgin Mary and John the Baptist, seen as humanity's intercessors in the sculpted tympanum, are now accompanied by Virgin martyrs and, opposite, King David, Moses, prophets, sibyls and others who lived before Christ's coming. Dürer greatly expanded the number of figures in this tier beyond the drawing's initial scheme. His figural arrangements here are more complex than in the *Feast of the Rose Garlands*. Mary's humble and rather closed pose contrasts with John the Baptist's tense, almost contorted, body. Emperor Charlemagne, crowned and wearing the collar of the Golden Fleece, is viewed from the front while his papal counterpart faces inwards. The ranks of the elect merge around the circular opening behind this pair. A cardinal introduces Landauer, who is portrayed with shoulder-length hair and clutching his fur hat. The woman behind him staring out at the viewer may be Dorothea, Landauer's only child. His son-in-law, Wilhelm Haller, has been identified as the armoured figure on the right. Finally Dürer, holding an over-size *cartellino* ('Albertvs Dvrer Noricvs … 1511'), stands by himself in the landscape. Much like Saint John the Evangelist in the *Apocalypse* (see 46, 51), he experiences a heavenly vision. In painting the altarpiece for Landauer, who moved into the house in 1510, and for an ever-renewing audience of craftsmen, Dürer solicited their admiration of his skills and their prayers for his salvation. The panoramic vista, inspired by a lost watercolour of Lake Garda in northern Italy, has its own perspective scheme distinct from that of heaven, where the viewer's vantage point is at the eye-level of the pope and emperor. In the far distance are a few diminutive figures in boats, on horseback and walking.

101
*Design for
the Landauer
Altarpiece,*
1508
Pen with
blue, green
and red washes;
39.1 × 26.8 cm
(15⅛ × 10½ in)
Musée Condé,
Chantilly

102
*Adoration
of the Holy
Trinity
(Landauer
Altarpiece),*
completed 1511
Oil on
lindenwood
panel;
135 × 126 cm
(53⅛ × 49⅝ in)
Kunsthistor-
isches
Museum,
Vienna
Anonymous
sculptor
(Ludwig Krug?)
working after
Dürer's design
Wooden frame;
284 × 213 cm
(111⅞ × 83⅞ in)
Germanisches
National-
museum,
Nuremberg

The altarpiece's colours are dazzlingly rich and subtly modulated.[16] God's robe and cloak contain virtually every hue seen elsewhere in the picture. Dürer's bright reds and, less insistently, cooler greens move the viewer's eyes around the composition. The dominant greens and blues of the clothing change carefully in response to light and shadow. To prevent the colours from reading too flat, Dürer accented the physicality of the fabric. The green inner lining of God's cloak rests on and bends around the curved surface of the upper rainbow. The *Landauer Altarpiece*, with its blue and gold frame, must have sparkled brilliantly in concert with the chapel's stained-glass windows. In spite of his complaints to Jakob Heller about the labour, time and material costs required to make one of his finely painted pictures, the artist accepted Landauer's commission and what must have been a handsome payment. The resulting altarpiece reveals why his contemporaries coveted his paintings and praised his skills. At this moment Dürer knew that he had few, if any, peers among Germany's painters.

Assistants aided Dürer in executing the *Heller* and *Landauer* Altarpieces. This is hardly surprising given the scale and complexity of these pictures. Unlike his own teacher, Wolgemut, Dürer never directed a large workshop.[17] The character of most of his projects, especially his prints and designs, precluded delegating many tasks to others. He employed woodblock cutters and press assistants, but there is less secure information about his use of apprentices and young journeymen. Dürer trained an apprentice sent to him by Friedrich the Wise, as well as his younger brother Hans and, according to Neudörfer, Hans Springinklee (1490/5– after 1525), who lived in the artist's household from 1507 to 1510.[18] Hans Baldung Grien and Hans Schäufelein trained in other cities before residing in Nuremberg between about 1503 and 1506/7. Although stylistic arguments can be made for their close association with Dürer, it cannot be proved that they were in his atelier. The same situation holds for Wolf Traut (c.1480–1520) and Erhard Schön (c.1491–1542), two local artists. As his theoretical

writing attest, Dürer aspired to be a master teacher. His art proved the most effective means for directly conveying his ideas to others. Virtually every artist active in or near Nuremberg felt his stylistic influence. Occasionally Dürer's drawings were executed by others, as in the case of the *Epitaph of Lorenz Tucher* (d. 1503; 104).[19] Busy with other projects, Dürer limited his direct involvement to preparing the exquisite sketch, a *sacra conversazione* with the deceased provost of the church of Saint Lorenz and his patron

103
Hans von Kulmbach,
Epitaph of Lorenz Tucher (detail), 1513
Oil on lindenwood;
167 × 653 cm
(65¼ × 257 in)
Saint Sebaldus Church,
Nuremberg

saints adoring the Virgin and Child. The large painting by Hans von Kulmbach (c.1476/85–1522) in Saint Sebaldus in Nuremberg, completed in 1513, carefully follows its model (103).[20]

Before the second Venetian trip Dürer often strove for eye-catching compositions and technical virtuosity in his prints. His ambitiousness is fully displayed in *Saint Eustace* (105), his largest engraving.[21] Eustace enjoyed great popularity as one of the

*Design for
the Epitaph of
Lorenz Tucher,*
1511
Pen and
ink with
watercolour;
10.9 × 30 cm
(8⅜ × 11⅞ in)
Kupferstich-
kabinett, Berlin

Fourteen Holy Helpers and the patron saint of hunters. According
to Jacobus de Voragine's *Legenda aurea* (*Golden Legend*), which
Anton Koberger published in 1488, Eustace was a Roman general
during the reign of the emperor Trajan (r. 98–117). One day while
hunting he encountered a stag with a crucifix among its antlers.
Eustace converted and was later martyred for his faith. The saint,
dressed in contemporary German hunting attire, kneels before
the majestic stag. Dürer invites viewers to examine the landscape
with its myriad details, including the stream's reflective surface
and foliage. For all of its beauty and meticulous naturalism, the
engraving is rather static. Its primary features appear plucked from
separate sketches. Indeed, a surviving drawing exists for the dog
closest to Eustace.[22] Nevertheless, the grandeur of the saint and his
landscape is unsurpassed by contemporary printmakers.

Nuremberg's churches are filled with carved, painted and glazed

heraldic shields, social emblems marking the support provided by
the city's leading families. Throughout his career Dürer designed
armorials, including his own. His *Coat of Arms of Death* (106)
playfully satirizes personal vanity.[23] The helmet is adorned with
bird's wings and exuberant foliate tendrils. On the shield a jawless
skull ominously stares with empty eyes. An elderly wildman
caresses a young woman who wears a bridal crown.[24] Wildmen,
quasi-human creatures that shunned society and its conventions
by living in Germany's halcyon forests, were known for their
uninhibited lust. The maiden clearly enjoys his attention but
is oblivious to death's nearness. Perhaps Dürer's illness in 1503
inspired this amusing commentary on human sexual urges and
social pretensions.

Between 1507 and 1511 Dürer's graphic output was prodigious in
spite of the time he devoted to painting. He focused on elaborate

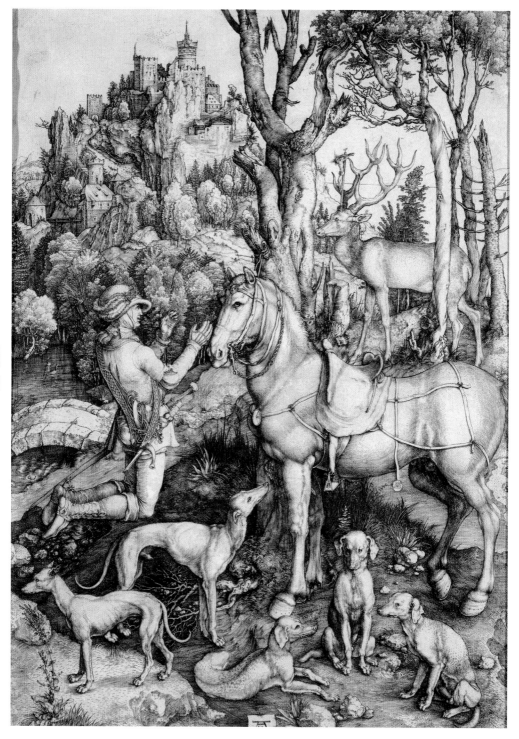

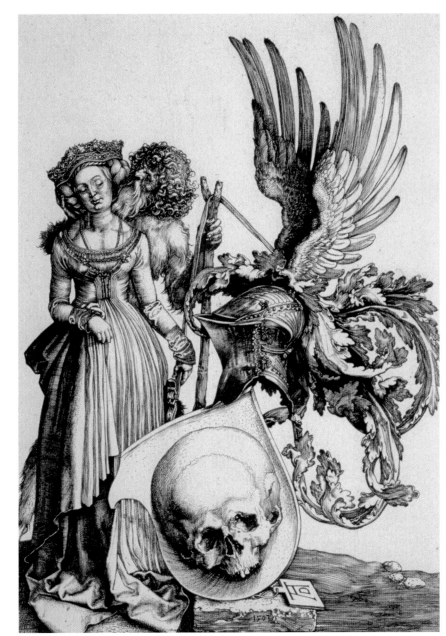

105
Saint Eustace,
c.1501
Engraving;
35.6 × 26 cm
(14 × 10¼ in)

106
*Coat of Arms
of Death,* 1503
Engraving;
22 × 16 cm
(8⅝ × 6¼ in)

series more than single prints. In 1511 Dürer published four books of woodcuts. The *Apocalypse* of 1498 was reissued with a new title page.[25] He referred to this, the *Life of the Virgin,* and the *Large Passion* as the *Large Books* because of their folio size. Although the woodcuts of the *Apocalypse* and *Large Passion,* each measuring around 39.5 by 28.5 cm ($15\frac{1}{2} \times 11\frac{1}{8}$ in), are slightly larger than those of the *Life of the Virgin,* all are printed on identically sized sheets of paper. This permitted the three series to be bound and sold together. More diminutive in scale if not in expressiveness is the *Small Passion,* created between 1509 and 1511. Meanwhile, Dürer worked on the *Engraved Passion* (1507–13). Excluding the *Apocalypse,* the other four series contain eighty-five prints, most of them post-dating the second Venetian trip. Each cycle differs in terms of size, narrative strategies, ambition and potential audience.[26] These prints collectively exerted a tremendous impact on Europe's artists well into the seventeenth century.

The *Life of the Virgin,* begun in 1502, consists of a title page and nineteen large woodcuts.[27] Seventeen of the prints circulated separately by 1505; however, Dürer completed the remaining two images in 1510 and added a title page a year later. The folio-size book contains the text by Benedictus Chelidonius (Benedikt Schwalbe), noted neo-Latin poet and Benedictine monk, who taught at Saint Egidien's in Nuremberg. He contributed the poetic texts for the *Large Passion* and *Small Passion* too, each composed in a different classical rhetorical style appropriate to the book's character.[28] In this instance his elegy's intimate, mournful quality suits Mary's sorrowful life. The text, printed in Roman type, appears on the verso (or left) page facing the woodcut on the recto (or right) page. Texts and images, although conceived independently, often share mood.

The *Sojourn in Egypt* (107; see also 196) is typical of the pre-Venice woodcuts.[29] The complex setting is richly filled with anecdotal details. Dürer's fascination with mathematical

perspective is evident as the orthogonal lines recede to a point located in the centre of the rounded arch above Mary and the angels' heads. He delighted in designing intricate spaces like the staircase on the left. Features such as the dilapidated building, the large fragmentary arches, the rightwards perspectival pull, the distant hill town and the placement of the sky, which peeks through at the upper left and fills the diagonal-shaped space at the upper right, reappear in his *Adoration of the Magi* of 1504 (see 99). Since the Bible is silent about the years that the Holy Family spent in Egypt after escaping Herod's troops, artists relied on texts such as *Pseudo-Matthew*, an apocryphal gospel, and the popular *Legenda aurea*. Dürer depicted Mary spinning thread as she watches the Christ Child in his wooden cradle, which Joseph has built. Their labours recall those of the first exiles: Adam, who hoed the soil, and Eve, who spun.[30] Mary epitomizes domesticity. Almost unseen amid the archangels Michael, Raphael and Gabriel, a curious little angel stares in awe at the infant. Meanwhile, Joseph works to support the family. Five small angels, one wearing the carpenter's hat, assist him. Two others play with a whirligig toy. The viewer can readily imagine the sounds associated with this tranquil scene.

By 1510, when he added the *Assumption and Coronation of the Virgin* (108), Dürer's style had changed.[31] Even accounting for the demands of the subject, his figures are much larger, the space is stripped of incidental features and the lighting effects are more pronounced than in the earlier prints. He repeated the basic composition of the recently finished *Heller Altarpiece* (see 96). Some apostles have similar, but not identical, poses. The disciple at the far left with his upturned head recalls the altar's Saint Peter, although his praying hands derive from another figure. The woodcut conveys a more visionary feeling than the picture. Its heavenly zone, with its horizontal shading and clear boundaries, contrasts vividly with the deeper space behind the apostles and the area's dark, dense hatching. The cloud surrounding heaven seems

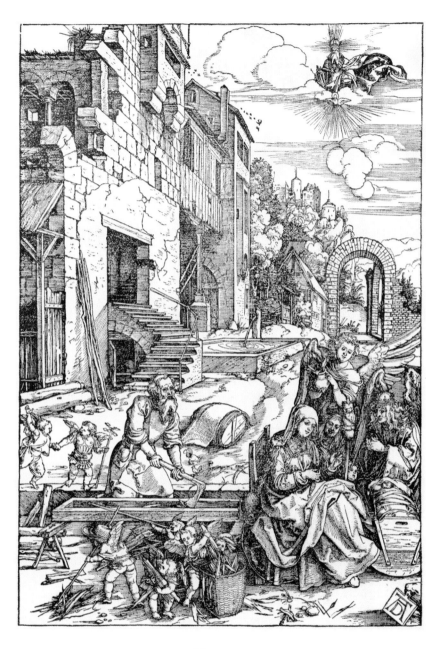

107
*Sojourn in
Egypt*, c.1502
Woodcut in
the Life of
the Virgin
(Nuremberg,
1511);
29.5 × 21 cm
(11⅝ × 8¼ in)

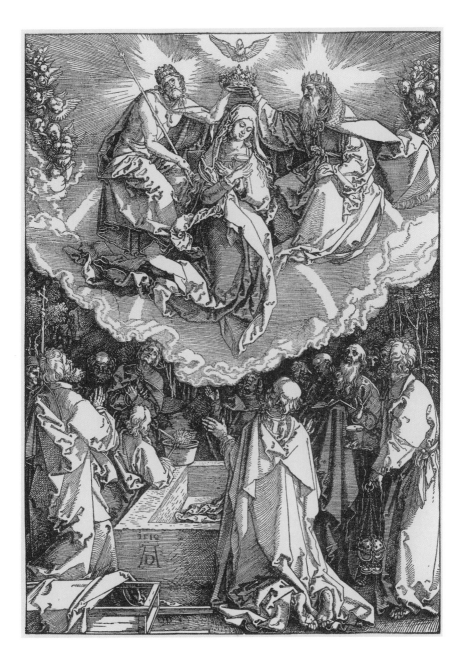

108
*Assumption
and Coronation
of the Virgin*,
1510
Woodcut in
the *Life of
the Virgin*
(Nuremberg,
1511);
29 × 20.7 cm
(11⅛ × 8⅛ in)

to cast a shadow behind the tomb. This accentuates the contrast between the sombre mood of the apostles and Mary's joyous reception into heaven.

During the late 1500s the artist began experimenting with grey middle-tone shading to complement his customary hatchings and cross-hatchings. As seen clearly in the lower portion of Mary's robe and in the fabric of the apostle holding the book, a series of parallel lines separate from the normal contour and shading lines runs horizontally across the forms. These stand half-way between the brilliant white highlights and blackness of the deeply worked passages. Dürer exploited this technique to separate primary and secondary figures. The viewer, presumably, is bathed in the same celestial light as the apostles in the foreground. Our vantage point, roughly at the same eye-level as the kneeling apostle, permits a clear view of the death bier, aspergillum, processional cross, book and censer used in Catholic burial ceremonies.

Certainly with Dürer's approval, Chelidonius dedicated the text to Caritas Pirckheimer, Willibald's older sister and the abbess (r. 1503–32) of the Franciscan convent of Saint Klara's in Nuremberg.[32] The poet stressed her renowned knowledge of Latin literature, her care for other nuns and her virginal life. Dürer's woodcuts are visually alluring regardless of the viewer's literacy level. This intimate recounting of the life of Mary, 'the ruler of nuns', coupled with the Latin poems held special attraction and, in Mary, a role model for educated nuns, such as the daughters of wealthy Nuremberg patrician families who populated Saint Klara's.

Dürer's prints, however, attracted the unwanted attention of copyists. In his life of Marcantonio Raimondi, Giorgio Vasari writes that when the young printmaker first moved to Venice he spent almost all of his money buying Dürer's woodcuts and engravings on sale in the Piazza San Marco.[33] He immediately

turned his attention to every detail of those prints with all diligence, and thus to copying Albrecht's prints, carefully studying stroke by stroke how the whole of the prints he had bought had been made. … Marcantonio copied there the sign which Albrecht had made on his works, that is, the letters A.D. He succeeded in capturing Albrecht's style to such an extent that the prints were believed to be by Albrecht, and were bought and sold as such, since no one knew that the prints had been made by Marcantonio. When this situation was described to Albrecht in Flanders, and when one of the said copies was sent to him, Albrecht was moved to such fury that he left Flanders and went to Venice, where he complained about Marcantonio to the Senate. However, he got nothing but the sentence that Marcantonio could no longer add the name or monogram of Albrecht to his works.[34]

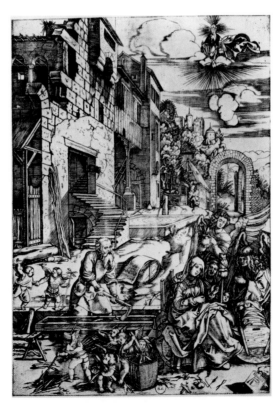

**109
Marcantonio
Raimondi,**
*Sojourn in
Egypt* (copy
after Dürer),
1511 or later
Engraving;
29.3 × 21 cm
(11½ × 8¼ in)

Starting in 1506 and continuing after moving to Rome around 1509, Raimondi engraved copies of about seventy of Dürer's prints, including the entire *Life of the Virgin* and *Small Passion* series. His replica of the *Sojourn in Egypt* (109) reveals how adeptly he mimicked Dürer's woodcut.[35] Side by side, however, the expressive woodcut lines contrast with the rigid, rather lifeless character of Raimondi's engraving.

While Dürer complains to Pirckheimer that Venice's artists copied his works wherever they found them, he never mentions lodging a formal complaint with the Senate. Vasari's story may be apocryphal. Almost half of Raimondi's versions, including the *Sojourn in Egypt*, bear Dürer's monogram. Given the lack of copyright or legal restraints against unauthorized copies, there was little that Dürer could do. When he discovered pirated impressions of his prints being sold near the Nuremberg Rathaus in 1511, he sought action by the city council.[36] On 3 January 1512 it ruled that only Dürer's monogram was legally protected, a decision in line with the Venetian Senate's reputed response. Copies bearing his mark could be confiscated, but others issued without the monogram could be sold.

The concept of intellectual property with appropriate legal protection was just beginning to be discussed during this period. In fact, Dürer sought and obtained imperial privileges for his four books published in 1511 as well as his later treatises. The text beneath the final woodcut in the *Life of the Virgin* reads:

> Beware, you envious thieves of the work and invention
> of others, keep your thoughtless hands from these works
> of ours. We have received a privilege from the famous
> emperor of Rome, Maximilian, that no one shall dare
> to print these works in spurious forms, not sell such
> prints within the boundaries of the empire … Printed in
> Nuremberg, by Albrecht Dürer, painter.[37]

Such privileges were often difficult to enforce outside the domain

of the granting town or noble. Maximilian's authority did not extend to Venice or Rome. Nevertheless, Dürer's actions were cited as a legal precedent in 1533, when the imperial court in Speyer heard a case involving rival publications of two expensive illustrated herbals.[38]

The woodcuts for the *Large Passion* were made in two campaigns and circulated widely as independent prints before their compilation as a book in 1511. Seven of the prints date to 1496–1500. The remaining four were completed in 1510 (see also 172), and the title page was added a year later. *Christ in Limbo* (110) exemplifies the power of the final prints in this series.[39] According to the apocryphal *Gospel of Nicodemus* and the *Legenda aurea*, Christ descended into Limbo after his death on the cross. Limbo's thick wooden door lies smashed on the ground. Impervious to the threats of four devils, Christ heroically dominates the space. His halo's intense radiance obscures the nearby wall and illuminates the scene. Grasping his victory standard, Christ comes to save the innocent and the worthy who died before he did. He reaches down and clasps a man by the wrist. John the Baptist, at the lower right, and the viewer, whose analogous position is determined by a slightly higher vantage point, wait for Christ's help. Dürer's monogram cut into the stone is, like the nearby figures, half-shaded. Behind, the aged but still robust Adam holds an apple, symbol of humanity's fall, and a cross, the means of humanity's redemption. Dürer deftly used the grey middle-tone technique to shade Eve's body. For his accompanying poetic text, Chelidonius chose an epic style, one that flows seamlessly from page to page independent of the woodcuts. The dactylic hexameters, borrowed from fifteenth-century Italian writers, match the pathos and grandeur of Dürer's Christ.

The *Small Passion*, so named because the woodcuts average 12.6 by 9.8 cm, is the most expansive of the narratives.[40] The thirty-six scenes and title page date from between 1509 and 1511. Once again

many of these prints circulated separately without Chelidonius's text. Even though it begins with the Fall of Man and ends with the Last Judgement, thus encompassing all of human time, most of the cycle methodically recounts Christ's last days. An uncut folio-size sheet (111), today in Amsterdam, shows how the artist printed four consecutive scenes on a single page.[41] The small scale of the woodcuts requires the reader's careful attention. Dürer stressed poignant storytelling, not the stylistic finesse observed in the previous two series.

Following the episode of Pilate washing his hands, which signals the inevitability of Christ's fate, Jesus staggers under the weight of the cross as he walks out of Jerusalem towards Golgotha. His highlighted right arm, fully extended, barely supports his weight. Even though prodded to get up, Christ stares at Saint Veronica, the kneeling woman who has just wiped his face with her veil. His mouth opens, either to speak or to gasp for a breath. The viewer is invited to reflect on this exchange.[42] Helping Christ at a moment

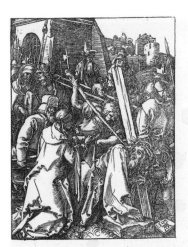

110
Christ in Limbo, 1510
Woodcut in the *Large Passion* (Nuremberg, 1511);
39.5 × 28.4 cm
(15¹⁄₂ × 11¹⁄₈ in)

111t
Christ Carrying the Cross; Saints Peter, Veronica and Paul; Christ Nailed to the Cross; Christ on the Cross, 1509–11
Four woodcuts on an uncut folio-size sheet in the *Small Passion* (Nuremberg, 1511); each print:
12.7 × 9.7 cm
(5 × 3¹⁄₄ in)
Rijksmuseum (Rijksprentenkabinet), Amsterdam

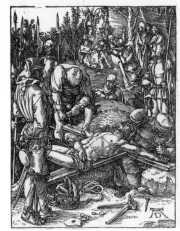

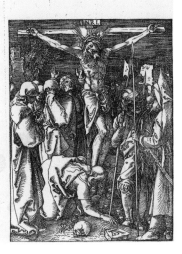

when no others will, Veronica personifies faith in action. Gradually the viewer notices Simon of Cyrene, holding the base of the cross, Mary, John the Evangelist and a few others amid the exotically dressed crowd. Christ moves from left to right, a device the artist employs often in this series to direct the viewer towards the following scene.

The next woodcut initially seems out of place. Saints Peter, Veronica and Paul stand in a simple room. Dürer inserted a pause, a reflective halt in the passion narrative. Chelidonius's text mentions that Veronica's *Sudarium* was then a relic in Saint Peter's Basilica in Rome and the object of an indulgenced pilgrimage. Peter and Paul, the pillars of the Catholic Church, stand on either side. Some viewers, of course, may ponder Peter's absence during the final stages of the Passion or Paul's persecution of Christians before his conversion: these three figures embody different paths to faith.

Christ Nailed to the Cross is graphically brutal. Dürer has placed the viewer uncomfortably close to the action. One soldier drives the nail through Christ's left hand. Another drills the hole on the opposite end of the cross. Various instruments of the Passion rest on the ground, while the standing man at left holds a flask containing vinegar. Behind, Mary, John and the others mourn. One woman, probably Mary Magdalene, has boldly crept closer.

The drama culminates in *Christ on the Cross*, the twenty-fifth print. Although Dürer followed standard Crucifixion iconography, he stressed the reactions of Christ's followers. The guards, including Longinus (holding the lance), allow them to approach the dead body. They grieve differently: some women quietly sob; John raises his arms in sorrow as he stares at Jesus; Mary Magdalene embraces the cross and caresses his feet, which once she perfumed with precious oil. Amid Golgotha's darkness, which matches their collective mood, Christ's halo shines faintly.

In conceiving the *Small Passion*, Dürer may have been inspired by the success of such popular devotional books as Ulrich Pinder's *Speculum passionis*, published in Nuremberg in 1507 with seventy-six woodcuts by Hans Schäufelein and Hans Baldung Grien.[43] Yet his ability to vary his compositions and to focus on the experiential essence of each episode is unrivalled. Sometimes playfully and at other times mournfully Dürer included his monogram almost as another protagonist in every scene.[44] In the title page Christ sits on a block of stone chiselled with the letters AD. *Cartellinos* with his monogram hang from trees, rest on the ground or are propped up on various surfaces. In *Christ Cleansing the Temple*, the monogram, like the adjacent table, has been knocked over and partially falls out of the scene. Like the sleeping Saint Peter in *Christ in the Garden*, the *cartellino* is shaded as though in slumber. It twists along with Jesus's body in the *Mocking of Christ*. If Christ's arm slips in the *Carrying of the Cross*, he will land on the monogram. It mimics the room's perspective in *Saints Peter, Veronica and Paul*, while in the next two scenes it lies among the instruments of the Passion and by Mary Magdalene's hand. In the *Entombment* the monogram adorns a piece of paper, eerily reminiscent of the *Sudarium*, attached to the tomb.

Dürer's authorial presence is almost matched by Chelidonius's poetry. As David Price notes, the lyric odes of the *Small Passion* are the flashiest in style.[45] Chelidonius wrote thirty-seven poems in twenty different metres, a feat in emulation of Horace's odes. The book also includes two short poems by Pirckheimer and Johannes Cochlaeus, the schoolmaster of the church of Saint Lorenz. The latter, while praising Chelidonius's poetry, ends sombrely by telling the reader that he or she will find 'No charming trifles or games, but the thorns and wounds of Christ / And the hard death – the great trophies of God'.[46] Even if the Latin poems were intended for an educated clientele, the narrative richness of Dürer's woodcuts and the smaller size of the book appealed to a wider

audience than either the *Life of the Virgin* or the *Large Passion*. In August 1520 during his Netherlandish trip Dürer charged the same price for the *Small Passion* as he did for any of the three *Large Books*.[47] At a quarter of a florin each, these books sold for half the cost of the *Engraved Passion*.

Jordan Kantor helpfully compares depictions of the Passion with a jazz standard.[48] Everyone knows the basic story or melody, but it falls to each artist to personalize or improvise in a manner that is highly self-conscious yet still true to the sources of inspiration. The *Engraved Passion* is moodier and darker in character than the two other Passion cycles, owing in part to the greater detail and chiaroscuro possibilities of the medium.[49] The cycle consists of fifteen prints (sixteen, if the image of *Saints Peter and John Healing a Cripple* is added). Sixteenth-century sets do not always include the latter, which may have been intended for a separate series on the *Acts of the Apostles*. Since the engravings average 11.7 by 7.3 cm (4⅝ × 2⅞ in), they were printed four to a folio sheet just like the *Small Passion*. Thus sixteen was a more efficient number to publish. Dürer began the series in 1507, but ten of the prints date to 1512, the year after the completion of the other books and the *Landauer Altarpiece*.

In *Christ on the Mount of Olives* (112) Dürer exploited the nocturnal hour to heighten the drama.[50] As recounted in three of the four gospels, Christ retreats to Gethsemane to pray. Even though he urges Peter and two others to stay awake with him, they fall asleep. Christ asks, 'Father, if you are willing, remove this cup from me; yet, not my will but yours be done.' Then an angel from heaven appears to him and gives him strength. In his anguish he prays more earnestly, and his sweat becomes like great drops of blood falling down on the ground (Luke 22:42–4). Dürer stresses Christ's physical and emotional energy as he throws his arms upwards and stares intently at the cross held by the angel. The angel's radiance illuminates the entire foreground. As the

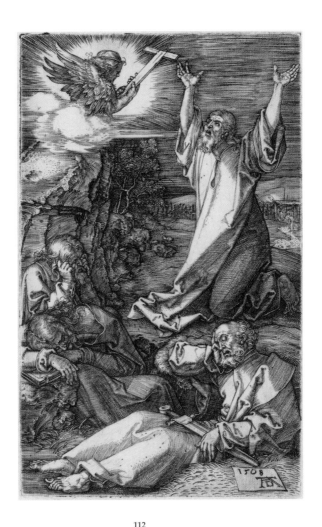

112
Christ on the Mount of Olives, 1508
Engraving in the *Engraved Passion* (Nuremberg, 1513);
11.6 × 7.1 cm
(4⅝ × 2¾ in)

light shines brightly on Christ's face and the front of his robe, it also psychologically isolates him from the others. Meanwhile, the circular arrangement of the foreground figures almost causes the viewer to overlook the arrival at the garden's gate of Judas and others, with their puny torches, coming to arrest Christ.

When Dürer portrayed *Pilate Washing his Hands* (113) four years later, he focused on the event's impact on those encountering Christ.[51] According to Matthew 27:24, 'So when Pilate saw that he could do nothing, but rather that a riot was beginning, he took some water and washed his hands before the crowd, saying, "I am innocent of this man's blood; see to it yourselves".' At first Christ is scarcely visible. Attention centres on Pilate, who is dressed as an Ottoman Turk. Aided by two servants, one of them Moorish, he looks exhausted by the ordeal and by his personal failure to halt the death of an innocent man. Notice how Dürer links Pilate and Christ. Both are shown in profile with downwards-turned heads. Although each is surrounded by two other men, they are alone, introspective and resigned to their fates. Behind Christ one cross already passes through the palace gate. Dürer's floating monogram and the date highlight distant Golgotha.

During these years immediately following the second Venetian trip Dürer was engaged in other religious and secular projects. Yet the two great altarpieces for Frankfurt and Nuremberg and these print series commanded most of his attention. By their very nature, cycles tend to be more memorable for their collective contributions rather than the brilliance of any particular print. After completing the *Engraved Passion* Dürer focused once again on single masterful prints. The results include, arguably, his most beautiful engravings and a handful of other truly remarkable woodcuts, drypoints and etchings.

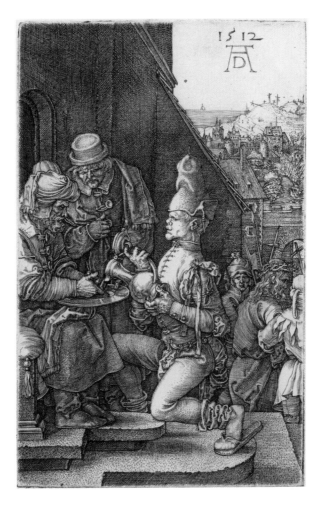

113
*Pilate Washing
his Hands,*
1512
Engraving in
the *Engraved
Passion*
(Nuremberg,
1513);
11.6 × 7.4 cm
(4⅝ × 2⅞ in)

114
Erasmus, 1526
Engraving;
24.7 × 19 cm
(9¼ × 7½ in)

In 1526 Dürer engraved Erasmus's portrait (114). Two years later
this and other prints inspired the renowned humanist to compose a
laudatory eulogy comparing Dürer with Apelles. Giving a different
twist to this over-used topos, Erasmus exclaimed that Dürer
surpassed Apelles because his art did not have to rely on colours.
He wrote:

> What does he not express in monochromes, that is,
> by black lines? Shade, light, radiance, projections,
> depressions. Moreover, from one object [he derives] more
> than the one aspect which offers itself to the beholder's
> eye. He accurately observes proportions and harmonies.
> He even depicts what cannot be depicted: fire; rays of
> light; thunderstorms; sheet lightning; thunderbolts;
> or even, as the phrase goes, the clouds upon a wall;
> characters and emotions – in fine, the whole mind of
> man as it shines forth from the appearance of the body,
> and almost the very voice. These things he places before
> our eyes by the most felicitous lines, black ones at that,
> in such a manner that, were you to spread on pigments,
> you would injure the work. And is it not more wonderful
> to accomplish without the blandishment of colours what
> Apelles accomplished only with their aid?[1]

The decade of the 1510s witnessed comparatively few paintings
(see 191) by Dürer. Instead the 'Apelles of black lines' concentrated
on his prints, his projects for Emperor Maximilian I and his
theoretical musings. He travelled rarely, and then only briefly.
In 1509 he purchased a large house (115, see 197, 198), formerly
owned by the astronomer and mathematician Bernhard Walther,
just opposite the Tiergärtnertor beneath the castle.[2] This afforded
him considerably more living and working space. Three years later
he acquired a garden plot, with well rights, located outside this gate

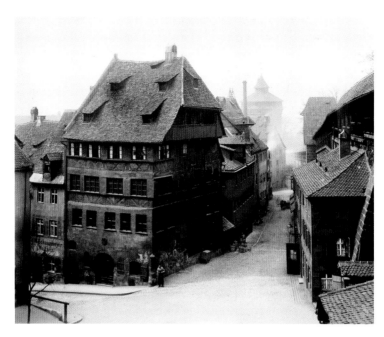

115
Dürer's house
in Nuremberg,
c. 1890
Early fifteenth
century with
later additions,
remodelled in
1501–3

along the road to the Saint Johannis cemetery.[3] Dürer's financial
situation improved dramatically after returning from Venice. In
1509 he began investing money through the city government.[4]
His economic success, which was probably due more to the sale
of his prints than to the substantial payments that he received for
the *Heller* and *Landauer Altarpieces*, provided him with a new
measure of artistic freedom.

In 1511, besides publishing the three *Large Books* and the *Small
Passion*, Dürer created the *Mass of Saint Gregory* and the *Holy
Trinity* (116, 117), two of his most technically sophisticated
woodcuts. The theme of the Mass of Saint Gregory enjoyed great
popularity during the late fifteenth and early sixteenth centuries.
Spurred by the prospect of excellent sales, Dürer played with the
concept of inclusion and exclusion to devise a novel print. One day
while performing mass, Pope Gregory the Great (r. 590–604), one
of the four Fathers of the Western Church, had a vision. Christ
as the Man of Sorrows appeared above the altar, thus proving the
dogma of transubstantiation, in which the Eucharistic wine and

bread are literally transformed into Christ's blood and body during communion. In the woodcut Christ displays his wounds and stares directly at the awestruck Gregory, who alone experiences this vision.[5] The two deacons assisting Gregory, absorbed solely in the liturgy, are oblivious to the apparition. Using the grey middle-tone technique, Dürer casts the cardinal holding Gregory's tiara and other high-ranking clergy into the shadows as they, too, are unaware of Christ's appearance. The rising cloud of incense filling the background is reminiscent of the smoke in *Saint John the Evangelist Devouring the Book* (see 51).

The *Holy Trinity* recalls the *Landauer Altarpiece* (see 102), completed in the same year.[6] In both instances God holds the dead Christ while flanking angels carry the instruments of the Passion. A rigid symmetry dominates the painting, with all three members of the Trinity aligned on the central axis. God conveys a sense of gravitas as he looks unblinkingly forwards. In the woodcut God stares sadly at Christ, whom he tenderly cradles in his lap. Their two heads now fall on either side of the vertical centre line. Here angels touch and press close to Christ. Their grief heightens the scene's emotional charge. The tonal range and diversity of lines are unsurpassed in any other of Dürer's woodcuts. Even a quick comparison with the early *Samson and the Lion* (see 44) or the *Apocalypse* prints (see 47, 48, 50, 51) reveals the subtleties of his mature woodcuts. The expressive potential of the woodcut lines is retained yet combined with a painterly sensitivity to light and form.

Dürer briefly experimented with drypoint, an intaglio technique employing a needle to scratch the design directly into the copper plate. During the 1490s he was influenced by the attractive, if rare, drypoints of the Housebook Master. Perhaps this memory inspired him to try the technique in 1512. As seen in *Saint Jerome by the Pollard Willow* (118), one of only three drypoints by Dürer, the lines are very delicate.[7] Unlike his typical deep burin strokes,

116
*Mass of Saint
Gregory,* 1511
Woodcut;
29.8 × 20.7 cm
(11¾ × 8⅛ in)

117
Trinity, 1511
Woodcut;
38.9 × 28.2 cm
(15⅜ × 11⅛ in)

the needle marks are quite shallow. The burr, the resulting ridge of metal that is raised beside each scratched line, retains ink and yields a soft, rather fuzzy line in early impressions. The pressure of printing, however, soon wears down the burr. Consequently, drypoints yield fairly few good impressions and, as a result, small potential profits. Dürer, however, tested the atmospheric possibilities of the technique. Jerome, seated amid a wild rocky landscape, is softly bathed in light, although the chiaroscuro range is rather muted. Greater contrasts are evident between the sky's luminosity and the rather dusty tonality of the willow and the rest of the saint's immediate surroundings. The drypoint lines have a certain uniformity of feel since the needle does not permit the swelling and tapering lines of a burin. Sometimes Dürer selectively inked and wiped the plate to achieve varied expressive effects. This anticipates the manipulations later practised by Rembrandt, the greatest drypoint master.

118
*Saint Jerome
by the Pollard
Willow*, 1512
Drypoint;
20.6 × 18.3 cm
(8¹/₈ × 7¹/₄ in)

Dürer's skills as a printmaker peak in 1513–14 with the creation of three impressive engravings: *Knight, Death and the Devil* (119), *Saint Jerome in His Study* (121) and *Melencolia I* (122).[8] Like *Adam and Eve* (see 63), each print is the product of careful preparation and meticulous execution. These works have long been grouped together because of their similar size, artistic finesse and loose thematic associations. A more specific link, however, is supported neither by Dürer's writings nor by his sales practice. Only from the nineteenth century are the prints collectively referred to as the *Master Engravings*.

Knight, Death and the Devil portrays an ageing and world-weary rider passing through inhospitable terrain.[9] The rocky hillside is filled with dead trees and bare bushes. Only the distant town at the end of the path potentially offers some respite. Dürer modelled the rider and his mount closely on a detailed drawing from 1498 of a *Knight in Armour* (120).[10] Although he writes on the sketch that this type of armour was worn at the time in Germany, the

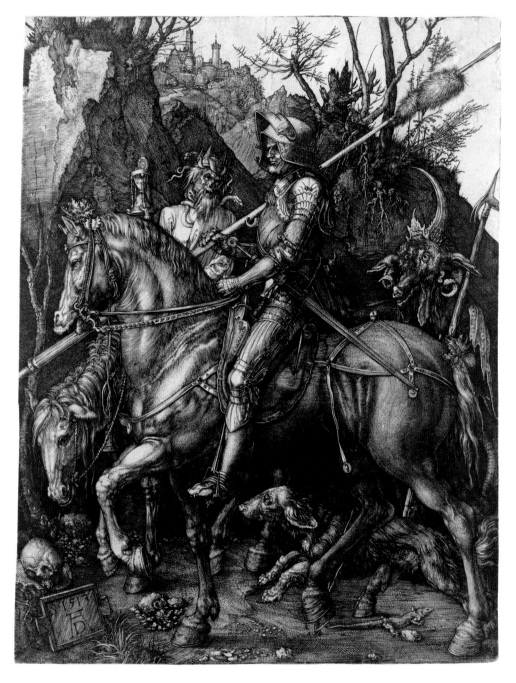

119
*Knight, Death
and the Devil,*
1513
Engraving;
24.4 × 18.8 cm
(9⅝ × 7⅛ in)

expensive suit was somewhat antiquated fifteen years later. For
the print he made only minor changes to the knight's face, the
angle of the sword, the position of the left hand holding the reins
and the length of the lance.[11] The engraved horse is more robust
and more muscular. Dürer retained the left hind leg and rump of
the horse, as well as the position of the right foreleg, but adjusted
the other legs to convey a walking motion. As Dürer altered the
right hind leg and hoof, he transformed their original contours
rather awkwardly into a clump of weeds. Was this pentimento
intentionally not fully corrected in order to show the artist's
invention and his willingness to make creative adjustments? The
knight's faithful retriever warily eyes Death riding a decrepit
steed. As in the *Four Horsemen* (see 50) and *The Ravisher* (see 52),

121
*Saint Jerome
in His Study,*
1514
Engraving;
24.9 × 18.9 cm
(9¾ × 7½ in)

122
Melencolia I,
1514
Engraving;
23.7 × 18.7 cm
(9⅛ × 7⅜ in)

Death is a skeletal figure with rotting flesh. Serpents coil around his neck and crown.[12] He raises an hourglass, a symbol of life's transience, to remind the rider of his mortality. Since the upper chamber still contains some sand, the knight's death does not seem imminent. Death's nag looks almost sympathetically at the human skull resting on the rock above Dürer's *cartellino*. At right, an oddly passive devil holds up its right claw, as though warning the knight. On the ground a salamander scurries away.

Dürer referred to this print simply as the *Knight*. The absence of a clear narrative or allegorical title has spawned a host of interpretations, none of them wholly satisfying. Undeterred by plausibility and the lack of a clear portrait, some scholars identify the knight as a specific person, from the German hero Siegfried to Erasmus or Luther. Vasari labelled the print merely as an armoured man on a horse. In a Nuremberg inventory of 1530 the print is listed as depicting Philipp Rink, a local man who supposedly encountered Death and the Devil while lost in a forest. In 1675 Joachim von Sandrart stated that the figure personifies the Christian knight (*miles christianus*) in spite of the lack of a cross or another Christian sign.[13] The iconographic complexities of *Melencolia I* and, to a lesser degree, *Saint Jerome in His Study* have encouraged the quest for deeper meanings in this print than ever intended by the artist. Given the dog's attentive gaze, Death and the Devil are real. The knight is equally attentive to his path and its potential dangers as he rides resolutely forwards. For the professional knights and mercenaries of this period death and temptations were always present. The steadfastness of the knight on life's path offers a positive stoic model to anyone actively engaged in the world. Or the print can be read as a *memento mori*. Ernst Gombrich linked this print with Dürer's illustrated poem *Death and the Landsknecht* of 1510, which stressed the need for personal contrition before the unknown hour of one's death.[14] This range of possible readings may have been intentional to appeal to a broad audience.

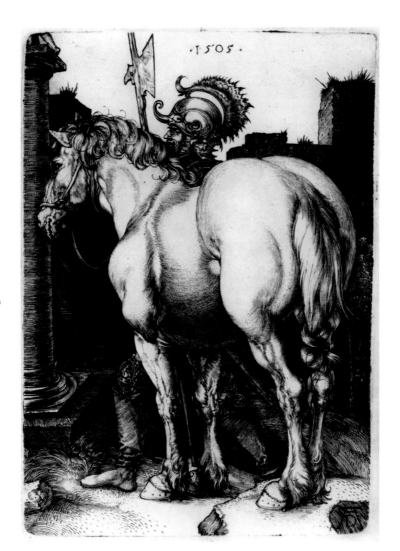

123
Large Horse,
1505
Engraving;
16.6 × 11.9 cm
(6½ × 4¼ in)

Horses fascinated Dürer. He awkwardly depicted them from
different angles in *The Cavalcade* (see 16) of 1489. Saint Eustace's
careful studied horse (see 105) is followed by two drawings from
1503 of a horse trotting and, a couple years later, the engraved
Small Horse and *Large Horse* (123), among other works.[15] Like
his *Adam and Eve* (see 63), Dürer's equine studies combine
direct observation with ideal proportional theory. Concurrently
with *Knight, Death and the Devil*, Dürer worked on a treatise
on painting.[16] The fourth of ten planned chapters was to be

devoted to the proportions of a horse. In the foreword to his Latin translation of the *Four Books on Human Proportions* (1532) Camerarius remarks that Dürer intended to write a separate book on the 'symmetry of the parts of the horse' and had undertaken numerous measurements. 'I also know that he lost all he had done through the treachery of certain persons, by whose means it came about that the author's notes were stolen, so that he never cared to begin the work afresh.'[17] The suspect, whom Dürer decided not to accuse, may have been Sebald Beham, one of the artist's Nuremberg followers.[18]

Dürer presented the impressive steed in profile, a position that permits careful scrutiny (see 123). The equine proportional scheme developed in the Middle Ages and perfected by Leonardo da Vinci (1452–1519) is based on the length of the head.[19] The body is three heads long; the rump is three heads high. If the body and legs, without the head, are inscribed by a square, each side of this square will be three heads in length. The remaining ratios can be figured by dividing this square into nine smaller ones. The curves, such as the rump, are drawn using a compass. Dürer knew something of Leonardo's ideas, and he may have seen Leonardo's drawings, probably through copies, a few years before his second Venetian trip. One logical source was Galeazzo de San Severino, who was Pirckheimer's house guest during the summer of 1502. Galeazzo was the son-in-law and captain of Lodovico Sforza, duke of Milan (r. 1494–9), and Leonardo's patron. Leonardo had access to Galeazzo's stables, where he studied horses while preparing the full-scale model of the equestrian statue of Lodovico.[20] During the siege of Milan in 1499, French troops demolished this statue, and Leonardo's treatise on horses was lost.

While in Italy, Dürer certainly admired the four majestic Greek horses adorning the façade of the basilica of Saint Mark's in Venice, Andrea Verrocchio's equestrian monument to *Bartolommeo Colleoni*, erected in the same city in 1496, and perhaps Donatello's

Gattamelata, erected in Padua in 1453.[21] These bronzes celebrate equine beauty and power in addition to honouring mercenaries in the latter two cases. Whereas Verrocchio emphasized Colleoni's prideful dominance of the massive beast, Dürer achieved a harmonious balance between horse and rider, one accenting their unblinking unity of purpose. His choice of a low vantage point may reflect, albeit less drastically, the viewer's upward glance at any of these elevated statues.

The knight's steady movement through the world contrasts with the contemplative life exhibited in *Saint Jerome in His Study* (121).[22] Jerome enjoyed great popularity especially among scholars, who viewed him as a proto-humanist.[23] He sits writing in a sun-filled cell. Dürer brilliantly conjured a mood of quiet serenity, much like a Sunday afternoon. The dog sleeps and the lion will doze again once assured that the viewer will not disturb its master. Light pours through the bull's-eye glass windows. The circular patterns and crossbars of the windows are reflected in the adjoining masonry. Jerome's simple wooden table is defined solely by a few summary lines, the occasional nicks and the few objects resting on top. Its trestle legs and their cast shadows are meticulously cross-hatched. Although it is just unadulterated paper, Jerome's halo seems to glow with unearthly intensity. Dürer deftly contrasted textures, such as the leather-bound books, soft fabric of the pillows (see 20), brittle skull resting on the stone ledge, wood-grains of the ceiling beams, calligraphic twists of the gourd's tendrils and different naps of the animals' fur. Their collective realism almost masks the sharp perspectival recession as the room presses down on Jerome. Dürer replaced the broad chiaroscuro range of earlier engravings (see 72, 105) with a subtler tonal palette, one that defines and binds the composition together. The artist's monogrammed *cartellino*, receding in correct mathematical perspective, situates Dürer within Jerome's cell. One man uses a quill pen and the other a burin. Both are creatively engaged and divinely inspired.[24]

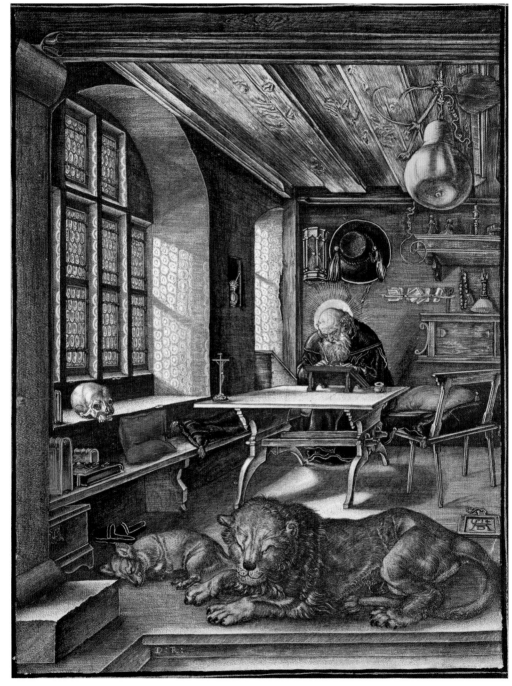

Erasmus's praise for the 'Apelles of black lines' raises the question: what would Dürer's prints look like in colour? Unlike Wolgemut, he did not employ a *briefmaler* to colour his prints by hand or stencil. Neither did he experiment with chiaroscuro woodcuts like Lucas Cranach the Elder, Hans Burgkmair or Hans Baldung Grien (see 92). Nevertheless, many of Dürer's woodcuts and engravings exist in coloured impressions. Sometimes this was done to mask weak late impressions of a print (see 131). In other cases careful hand-colouring transformed a prized yet inherently reproductive image into a unique object. In 1594 Domenicus Rottenhammer (active c.1594–1640?) of Augsburg beautifully illuminated an impression of *Saint Jerome in His Study* (124).[25] His delicate transparent washes do not obscure the printed lines. Rottenhammer, like Hans Mack (active c.1536–85) and Georg Mack the Elder (active c.1556–1601) of Nuremberg, catered to the intense demand for Dürer's art from collectors in the late sixteenth century.

124
Dürer and Domenicus Rottenhammer,
Saint Jerome in His Study, 1514 and 1594
Engraving with transparent washes and body-colours, highlighted with gold;
24.8 × 19.1 cm (9¼ × 7½ in)
Kunstsammlungen der Veste Coburg

Melencolia I (122), the third of the *Master Engravings*, remains a puzzle.[26] It is Dürer's only print inscribed with a title. The odd assemblage of figures and objects presumes an allegorical reading. Thereafter scholarly consensus evaporates, even though this is the single most written-about work in Dürer's *oeuvre*. In his *Elementa rhetoricae* (1541) Camerarius includes a lengthy discussion of the engraving as an example of *ekphrasis*, the ancient rhetorical practice of describing a work of art. It begins:

> Albrecht Dürer, the most accomplished artist, from whose divine Hand many immortal works still exist, represented in the following manner the emotions of a deep and thoughtful mind which are called Melancholic (they are justly attributed to those in whom the black bile, as the physicians call it, is superabundant): a woman is seated, her head inclined and this she supports with her hand, resting upon her elbow which she props up upon her knee; and her facial expression grave, as if in deep thought, she never looks up but, her eyelids lowered,

she contemplates the ground. Everything about her is in twilight. She has keys appended to her side. Her hair is rather neglected and straying. Next to her we can see instruments belonging to the *artes*, books, rulers, compasses, squares and, besides, tools of metal and several of wood. In order to show that such minds commonly grasp everything and how they are frequently carried away into absurdities, he reared up in front of her a ladder into the clouds, while the ascent by means of rungs is as it were impeded by a square block of stone.[27]

This textual summary, while vivid, is imperfect. The block does not prevent access to the ladder, and later he mistakenly identifies the magic square of numbers as a spider's web.

This account illustrates the problem of reception. Camerarius was Dürer's close friend and an astute student of his art. Other than labelling the woman as a melancholic and suggesting the ladder might permit one to be 'carried away into absurdities', he has little idea of, and even less concern for, the print's iconographic meaning. If Camerarius cannot offer a better reading of *Melencolia I*, is it reasonable to expect that a contemporary viewer in Antwerp or Bamberg or Venice would have more insight? What might someone not conversant with neo-platonic literature or other esoteric authors, who have been cited as possible iconographic sources, glean from this engraving? I suspect this, like the *Adam and Eve* (see 63), can be read on different levels. The print itself conveys a brooding figure under the influence of melancholy.

Based on the surrounding attributes, the woman is associated with Geometry and Astronomy, two of the seven liberal arts.[28] She idly holds a compass while a closed book rests in her lap. Keys and a purse hang from her waist. On one of his preparatory drawings Dürer notes that 'keys mean power, purse means wealth'.[29] If so, neither presently benefits the woman. A sphere, truncated rhombohedron, and woodworking tools are scattered on the

ground around her. The chaos contrasts vividly with Saint Jerome's orderly room. She sits inert with her head resting on her arm, a recognized pose of the melancholic.[30] Her gloom is signalled by the dark shadow covering her face. Dürer's monogram, located beneath her, is also shaded as though sharing her fate. Only the eyes indicate her mental alertness. She remains earthbound in spite of her wings. Her canine companion sleeps rather furtively; it lacks the tranquillity of Jerome's dog.

The text 'MELENCOLIA I' held by the bat conveys the nature of her paralysis. As Panofsky suggests, Heinrich Cornelius Agrippa von Nettesheim's *De occulta philosophia* (c.1510) influenced Dürer's interest in the bodily humours.[31] Pirckheimer probably brought this and other texts to his friend's attention. Artists are particularly susceptible to the effects of melancholy (modern depression), caused by a surplus of black bile. Agrippa describes three types of creative melancholy. The basest form, affecting artists, is operative here, as the inscription makes clear. The second type afflicts scholars, physicians and statesmen, who are governed by reason. The highest form debilitates theologians, who excel in intuitive thought. The woman wears a wreath of watercress and other moist plants to offset the dryness associated with melancholy and the influence of the planet Saturn. Some other details are also read as curatives. For instance, the magic square, whose numbers horizontally, vertically and diagonally add up to thirty-four, was a counterbalancing astrological talisman associated with Jupiter.

The engraving presents a broader allegory about artistic genius. Although skilled, the woman is paralysed by ideas that are just beyond her grasp, or by creative thoughts that she cannot translate into a work of art, or, perhaps, by some personal loss. Like Agrippa's lowest class of melancholics, she is restricted only by the heights of her imagination. Meanwhile time passes, as indicated by the hourglass, which appears in each of the three

Master Engravings. Given the scene's sombre mood, it is easy to overlook the small winged genius or putto on the central axis. The figure actively draws on a wax or slate tablet, the form of which is virtually the same as Dürer's monogrammed *cartellino* in *Saint Jerome in His Study*. The genius is framed by a millstone and scale, symbols of industry and balance. Perhaps Dürer included the diligent genius, the embodiment of labour, as the only true cure for the doubts that afflict all artists.

Panofsky and other scholars describe *Melencolia I* as a spiritual self-portrait of the artist.[32] This is an attractive and potentially correct idea; however, few contemporary viewers would have made this association. At best they might have understood this figure, surrounded by the attributes especially of Geometry, as an artist's melancholy. Melanchthon, who knew the artist well, later refers to 'Dürer's most noble melancholy'.[33] In about 1512–13 the artist drew an unusual *Self-Portrait* (125) in which, clad only in underwear, he points to his left side.[34] The inscription reads: 'There where the yellow spot is and the finger points, there it hurts me.' This pain map may refer to an actual illness of his spleen; however, Dürer was certainly aware of the artist/melancholic associations since the spleen was considered the bodily seat of melancholy.

Dürer conceived this print during a period of prodigious and certainly exhausting activity. His meditation on the link between artists and melancholy was fuelled by his intense theoretical studies. As he struggled to formulate the contents of his planned treatise on painting, there may have been times when he felt inadequate to, or paralysed by, the profundity of the task. The engraving, alas, invites speculation but yields few certain answers. I concur with Koerner's conclusion that the 'engraving's obscurity is partly the artist's intention. … Instead of mediating one meaning, *Melencolia* seems designed to generate multiple and contradictory readings, to clue its viewers to an endless exegetical labour until, exhausted in the end, they discover their own portrait

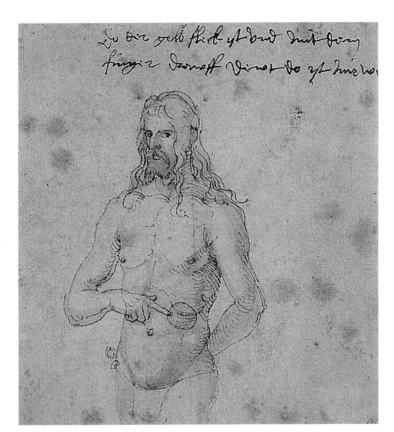

125
Self-Portrait,
c.1512–13
Pen and
ink with
watercolour;
11.8 × 10.8 cm
(4⅝ × 4¼ in)
Kunsthalle,
Bremen

in Dürer's sleepless, inactive personification of melancholy'.[35] It is
a conversation piece with its own rhetoric of self-exploration.

Does the gloomy mood of *Melencolia I* reflect Dürer's personal
situation, perhaps his own state of depression, in 1514? Scholars
tend to disassociate Dürer the private individual from Dürer the
public artist, even though his self-portraits, his self-consciously
placed monograms and other features present evidence to the
contrary. Mende, among others, links the upper right segment of the
engraving with the death of his mother.[36] Barbara Holper died on
16 May 1514. She had lived with her son since 1504. The numbers
in the top line of the magic square (16, 3, 2, 13) can be read as her
death date: 16 / 3 + 2 = 5 (May) / 1 + 3 = 4 (therefore 1514). The
hourglass and the death bell had appeared a year earlier in *Knight,
Death and the Devil*. This suggestion remains quite speculative.

On 19 March 1514 Dürer made an unflinching charcoal sketch of his mother (126).[37] The elderly are often shown in art as decrepit or morally impaired.[38] Dürer, however, tenderly portrayed the ravages of age. Barbara was old by the standards of the time. The skin is taut over her sunken cheeks and almost emaciated-looking neck. Rows of wrinkles crease her forehead. A prominent vein protrudes at her left temple. Barbara's long nose almost overhangs her upper lip. The mouth is rather hard and slightly pulled down. Her eyeballs bulge forwards while the surrounding sockets recede. She looks weary and ill. The portrait's apparent accuracy has inspired a medical diagnosis.[39] Barbara, who had borne eighteen children, had once had a very vigorous constitution. Based on the lack of fatty deposits on the neck and cheeks and the loss of muscle, Pirsig speculates that she suffered from a cancerous stomach tumour. This ailment has caused her cachexia, the general wasting of her body, as well as the loss of her front teeth especially on the upper jaw. He is uncertain about the protruding eyeballs.

When Dürer finished the drawing, he added the date and Barbara's age as sixty-three. A second inscription confirms her death less than two months later. This practice of documentation appears too on his perceptive portrait of Michael Wolgemut (see 13) painted in 1516 and inscribed again following his death in 1519.[40] In the surviving fragment from his *Gedenkbuch* Dürer penned a lengthy description of his mother and her death.[41] A year earlier, on 26 April 1513, Barbara was so weak that they had to break into her room and carry her downstairs. She received the sacraments and absolution but, to the artist's surprise, Barbara did not die. The artist remarks that her health had been poor since his father's death in 1502. When Dürer drew her portrait, Barbara's health had been extremely fragile for almost a year. On 16 May 1514, she again received the last rites and told her son to keep himself from sin. He observes: 'She feared death very much, but she said that she was not afraid to come before God. Also she died hard, and I noticed that she saw something frightening; for she asked

126
Barbara Holper (Dürer's Mother), 1514
Charcoal;
42.2 × 30.6 cm
(16⅝ × 12 in)
Kupferstich-
kabinett, Berlin

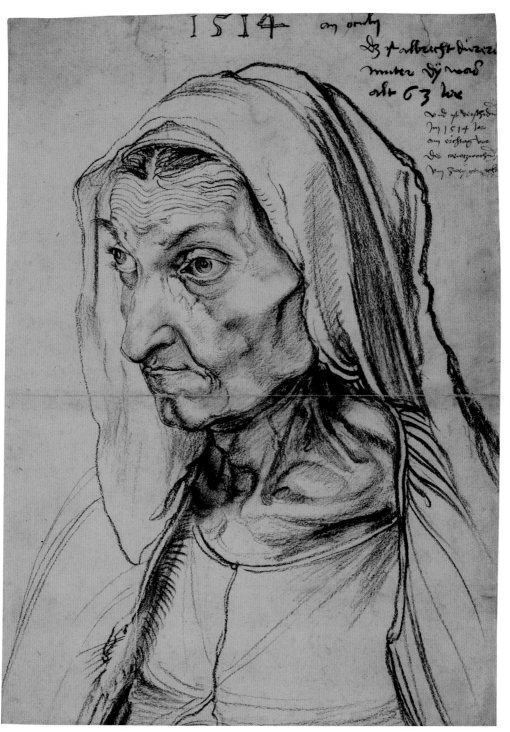

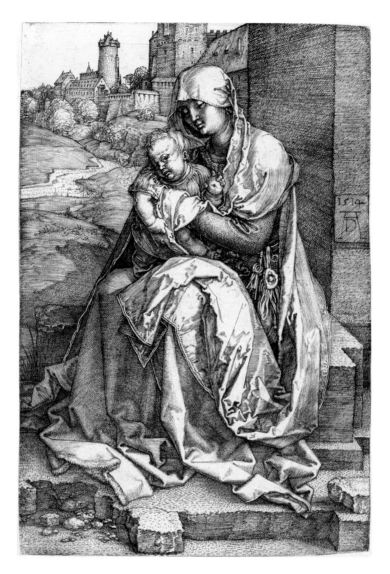

127
*Virgin and
Child Seated by
the Wall,* 1514
Engraving;
14.7 × 10.1 cm
(5¼ × 4 in)

128
*Sudarium
Held by an
Angel,* 1516
Etching;
18.6 × 13.6 cm
(7⅛ × 5⅛ in)

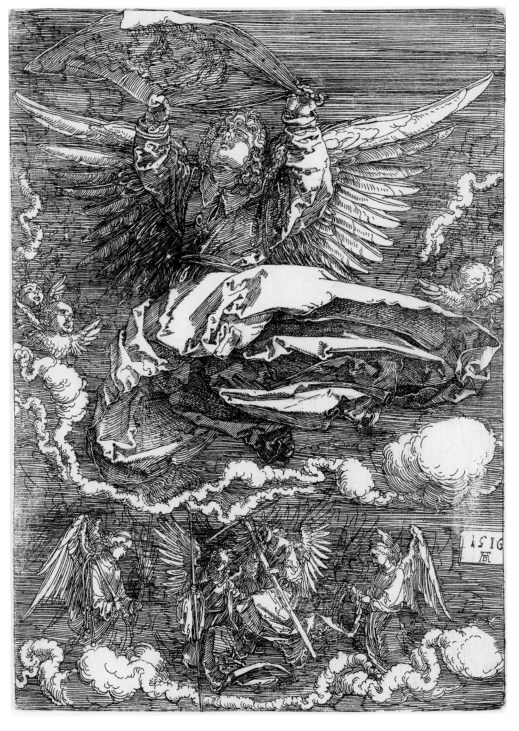

for the holy water and then said nothing for a long time. Then her eyes closed. I saw, too, how Death gave her two great strokes to the heart, and how she closed her mouth and eyes and departed in pain. … And in her death she looked more lovely [or sweet] than in life.'

Did Barbara's sickness and death inspire the *Virgin and Child Seated by the Wall* (127), one of Dürer's most poignant

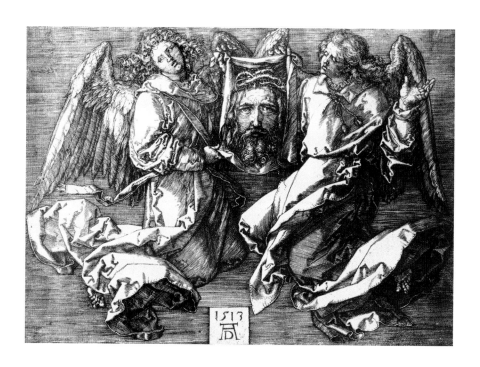

Madonnas?[42] Mary gently embraces her infant son. As the new Adam, Christ holds an apple while glancing at the viewer. Otherwise, the artist included no other discernible markings of their divinity. Mary's seated pose recalls that of the melancholic woman, although her quiet industry contrasts with the latter's inaction. The keys and purse, secured tightly to Mary's belt, allude to her domestic responsibilities. Dürer's fine treatment of the drapery, including the crisp folds and vividly accented highlights, is almost identical in the two engravings.

Mary looks like a Nuremberg *hausfrau*. Indeed, she is seated within the walls of the town. As first recognized in 1928, the cityscape behind is a reversed view of the vista of the castle precinct looking north from the third upper floor of Dürer's house.[43] This just happens to be the location of Barbara's bedroom. The castle's Romanesque double chapel, the so-called Heathen's Tower, is immediately above Mary's head and, from right to left, the city's Sinwell Tower, the Five-Cornered Tower,

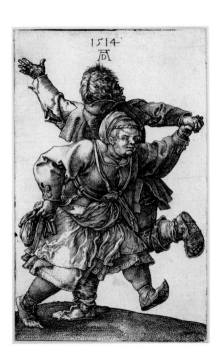

the Kaiserstallung or civic granary built in 1494–5 and the Luginsland.[44] The land beneath the castle was then slightly more open and verdant; however, Dürer intentionally omitted all of the buildings between his house and the summit. The specificity of the view, the maternal nature of the theme and his comments about Barbara's piety support the suggestion that this print honours his mother's memory. Notice, too, how the date and his monogram are shaded, as though in mourning.

Between 1515 and 1518 Dürer experimented with etching.[45] The technique, adapted from armour-makers, involves covering the surface of a metal plate, usually iron, with an acid-resistant ground. The artist draws an etching needle through the ground to expose the surface of the plate. Unlike engraving or drypoint, the needle does not cut the metal. The plate is placed in a mild acid bath. The acid bites into the metal wherever it is exposed, and thus creates grooves in the plate. The remaining ground is then removed, and the plate is inked and printed like an engraved plate.

In the *Sudarium Held by an Angel* (128) Dürer exploited the expressive character of etching to create one of his most emotionally charged prints.[46] The Sudarium is normally clasped by Saint Veronica (see 18, 111). In 1513 Dürer devised a more iconic composition (129) in which the two hovering angels sadly unfurl the holy relic.[47] Christ's tormented face stares at the viewer. The print, with its symmetric angels and tightly controlled engraved lines, invites quiet personal reflection. Dürer's conception three years later is altogether different. Now the viewer looks up sharply at the angel. Its twisted pose, the explosive sideways movement of drapery and the stark lighting contrasts create a palpable tension. One struggles to glimpse the Sudarium. With the illumination coming from above, the miraculous portrait is deeply shaded. Only the bent upper corner of the cloth is brightly lit. The top edge seems to project out from the print since the artist placed it just above the last horizontal stroke demarcating the sky. One must rotate the print to see Christ's face clearly. The rough, uneven etched lines contrast vividly with the discipline of the engraved lines. In the latter the sky is defined by closely spaced parallel marks; the swelling and tapering burin lines add a modicum of texture, whereas his etched horizontals are irregular and sometimes even intersect. Their often muddied legibility is intentionally complicated by a host of faint strokes that form wisps of clouds or the barest outlines of other angels receding into the darkened sky. Like the relic, the whole composition is initially

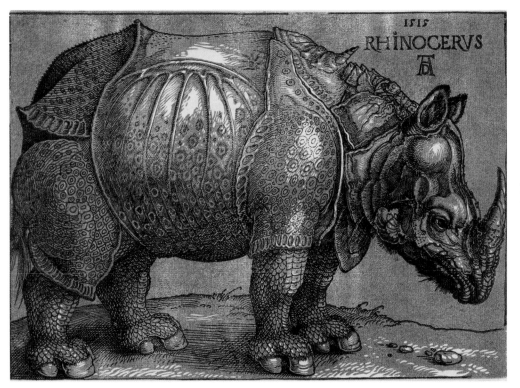

131
Rhinoceros,
1515
Chiaroscuro
woodcut with a
blue-grey tone
block printed
after 1620
by Willem
Janssen;
21.3 × 29.8 cm
(8⅛ × 11¼ in)
British
Museum,
London

hard to read. Even Dürer's curling monogram threatens to blow away, while in the engraving it has the same fixed permanence as Christ's image. In spite of the technique's potential and its draughtsman-like quality, the artist made only six etchings as he felt greater affinity for, and perhaps more in control of, engravings and woodcuts.

During this period Dürer created a few genre engravings, such as *Dancing Peasants* (130).[48] It would be a mistake, however, to dismiss this pair of stocky and rather crude figures too quickly, especially given the technical sophistication of the print. Typically, peasants are parodied as bumpkins and socially inferior to educated, print-buying urbanites.[49] Dürer's figures play to these stereotypes. The man's clothing is torn, and one boot is worn through. His leaping dance step and open mouth, as though singing, certainly lack the decorum of the patrician dances held in the Great Hall of Nuremberg's Rathaus (see 143). The man's uninhibitedness contrasts with the woman's calculated stare. She carefully clutches her purse, keys and knife. Her control of the purse may explain why her clothes are better than his. The print allows viewers to supply their own narrative or commentary. Looking carefully, one notices the peasants' co-ordinated movements are quite complex as they dance in a circle. As Mende observes, the proposed contents for Dürer's 'Speis der Malerknaben' includes a chapter on movement. Once the pupil learns human proportions, he next studies 'how one should make them bend' (*wy man dy selben pigen mus*).[50] In the engraving Dürer used the joints of the ankles, knees, hips, arms and hands to express movement. The motion is further highlighted by the composition's tight framing on three sides. Their energy seems to ricochet from left to right to left. Only the artist's monogram halts this action.

Dürer's inherent fascination with the exotic or the abnormal is expressed in such works as the *Monstrous Sow of Landser*

engraving of 1496, depicting a deformed creature born with a
single head and two bodies, or the painted *Bearded Child* of 1527,
today in Paris (Musée du Louvre).[51] By far the most famous and
most widely reproduced of these was the *Rhinoceros* woodcut
(131).[52] On 20 April 1515 an Indian rhinoceros arrived in Lisbon
from Goa as a present to Manuel I, king of Portugal, from Sultan
Muzafar II, ruler of Gujarat. Fascinated by the strange beast,
the king arranged for it to fight an elephant, which fled in panic.
Valentin Ferdinand, a Moravian printer living in Lisbon, sent a
report along with a drawing of the rhinoceros to Augsburg and
Nuremberg. To modern audiences familiar with rhinoceroses,
although not the now extinct Indian species, Dürer's preparatory
drawing and woodcut look comical. The hide is rendered as discrete
plates reminiscent of armour. An odd spiral dorsal horn sprouts
behind the head. The splotchy scale pattern may be the result
of a fungus acquired during the long sea voyage. This strange
creature attracted the attention of many, for Hans Burgkmair of
Augsburg also prepared a woodcut, which exists only in a unique
impression in Vienna (Albertina).[53] Dürer's fanciful version,
rather than Burgkmair's more accurate representation, captivated
the public imagination. The detailed text recounts some of the
rhinoceros's story, although not the beast's demise. The king sent
the rhinoceros to Pope Leo X. After stopping *en route* in Marseille,
the boat carrying it sank, and the animal drowned.

Dürer's woodblock was repeatedly printed after his death. When it
was acquired after 1620 by Willem Janssen, the block was severely
degraded from at least six separate earlier editions. To help mask its
chipped edges, the long horizontal crack running through the legs
and woodworm holes, Janssen added a coloured tone block. Besides
the blue-grey colour seen here, other impressions were printed in
olive-green and dark green. Such effort to prolong the life of this
woodcut typifies the strong demand for and profitability of Dürer's
prints long after 1528.

> This is Emperor Maximilian, whom I, Albrecht Dürer,
> portrayed way up high in his small chamber in the tower
> at Augsburg on Monday after the feast day of Saint John
> the Baptist in the year 1518.

The title of this chapter – 'Graphic Ambitions' – applies to patron
and artist. The emperor, Maximilian I, was the first Renaissance
prince to recognize the power of the print for communicating
personal conceits and imperial propaganda. Never one to eschew
attention, Dürer enjoyed the celebrity of working for the emperor.
The humanist-inspired projects offered him unique opportunities
to display his inventiveness.

132
*Maximilian I,
1518*
Drawing, black
chalk, coloured
chalks for
flesh tones,
heightened
with white;
38.1 × 31.9 cm
(15 × 12½ in)
Albertina,
Vienna

As he documents in the inscription above, Dürer sketched
Maximilian's portrait (132) during a private meeting on 28
June 1518.[1] Both men were in Augsburg for what would be the
emperor's last imperial diet. The only surprising thing about
this portrait sitting was that it had taken so long to take place.
Dürer started working for Maximilian in 1512 at the latest.
During the intervening years the artist depicted him often,
although the likenesses were based on supplied models. In
Augsburg, Maximilian granted Dürer a formal sitting. The artist
worked quickly, using chalk to block out the shoulders and the
salient contours of the head. Features such as the emperor's
robe, collar and beret are summarily defined. A strong wavy
vertical line, subsequently reinforced, starts at the hat level just
above Maximilian's right eye and extends down to the chin,
establishing the head's position. Dürer has already accounted for
the projecting tip of the emperor's prominent nose. Gradually he
added the more subtle features, such as the wrinkles around the
left eye, slight puffiness of his lower lip and sagging left cheek.

133
Charlemagne,
1510–13
Tempera
and oil on
lindenwood;
190 × 89 cm
(74¼ × 35 in);
with frame:
215 × 115 cm
(84⅝ × 45¼ in)
Germanisches
National-
museum,
Nuremberg

Dürer diplomatically downplayed the famous Habsburg receding chin. After the sitting the artist added coloured chalk and white highlights. He prepared a separate study of Maximilian's clothing.

Although many portraits of Maximilian exist, especially by Bernhard Strigel (1460–1528), his court painter, Dürer's drawing largely defines posterity's image of the emperor.[2] It served as the model for at least two paintings and a woodcut. When they met in Augsburg, Maximilian was ailing; he died six months later. The resulting drawing is deeply sympathetic in contrast with the artist's typical matter-of-fact portrait style (see 150). Dürer's emperor is introspective, with a hint of weariness. Still the strong upright pose and distant gaze convey a regal dignity, traits that Maximilian cultivated.

134
Sigismund,
1510–13
Tempera
and oil on
lindenwood;
189 × 90 cm
(74⅜ × 35⅜
in); with frame:
215 × 115 cm
(84⅝ × 45¼ in)
Germanisches
National-
museum,
Nuremberg

This drawing, unintentionally, proved symbolic of the artist's
relationship with the emperor. Most of Maximilian's ambitious
projects were unfinished when he died on 12 January 1519.
Regardless of whether Dürer's drawing was originally intended
as the basis for a painted and/or printed portrait, neither was
completed until later in 1519. Maximilian's death left Dürer
unpaid and forced to adapt the drawing to new artistic ends.

Before his engagement by Maximilian, Dürer had painted two
older emperors: Charlemagne (r. 800–14; 133) and Sigismund (r.
1410–37; 134).[3] The Nuremberg city council commissioned these
two panels as doors for a cabinet or a wall niche in the treasury
room (*heiltumskammer*) of the Schopperhaus on the Hauptmarkt.
Annually on the second Friday after Easter, the town celebrated its

Feast of the Holy Lance, or *Heiltumsfest*, in the market.[4] During the accompanying two-week fair Dürer's wife and mother sold his prints perhaps from a rented stall. Charlemagne was celebrated as the first Holy Roman emperor and as a saint. Sigismund was honoured because in 1423 he designated Nuremberg as permanent custodian of the imperial relics and regalia.[5] The objects were transferred a year later from Bohemia, which at that time was racked by the Hussite upheavals, to Nuremberg. On the night before Nuremberg's feast the items were placed in this cabinet. The rest of the year the relics and regalia were housed in a silver chest that was encased in iron and suspended from the vaults of the Heilig-Geist-Kirche. On the feast day the relics and regalia were displayed by the city councillors and important clergy from a temporary but sturdy three-storey wooden display tower (the *Heiltumsstuhl*) erected before the Schopperhaus. Following the ceremony the objects were returned to the Heilig-Geist-Kirche, and the storage cabinet sat empty for another year.

City officials ordered the paintings in 1510 to replace another set made in 1430. Dürer received a payment of 85 florins, signalling completion, on 13 February 1513. The panels are two-sided. The exteriors, visible when the cabinet was closed, exhibit the emperors' coats of arms and identifying inscriptions against a black backdrop. Inside Sigismund, based on a supplied model, wears a crown patterned on the private or house crown used by Friedrich III, Maximilian's father. Lacking a true portrait of Charlemagne, Dürer envisioned him as a dignified, old, yet physically imposing man akin to God the Father in the *Landauer Altarpiece* (see 102). He accurately replicated Charlemagne's crown, sword, orb and gloves, which are today in Vienna.[6] On one preparatory drawing Dürer writes, 'This is Charlemagne's sword in actual size and the blade is as long as the string that is tied to the paper.'[7] In reality the regalia post-date this sainted emperor's reign. The sword was made in Palermo for Emperor Friedrich II (r. 1215–50), while the knob was added by Emperor Charles IV (r. 1347–78). The beautiful

crown belonged to Emperor Otto I the Great (r. 962–73) or, more probably, Otto II (r. 973–83), with its cross added by Heinrich II (r. 1002–24) and the jewelled arch appended by Konrad II (r. 1024–39). The golden orb, set with precious stones and pearls, was created in Cologne around 1200.

Dürer's professional relationship with Maximilian began when the emperor visited Nuremberg in February 1512. Over the next seven years the artist worked on his *Triumphal Arch*, the *Triumphal Procession, Prayer Book*, tomb and portraits, among other projects. In July 1515 Dürer wrote to Christoph Kress, Nuremberg's ambassador at Maximilian's court, complaining that he had served the emperor for three years but had never been paid.[8] Kress's efforts soon proved successful, since on 6 September Maximilian awarded Dürer a lifetime annuity of 100 Rhenish guilders, a significant sum, to be paid by Nuremberg's government from the funds it owed the emperor. This may be compared with the contracted payment of 130 guilders for the *Heller Altarpiece* (see 96).

Maximilian's intimate involvement in the form and content of his projects caused frequent delays.[9] As exemplified by the *Triumphal Arch of Emperor Maximilian I* (*Die Ehrenpforte* or *Gate of Honour*; 135), most required the collaboration of scholars and artists.[10] Maximilian was often without funds but never without ambition. As emperor, he admired Roman triumphal arches, which he knew only through literary descriptions and Classical coins. Instead of erecting his own in stone, he dreamed of a monumental printed arch, one that could be published in multiple impressions and displayed throughout the Holy Roman Empire. The court historian Johann Stabius and the court painter Jörg Kölderer (active 1512–40), who worked in Innsbruck, teamed up with Dürer. Coats of arms, indicating joint authorship, appear at the lower right corner of the arch. Since his and Kölderer's drawings do not survive, Dürer's role in shaping the arch's final appearance is unknown. Dürer devised much of the arch's artistic content

and ornament, although how many of the arch's woodblocks he personally designed is uncertain. The historical scenes recounting episodes from the emperor's life are attributed to Dürer's former pupil Hans Springinklee (c.1490/5–after 1525) and Wolf Traut, while Albrecht Altdorfer authored those of Maximilian's private life on the outermost towers. The printed date of 1515 merely indicates the end of the design stage, since the Nuremberg *formschneider* Hieronymus Andreae and his assistants finished the cutting and printing of the blocks only in 1517, when a proof edition was published. In January and February 1518, 700 impressions were delivered to Maximilian.[11] The emperor was obviously delighted with the results since later that year, on 8 September, he wrote to the Nuremberg council authorizing a payment of 200 guilders to Dürer for this and other projects.[12]

The medium and complexity of the *Triumphal Arch* were unprecedented. It consists of 192 woodcuts printed on thirty-six sheets, which when glued together measure 357 by 295 cm (140 × 116 in). It was at the time the largest print ever made.[13] The project's audacity was matched by Maximilian's expectations that nobles and communities who received the *Triumphal Arch* would mount and exhibit it. Much in the spirit of modern political advertising, the set offers a flattering biographical and allegorical 'portrait' of Maximilian to subjects and adversaries alike. Here he is the perfect prince, regardless of the actual facts of the emperor's life. Stabius's text under the central dome reads in part: 'This Arch of Honour with its several portals is erected in praise of the most serene, all-powerful prince and sovereign Maximilian, elected Roman emperor and head of Christendom … in memory of his honourable reign, his gentility, generosity and triumphal conquests.'[14] The left and right arches, the portals of Praise and Nobility, illustrate events from Maximilian's life. These are flanked by busts of emperors, kings and ancestors. In the central portal of Honour and Might the winged Lady Honour bears a crown of glory for the emperor, who, alone, would symbolically pass

135
Dürer and other artists, *Triumphal Arch of Emperor Maximilian I*, 1512–17/18 (1559 Vienna edition) Woodcut printed on 36 sheets from 192 blocks and hand-coloured by a later artist; 341 × 292 cm (134¼ × 115 in) Kupferstich-kabinett, Berlin

through the arch. The central tower is adorned with a genealogical tree culminating in the enthroned Maximilian and flanking coats of arms. In short, the *Triumphal Arch*, like so many of the emperor's projects, glorifies Maximilian's life, his real and mythic ancestry and his heraldry.

Dürer designed the central dome.[15] The inscription by Stabius is flanked by trumpeters and heralds of the Holy Roman Empire (left) and Habsburg-Austria (right). Above, paired nude female torch bearers, column lamps, satyrs, griffons and tambourine-playing cupids surround Maximilian. The depiction of Maximilian derives from Pirckheimer's Latin translation of the *Hieroglypica*. This Greek text, written in the fifth century AD by Horapollo of Alexandria, was rediscovered in 1419 and first published in 1505. The copy that Pirckheimer presented to the emperor in 1514 includes seventy drawings after Dürer's originals.[16] Maximilian was intrigued by this manuscript, which he and others believed held a key to understanding ancient Egyptian hieroglyphs or picture writing. The book's emblematic language appealed to the emperor's fascination with symbols of all sorts. This crowning image of Maximilian on the arch, referred to as the Mystery (*Misterium*), is based on Dürer's drawing for the frontispiece of Pirckheimer's manuscript.[17] He is shown seated on and surrounded by numerous creatures. According to Stabius's explanation, written beneath the arch,

> Maximilian is a prince [dog draped with a stole] of great piety [star on the emperor's crown], most magnanimous, powerful and courageous [lion], ennobled by imperishable and eternal fame [basilisk on the emperor's crown], descending from ancient lineage [the sheaf of papyrus on which he is seated], Roman emperor [eagle …] endowed with all the gifts of nature and possessed of art and learning [dew descending from the sky] and master of a great part of the terrestrial glove [snake encircling the sceptre] – has with warlike virtue and great discretion [bull] won a shining

victory [falcon on the orb] over the mighty king here
indicated [cock on a serpent, meaning the king of France],
and thereby watchfully protected himself [crane raising
its foot] from the stratagems of said enemy, which has
been deemed impossible [feet walking through water by
themselves] by all mankind.[18]

Without the accompanying key the meaning of this and other
allegorical sections of the arch would be too esoteric even for well-
educated contemporary viewers. The arch's ornamental language
mixes ancient and Renaissance elements into a pseudo-Classical
style that was especially popular in Rome and northern Italy
around 1500.[19] This was the only one of Maximilian's colossal
woodcut projects to be completed before his death.

In 1515 Dürer contributed forty-five pages of exquisitely original
pen drawings to the *Prayer Book of Emperor Maximilian I*.[20] For
once, the artist had the freedom to be whimsically creative. The
Prayer Book was conceived as a devotional text for members
of the Order of Saint George, a chivalric group founded by
Maximilian's father in 1467. Maximilian renewed the order in
1494 and established a lay brotherhood based in the Georgskapelle
in his castle in Wiener Neustadt. In Augsburg the noted humanist
Konrad Peutinger co-ordinated the book project and worked with
Hans Schönsperger the Elder, who in 1508 was named the court
printer. Their intention was to create a deluxe printed book, the
specially designed Fraktur type of which would rival a handwritten
manuscript. Eight of the ten known luxury trial editions printed on
parchment between late 1513 and early 1514 survive. The unbound
folios of one copy were then sent first to Dürer, who defined the
basic character of the illustrations, and then to Cranach, Baldung,
Burgkmair, Jörg Breu the Elder (c.1475/80–1537), Altdorfer and an
anonymous artist perhaps in the latter's workshop. These coloured
pen drawings were apparently intended as models for woodcuts for
a definitive published edition. Unfortunately, Maximilian's death
halted the project.

Dürer's *Annunciation* (137), opening the Hours of the Virgin, emulates manuscript marginalia.[21] He filled the borders with drolleries and calligraphic caprices. Naturalistic birds squawking at an owl are paired, on the left, with grotesques. Dürer delighted in line-play. As seen on the left, some strokes reflect the sheer joy of moving the pen across the margin. Seemingly random marks are suddenly repeated in reverse, a bisymmetry yielding a pleasing linear pattern or pairs of rabbits and masks.[22] He challenged viewers to determine where his pen started and stopped. Following the artist's hand becomes an enjoyable end in itself. One is aware of Dürer's creative presence even in a simple line. God, wearing a crown akin to Emperor Sigismund's (see 134), blesses the humble Mary below. Simultaneously, fire and brimstone rain down on the angry and once proud devil. The inclusion of the devil and a fantastic fish opposite refer to part of the accompanying text from Psalm 95:4–6: 'In his hand are the depths of the earth; the heights

136
Annunciation,
1515
Pen and ink
drawing in the
Prayer Book
of Emperor
Maximilian I;
page:
28 × 19.5 cm
(11 × 7⅝ in)
Bayerische
Staatsbiblio-
thek, Munich,
L. impr.
Membr.
64, folio
35 verso

137
Annunciation,
1515
Pen and ink
drawing in the
Prayer Book
of Emperor
Maximilian I;
page:
28 × 19.5 cm
(11 × 7⅝ in)
Bayerische
Staatsbiblio-
thek, Munich,
L. impr.

138
Brazilian
Indian, 1515
Pen and ink
drawing in the
Prayer Book
of Emperor
Maximilian I;
page:
28 × 19.5 cm
(11 × 7⅝ in)
Bayerische
Staatsbiblio-
thek, Munich,
L. impr.
Membr.
64, folio 41
Membr. 64,
folio 36

of the mountains are his also. The sea is his, for he made it, and the
dry land, which his hands have formed. O come, let us worship and
bow down, let us kneel before the Lord our Maker!' Meanwhile,
two putti play on the potted tree at right. Other folios illustrate
the expected, such as images of Christ, Mary and saints, as well as
the unexpected, including a Turk leading a camel, monkeys, a wily
fox, dancing and drunk peasants, fighting scenes, a doctor holding a
urine sample, a satyr and Hercules (twice).

Dürer represented a Brazilian Indian (138).[23] (The identification
is based on the clothing and weapon rather than upon the man's
Moorish appearance.) The Portuguese fleet of Pedro Alvares Cabral
discovered Brazil in 1500. The sailors traded with the Tupinamba
Indians for bows, headdresses and other items. Drawings of these
objects circulated in south Germany around 1505. His Indian
holds a wooden war club decorated with feathers bound by a

cotton net. The man wears a necklace, bracelets and cap of feathers. Since his source showed each object separately, Dürer mistakenly transformed the warrior's cape into a skirt and his club into a lance. The origin of the spoon or ladle is unknown. The relevance of the Indian on this folio can be explained as Dürer's response to Psalm 94:1: 'The earth is the Lord's and all that is in it, the world, and those who live in it.' He represents the people of the newly found Americas.

In 1515 Dürer drew a standing warrior clad in rather fanciful armour (139).[24] The sheet is inscribed 'Ottoprecht fürscht' (Prince Ottoprecht) plus several colour notations, such as yellow for the dragon shield. Ottoprecht (Ottobert), son of a Burgundian–Merovingian king and considered the first Habsburg, was a preliminary model for one of the over-life-size, free-standing bronze and brass statues that eventually surrounded Maximilian's

139
Prince Ottoprecht ('Ottoprecht fürscht'), 1515
Pen and brown ink drawing; 25.2 × 15.6 cm (9⅞ × 6⅛ in) Kupferstich-kabinett, Berlin

140
Peter Vischer the Elder (workshop) after Dürer's design, *King Arthur, Tomb of Maximilian I,* 1513 Cast in brass; height: 211.5 cm (83¼ in) Hofkirche, Innsbruck

cenotaph in Innsbruck's later Hofkirche.[25] As early as 1502, the emperor initiated plans for his monumental tomb. When he died, only ten of the original forty proposed ancestral statues were completed. If Ottoprecht was in this initial group, he was dropped when the size of the entourage shrank to twenty-eight. Dürer designed at least three other statues. His now lost sketches for King Arthur of England (140) and Theodoric, king of the Ostrogoths (d. 526), must have been created in about 1512.[26] Arthur, one of Maximilian's mythic ancestors, is the most elegant of all. Like the other males, he is clad in armour and supports his armorial shield. Unlike the others, who tend to be rather squat and massive, Arthur appears elongated, and Dürer has endowed him with a relaxed, regal bearing. Both Arthur and Theodoric were cast in 1513 by the Vischer family workshop of Nuremberg, the empire's best brass-smiths, rather than in the imperial foundry in Innsbruck. The finesse of the details of the armour and the more lifelike face testify to their skills.

Juggling the different imperial projects challenged the emperor and his artists. The *Triumphal Arch* was originally to be paired with an *Arch of Devotion* (*Die Andachtspforte*), never executed, and a 54–metre long *Triumphal Procession*. In 1512 Maximilian dictated the programme for the procession to Marx Treitzsaurwein, his secretary, and the artistic lead was given to Hans Burgkmair in Augsburg. He and his collaborators completed most of the woodcut cycle between 1516 and 1518. It remained unfinished in 1519 and was only first published in a run of 200 copies in 1526 for Archduke Ferdinand, whose interest in it was that of a family member as well as that of a connoisseur. Dürer's contribution was to be the final scene. His drawing, made in about 1512, shows Maximilian and his family in a luxurious horse-drawn wagon.[27] This was reduced in the final version to two woodcuts (sheets 135 and 136), known as the *Small Chariot*, depicting a chariot commemorating Maximilian's marriage to Mary, duchess of Burgundy (r. 1477–82).[28]

The emperor and Dürer's ideas about the image continued to evolve. In 1518 the artist prepared an exquisite drawing for a much more elaborate chariot (141).[29] Ratio (Reason) drives a massive vehicle now drawn by six pairs of horses, each led by two virtues. While his family is placed before him, Maximilian sits alone in glory beneath a golden canopy inscribed: 'That which the sun is in the heavens, the emperor is on earth.' The elaborate programme, devised by Pirckheimer, includes twenty-two separate laurel-wreath-bearing female virtues. Everything from the reins with which Ratio leads the horses (Power and Nobility) to the four wheels of the chariot (Dignity, Honour, Magnificence and Imperial Glory) is labelled with traits that Maximilian, in his person and through his office, embodied. Emblematic animals, akin to those at the apex of the *Triumphal Arch*, adorn the chariot. Dürer proved adept at devising a quasi-antique and highly decorative visual language that suited the emperor's taste.

With Maximilian's death in early 1519, Dürer temporarily halted work on the chariot. It ultimately appeared in two quite different forms. In 1522 the artist completed and published the *Large Triumphal Chariot of Maximilian I* (142), consisting of eight woodblocks cut by Hieronymus Andreae.[30] The twelve horses and their accompanying virtues are virtually identical to those in the 1518 drawing. Dürer, however, altered the form of the chariot and deleted the emperor's family. Maximilian alone is glorified as the embodiment of the virtuous 'true image of the prince'. Dürer lopped off the front half of the chariot, repositioned Ratio and emphasized the canopy's blazing sun and the imperial eagle. Pirckheimer's texts located above each pair of horses were initially in German; a Latin edition appeared in 1523. In the drawing and print Maximilian wears Charlemagne's crown and wields Sigismund's sceptre (see 134).

On 11 August 1521 Nuremberg's city council asked Dürer, who had just returned from the Netherlands, to prepare with

141
*Triumphal
Chariot of
Maximilian I,*
1518
Pen and ink
with green,
yellow
and violet
watercolour;
45.5 × 250.8 cm
(17⅞ × 98¼ in)
Albertina,
Vienna

142
*Large Triumphal
Chariot of
Maximilian I,*
1518/22
Woodcut,
blocks cut by
Hieronymus
Andreae;
45 × 228.1 cm
(17¼ × 89¼ in)

143
Lorenz Hess,
Interior of the
Great Hall of
the Nuremberg
Rathaus, 1629
Oil on
pinewood
panel;
91.6 × 74 cm
(36 × 29¹⁄₈ in)
Germanisches
National-
museum,
Nuremberg
(on loan to the
Stadtmuseum
Fembohaus)

Pirckheimer a programme for redecorating the Great Hall of the
Rathaus.[31] The fourteenth-century chamber (143), measuring 40
metres long and 14 metres high, was then the largest civic room in
Germany.[32] The resulting plan alluded to the chamber's multiple
functions. The western end served as a law court, so the adjoining
portion of the north wall was painted with the *Calumny of Apelles*,
a warning against bearing false witness and perverting justice.[33]
Next to this, seven civic musicians were painted performing on
a balcony that mimics the actual adjoining *pfeiferstuhl*.[34] They
played for the patrician dances, the highlight of the local social
season, which took place here. For the walls between the windows
on the south side Dürer's initial sketch depicted the Power of
Women, using the stories of David seeing Bathsheba at her bath,
Delilah cutting Samson's hair and Phyllis riding Aristotle as a
playful warning.[35] Perhaps this was considered indecorous, since
the walls were ultimately covered with the Justice of Trajan and
other episodes of ancient Roman virtue.[36]

The Great Hall hosted many imperial meetings. As stipulated in the Golden Bull of 1356, each newly elected Holy Roman emperor had to hold his first diet in Nuremberg. Since the later fourteenth century an imperial throne had stood in the eastern end of this chamber. Crowning the hall's programme along the eastern half of the north wall, Dürer replicated his *Large Triumphal Chariot*. Had Maximilian still been alive, he would surely have appreciated the monumental scale of this mural painting. While honouring Nuremberg's warm relations with Maximilian, the cycle presents an image of the ideal ruler to all future emperors. The council's decision to renovate the hall was made in the aftermath of the decision by the newly crowned Charles V (r. 1519/20–56) to hold his first diet in Worms rather than Nuremberg. The threat of plague in Nuremberg was given as justification, although the city's growing support for Martin Luther may have been a factor. An assembly was held in the Great Hall in 1522 but without the emperor, who first visited Nuremberg only in 1541.[37]

Dürer designed the Great Hall's decorations, but these were painted by his associates Georg Pencz, Hans Springinklee and perhaps Hans von Kulmbach in late 1521 and early 1522. In the case of the *Large Triumphal Chariot,* Dürer must have supplied the painters with a detailed drawing similar to the definitive image used for the 1522 woodcuts. Lorenz Hess's view, seen here, shows the room following the renovations of 1613, which included the repainting of the earlier murals. In December 1521 the council asked Dürer for an accounting of his costs, and in March he was paid 100 guilders.

The artist's sketch from 1518 of Maximilian (see 132) served as the cartoon for at least three posthumous portraits. When examined in raking light, the drawing reveals incised lines tracing all of the contours and salient features.[38] He transferred its design, probably by means of inserting a carbon-coated sheet of paper between the sketch and the surfaces of two paintings and one

woodblock. The facial measurements are identical in all cases. The first of these is the unsigned tempera painting on canvas today in Nuremberg (Germanisches Nationalmuseum), which may have been a *modello*.[39] Far more impressive is the oil painting (144) in Vienna.[40] Dürer expanded the core composition to include Maximilian's arms, resting on an unseen ledge. One arm holds the orb-like pomegranate, his personal symbol that had several meanings, including substance over appearance. Although a rather unimpressive fruit on the exterior, the pomegranate is abundant and nourishing on the inside. The pose recalls Dürer's *Self-Portrait* of 1493 (see 21). The emperor wears a beautiful robe of red silk trimmed in fur and a black velvet beret adorned with a golden Virgin and Child medallion. His hair is much greyer than in the drawing. Dürer further accented the sagging flesh of the chin and cheek. The artist created a humanized state portrait, one that nicely balances Maximilian's inherent dignity as a person and his imperial nobility. The lengthy Latin inscription and crowned coat of arms, coupled with its exquisite execution, suggest this was an official portrait, possibly made as a gift for Charles V or another member of the Habsburgs. Unfortunately, nothing is known about its provenance before its listing in the Viennese imperial collection in 1783.

In the *Journal* of his trip to the Netherlands in 1520–1 Dürer twice mentions a third, now lost, painted portrait of Maximilian. On 6 June 1521, during a visit to Mechelen, Dürer offered the picture to Margaret of Austria, Maximilian's daughter and regent of the Low Countries.[41] He notes that he 'would have presented it to her, but she so disliked it that I took it away with me'. This, like most of his interactions with Margaret, disappointed the artist. He eventually swapped the portrait for a white English cloth.

The drawing made in Augsburg is closest to Dürer's large woodcut of Maximilian (145) with its bust format and pomegranate-pattern brocaded robe.[42] It is unknown whether Dürer and the emperor

144
Maximilian I,
1519
Oil on
lindenwood;
74 × 61.5 cm
(29⅛ × 24¼ in)
Kunsthistori-
sches Museum,
Vienna

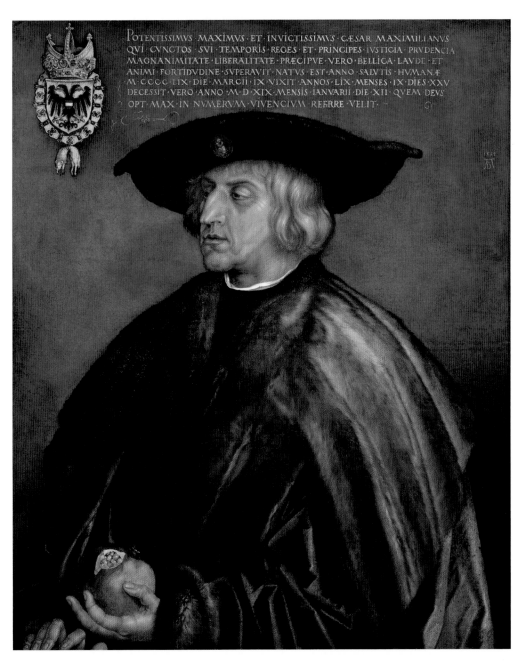

POTENTISSIMVS MAXIMVS ET INVICTISSIMVS CAESAR MAXIMILIANVS
QVI CVNCTOS SVI TEMPORIS REGES ET PRINCIPES IVSTICIA PRVDENCIA
MAGNANIMITATE LIBERALITATE PRAECIPVE VERO BELLICA LAVDE ET
ANIMI FORTIDVDINE SVPERAVIT NATVS EST ANNO SALVTIS HVMANAE
M·CCCC·LIX·DIE·MARCII·IX·VIXIT·ANNOS·LIX·MENSES·IX·DIES·XXV
DECESSIT·VERO·ANNO·M·D·XIX·MENSIS·IANVARII·DIE·XII·QVEM·DEVS
OPT·MAX·IN·NVMERVM·VIVENCIVM·REFRRE·VELIT·

ever discussed a printed portrait. After Maximilian's death the artist created this widely reproduced memorial likeness. The inscribed scroll refers to him as 'Maximilian, risen to heaven, supreme commander and emperor, pious, successful and majestic'.[43] The word 'divus' was used historically to describe ancient Roman emperors who through death had become divine. Maximilian's piety is signified by the Virgin and Child medallion. He wears the collar of the Order of the Golden Fleece, which was largely undefined in the sketch. As both a member and ruling sovereign of Europe's most famous chivalric brotherhood, Maximilian was the paragon of knightly virtues. The collar also recalled his marriage to Mary, duchess of Burgundy, and, by extension, Habsburg claims to the heritage and lands of the Valois dukes of Burgundy.

The woodcut exists in four separate versions, made from four different woodblocks. Three of these differ only in the form of their inscriptions. The fourth frames the portrait with elaborate columns and ornament plus a small German text below. None bears Dürer's monogram. This raises the question of Dürer's personal involvement once the initial woodcut design was finished. The second version is probably a faithful copy by Jost de Negker (c.1485–1544), the talented Netherlandish *formschneider* working in Augsburg.[44] Maximilian's posthumous popularity explains the continued demand for this woodcut. This particular example is augmented with gold printed over the line block and sensitive hand coloration, so the overall effect mimics an illuminated manuscript or small painting.

Dürer first portrayed Maximilian in the *Feast of the Rose Garlands* (see 82) of 1506, where he replicated a Venetian drawing showing the prince in profile.[45] Word of the success of this altarpiece probably reached the emperor through mercantile channels. Yet it was Dürer's tremendous graphic production in 1511, coupled with Maximilian's growing recognition of the potential of prints, that brought the two men together. Pirckheimer, Stabius and possibly

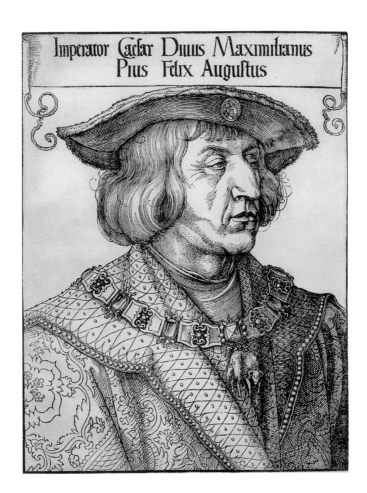

145
Maximilian I,
c.1519
Woodcut
printed by
Johann Kramer;
44.5 × 32.8 cm
(17½ × 12⅞ in)
British
Museum,
London

Peutinger, three brilliant humanists with their own scholarly
interest in investigating the Classical past for the betterment of
the German present, facilitated this relationship. Far more than
Burgkmair, who actually made many more images of Maximilian,
Dürer created posterity's collective portrait of the emperor. In
paint and in print he conveyed Maximilian's inherent nobility
to audiences across the Holy Roman Empire and beyond. He
had the talent to translate Maximilian's ambitions and symbolic
pretensions into appealing images of often unprecedented
grandeur. Dürer did not invent the use of art as propaganda.
He did, however, successfully link the means (a reproducible
image) and message in a fashion that transformed the subsequent
portraiture of rulers.

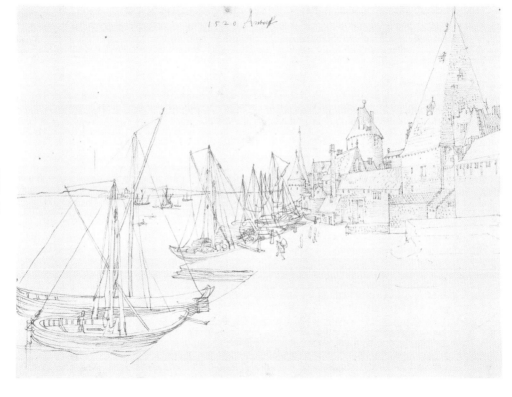

146
*Antwerp
Harbour,* 1520
Inscribed
'Antorff'
Pen and ink;
21.3 × 28.8 cm
(8⅛ × 11⅛ in)
Albertina,
Vienna

Did curiosity kill Dürer? Sadly yet ironically, because of his innate
inquisitiveness he contracted malaria, which hastened his demise
in 1528. On 12 July 1520 Dürer, Agnes and Susanna, a maid, left
Nuremberg on a trip that would last slightly more than a year.
The primary goal of this, the artist's third great foreign journey,
was to secure the continuation of his annual pension of 100
guilders that Emperor Maximilian I first awarded in 1515. With
Maximilian's death in January 1519, Dürer sought its renewal by
Charles V, his successor. After discussions with friends and officials
in Nuremberg, Dürer resolved to petition the young Habsburg
prince and king of Spain during his scheduled investiture in
Aachen. Early in 1519 Dürer wrote to Georg Spalatin, secretary
and chaplain of Elector Friedrich the Wise in Wittenberg, that
his concern over the potential loss of his pension was heightened
by worries about his own health. 'As I am losing my sight and
freedom of hand my affairs do not look well.'[1] Although changes
in eyesight are inevitable for most people, they are a potentially
devastating impairment for an artist, as is any sort of hand
tremor or palsy. During the trip he bought three sets of corrective
eye-glasses.

Dürer's journey to the Netherlands stands as one of the most
fascinating chapters of his career. In contrast with his stays in
Venice, no dramatic artistic changes or grand altarpieces can
be associated with his residence in the Low Countries, yet the
occasion provides invaluable insights into his character and
contemporary fame. Our knowledge about this trip comes from
four main sources: the artist's journal, the drawings and paintings
that he made, other archival records and the impact that his art had
on the artists then active in the Netherlands.[2] Dürer's personality
emerges with a fullness that is exceptional for this period, since his

journal includes detailed financial notations as well as observations about whom he met, what he saw and did and where he travelled. Ever since Christoph Gottlieb von Murr first published the journal in 1779, its contents have become a central part of Dürer's biography and lore.[3] Virtually nothing is known about the private thoughts and aesthetic judgments of his artist peers.

The journal permits the party's route to be tracked on an almost daily basis. They travelled first to Bamberg to obtain a toll-pass from Bishop Georg III Schenk von Limburg (r. 1505–22). Dürer knew the bishop, whose portrait he had painted in October 1517.[4] Throughout his trip the artist proved to be an astute gift-giver. It was common social practice to present a gift in the expectation of receiving something of equal or, if dealing with someone wealthier or of higher social standing, greater value than the initial offering. Bishop Georg received a painting of the Virgin, both the *Life of the Virgin* and the *Apocalypse*, and a guilder's worth of engravings. In exchange he paid Dürer's bill at the inn and supplied him with three letters of introduction and a toll-pass. Although mentioned only in Bamberg documents, Dürer, Agnes and Susanna made a brief excursion to Vierzehnheiligen, the pilgrimage church of the Fourteen Helper Saints north of Bamberg, perhaps to pray for a safe journey.[5] They travelled by boats, the easiest mode of transport, along the River Main from Bamberg to Frankfurt and then to Mainz, from where they floated down the Rhine to Cologne. They crossed innumerable different local and princely jurisdictions. With just a few exceptions the bishop's pass exempted the party from paying tolls and any customs on their property. Occasionally Dürer had to swear that he was not transporting commercial wares. The thousands of prints and several paintings that he sold or bartered in the Low Countries may have been shipped separately to Antwerp by the agents of Hans Imhoff the Elder. When they arrived at Lahnstein, opposite Koblenz on the Rhine, the toll agent 'gave me also a tankard of wine, for he knew my wife well and was glad to see

me'.[6] Agnes passed through Lahnstein on one or more occasions as she travelled probably to Cologne to sell her husband's art. Perhaps then, as in 1520, she stayed in Cologne with Niklas Dürer, the artist's cousin, a goldsmith who had trained with Albrecht the Elder and once worked in Nuremberg. After a few days' visit the party continued on by cart or horseback to Antwerp, where they arrived three weeks after leaving Nuremberg. They rented a set of rooms with cooking facilities at the Engelenborch, Jobst Planckfelt's inn on Wolstraat. This accommodation proved satisfactory, since they stayed there until their departure on 3 July 1521. Dürer dined with Planckfelt when he was not a guest elsewhere. Agnes and Susanna normally ate in their suite. For the next eleven months Antwerp served as Dürer's base of operations. By 1520 the city had displaced Bruges as the international commercial hub. In 1501 the Portuguese made Antwerp the centre of their lucrative staples market as spices, among other commodities, from Asia and Africa were exchanged here for silver and copper from central Europe. The city's famed fairs and the rather open character of its art markets attracted artists, merchants and, critically, buyers from well beyond the Low Countries. Antwerp is centrally located and in close proximity to the region's other major towns. With its population soaring over 50,000, the city had the character of a boom town filled with possibilities.[7] Antwerp hosted a large community of German merchants, including many from Nuremberg and Augsburg. As in the case of Venice's Fondaco dei Tedeschi, these connections facilitated the artist during his stay, especially with the flow of goods and communication.

Soon after arriving, Dürer sketched a section of the harbour near the abbey of Saint Michael (146).[8] The Eeckhof, the guild of painters' warehouse, is the large building with the tall roof at right. Small boats of varying sizes line the wharf; larger vessels float in the River Scheldt. The far shore is the Vlaans Hoofd, or Flemish side of the river, which a few years later would become

quite popular as wealthy Antwerpers erected country houses. Dürer conveyed the impression of peering towards the quay from the window of a nearby building. Several figures move within the boats or along the walkway.

This drawing's sense of immediacy is often matched by Dürer's vivid descriptions. While visiting the Eeckhof he remarks that the painters were busily preparing four hundred triumphal arches, each 12 metres wide (40 feet) and two storeys high, for the entry of Charles V into Antwerp, which occurred on 23 September. The text relates Dürer's experiences as he settled into the rhythms of Antwerp's calendar, including its holy festivals and carnival celebrations.[9] Most entries list his professional activities and social engagements.

147
*Lazarus
Ravensburger
and the Tower
of the Van Liere
Residence in
Antwerp*, 1520
Silverpoint
on white
prepared paper;
12.2 × 16.9 cm
(4¼ × 6⅝ in)
Kupferstich-
kabinett, Berlin

Dürer carefully notes (and delights in) the honours paid to him. Unlike the second Venetian trip, when he laboured to improve his reputation as a painter and colourist, he was in 1520 at the peak of his renown, if not of his creative output, which had declined somewhat in the previous couple of years. Dürer was an international celebrity. He dined with Bernhard Stecher, the factor or head of the Fuggers' corporate branch in Antwerp, the night of his arrival in the city. Three days later the city's painters hosted Dürer, Agnes and Susanna at their guild house.

> All their service was of silver, and they had other splendid ornaments and very costly meats. All their wives also were there. And as I was being led to the table the company stood on both sides as if they were leading some great lord. And there were among them men of very high position, who all behaved most respectfully towards me with deep courtesy, and promised to do everything in their power agreeable to me that they knew of. And as I was sitting there in such honour the Syndic of Antwerp came, with two servants, and presented me with four cans of wine in the name of the Town Councillors of Antwerp,

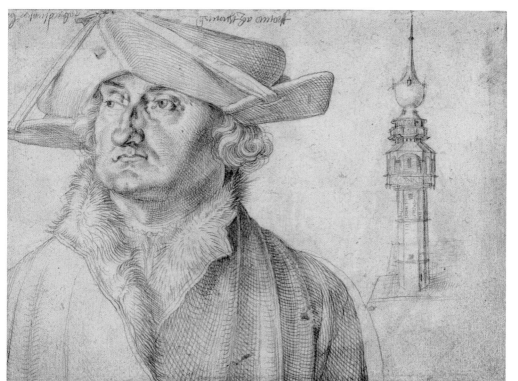

and they had bidden him say that they wished thereby to show their respect for me and to assure me of their good will. Wherefore I returned them my humble thanks and offered my humble service. … So when we had spent a long and merry time together till late in the night, they accompanied us home with lanterns in great honour. And they begged me to be ever assured and confident of their good will, and promised that in whatever I did they would be all-helpful to me. So I thanked them and laid me down to sleep.[10]

Their welcome contrasted starkly with his frosty reception by Venice's painters in 1505–7. Later that week Dürer would be the guest of two important Nuremberg merchants and of João Brandão, the Portuguese factor who became the artist's frequent host and good friend.

Planckfelt, the innkeeper, guided Dürer around Antwerp. He
showed him the painters' warehouse, the home of Quinten Massys
(or Quentin Metsys; 1466–1530), the city's leading painter, and
the new house of Burgomaster Aert van Liere (147).[11] Dürer
describes the latter house: 'It is newly built and beyond measure
large, and very well ordered, with spacious and exceedingly
beautiful chambers, a tower splendidly ornamented, a very
large garden – altogether a noble house, the like of which I have
nowhere seen in all Germany. The house also is reached from
both sides by a very long street, which has been quite newly built
according to the burgomaster's liking and at his charges.'[12] He
drew the tower in '*mein büchlein*', a silverpoint sketchbook that
he frequently carried. In late October he added the portrait of
Lazarus Ravensburger, overseer for a major German firm trading
with Portugal, on the same sheet. Fifteen folios with twenty-seven
different pages of drawings survive.

Dürer soon settled down to business. Needing to support his party
during the trip, the artist began selling, bartering or strategically
presenting the huge quantity of prints and other works that
he had shipped to Antwerp. Not long after his arrival he sold a
large number of prints to Sebald Fischer, who probably was an
art merchant or an agent for a dealer in another town. Fischer
purchased '16 small Passions for 4 fl., 32 of the Large Books
for 8 fl., 6 engraved Passions for 3 fl., half-sheets – 20 of all kinds
taken together at 1 fl. – of these he took 3 fl. worth and again 5 ¼
fl. worth, quarter-sheets – 45 of all kinds at 1 fl. – for 5 ¼ fl., and
of whole-sheets 8 of all kinds taken together for 1 fl. It is paid.'[13] On
24 November he earned 8 florins from the sale of '2 *Adam and Eves*,
1 *Sea-Monster*, 1 *Jerome*, 1 *Knight*, 1 *Nemesis*, 1 *Eustace*, 1 whole
sheet, further 17 etched pieces, 8 quarter-sheets, 19 woodcuts, 7 of
the bad woodcuts, 2 books and 10 small woodcut *Passions*' from an
unknown buyer.[14] Such large-scale sales were rare.

Dürer priced single prints according to size and medium. A whole

sheet measures 35.9 by 27.7 cm (14⅛ × 10⅞ in); a half sheet 30.1 by 20.5 cm (11⅞ × 8¾ in); and a quarter sheet 17.4 by 12.4 cm (6⅞ × 4⅞ in).[15] His best-known engravings, such as *Adam and Eve* or *Knight, Death and the Devil*, were considered whole sheets even though their actual plate dimensions are smaller. An engraving had twice the value of a comparable-size woodcut. Dürer rarely sold one print on its own, although once he charged 4 stuivers for the engraved *Adam and Eve*. There were 24 stuivers in a Rhine florin (guilder/gulden). For comparison, Dürer paid Planckfelt 11 florins per month for his accommodation and 2 stuivers for his evening meal. He spent 4 stuivers on a tortoise, on his tip to the priest who heard his confession, on a good meal, on his hotel per night during his first stay in Brussels, and on one of his larger gambling debts. Dürer scarcely could have imagined that the sale of one superb impression of *Adam and Eve* in the twenty-first century would have paid for his entire trip.

Dürer's selection of which prints to send to the Netherlands reflected his (and perhaps Agnes's) well-honed understanding of the marketplace. His journal fails to mention whether he received new shipments from Nuremberg to replenish his stock. A calculation of how many prints he sold or gave away is impossible. He may not have written down every exchange. Furthermore, Dürer lists giving 'whole sets' away on seven occasions, presenting his 'best prints' to King Christian II of Denmark, and trading 8 and 6 florins' worth of prints respectively with Lucas van Leyden (c.1494–1533) and Tommaso di Andrea Vincidor (d. 1534/6) of Bologna. A whole set should be understood as a package of his better images rather than impressions of every print. For practical purposes the artist preassembled sets of prints according to size, which could be distributed as a group or, if he chose, as individual engravings.[16] Included among the most popular prints listed by title are *Saint Jerome in His Study* (fifteen), *Melencolia I* (eight), *Saint Eustace* (six), *Adam and Eve* (five) and *Nemesis* (five).[17] He did not sell or give away *Saint Jerome in His Study, Knight,*

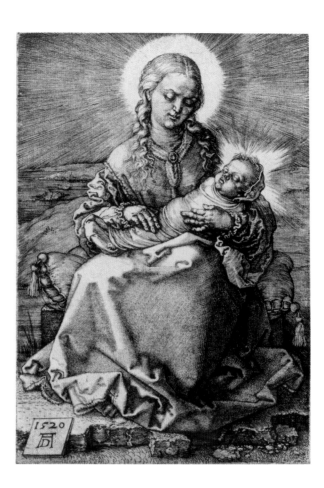

148
*Virgin with
the Swaddled
Child,* 1520
Engraving;
14.3 × 9.7 cm
(5⅝ × 3¾ in)

149
*Saint Anthony
before a City,*
1519
Engraving;
10 × 14.1 cm
(3⅞ × 5½ in)

Death and the Devil or *Melencolia I* as a distinct set.[18] Demand
was greatest for his books. Twice he sold sixty-eight 'Large Books',
although the titles are not specified. The three 'Large Books'
(*Apocalypse, Life of the Virgin* and *Large Passion*) were dispensed
together four times. Once he vended four books, including
presumably the *Small Passion* together, and five times just two
books. Separately he lists ten sets of the *Life of the Virgin,* five
Apocalypses, five *Large Passions,* thirty-one *Small Passions* and
twenty-four *Engraved Passions.*

Dürer brought prints dating from the late 1490s to the eve of his
journey. He sold seventeen *'New Marys'* and six *Saint Anthony
before a City* (148, 149) half-sheet engravings. The *Virgin with*

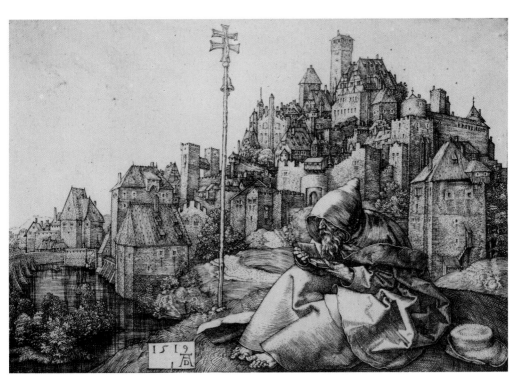

the Swaddled Child, one of the three Marian scenes of 1519–20,
displays a new, quiet intimacy.[19] Dürer stripped the scene to its
essence. The minimal background is enveloped in cool nocturnal
shadow. Mary, who is surprisingly monumental, tenderly holds
her sleeping son. Both are illuminated by the intense light of their
halos. By contrast, the hermit Saint Anthony sits reading before
a highly detailed and geometrically conceived cityscape.[20] If the
Virgin with the Swaddled Child anticipates the spare prints of the
1520s, Saint Anthony recalls engravings, such as *Saint Eustace* (see
105), which are chock-full of visual delights. Dürer also took to the
Netherlands art by Hans Schäufelein, Hans Baldung Grien and the
unidentified Master Franz.[21]

Portraiture proved a lucrative source of income. According to the
journal, Dürer made at least 120 portraits, including eight oils.
These were often done during social occasions, especially when

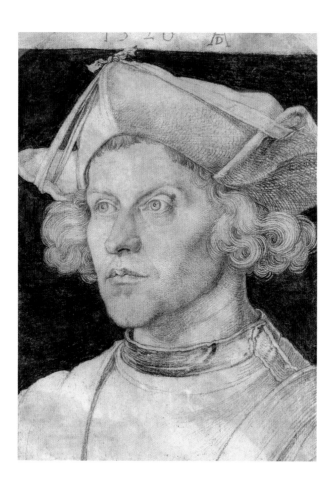

150
Young Man,
1520
Monogrammed
Black, brown
and reddish
brown chalk
with brush and
grey wash;
36.6 × 25.8 cm
(14⅛ × 10⅛ in)
Kupferstich-
kabinett, Berlin

he was a dinner guest. Some he drew out of goodwill or in tacit exchange for the meal or a small gift. Other sitters paid him about 1 florin for a charcoal portrait. Most drawings were sketched in charcoal (thirty-eight), chalk (seven), silverpoint (twelve), pen (one) and pencil (one), although often the medium is not specified. An accurate count is impossible. Several sketches, including two of Agnes (see 164), are unrecorded. Once he remarks: 'I have also at one time and another done many drawings and other things to serve different people, and for the more part of my work have received nothing.'[22] These unremunerated works included portraits.

The sitters ranged from the now unknown to the famous. The format, if not the technique, of a *Young Man* (150) is typical.[23] The bust-length figure is presented in a three-quarter view of

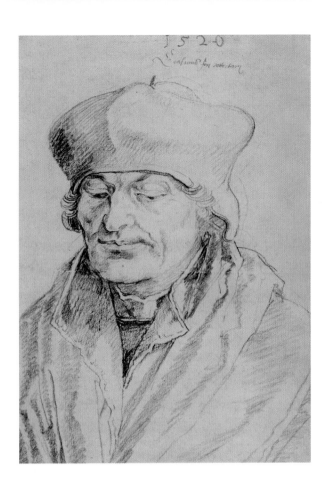

151
Erasmus,
1520
Later inscribed
'*Erasmus fon
rottertam*'
Charcoal;
37.3 × 26.8 cm
(14⅝ × 10½ in)
Musée du
Louvre, Paris

the face. Dürer began at the left, with a strong line tracing the contour of the face, as is visible above the sitter's right eye, then down the cheek to the chin and, more faintly, up the underside of the left cheek. He emphasized the energetic fluidity of the curly hair. The hatchings and cross-hatchings quickly but deftly define the play of light across the sitter's face. Dürer added a grey wash, applied with the point of the brush, to enhance some details, notably in the shaded areas. The eyes reflect a window. Dürer blackened the background to set off the head. A strip at the top, now trimmed somewhat, was left uncoloured as a field for the date and monogram.

This drawing's high finish contrasts with Dürer's quick charcoal sketch of *Erasmus* (151).[24] The artist blocked out the figure and

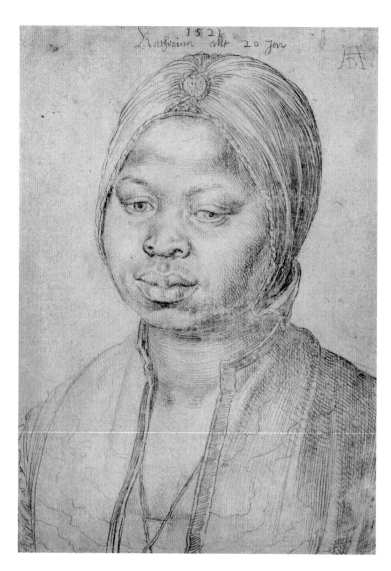

152
Katharina,
1521
Inscribed
*'Katharina
allt 20 jar'*
Silverpoint;
20 × 14 cm
(7⅞ × 5½ in)
Galleria degli
Uffizi, Florence

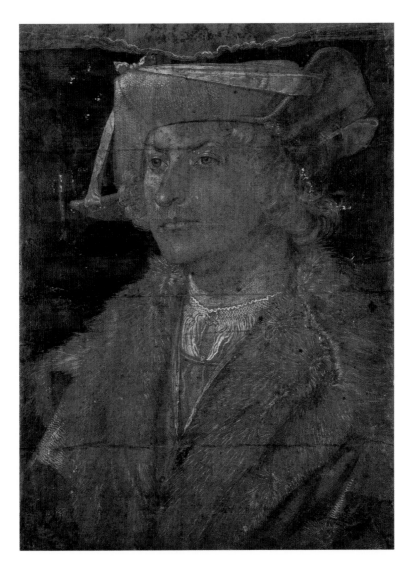

153
*Rodrigo
Fernandez
d'Almada*, 1521
Black pencil
with white
highlights
on paper with
a grey-violet
ground;
37.3 × 27.1 cm
(14⅝ × 10⅝ in)
Kupferstich-
kabinett, Berlin

cap. The shading and the lines of the face, especially around his right eye, are still rather preliminary. He depicted the humanist looking down as though in thought or reading. In a letter to Pirckheimer of 14 March 1525 Erasmus mentions that while Dürer was taking his portrait they were interrupted by three dignitaries from Nuremberg.[25] This explains the incompleteness of the sketch. On 1 September 1520 Dürer notes in his journal: 'I have once more taken Erasmus of Rotterdam's portrait.'[26] Presumably this now lost drawing served as the model for his engraving of Erasmus (see 114).

Dürer's choice of technique varied according to his intentions. In late March or early April 1521 he remarks: 'I have drawn the portrait in charcoal of Factor Brandão's secretary. I drew with the metal-point a portrait of his Moorish servant, and one of Rodrigo with the pencil in black and white on a large piece of paper' (152, 153).[27] The first may have been a quick likeness. Dürer's silverpoint of the twenty-year-old Katharina was not his first portrait of a black person, since he had sketched the very dignified face of an African man in 1508.[28] He sensitively captures Katharina in a thoughtful or introspective moment. One is tempted to see a hint of resignation or sadness in her face; however, there is always the danger of imposing our modern reading in ways never intended by the artist. His primary interest was physiognomic. In a draft for his *Treatise on Human Proportions*, dating to about 1513–15, Dürer observes that 'the faces of Moors are rarely handsome because of their flat noses and thick lips. But I have seen some whose entire bodies were so well formed and excellent that I have never seen, and cannot even imagine, anyone better formed.'[29]

Rodrigo Fernandez d'Almada, the new Portuguese factor in Antwerp, was Dürer's frequent host and close acquaintance during the Netherlandish trip. They may have first met when Rodrigo was in Nuremberg in 1519. They exchanged numerous presents, including a parrot for Agnes and a set of prints for Rodrigo. The

154
Saint Jerome,
1521
Oil on oak;
59.5 × 48.5 cm
(23⅜ × 19⅛ in)
Museu nacional
de Arte antiga,
Lisbon

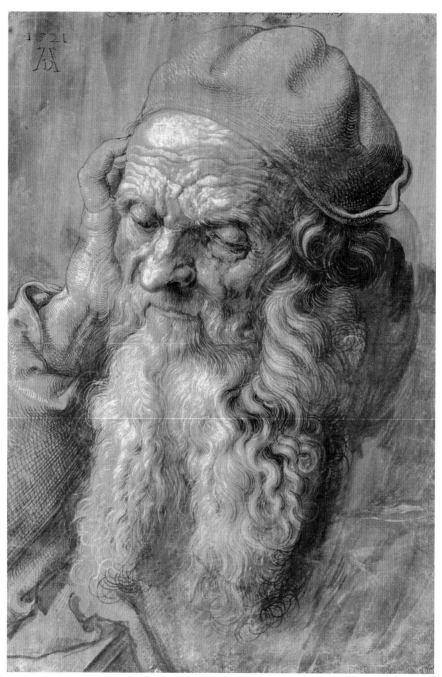

155
*Ninety-Three-
Year-Old Man,*
1521
Black pencil
with white
highlights
on grey-violet
prepared paper;
42 × 28.2 cm
(16½ × 11⅛ in)
Albertina,
Vienna

drawing, the only one mentioned in the journal as done in pencil, may be the exquisite, if damaged, portrait in Berlin.[30] Dürer drew in black on a grey-violet toned paper. Deft touches of white accent light playing across the fur of the expensive robe, hat, hair and face. The portrait is painstakingly detailed and highly finished.

Dürer painted *Saint Jerome* (154) for Rodrigo as a gift or commission.[31] The elderly Jerome sits at his desk contemplating mortality. With his head resting on his right hand, the melancholic (or introspective) saint touches a skull with his left index finger. The deeply wrinkled face and gnarled left hand underscore the saint's own advanced age. In preparation Dürer paid an old man 2 stuivers to model for him in January 1521.[32] One drawing (155) is inscribed: 'The man was ninety-three years old and healthy and of good spirits, at Antwerp.'[33] For the final painting Dürer combined this pose with the open eyes featured in another, probably initial, sketch. Jerome gazes intently at the viewer as though to ensure that we understand that life, like fame or fortune, is transitory. Only Christ's death, in the form of the wooden crucifix, has significance. This painting remained with Rodrigo in Antwerp until he returned to Portugal in 1548.[34] Its presence sparked a controversy as to whether Dürer or Quinten Massys originated this subject. The Nuremberg artist's composition inspired dozens of variants by such Netherlandish artists as Lucas van Leyden, Marinus van Reymerswaele (c.1490/5–c.1567), Joos van Cleve (c.1485/90–1540/1) and Jan Massys (c.1509–1575).

This would not have surprised Dürer, who often created designs for others. He sketched coats of arms directly on woodblocks, devised sword hilts and invented attractive carnival masks. For Antwerp's wealthiest merchants' guild, he drew a seated Saint Nicholas, apparently a model for an altar cloth for their chapel in the church of Our Lady.[35] Dürer also developed plans for an entire house 'according to which he [Margaret of Austria's doctor] intends to build one; and for drawing that I would not care to take

less than 10 fl'.[36] Given the high valuation, the artist must have devoted considerable time to this unusual task. For his good friend Tomasin (Tommaso Bombelli) of Genoa, a wealthy silk merchant and Regent Margaret's paymaster, Dürer carefully invented decorations 'after which he intends to have his house painted'.[37]

Soon after arriving in Antwerp, Dürer met the painter Joachim Patinir (c.1480–1524), who almost immediately aided the visiting artist by lending him the service of his apprentice, some colours and, less certainly, studio space.[38] Dürer repaid this debt with a gift of prints. Later he made Patinir's portrait and, on 5 May 1521, attended his wedding as an honoured guest. In referring to him as 'the good landscape painter', Dürer acknowledges Patinir's specialized talents. Patinir often relied on collaborators, including Quinten Massys, for his figures. Twice Dürer provided him with drawings. One is described simply as a drawing in half-colours, while on 19–20 May he writes that 'for Master Joachim have I drawn 4 small Saint Christophers on grey paper'. The subject is apt since the saint is typically shown fording a river, in accordance with his legend. Possibly in preparation for this task Dürer sketched *Saint Christopher Carrying the Christ Child* nine times on a single sheet of paper (156).[39] Each depiction differs slightly. Dürer conceived his figures as though he had before him a wooden statue or jointed mannequin which he slowly rotated as he posed it frontally, from the left and right profile views and several in-between positions. Patinir could easily have benefited from the highly plastic figures, the twisting masses of cloth and the attention to light moving across the varied surfaces.

Artists fêted Dürer at private dinners and large banquets. Besides being hosted by Antwerp's painters soon after his arrival, he and Agnes were the honoured guests of the city's goldsmiths on Carnival Sunday (10 February). At the insistence of the painter Jan Prevost (Provoost; c.1465–1529), on 6–9 April Dürer visited Bruges, where the goldsmiths, painters and merchants prepared

156
*Saint
Christopher
Carrying
the Christ
Child,* 1521
Pen and
black ink;
22.8 × 40.7 cm
(9 × 16 in)
Kupferstich-
kabinett, Berlin

a lavish banquet in their guild house. 'They gave me presents, sought to make my acquaintance and did me great honour. … the whole assembly, more than 60 persons, accompanied me home with many torches.'[40] On his arrival in Ghent on 10 April he was welcomed by the dean of the painters' guild and the city's major painters, who dined with him. '[T]he painters with their Dean did not leave me alone, but they are with me morning and evening and paid for everything and were very friendly to me.'[41] When Dürer passed through 's-Hertogenbosch on 20 November 1520 while returning from Aachen and Cologne, the town's goldsmiths 'came to see me and they did me much honour'.[42] Mechelen's painters and sculptors visited his inn when he lodged there on 6 June 1521.[43]

157
Lucas van Leyden, 1521
Silverpoint;
24.4 × 17.1 cm
(9⅝ × 6¾ in)
Musée des Beaux-Arts, Lille

Dürer's contacts with artists in the Netherlands included virtually every major master except Quinten Massys and Jan Gossart (1478–1532). Shortly after settling in Antwerp, he sent a group of prints to Conrat Meit (1470/85–1550/1), a German sculptor from Worms who had entered the service of Margaret of Austria in Mechelen in 1512/14.[44] Dürer may have known 'the good sculptor, whose like I have not seen' when Meit worked for Friedrich the Wise in Wittenberg between 1505/6 and 1509. The Nuremberg master diplomatically cultivated good relations with Meit in the hope that he would speak favourably on his behalf with Regent Margaret, whose support he needed to secure the renewal of his pension. Together in Brussels a few days later Dürer sketched Meit's portrait by candlelight. In May he hosted Meit in Antwerp. Dürer mentions meeting Jean Mone (c.1485/90–1549[?]) of Metz, 'the good marble sculptor', Bernard van Orley (c.1488–1541), Prevost, the stained-glass painters Dirck Vellert (c.1484/5–after 1549) and Aert van Ort (Ortkens; fl. 1490–1536), Susanna Horenbout (fl. 1520–50) and Lucas van Leyden, among others.[45]

He sketched Van Leyden (157), whom he described as a little man, and exchanged prints.[46] According to Van Mander's account of

158
Jan de Bisshop (copy after Tommaso di Andrea Vincidor), *Albrecht Dürer* (1520), c.1660–70 Drawing; 35.3 × 22.8 cm (13⅞ × 9 in) Germanisches National-museum, Nuremberg

159
Aachen Cathedral, 1520 Silverpoint; 12.6 × 17.4 cm (5 × 6⅞ in) British Museum, London

their meeting in Antwerp in mid-June 1521, which conveys local patriotism, Dürer 'is said to have looked with such great surprise and astonishment that his speech and breath stuck in his throat, after which he affectionately took him in his arms, most amazed at his small form and his great, honourable and dignified name'.[47] Since Dürer's journal was first published in the eighteenth century, Van Mander relied on a separate Dutch source.

In 1515 Dürer sent a now lost self-portrait to Raphael (1483–1520) and received some nude figure studies by or in the style of the Italian master in return.[48] Thus he was pleased to meet Tommaso di Andrea Vincidor, a pupil of Raphael, whom Pope Leo X sent to Brussels to oversee the design and weaving of tapestries for the Vatican palace.[49] On 1 October 1520 Dürer writes: 'I gave Thomas of Bologna a whole set of prints to send for me to Rome to another painter who should send me Raphael's work in return. ... The Bolognese has made my portrait, he means to take it with him to

Rome.' Tommaso, however, remained in the Low Countries until
his death. His portrait of Dürer later entered the famed Antwerp
art collection of Cornelis van der Geest in 1628, but it survives
only in several variants (158).[50]

Dürer peppered his journal with references to art seen and
towns visited. Between 7 and 26 October 1520 he attended the
investiture of Charles V in Aachen. He remarks that 'at Aachen
I saw the well-proportioned pillars with their good capitals of
green and red porphyry and "Grossenstein" [compacted mortar]
which Charles the Great had brought from Rome thither and set
up. They are correctly made according to Vitruvius' writings.'[51]
He paid to see the city hall, which he carefully depicted in his
sketchbook. From one of its windows he drew the cathedral (159)
with Charlemagne's octagonal core and the airy chapel of Emperor
Charles IV, begun in 1355.[52] This offers an invaluable historical
record of the appearance of the building and nearby courtyard.

While in Cologne from 28 October to 4 November, Dürer visited the church of Saint Ursula with its lavish display of relics, and he paid to see 'Master Stefan's picture' in the Rathaus chapel.[53]

During his first trip to Brussels in late August 1520 Dürer toured the town hall with its 'four paintings which the great Master Roger made'.[54] The Justice cycle by Rogier van der Weyden adorned the great hall until destroyed in the French bombardment of the city in 1695. Dürer paid to see *Saint Luke Painting the Virgin*, probably Van der Weyden's picture in the chapel of the painters' guild. At the count of Nassau's house he admired the view, a chapel painted by 'Master Hugo', presumably Hugo van der Goes (c.1440–1482), a giant bed that could hold fifty guests, and a meteorite. Nothing captivated Dürer more than the Aztec treasures that Hernán Cortés obtained from Montezuma (Motecuhzoma) in 1519. Charles V had these exotic treasures displayed in the Coudenberg palace. Dürer marvels:

> I saw the things which have been brought to the King
> from the new land of gold, a sun all of gold a whole
> fathom broad, and a moon all of silver of the same size,
> also two rooms full of the armour of the people there,
> and all manner of wondrous weapons of theirs, harness
> and darts, very strange clothing, beds and all kinds of
> wonderful objects of human use, much better worth
> seeing than prodigies. These things were all so precious
> that they are valued at 100,000 florins. All the days of my
> life I have seen nothing that rejoiced my heart so much
> as these things, for I saw among them wonderful works
> of art, and I marvelled at the subtle *Ingenia* of men in
> foreign lands. Indeed I cannot express all that I thought
> there.[55]

At Jan Prevost's urging, from 6 to 10 April 1521 Dürer made a quick trip to Bruges and Ghent.[56] In the ducal palace in Bruges he admired the chapel painted by Rogier van der Weyden 'and

some pictures by a great old master'. In the church of Saint Jacob he was shown 'the precious pictures by Roger and Hugo, who were both great masters. Then I saw in Our Lady's Church the alabaster Virgin, sculpted by Michelangelo of Rome.' Although these paintings have disappeared, Michelangelo's marble seated *Virgin and Child* (1503/5) is still *in situ*.[57] While in Ghent, Dürer writes: 'On Wednesday they [the painters] took me early to the belfry of Saint John [now Saint Bavo's Church], whence I looked over the great wonderful town, yet in which even I had just been taken for something great. Then I saw Jan's picture; it is a most precious painting, full of thought, and the Eve, Mary and God the Father are specially good. Next I saw the lions and drew one with metal-point.'[58] As he surveyed Ghent's rooftops, he reflected on the honour that the artists of this great city had just paid to him. *Adoration of the Mystic Lamb* (1432) by Jan van Eyck (c.1390–1441) merited brief praise. Yet none of these works of art inspired a drawing. By contrast, when he encountered a living lion, perhaps for the first time, Dürer made three careful studies in his sketchbook (160).[59] This creature is altogether different from the fanciful, toy-like lions that inhabit the artist's earlier prints (see 17, 44, 121).

While modern readers hunger for meatier comments on art and artists, Dürer's recollections are virtually unique among his professional peers at this time. Only once did he express a slightly negative judgement. When he visited Middelburg in Zeeland in early December 1520, he remarked that the town was 'excellent for sketching' and that it had a beautiful town hall and abbey. The church possessed a 'great picture painted by Jan de Mabuse [Gossart] – not so good in the modelling as in the colouring'.[60] The altarpiece (1518/20) was destroyed by fire in 1568.

The trip to Zeeland occurred just a few weeks after Charles V confirmed Dürer's pension on 4 November 1520.[61] The campaign for the annuity's renewal was achieved 'after great trouble and

160
*Two Drawings
of Lions*, 1521
Silverpoint;
12.1 × 17.1 cm
(4¼ × 6¾ in)
Kupferstich-
kabinett, Berlin

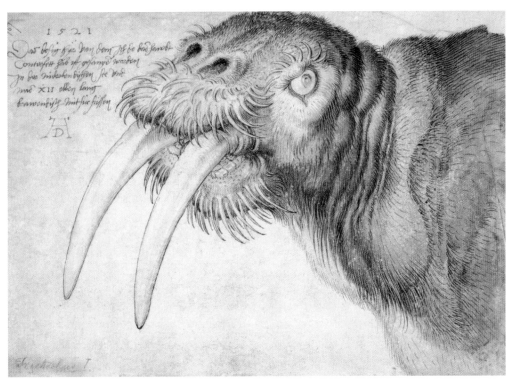

161
Walrus, 1521
Pen and brown
ink with
watercolour;
21.1 × 31.2 cm
(8⅛ × 12¼ in)
British
Museum,
London

labour'. His petition had required many meetings between the artist and powerful court officials, including Regent Margaret, as well as gifts of prints and portraits. Nuremberg's official delegates hosted the artist for eight days in Brussels, three weeks in Aachen and fourteen days in Cologne, largely at their expense during the social and political events surrounding the coronation in Aachen on 23 October. Their helpful service to him was rooted both in friendship and in their realization that Dürer's fame was a notable civic asset.

Soon after returning to Antwerp on 22 November, Dürer heard about a giant beached whale. He wrote: 'At Zierikzee in Zeeland a whale has been stranded by a high tide and a gale of wind. It is much more than 100 fathoms long and no man living in Zeeland has seen one even a third as long as this is. The fish cannot get off the land; the people would gladly see it gone, as they fear the great stink, for it is so large that they say it could not be cut in pieces and the blubber boiled down in half a year.'[62] News of this monstrous creature fascinated the artist, who was probably in good spirits after his success at Cologne. On 3 December he set out by boat and reached Goes the next day, but only after a very cold night without food or drink at anchor.[63] During this journey through the islands and to the few towns at the delta of the Rhine, Meuse and Scheldt rivers, Dürer experienced the power of nature. Near Arnemuiden 'we passed by a sunken place, and saw the tops of the roofs standing up out of the water'. At Arnemuiden he and Georg Kötzler, a Nuremberg citizen travelling with him, almost drowned. In a long passage Dürer recounts how as they were unloading, his vessel was bumped hard by a larger ship, which broke their docking ropes, and suddenly a 'storm of wind' pushed his boat back into the Scheldt. All of the crew other than the captain and his lad were already on shore. The skipper 'tore his hair and cried aloud', fearing that all was lost. Dürer writes that he calmed the captain, asked what he and the others could do, and after hoisting a small sail halfway the boat was able to make land

once again. 'And when the people on shore, who had already given us up, saw how we helped ourselves, they came to our aid and we got to land.' This episode was later immortalized in *Dürer in the Storm on the Scheldt* by Ferdinand Fellner (1799–1859), made for the 1828 Nuremberg jubilee honouring the artist.[64] As the boat founders, Dürer alone is shown clear-headed as he grabs the captain by the arm.

By the time Dürer and his companions finally reached Zierikzee, the whale had washed out to sea. Luckily, some time in 1521 the artist encountered another exotic creature: a walrus (161).[65] 'This stupid [sleepy] animal, of which I have sketched the head, was caught in the Netherlands sea and it was twelve Brabant ells [8.35 m] long with four feet', reads the accompanying inscription. The journal does not mention when and where he saw the walrus.

Dürer's curiosity proved deadly. Even though it was almost winter, the artist contracted malaria or a similar malady, probably from a mosquito bite. Soon afterwards, entries for doctor's visits and medicines, plus healing gifts such as sandalwood from his friends, appear in the journal. From 14 to 20 April 1521 Dürer was incapacitated by fever. He notes: 'In the third week after Easter a violent fever seized me, with great weakness, nausea and headache. And before, when I was in Zeeland, a wondrous sickness overcame me, such as I never heard of from any man, and this sickness remains with me.'[66] The artist's health was weakened permanently. In 1522, after returning to Nuremberg, Dürer drew his *Self-Portrait as the Man of Sorrows* (162).[67] His body sags, while his face conveys a weary resignation. Although there may be other reasons for his association with the tormented Christ, including his current conflicted spiritual state, his physical decline vexed the once vigorous artist.

Dürer remained in the Low Countries another seven months after contracting the disease. The journal does not reveal whether

his sickness or the sheer joy of foreign travel was a reason for lingering so long after his initial goal of renewing his pension had been achieved. On 16 March 1521 he reports turning over a bale of his possessions for shipment back to Nuremberg.[68] Soon afterwards he lists the many presents that he acquired for Pirckheimer, Hans Imhoff, Jacob Muffel, Hieronymus Holzschuher (see 179) and other Nuremberg friends. At least five further shipments, including his 'great bale', are recorded between mid-April and 2 July. Still other items, most notably parrots and a long-tailed monkey, must have accompanied the artist, Agnes and Susanna when they finally left Brussels on 12 July.

162
*Self-Portrait
as the Man of
Sorrows*, 1522
Metalpoint
on green
ground paper;
40.8 × 29 cm
(16⅛ × 11⅜ in)
Kunsthalle,
Bremen
(currently held
by the Russian
Federation in
Moscow)

The Dürers acquired and were given much during their stay in the Netherlands. Agnes's expenses are not recorded, although she must have taken advantage of the shopping possibilities available in cosmopolitan Antwerp. Apart from the works of art he obtained, including a gift of Patinir's *Lot and His Daughters Fleeing Sodom* (Museum Boijmans Van Beuningen, Rotterdam), Dürer favoured exotic items.[69] The journal is replete with listings of things from Calicut (India), which refers to anything from south Asia and possibly the Portuguese ports of trade in Africa. This includes a wooden weapon, feathers, coconuts, nuts, two ivory salt-cellars, silk clothing, the round shield covered with fish skins and two gloves ('with which the natives there fight'). He also possessed an old Turkish whip, Turkish cloth and Moroccan leather. Dürer delighted in nature's artistry as he amassed veined shells, branches of coral, an elk's foot, lots of horns, a sprouting bulb from Zeeland, a musk-ball from a musk-deer, a snail's shell, porpoise-bristle brushes, perhaps a dried octopus, a possibly living tortoise and a large turtle shell. Wenzeslaus Link, the vice-general of the Augustinians in Saxony, transported Dürer's 'great turtle shell, the fish-shield, the long pipe, the long weapon, the fish-fins and the two little casks of lemons and capers' to Nuremberg.[70] This combination of art and natural curiosities anticipates the art and wonder chambers that were soon to become popular. In addition, Dürer amassed several

coats, other items of clothing, rings and precious stones. His acquisition of Martin Luther's publications and his concern over the reformer's safety will be addressed in the next chapter.

As Dürer settled his affairs with his innkeeper on 29 June he observed: 'In all my doings, spendings, sales and other dealings, in all my connections with high and low, I have suffered loss in the Netherlands; and Lady Margaret in particular gave me nothing for what I made and presented to her.' Unless the artist kept a separate account book, which seems unlikely, his conclusion is based on his general perception rather than on an accurate tally of his dealings. The value of his prints and the portraits that he created, both through sales and gift equivalences, covered his expenses. Some of his earnings were in the form of objects rather than cash, and this may explain his decision to borrow 100 gold florins on 1 July from Alexander Imhoff to cover his expenses for the trip home.[71] His dealings with Margaret of Austria may have coloured his statement.[72] Although she supported his pension petition and escorted him through her palace in Mechelen, she failed to compensate him for his gifts to her of an *Engraved Passion* and, on another occasion, a whole set of his prints plus 'two pictures on parchment [done] with the greatest pains and care' that he valued at 30 florins. Furthermore, when Dürer visited Margaret earlier in June, she disliked his portrait of Emperor Maximilian I, her father, so he took it away before offering it to her. Also he was disappointed that Margaret already had promised to give Jacopo de' Barbari's book of drawings to Van Orley, her court painter.

Viewed more dispassionately, Dürer's trip to the Netherlands was a success by any criterion other than medical. He secured his annual pension, he was fêted everywhere he travelled, he enjoyed the company of artists and many notable people and he saw the region's sights and artistic treasures. Tales of his visit continued to be recounted by Van Mander and others in later centuries. In a letter of 17 October 1524 addressed to Nuremberg's city council,

163
Christian II,
King of
Denmark, 1521
Charcoal; 39.9
× 28.7 cm
(15¼ × 11¼ in)
British
Museum,
London

Dürer states that he was once offered civic painting posts in Venice,
with a salary of 200 ducats per year, and Antwerp.[73] 'So too, only
a short time ago when I was in the Netherlands, the Council of
Antwerp would have given me 300 Philipsgulden a year, kept me
there free of taxes, and honoured me with a well-built house; and
besides I should have been paid in addition at both places for all the
work I might have done for the gentry.' He hoped this information
and a quip that most of his income had been earned from outside
Nuremberg would bolster his request to the city council to invest
1,000 Rhenish florins of his money at a 5 per cent interest rate
so that 'I and my wife will then, now that we are both growing
daily older, feebler and more helpless, possess the certainty of a
fitting household for our needs'. The job offers cannot otherwise

be verified; however, there is little reason to doubt his claims. Dürer died a wealthy man, but his writings show that he perceived himself as poorer than he actually was.

On 2 July 1521, literally the day Dürer planned to leave Antwerp on his journey to Nuremberg, Christian II, king of Denmark (1481–1559), 'sent for me to come to him at once to make his portrait. That I did in charcoal....'[74] Dürer's portrait (163) conforms to the basic type, with the sitter posed in three-quarter view against a blacked-in background. His monogram and the date appear at the top. The artist devoted only a bit of extra detail and finesse to the handling of the king's beard and hair. Christian was sufficiently pleased with the drawing to invite Dürer to dine with him. He then asked Dürer to travel with him to Brussels and paint his portrait in oils. In his journal he recounts how 'with great pomp' Charles V, accompanied by Margaret of Austria, rode to meet his brother-in-law outside Brussels. Over the next several days Dürer witnessed the emperor's dinner for Christian, and he was an invited guest at the banquet the Danish king hosted. On 4 July, the artist purchased the wooden panel and colours for the portrait, which was painted and framed by 7 July. This event confirms that Dürer could paint very quickly if required. Christian paid Dürer 30 florins. In return, the artist gave the king 'choice things', probably a selection of his best prints.

Dürer, Agnes and Susanna finally left Brussels on 12 July and headed for Cologne, where the journal stops. On the trip home Dürer added at least two more silverpoints to his sketchbook. On one sheet he first drew a young girl dressed in Cologne attire (164).[75] Then a few days later, as they travelled by boat back up the Rhine, he portrayed Agnes. The inscription reads: 'My wife, drawn on the Rhine near Boppard.' She seems to stare attentively at something, perhaps the passing vineyard-covered landscape. One can only wonder how she responded to this grand Netherlandish adventure and to the universal acclaim accorded her husband.

164
*Agnes Dürer
and Young Girl
in Cologne
Clothing,* 1521
Silverpoint;
13.5 × 19.6 cm
(5⅜ × 7¼ in)
Albertina,
Vienna

10

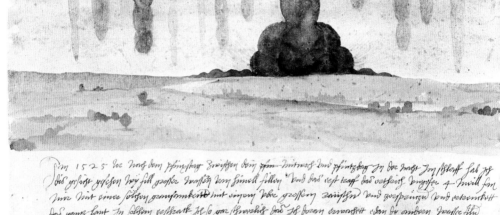

165
Dream Vision,
1525
Watercolour
drawing; sheet:
30.1 × 43.7 cm
(11⅞ × 17¼ in)
Kunsthistori-
sches Museum,
Vienna

In 1525 in the night between Wednesday and Thursday,
after Whitsunday, I saw this appearance in my sleep –
how many great waters fell from heaven. The first struck
the earth about four miles away from me with terrific
force and tremendous noise, and it broke up and drowned
the whole land. I was so sore afraid that I awoke from it.
Then the other waters fell, and as they fell they were very
powerful and there were many of them, some further
away, some nearer. And they came down from so great a
height that they all seemed to fall with an equal slowness.
But when the first water that touched the earth had very
nearly reached it, it fell with such swiftness, with wind
and roaring, and I was so sore afraid that when I awoke
my whole body trembled and for a long while I could not
recover myself. So when I arose in the morning I painted
it above here as I saw it. God turn all things to the best.

During the night of 7–8 June 1525 the Nuremberg artist
experienced a vivid nightmare of a watery cataclysm. The next
morning he recorded the memories of his dream both in words
and in a remarkable watercolour (165).[1] The broad landscape
is dotted with trees and, in the distance, the towers and walls
of a city. These are dwarfed by the gigantic plumes of falling
water that on striking the earth explode with tremendous force.
Some spread horizontally; other waves, drawn with faint blue
brushstrokes, splash back into the air. Dürer varied the intensity
of colour of these clouds of water according to their proximity to
the foreground. For a modern viewer, this spectre eerily anticipates
images of a nuclear explosion, although inverted. Even seen
seemingly in slow motion and at a distance, the flood's potential
for devastation is truly horrific. Dürer's powers of naturalistic

observation now describe a terror that is far more chilling than anything from his *Apocalypse* series (see 48, 50).

Dürer's drawing is as remarkable as it is unique. The detailed documentation of an actual dream has few precedents in Renaissance art although it was a literary device.[2] As much as any single work can, it embodies the artist's creativity amid the wrenching cultural and personal upheavals that characterized the last years of his life. From 1521 to 1528 Dürer focused on the nascent Reformation and its impact on art, on portraiture and on his theoretical writings. It is easy to dismiss the artist's fear as superstition. Dürer, like his contemporaries, believed in or was at least fascinated by miraculous portents, such as comets, exceptional weather events, such as the rain of crosses that he witnessed in 1503, and aberrant creatures.[3] In 1499 a great flood was predicted for Europe in February 1524.[4] Some people in different countries sold their belongings and moved to the mountains. The mayor of Toulouse reportedly built an ark. While the deluge never occurred, it inspired at least fifty-six different authors to debate the prognosis between 1517 and 1524. In his *Practica teutsch* (1522) Johann Virdung claimed that 'tremendous waters will fall with impetuous winds and thunderstorms'. He ended with the same prayer that Dürer used three years later. Regardless of whether he knew Virdung's text or any of the other 133 pamphlets on the topic, Dürer was probably aware of the prediction and its harmless passing. Yet cataclysm and deluge may have been linked in the artist's mind, particularly after experiencing nature's power in flooding parts of Zeeland in late 1520.

The careful drawing, the neatly penned description and the full signature testify to the importance Dürer attached to this particular dream. In an early draft of his thoughts on beauty, dating to 1512, the artist remarks: 'I often see great art and good things while asleep that do not occur to me awake. However, when I wake up the memory of them is lost.'[5] Dürer clearly was

determined to record this disturbing vision before the memory of it slipped away. He intended to show the *Dream Vision* to his closest friends. In March 1522 Pirckheimer wrote to Ulrich Varnbüler (see 173), the noted jurist and humanist, 'Do you remember how Dürer some time ago talked to us about his dreams? We were standing at my window and were watching the parade in the street.'[6] Unlike the 1522 dream, which was a positive one, the latest was filled with foreboding. Nuremberg and the Holy Roman Empire were threatened from without and within. In 1521 Süleyman I the Magnificent, the Ottoman sultan (r. 1520–66), captured Belgrade and boasted that he would soon conquer Europe. Nervous delegates attending the 1522 imperial diet in Nuremberg debated how to combat the growing Turkish threat. Süleyman's European ambitions were thwarted only in October 1529, when he retreated after his unsuccessful siege of Vienna.

Closer to home, the German Peasants' War began in 1524 but peaked between February and June 1525.[7] Disaffected peasants, who sought better social and economic conditions, revolted in Thuringia, Franconia, Swabia and Württemberg. Their armies sacked monasteries, castles and towns. The peasants were brutally suppressed, with over 100,000 casualties. In the *Instruction in Measurement*, published the same year, Dürer included a two-part woodcut design for a monument commemorating the defeat of the peasants (166).[8] His accompanying text begins: 'If someone wishes to erect a victory monument after vanquishing rebellious peasants, he might use paraphernalia according to the following instructions.'[9] On the base they should place tied-up cows, sheep and pigs. On the block above, Dürer has set four baskets filled with butter, eggs, onion and herbs. The column consists of a strong chest, an upside-down kettle, a cheese bowl covered with a thick plate, a 3-foot-high keg of butter with a spout, a milk jug, four rods on which hang hoes, pitchforks, flails and other peasant tools. Surmounting this is a chicken basket topped with a lard tub. On this 'sits a sad [melancholy] peasant with a sword stuck into his

166
*Peasant
Monument,*
1525
Montage of
two woodcuts
in the
*Instruction in
Measurement*
(Nuremberg,
1525), folios
J1 recto and
verso; base:
6.4 × 18.5 cm
(2½ × 7¼ in);
column:
22.2 × 7.5 cm
(8¾ × 3 in)

back, as I have drawn'. This is hardly the sort of triumphal column that Dürer might have seen in Italy or in Italian prints. Scholarly readings of this image have spanned the modern political spectrum from the artist belittling the peasants for their rebellion to his sympathy for the underclass, stabbed in the back by the princes and civic authorities. Dürer's depictions of peasants (see 130) before 1525 are generally caricatures showing thick bodies, coarse faces, and often crude behaviour.[10] The mock-heroic composition of this column hardly suggests his support for the peasants. How proverbial was a stab in the back in 1525? Was the wound self-inflicted or was the peasant betrayed? Or was this the sword of justice administered to law breakers? In his treatise Dürer followed

this memorial with another, dedicated to the drunkard. Neither shows its subject positively. Dürer's attitude probably reflected that of Luther, who bitterly condemned the peasants and their revolt against authority but also faulted the princes for limiting the peasants' access to the word of God.[11] Nuremberg was spared the worst of the upheavals, yet its concerned citizens received reports of battles and negotiations. For example, the peasants and their allies who had seized Würzburg were forced to surrender the city on 6–8 June, concurrent with the *Dream Vision*.

The year 1525 was one of high drama and permanent change in Nuremberg. For Dürer and his contemporaries religion was foremost in their minds. Threatening Turks and marauding peasants might be perceived as a warning from God. Following twelve days of intense debate between local Catholics, as represented by Franciscan and Dominican preachers, and Protestant theologians, Nuremberg's Greater Council voted on 17 March to adopt Lutheranism.[12] Dürer, a council member since 1509, must have listened to the debates and participated in council deliberations. He is also documented among a small group, known as the Sodalitas Staupitziana, who from 1516 gathered at the local Augustinian church to listen to the sermons and thoughts of Johann Staupitz, general vicar of the Augustinian order and Luther's mentor. By 1519, under the informal direction of Lazarus Spengler, the city secretary and Dürer's neighbour, the members referred to their group as the Sodalitas Martiniana, reflecting their interest in Luther's ideas.[13]

Dürer's preoccupation with these religious discussions is well documented. In his biography of Jan van Scorel (1495–1562) Van Mander recounts that the Dutch painter stopped in Nuremberg, probably in 1519, and stayed a while with Dürer.[14] 'But since at that time Luther began to stir up the peaceful world with his teaching, and because Dürer also began to involve himself somewhat with these matters', Van Scorel, a Catholic cleric and

later canon, continued his journey to Austria and Italy. In his letter
of early 1520 to Georg Spalatin, Friedrich the Wise's secretary,
Dürer wrote: 'God helping me, if ever I meet Dr Martin Luther,
I intend to draw a careful portrait of him from the life and to
engrave it on copper, for a lasting remembrance of a Christian man
who helped me out of great distress. And I beg your worthiness to
send me for my money anything new that Dr Martin may write.'[15]
Dürer avidly collected Luther's publications. Prior to his trip to the
Netherlands, the artist possessed sixteen texts that Luther wrote
between 1516 and 1520.[16] While in Cologne, waiting for Charles
V to decide about his pension, Dürer purchased one of Luther's
tracts and the *Condemnatio Lutheri*, a response to Luther's writing
by the theologians at the universities of Cologne and Leuven.[17]
In late June 1521 he gave his *Three Books* to Cornelius Grapheus,
Antwerp's city secretary, in exchange for Luther's *Babylonian
Captivity*, which had first appeared in October 1520.[18]

The longest entry in the Netherlandish journal is Dürer's poignant
lament over the misinformation that Luther had been seized
and possibly killed as he returned under safe conduct from the
imperial diet at Worms.[19] Dürer feared the worst, even though it
was subsequently learned that Luther had been spirited away for
his own protection to Wartburg Castle, above Eisenach, at the order
of Friedrich the Wise, his benefactor. The artist remarks that Luther
'has suffered for the truth of Christ and because he rebuked the un-
Christian papacy, which strives with its heavy load of human laws
against the redemption of Christ. … Every man who reads Martin
Luther's books may see how clear and transparent is his doctrine,
because he sets forth the holy Gospel.' Dürer repeatedly stresses
the absolute importance of the Word of God and Luther's role in
preaching 'the holy, pure Gospel, which is not obscured by human
doctrine'. He rails against what he and others see as papal oppression
and avarice. At one point he urges God to 'destroy this self-assumed
authority of the Roman Chair'. He naïvely pleads for Erasmus to
take up Luther's cause and thereby 'attain the martyr's crown'.

The nascent challenge to the Catholic Church roiled Germany during the 1520s. While many artists, including Lucas Cranach the Elder and Albrecht Altdorfer, embraced Lutheranism, Dürer stands apart in leaving documentation, such as his journal comments, concerning his active intellectual and spiritual engagement in this religious debate. He knew several of the leading reformers. Andreas Bodenstein von Karlstadt, one of Wittenberg's foremost preachers before his radical turn in 1522–3, dedicated his pamphlet on the proper veneration of the Holy Sacrament to Dürer, a 'benevolent supporter', in 1521.[20] Two years later the artist sent his greetings to Ulrich Zwingli, the radical Swiss reformer, whom Dürer had met during his trip to Zürich in the spring of 1519.[21] Although he never encountered Dürer, Luther praised the artist soon after learning of his death.[22] The Nuremberg master was closest, however, to Philipp Melanchthon (see 176), as will be discussed below. Dürer complained about religious abuses, including the wildly popular pilgrimage to the shrine of the Beautiful Virgin in Regensburg. On the bottom of his copy of Michael Ostendorfer's woodcut of c.1520 celebrating the pilgrimage, he penned: '1523. This spectre has arisen against the Holy Scripture in Regensburg and is permitted by the bishop because it is useful for now. God help us that we do not dishonour the worthy mother of Christ in this way but [honour] her in His name, Amen.'[23] Once again he added to his autobiographical record.

Dürer grappled with changing attitudes about the appropriate forms and uses of religious art.[24] Reformers advocated the radical curtailment of art within churches. In his pamphlet *About the Abolishing of Pictures and How Christians Should Not Be Begging*, published in Wittenberg on 27 January 1522, Karlstadt called for the destruction of religious art as the best means for purging 'idols' from one's eyes, heart and mind. Within days Karlstadt's followers destroyed most of the paintings and sculptures in Wittenberg's parish church. Zürich soon followed, sanctioned by Zwingli. Attacks on art became commonplace across the German-speaking

lands. Luther softened his early anti-image remarks perhaps because of his friendship with Cranach. He eventually argued for the pedagogical benefits of a very limited use of biblically appropriate art, such as a single altarpiece illustrating such a theme as the Last Supper or Baptism of Christ, within places of worship. For painters and sculptors the situation was potentially dire since most relied heavily on religious commissions for their livelihoods. Dürer felt that the criticism of art was misplaced. In the dedication to Pirckheimer of the *Instruction in Measurement*, he writes:

> And ['all eager students of Art'] will not be misled by those now among us who, in our own day, revile the Art of Painting and say that it is the servant to Idolatry. For a Christian would no more be led to superstition by a picture or effigy than an honest man to commit murder because he carries a weapon by his side. He must indeed be an unthinking man who would worship picture, wood or stone. A picture therefore brings more good than harm, when it is honourably, artistically and well made.[25]

The Nuremberg artist's output of new paintings and prints, however, dropped dramatically in the 1520s when compared with earlier decades. Poor health was a factor. Dürer devoted much of his energies to his theoretical treatises and, secondarily, to portraiture, although one could argue that this shift to ideologically safe ground occurred as a result of the prevailing image debate. Nevertheless, he did continue to make religious art. His last known painting, now lost, was a small grisaille of *Christ Carrying the Cross* of 1527.[26] The character and themes of his religious images did, however, change. As already anticipated by the *Virgin with the Swaddled Child* of 1520 (see 148), Dürer's late style is simple and often quite spare. He emphasized figures, not the lighting pyrotechnics or complex compositions of his great engravings of the early 1510s. From 1522 onwards, Dürer represented only Christ, Mary and their disciples – that is, subjects grounded in the Bible, the Word of God.

167
Enthroned Virgin and Child with Saints and Music-Playing Angels, c.1521
Pen and ink; 31.5 × 44.4 cm (12⅜ × 17½ in)
Musée Bonnat, Bayonne

While still in the Netherlands and after his return to Nuremberg,
Dürer prepared numerous sketches for an enthroned Virgin and
Child surrounded by saints (167).[27] This general configuration
harks back to Venetian *sacra conversazione* paintings. Nothing
is known about the patron or project details. Unusually, the
artist kept changing his mind about the number of figures
and the overall appearance, including whether the format
should be horizontal or vertical. One might dismiss this scene
as unimportant were it not for the stunning character of his
drawings for individual saints. Particularly impressive is *Saint
Apollonia* (168), who may be identified by the pincers with
a tooth, the symbol of her martyrdom, that she holds in the
Bayonne compositional sketch.[28] Whether based on a model or
from his imagination, Apollonia is monumentally conceived. The
artist captured her quiet dignity and palpable physical presence.
As Strieder notes, Dürer located the figure as though standing
with her back to a light-filled window.[29] Dark shadows carry the
burden of defining the body. Apollonia anticipates the physical and
spiritual strength of the *Four Apostles* (169, 170).

This same spare, essentialized aesthetic occurs in his *Last Supper* woodcut of 1523 (171).[30] It is the only narrative religious print that Dürer made after returning from the Netherlands. Originally, he may have intended it to be part of an oblong-format Passion series. The woodcut stands alone as a statement of the artist's faith. When compared with the same subject in his *Large Passion* (172) of 1510, his thematic and stylistic objectives are strikingly different.[31] The earlier print is filled with drama as Christ announces that one of his disciples will betray him. The men gesture wildly. The complex interplay of light and shadow animates their faces. The disciple at left pouring wine is largely in the shadows while, opposite, light broadly illuminates Judas's back and head, which turns from Christ. The balanced arrangement of the lower half of the composition and asymmetry of the groin vaults heighten the tension. The 1523 woodcut exhibits much simpler lighting and spatial schemes. Christ is positioned left of centre. Judas has departed. The remaining eleven apostles quietly attend Christ's words. Their poses, while varied, are subdued.

The later print illustrates a different moment in the biblical story. The chalice on the table and the bread with the wine pitcher on the floor allude to the heated contemporary debate about the Eucharist, specifically about the nature of consecrated wine and the host as well as whether the laity should receive both, instead of just the bread, during communion. (Karlstadt's treatise dedicated to the artist had addressed just this topic.) Holy Communion in both kinds was first celebrated, although without civic sanction, in the Augustinian monastery in Nuremberg on the Thursday before Easter 1523.[32] While the wine and the bread, markers of Protestant liturgical identity, are clearly present and of theological consequence, Christ holds neither. Instead, as Price has astutely remarked, Dürer emphasized Christ speaking.[33] Gesturing with his open left hand, he preaches the Word of God. Following Judas's departure, Christ issues a new commandment 'to love one another. Just as I have loved you, you also should love another.

168
Saint Apollonia,
1521
Black chalk on green prepared paper;
41.4 × 28.8 cm (16⅛ × 11⅜ in)
Kupferstich-kabinett, Berlin

169
Four Apostles
(left side: John
the Evangelist
and Peter),
1526
Oil on
lindenwood;
214 × 76 cm
(84¼ in ×
29⅞ in) Alte
Pinakothek,
Munich

170
Four Apostles
(right side:
Mark and
Paul), 1526
Oil on
lindenwood;
215 × 76 cm
(84⅝ in
× 29⅞ in)
Alte
Pinakothek,
Munich

171
Last Supper,
1523
Woodcut;
21.4 × 30.1 cm
(8⅛ × 11⅞ in)

172
Last Supper,
1510
Woodcut in the
Large Passion
(Nuremberg,
1511);
39.8 × 28.7 cm
(15⅝ × 11¼ in)

By this everyone will know that you are my disciples, if you have love for one another' (John 13:34–5). He lovingly cradles John the Evangelist. In John 14 and 15 Christ expounds on the central importance of love for his earthly ministry. Luther made this commandment the focal point of the preface (folio 3 verso) to his *Septembertestament*, his 1522 German translation of the New Testament, which Dürer either owned or had ready access to. Luther used the passage as biblical proof of the doctrine of justification by faith alone, which stands at the heart of his theology.

Unlike the *Last Supper* woodcut with its broad audience, Dürer created his *Four Apostles* (see 169, 170) as a gift to Nuremberg's civic leadership.[34] This gesture provides a context for understanding his last great painting. The two life-size panels constitute a new type of religious art, unhinged from conventional devotional utility. From its inception, as demonstrated by technical examinations, it was designed to hang on the walls of a room in Nuremberg's Rathaus. It was not used for any form of pious Christian veneration or worship. Rather, the paintings served as a warning to all against moral or religious improprieties, much like the Last Judgements and Justice scenes that adorned many German city halls. Saints John the Evangelist and Peter, on the left, are paired with Mark and Paul. The title of the *Four Apostles*, first used in 1538 when Georg Pencz was paid by the city for gilding the frame, is inaccurate since technically Mark was an evangelist, not an apostle. The figures are identified by their attributes and accompanying inscriptions. John and Paul, shown in full length, dominate. Their stable poses and serious expressions enhance their spiritual authority. Paul, like Saint Apollonia, is back-lit. The fiery intensity of his gaze, rising out of the shadows, uncomfortably pierces the viewer's consciousness.

Dürer chose his protagonists carefully. Luther's theology, especially his concept of human salvation, is rooted in the writings

of John and Paul. In the foreword to his *Septembertestament* he singles out John's gospel plus the epistles of Paul and Peter as 'nobler' than the rest of the gospels. Mark's inclusion is explained by his scroll, which is inscribed, 'The beginning of the good news [*Evangeli*] of Jesus Christ, the Son of God' (Mark 1:1), the opening words of his gospel. Dürer emphasized the Word of God as central to, and the starting-point of, his own faith. Only Peter holds a key rather than a text. Peter is traditionally associated with the papacy and the key, his attribute, with papal authority to bind and loose, such as the power of excommunication. Here Peter's position is decidedly secondary. He glances down at John's open book as though to affirm that the divine word, rather than human institutions, is the proper foundation of the Christian Church.[35]

Each saint authored one of the biblical texts that Johann Neudörfer, the mathematician and calligrapher, carefully inscribed at the bottom of the panels. All of the German citations derive from the *Septembertestament*. The passage from 2 Peter 2:1–3 begins: 'But false prophets also arose among the people, just as there will be false teachers among you, who will secretly bring in destructive opinions.' This warning is reiterated in 1 John 4:1–3, which starts: 'Beloved, do not believe every spirit, but test the spirits to see whether they are from God; for many false prophets have gone out into the world.' These false prophets, John says, are the agents of the Antichrist. Paul (2 Timothy 3:1–7) and Mark (12:38–40) condemn the dishonest, the unholy 'lovers of themselves'. Mark's passage reads in part: 'Beware of the scribes, who like to walk around in long robes, and to be greeted with respect in the market places, and to have the best seats in the synagogues. … They devour widows' houses and for the sake of appearance say long prayers.' This union of text and image is unique within Dürer's paintings. He presented the four saints as authoritative witnesses, preachers whose words are directed at all who view the panels. Dürer prefaced these passages with his own counsel, a paraphrase of Revelation 22:18–19: 'All worldly rulers in these dangerous

times should give good heed that they receive not human misguidance for the Word of God, for God will have nothing added to His Word nor taken away from it. Hear therefore these four excellent men, Peter, John, Paul and Mark, [and] their warning.'[36]

Whom did Dürer fear? Catholics? Rampaging peasants? Luther was hardly alone in challenging the Catholic Church. Numerous competing evangelical sects arose during the 1520s, and each claimed its own exclusive, God-given authority.[37] In 1525 Luther published an influential sermon warning against false prophets. Within Nuremberg concern was greatest over the growing influence of the Anabaptists, who were known as the 'Spiritualists' since they believed in the continuing revelation of God's words through the Holy Spirit. In January 1525 Georg Pencz and the Beham brothers, Sebald and Barthel, artists associated with Dürer, were expelled briefly from the city for their 'godless' beliefs. They were linked with Hans Denck, rector of Saint Sebaldus's school since September 1523. After examining his mystical, Christ-in-us beliefs, the council permanently exiled Denck on 21 January 1525. Through censorship the council hoped in vain to control the flow of heretical ideas into the city. They banned the writings of the radical spiritualist Thomas Müntzer, who influenced Denck, in late 1524, followed by the texts of Karlstadt and Zwingli, among others, on 14 July 1526.

A brief dedicatory letter accompanied Dürer's gift of the two panels to the city council in late September or the beginning of October 1526. This reads in part:

> I have been intending for a long time past to show my respect for your Wisdoms by the presentation of some humble picture of mine as a remembrance; but I have been prevented from so doing by the imperfection and insignificance of my works, for I felt that with such I could not well stand before your Wisdoms. Now, however, that I have just painted a panel upon which I have

bestowed more trouble than on any other painting, I
considered none more worthy to keep it as a reminiscence
than your Wisdoms.[38]

On 5 and 6 October the council acknowledged and accepted the
paintings.[39] Representatives met with the artist and ultimately
reciprocated with a gift of 100 gulden plus a tip of 12 gulden for
Agnes and 2 gulden for his unnamed assistant. In 1547 Neudörfer
stated the pictures hung in the upper government chamber
('in der obern Regiments Stube').[40] Dürer knew the individual
members of the Inner Council well. They also respected him.
In late May 1527 Dürer and Lazarus Spengler were the only
citizens asked to join the Inner Council leaders when they hosted
Strasbourg's two envoys returning from the imperial diet in
Regensburg.[41] A member of the Greater Council and personally
immersed in the confessional debate, Dürer intended his *Four
Apostles* as an affirmation of the government's current Lutheran-
oriented policies. The leaders were faced as never before with
daily responsibilities for the religious life of the city, its churches,
schools and citizenry.

The *Four Apostles'* stay in the Rathaus lasted only a century. Dürer
sought a prominent civic setting for the paintings. With the art in
churches under iconoclastic threat, the placement of the panels in
an important secular building would assure their protection. He
was conscious of the paintings' function as a monument to his own
artistic skills, religious beliefs and reputation. Coincidentally, on 6
October the council ordered the transfer of Dürer's *Charlemagne*
and *Sigismund* (see 133, 134) to the Rathaus from the house of
Hans Fütterer on the Hauptmarkt, where formerly it had been
used during the now suppressed Feast of the Holy Lance.[42] These
were not the only paintings by Dürer exhibited in the city hall.
There are various reports, including that of Karel van Mander,
who visited in 1577, that the city possessed the *Self-Portrait* of
1500 (see 75) and a portrait of his mother, among others.[43] Not all

of these provenances can be verified. Reluctantly, the city sold the
Four Apostles to Maximilian I, elector of Bavaria (r. 1597–1651), in
1627.[44] At this moment in the Thirty Years' War (1618–48), when
Catholic forces were in the ascendancy, Protestant Nuremberg
was in no political position to deny the powerful prince's request.
Upon the arrival of the panels in Munich, Maximilian ordered the
offending texts at the bottom to be sawn off. He sent these back
to Nuremberg along with an inscription-less copy of the painting
now attributed to Georg Vischer (master 1625), a court artist. The
inscriptions were carefully preserved and re-attached in 1922.
The *Four Apostles* stands as a poignant memorial to Dürer's faith.
Although Pirckheimer grew disgusted with the Protestants, 'who
make the Popish look pious by contrast', the artist remained a
follower of Luther.[45] When Agnes died in 1539, she established a
permanent endowment of 1,000 gulden supporting the theological
studies of 'the son of an artisan' at the University of Wittenberg.[46]
This gift may reflect discussions that she had with her husband.
In the late 1520s a permanent break between Catholics and
Protestants had not yet occurred. Many on both sides of the
confessional divide hoped for reform and reconciliation of their
Christian faith.

Dürer's preoccupation with his own reputation is manifested in
his late portraits and his theoretical writings. In the former he
marked the fame of his celebrated sitters, his personal associations
with them and his own pictorial skills. His treatises testify to the
artist's practical intellect. Dürer created portraits throughout his
career, yet those made following his Netherlandish trip have a
distinct commemorative character.[47] During the imperial diet of
1522 in Nuremberg, the artist renewed his friendship, and even
discussed his dreams, with Ulrich Varnbüler.[48] His monumental
woodcut portrait (173), closely based on a black and brown chalk
drawing now in Vienna (Albertina), is of equal scale with, but
quite different in spirit from, the iconic posthumous print of
Emperor Maximilian I (see 144). With his large floppy hat, fleshy

173
Ulrich
Varnbüler,
1522
Woodcut;
43 × 32.6 cm
(16⅞ × 12⅞ in)

features, scruffy beard and variable lighting Varnbüler seems to
breathe, as though he is only momentarily frozen in time in his
near-profile pose. The figure is placed before a darkened wall.
The upper tip of his hat overlaps the blank strip reserved for text.
Varnbüler's tangible three-dimensionality is juxtaposed with the
spatially ambiguous inscription tablet at right. Is the latter, with
its curling edges, affixed to or floating before the wall? Dürer
playfully complicated the space, perhaps as a pictorial counterpart
to a humanist's wordplay. This element of whimsy is evident,
too, in the two Latin inscriptions. The sitter's name and date are
rendered in upper-case Roman script. The artist's name, done with
calligraphic flourishes, is in Gothic script. The text reads: 'Albrecht
Dürer of Nuremberg endeavours in this manner to portray Ulrich,
surnamed Varnbüler, Secretary of the Imperial Roman Regiment
and simultaneously Master Scribe, because of his singular

affection for him, and also to honour him by rendering this image for posterity.'[49] A horizontal strip, masking one or more letters in several of the lines, offers a philological puzzle to the enterprising viewer. The missing letters, when combined with the expanded abbreviations, state, 'an image honouring the respected jurist'. In 1522 Pirckheimer dedicated his edition of Lucian's *Navis seu vota* dialogue to Varnbüler.[50] Book and print are gestures of the three men's camaraderie. The artist knew this woodcut would never be as marketable as Maximilian's portrait.

Dürer was not the first German artist to make printed portraits of celebrated men, yet his are unarguably the most famous.[51] Between 1519 and 1526 he crafted six engravings of five of the most renowned princes and thinkers of his age. Only Luther was missing from this pantheon. These men also benefited from their being portrayed by the empire's most distinguished artist. Dürer's depictions in 1519 and 1523 of Cardinal Albrecht von Brandenburg, elector and archbishop of Mainz (r. 1514–45), were commissioned by the most powerful Catholic official in the empire.[52] Friedrich the Wise, elector of Saxony, was among the artist's first and most steadfast patrons. When Dürer drew his portrait in January or February 1523, during the imperial diet in Nuremberg, Friedrich was suffering from gout. The prince, who subsequently died in 1525, had limited mobility in his hands and feet. The resulting engraving (174) stresses his thoughtful gaze without minimizing Friedrich's wrinkles and weary demeanour.[53] Light and a nearby window reflect off his eyes. Although richly dressed, Friedrich lacks the chains and jewellery found often in Lucas Cranach the Elder's portraits of him. Dürer instead emphasized his sitter's inherent dignity.

The format of a bust-length portrait set behind a carved stone inscription tablet consciously emulates ancient Roman gravestones. Konrad Peutinger, Dürer's former collaborator, avidly collected examples found in and around Augsburg.[54] Although

174
*Friedrich the
Wise*, 1524
Engraving;
18.1 × 12.8 cm
(7⅛ × 5 in)

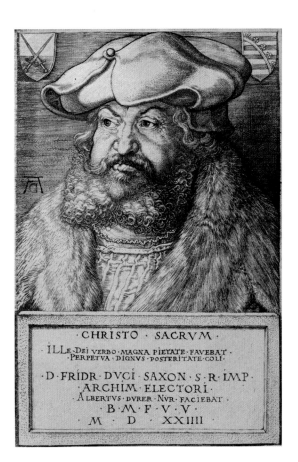

interested primarily in the texts, the humanist's research fostered
a better understanding of these Classical memorials among artists
such as Hans Burgkmair and Dürer. The Nuremberg master used
Roman capital letters of varying heights in his print. The Latin text
reads in translation: 'Sacred to Christ. He served the Word of God
with great piety. Worthy to be revered by posterity forever. The
Lord Friedrich, Duke of Saxony, Arch-marshal of the Holy Roman
Empire, Elector. Albrecht Dürer of Nuremberg made this. He made
it for the highly honourable one from life. 1524.' Friedrich's piety
and his protective patronage of Luther merit eternal fame. The
last line stresses Dürer's personal contact with the prince and the
veracity of the likeness. Mende notes the careful vertical alignment
of the names Christ, Friedrich and Dürer, one that accents the
artist's own Luther-influenced faith.[55]

When Dürer portrayed Pirckheimer (175) in the same year, he omitted the shaded back wall and coats of arms seen in Friedrich's engraving.[56] Nothing distracts from the humanist's immense head. The cascading waves of flesh, rippling nose, focused eyes, prominent forehead and rather unruly hair convey a powerful, indeed highly temperamental, personality, one that Dürer knew so well. Philipp Melanchthon would later remark that the artist often bested his learned friend when they argued.[57] It is easy to visualize this face erupting emotionally during their discussions. In 1523 Pirckheimer gave up his public duties, including his seat on the Inner Council, in order to devote himself to his scholarship. He also suffered from gout. Both factors may have prompted the reflective character of the 'chiselled' inscription: 'Portrait of Willibald Pirckheimer in his 53rd year. He will live on through his intellect, the rest is destined to die. 1524.' Pirckheimer's choice of text, taken in part from a collection of Classical writings known as the *Appendix Vergiliana*, in his library, reflected his meditations on mortality and immortality. His writings, like Dürer's art, would survive their respective deaths. Pirckheimer sent his engraved portrait to friends and family members. In 1525 Erasmus wrote to Pirckheimer: 'I have just received the ring and medal of Willibald, and the most happy picture from the hand of Dürer. I have adorned the walls of my bedroom with these, so that wherever I turn I am seen by the eyes of Willibald.'[58] Other impressions served as bookplates.

This topos of enduring fame recurs, but with a different twist, in *Philipp Melanchthon* (176), Dürer's finest engraved portrait.[59] The text reads: '1526. Dürer was able to depict Philipp's features as though living, but the practised hand could not portray his soul.' That is, Dürer skilfully records the scholar's appearance, but his true essence transcends the boundaries of art. There is a bit of false modesty expressed here, since the artist did his utmost to portray Melanchthon as an inspired thinker. He accented the sitter's eyes, the organ of the strongest of all senses, and his massive forehead,

175
Willibald
Pirckheimer,
1524
Engraving;
18.1 × 11.5 cm
(7⅛ × 4½ in)

176
Philipp
Melanchthon,
1526
Engraving;
17.4 × 12.9 cm
(6⅞ × 5⅛ in)

BILIBALDI·PIRKEYMHERI·EFFIGIES
AETATIS·SVAE·ANNO·L·III·
VIVITVR·INGENIO·CAETERA·MORTIS·
ERVNT·
M·D·XX·IV·

1526·
VIVENTIS·POTVIT·DVRERIVS·ORA·PHILIPPI
MENTEM·NON·POTVIT·PINGERE·DOCTA
MANVS

the seat of the intellect. Melanchthon is literally presented as a 'highbrow', much in conformance with Greek teachings on physiognomy, where a person's external appearance was believed to reflect the inner character.[60] The portrait, set against the sky, is figuratively filled with lofty thoughts. Dürer and Melanchthon were good friends. In November 1525 the city council brought Melanchthon, a professor of Greek at the University of Wittenberg and Luther's closest colleague, to Nuremberg. He devised the curriculum for the new Latin school at the Egidienkloster. This served as the prototype for Protestant schools across the German-speaking lands for the next several centuries. During this visit the scholar stayed with Pirckheimer and frequently had contact with Dürer. Perhaps the engraving was completed when Melanchthon returned to deliver the dedication oration for the school in May 1526. Did Dürer give him the copper plate (177)? Unlike the numerous extant woodblocks (see 45), few of Dürer's original intaglio plates survive.

Dürer experienced different challenges when creating his engraved portrait of Erasmus (see 114).[61] He sketched the famed humanist (see 151) twice during his Netherlandish trip in anticipation of making a painted or engraved portrait. For various reasons, not the least of which was the artist's disappointment that Erasmus did not come to Luther's support, the project languished for several years. Twice Erasmus urged Pirckheimer to encourage Dürer. 'I wish that I too could be portrayed by Dürer. Why not by such an artist? But how can it be accomplished? He started my portrait in charcoal in Brussels, but I imagine that I have been long put aside.'[62] Badgered by Pirckheimer, Dürer resumed the task, although for models he had only his earlier drawings and, at Erasmus's suggestion, the portrait medal from 1519 by Quinten Massys, which Pirckheimer possessed. As a result, the artist emphasized action over likeness. Like a modern Saint Jerome, to whom Erasmus was often compared, the scholar stands at his writing desk, as was his custom, and composes a letter. Two other letters rest by his side. He

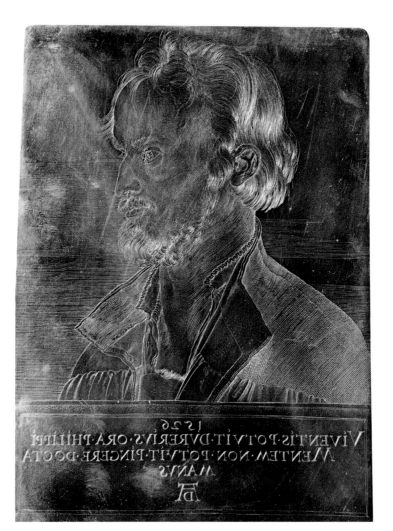

177
Philipp Melanchthon,
1526
Copper engraving plate;
17.3 × 12.6 cm
(6¾ × 5 in)
Schloss-museum,
Gotha

epitomizes scholarly insight and industry. The arrangement with
Erasmus working and surrounded by books harks back to a version
of Massys's painted portrait of Erasmus from 1517, which Dürer
probably saw while in Antwerp.[63]

Nevertheless, Dürer's intentions were far more ambitious. His
homage to Erasmus is also a sophisticated statement about *kunst*,
the art of art. He partially resolved the problem of likeness by
placing Erasmus back in space and minimizing the scale of the
head relative to the overall composition. His powers of observation

are showcased in the complex curving folds and shading of Erasmus's doctoral gown and hat. These establish his volumetric presence. The exquisite still-life of lilies of the valley and violets arranged in the pitcher and the textural exposition of the books in the foreground attest to Dürer's profound abilities to replicate physical objects. At the heart of the image are Erasmus's active hands. By locating these at the intersection of the scene's primary diagonals, Dürer draws the viewer's attention to the integral role of geometry. The *Instruction in Measurement*, the first of his published treatises, appeared the previous year. As will be discussed shortly, in Dürer's theory geometry is central to the intellectual foundation that all knowledgeable artists must possess. He showcased this concept here by structuring his space using parallel planes, right angles and one-point perspective. The orthogonal lines converge at the centre of the Greek inscription. Dürer played too with the viewer's expectations. We read the framed tablet as a solid form. It carries the Latin and Greek inscriptions: 'Portrait of Erasmus of Rotterdam drawn from life by Albrecht Dürer. His writings provide a better picture. 1526.' The tablet simultaneously suggests a window, which one would expect to provide the necessary illumination for the scholar. If writings offer a truer portrait of Erasmus than this one drawn from life, the engraving, in turn, offers a truer portrait of Dürer's skills as an artist who combines consummate craft with knowledge, nature with theory. Dürer boldly presented himself as Erasmus's artistic counterpart. Although Erasmus expressed disappointment that the portrait did not look like him, this engraving has largely shaped posterity's image of the great scholar.[64]

During the 1520s Dürer sketched and/or painted portraits of other powerful princes, merchants (including three members of the Fugger family), local patricians, scholars and artists such as Lucas Cranach (1524).[65] Among the artist's circle of friends was Hieronymus Holzschuher (1460–1529), a member of one of Nuremberg's oldest families. Dürer brought him a very large

animal horn from the Netherlands. Holzschuher participated in the Sodalitas Staupitziana and, as a leader of the Inner Council, in the city's embrace of Lutheranism. Yet, as noted by Caritas Pirckheimer, Willibald's sister and the abbess of Saint Klara's, Holzschuher was a voice for moderation as the city grappled with its new confessional identity.[66] Whether Dürer's portrait of Holzschuher at the age of fifty-seven (179) was a commission or a token of friendship is unknown.[67] The attire and arrangement of the figure recall the engravings of Friedrich the Wise and Pirckheimer. Here, however, Holzschuher stares directly at the viewer. Somewhat furtively out of the corners of his eyes he examines us, just as we study his features. The tactility of fur, hair and flesh heightens his realistic presence. Gone is the inscribed parapet used in the prints to provide a safe barrier between the sitter and his audience. Perhaps, too, the facial expression, one that seems on the edge of either a smile or a frown, explains the portrait's beguiling attraction.

Beyond its aesthetic appeal, this portrait is noteworthy since its original frame and cover (178) survive. The thick wooden frame includes a slotted opening into which a separate panel can be slid. This cover is painted with the date 1526 and the coats of arms of Holzschuher (a wooden shoe) and his wife, Dorothea, the daughter of the noted astronomer Hieronymus Müntzer. Protective covers, whether of this form or as a folding diptych (see 10, 11), were once commonplace.[68] Unfortunately, such covers were often discarded in later centuries as portraits changed from being family documents to collectable works of art. Valuable information about the sitters' identities and dates was irretrievably lost as well.

Dürer's *Johann Kleberger* (180), his most unusual commissioned portrait, and perhaps his last, was painted in 1526.[69] The nearly square composition blurs the boundaries between painting and sculpture as well as between fictive and real spaces. Dürer presented Kleberger, a Nuremberg merchant, as a living sculpture.

178
*Hieronymus
Holzschuher*
with original
frame
Lindenwood;
60.5 × 50.5 cm
(23⁷/₈ × 19⁷/₈ in)
Gemäldegalerie,
Berlin

179
*Hieronymus
Holzschuher,*
1526
Oil on
lindenwood;
48 × 36 cm
(18⁷/₈ × 14¹/₈ in)
Gemäldegalerie,
Berlin

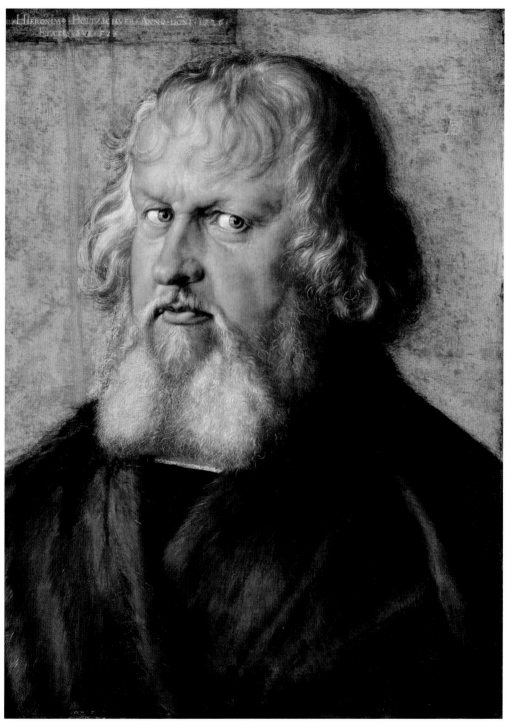

The nude bust terminating just beneath the neck mimics the
form found on many Classical coins and, from 1517–18, German
portrait medals.[70] In 1526 Kleberger ordered two profile portrait
medals of himself *all'antica*.[71] Dürer opted for a three-quarter
rather than a profile view. He placed the bust on the lower rim of a
circle cut through an illusionistic square block of stone. The lower
edge of the disembodied neck projects forwards slightly and casts
a shadow on the vertical surface of the stone. The bust seems to
balance successfully in a limited space between the viewer and the
green marble backdrop, which is inscribed in gold with Kleberger's
name, age (forty) and the zodiacal sign of the sun in conjunction
with Regulus in the constellation of Leo. The artist's monogram
and date, the six stars of Leo, and Kleberger's shield (a rebus of
Klee, represented by three sprigs of clover, and Berg, a stylized
mountain), and armorial helm adorn the four corners.[72] Dürer
emulated a stone bust yet used his colours and talents as a painter
to bring Kleberger to life. He located the bust in a plausible setting
but one that would be difficult to achieve in sculpture. Dürer
clearly had fun devising this ambiguous image, which is perhaps
his playful entry in the *paragone* debate about whether painting or
sculpture is inherently superior.[73]

Kleberger was Willibald Pirckheimer's son-in-law. Despite the
latter's strenuous objections, his eldest daughter, Felicitas, married
Kleberger in 1528, two years after the death of Hans Imhoff, her
first husband, who was Dürer's friend. When Felicitas died in 1530,
Pirckheimer accused Kleberger of poisoning her. Kleberger moved
to Lyon, where he grew wealthy through trade and the fees that
King Francis I authorized him to collect on boats being towed on
the River Rhone. At his death in 1546 he was one of Lyon's ten
richest citizens and known as the 'good German' for his charitable
donations. The painting was subsequently acquired by Willibald
Imhoff, Kleberger's stepson, and sold by Imhoff's heirs to Emperor
Rudolf II in 1588.

180
*Johann (Hans)
Kleberger*, 1526
Oil on
lindenwood
(slightly cut
down on all
sides);
37 × 36.6 cm
(14⅝ × 14⅛ in)
Kunsthistori-
sches Museum,
Vienna

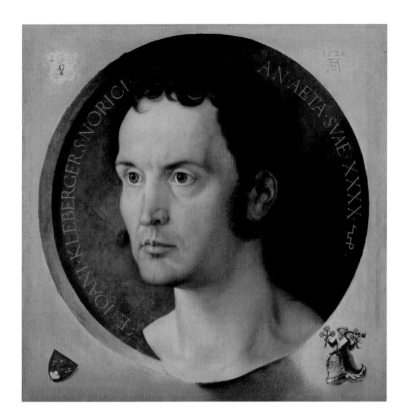

Dürer devoted much of the 1520s to his musings on the theoretical underpinnings of art. He published three treatises: the *Instruction in Measurement* (1525), the *Theory of Fortification* (1527) and *Four Books of Human Proportions* (1528).[74] Death prevented him from completing texts on the proportion of horses and, more broadly, on the art of painting. As he first started writing down his thoughts on art in 1512–13, Dürer observed:

> Many hundred years ago there were still some famous painters, such as those named Phidias, Praxiteles, Apelles, Polycleitus, Parrhasius, Lysippus, Protogenes, and the rest, some of whom wrote about their art and very artfully described it and gave it plainly to the light; but their praiseworthy books are, so far, unknown to us, and perhaps have been altogether lost. … Often do I sorrow because I must be robbed of the aforesaid Masters' books of art; but the enemies of art despise these things.[75]

Implicit in these remarks is Dürer's historical awareness of antiquity's great masters and his sorrow that time has destroyed all vestiges of their creativity other than a few scant references in Classical texts. Beyond their facility with brush or chisel, some of these fabled masters wrote about art. They offered a model for what great artists should do to achieve immortality through images and words. Even without any access to their writings, other than those of Vitruvius, Dürer assumed that they intellectualized art. This conformed neatly with the more humanistically inspired idea that painting was a liberal art rather than a mere craft. As noted earlier, Dürer defined art (*kunst*) as skill and knowledge. He lamented that there were no books 'that I might read for my improvement. For some hide their art in great secrecy and others write about things whereof they know nothing, so that their words are nowise better than mere noise.'[76] To rectify this sad situation, Dürer decided to share what he knew about art. Here and in the texts of his published treatises he stressed the practicality of his lessons for all artists who were eager to learn.

German art had no tradition of theoretical writing beyond a few 'how to' architectural manuals for constructing pinnacles.[77] Furthermore, the German language then lacked a critical vocabulary for artistic and scientific terms. Dürer's linguistic contributions to the development of scientific prose are of great importance. He often had to invent equivalents for Latin and Italian words. For example, there was no word for 'spiral' until Dürer coined '*schnecken lini*' (literally, 'snail line').

Dürer's theoretical interests were stimulated by his two trips to Italy. His early experiments with ideal human proportions are evident in his figure studies, the *Nemesis* and *Adam and Eve* (see 63, 67, 68, 72). Although he empirically understood perspective, he sought advanced instruction. Writing to Pirckheimer on 13 October 1506, Dürer stated that he was planning a trip to Bologna 'to learn the secrets of the art of perspective, which a

man is willing to teach me. I should stay there eight or ten days and then return to Venice.'[78] If the artist actually made this trip, his teacher may have been Luca Pacioli (c.1445–c.1514), a skilled mathematician who was a pupil of Piero della Francesca, a friend of Alberti, and an associate of Leonardo da Vinci. Pirckheimer owned a copy of Pacioli's *Somma di aritmetica, geometria, proportioni e proportionalita* (Venice, 1494). Joachim Camerarius linked Andrea Mantegna with Dürer in the preface (folio A3 recto) to his 1532 Latin translation of the *Four Books of Human Proportions*. On learning that Dürer was again in Venice, Mantegna summoned him to Mantua

> in order that he might fortify his [Albrecht's] facility and certainty of hand with scientific knowledge and principles. For Andrea often lamented in conversation with his friends that Albrecht's facility in drawing had not been granted to him nor his learning to Albrecht. ... But before he could reach Mantua Andrea was dead, and Dürer used to say that this was the saddest event in all his life; for high as Albrecht stood, his great and lofty mind was ever striving after something yet above him.[79]

Whether the story is true matters less than the association between these two great masters in the eyes of Dürer's contemporaries. This episode supports their image of Dürer's continual quest for knowledge.

In 1512 and 1513, before his projects for Emperor Maximilian I consumed much of his time, Dürer prepared various drafts on the art of painting. His unpublished 'Speis der Malerknaben' ('Nourishment for Young Artists') contains many of the core ideas articulated in later writings.[80] His basic thesis is that Germany possesses 'many painters who stand in need of instruction, for they lack all real art, yet they nevertheless have many great works to make'. He stresses the importance of 'the art of painting [which] is made for the eyes, for the sight is the noblest sense of man'. Dürer emphasizes that in the past the great art of painting was held in

such high esteem by kings that they made painters rich. A skilled
artist must have a keen sense of invention. Or, as Dürer says in
one of his most quoted comments: 'For the imagination of a good
painter is full of figures, and were it possible for him to live for
ever he would always have from his inward "ideas", whereof Plato
speaks, something new to set forth by the work of his hand.' Just
as bees draw pollen from many flowers to make their honey, so
artists striving for beauty should 'choose the head from one man
and the chest, arm, leg, hand and foot from others'. This Zeuxian
ideal, named after the ancient painter who supposedly copied parts
of several women when he portrayed Venus, is Dürer's recognition
that his early striving for a single ideal of male or female beauty
(see 67) was flawed. He eventually concluded that beauty, like
human diversity, transcends simple formulas, yet he never adopted
the Italian interest in idealism.

181
*The Principle
of the Constant
Angle of Sight
of a Column
and A Twisted
Column in Plan
and with its
Corresponding
Radial Widths*
Woodcuts in
*Underweysung
der Messung,
mit dem
Zirckel und
Richtscheyt …
(Instruction in
Measurement
with a
Compass
and Rule;*
Nuremberg,
1525),
folio H2v;
28.3 × 10.1 cm
(11⅛ × 4 in)
and folio H3r;
28.5 × 13.2 cm
(11¼ × 5¼ in)

On returning from the Netherlands, Dürer temporarily set aside
his partially written studies on human proportions to focus on the
practical instruction of geometry. The *Underweysung der Messung,
mit dem Zirckel und Richtscheyt* (*Instruction in Measurement
with a Compass and Rule*) was published in Nuremberg in 1525.[81]
Camerarius's Latin translation, which rendered the title as the
Instruction in Geometry, appeared in two parts in 1532 and
1535. A second, revised and expanded German edition, printed
through Agnes's efforts in 1538, included Dürer's new section on
perspective as well as twenty-two more woodcuts. As stated in
the book's dedication to Pirckheimer, the treatise was intended as
a practical foundation in geometry for painters, sculptors and all
who need this skill. The first two chapters explain linear geometry
(point, line, surface and solid) and the construction of two-
dimensional figures. Chapter 3 addresses solid bodies as well as the
use of such practical applications of cones and cylinders as columns
(181) and sundials.[82] It also contains a detailed analysis of the
rational construction of Roman and Gothic script letters. The final
chapter considers the properties of polyhedra, a detailed discussion

of perspective, including shadow projection, and an explanation
of four mechanical aids for drawing. Two devices aid in sketching
a vase and a reclining nude (182, 183).[83] To achieve the proper
foreshortening for a large figure close at hand, here a female nude,
a framed glass pane divided into equal square segments is placed
between artist and subject. Using the top of an obelisk to fix the

position of the artist's eye, he replicates what appears in each
segment on the squared sheet of paper before him.

Dürer drew on a variety of Classical and contemporary sources.
In Venice in 1507 he purchased Euclid's *Opera* (Venice, 1505), the

great ancient text on geometry. In January 1523 he acquired ten
books from the estate of Bernhard Walther, the mathematician
and astronomer, whose house he had bought in 1509. Although
the exact titles are unknown, Walther possessed a manuscript
copy of Leon Battista Alberti's *De pictura*, written 1435–6 but
first published in Basel only in 1540. Dürer paraphrased passages
from Piero della Francesca's then unpublished *De prospectiva
pingendi* (c.1474). Interestingly, the *De artificiale perspectiva* (Toul,
1505) of Jean Pellerin (Viator) influenced some of Dürer's ideas
on perspective, yet a new illustration in Pellerin's second edition
(1509) derives in turn from one of Dürer's woodcuts. He benefited
too from his associations with Johann Tschertte, the imperial court
architect in Vienna, as well as Nuremberg's Johannes Werner, a
mathematician, and Georg Hartmann, a skilled compass maker.

182
Device for Sketching a Vase
Woodcut in
Underweysung der Messung, mit dem Zirckel und Richtscheyt …
(Instruction in Measurement with a Compass and Rule;
Nuremberg, 1538 revised edition), folio Q3 verso;
8.5 × 21.7 cm (3⅛ × 8½ in)

183
Device for Sketching a Reclining Nude
Woodcut in
Underweysung der Messung, mit dem Zirckel und Richtscheyt …
(Instruction in Measurement with a Compass and Rule;
Nuremberg, 1538 revised edition), folio Q3 verso;
7.5 × 21.6 cm (3 × 8½ in)

In 1527 Dürer published his short *Various Instructions for the Fortification of Towns, Castles and Large Villages*, better known as the *Theory of Fortification*, as a practical defensive response to improvements in artillery.[84] He dedicated the book to Archduke Ferdinand I, the brother of Charles V and the crowned king of Bohemia and Hungary in October 1526, who faced the growing threat of the Ottoman Turks. The treatise presents different methods for constructing defensible bastions with bomb-proof storage rooms and shelters, a circular barrage fortification and the plan for an ideal fortified capital city. Dürer's interest in the subject may have been prompted by the siege of Hohenasperg, which he witnessed and sketched in spring 1519 while travelling with Pirckheimer and Martin Tucher on an official mission to Zürich.[85] Some of the ideas of the treatise are represented in the *Siege of a Fortress* (184, 185), a large independent woodcut of 1527.[86] From a high hillside vantage point, as defined by the kneeling onlooker in the right foreground, the viewer has a panoramic view of a town being attacked by a large army that has already despoiled the countryside. The rounded bastion with two rows of cannon openings and flexible gun emplacements on top is augmented by a wide moat studded with two barrage structures. This new defensive solution contrasts with the lower and much more vulnerable walls around the gate on the left.

Dürer died about six months before the publication of the *Four Books of Human Proportions*, on 31 October 1528.[87] Agnes and Pirckheimer, in spite of their enmity, brought it to completion. In a note at the end of Book 4, Pirckheimer stated that the artist had revised only Book 1 and the other three books were issued uncorrected. Hieronymus Andreae and his assistants cut the woodblocks and printed all three treatises. This book is the culmination of Dürer's investigation of the geometric and mathematical bases for human proportions. Dozens of exploratory drawings, especially those now gathered in the *Dresden Sketchbook* (186), and many textual drafts attest to his

184
*Siege of a
Fortress (left
half)*, 1527
Woodcut with
watercolour,
body-colour,
and touches
of gold;
22.7 × 38.1 cm
(8⅞ × 15 in)

185
*Siege of a
Fortress (right
half)*, 1527
Woodcut with
watercolour,
body-colour,
and touches
of gold;
22.5 × 35.2 cm
(8⅞ × 13⅞ in)

186
*Four
Constructed
Heads, Two
Faceted Heads
and Saint
Peter*, 1519
Pen and ink
drawing in
the *Dresden
Sketchbook*;
sheet:
20.6 × 20.6 cm
(8⅛ × 8⅛ in)
Sächsische
Landes-
bibliothek,
Dresden
(R-147, folio
101 verso)

preoccupation, an effort that would be described today as more scientific than strictly practical or artistic in character.[88]

Book 1 presents five different types and female bodies, each shown from the side, front and rear. These are based on Vitruvius' scheme in which the figure's relative proportions are determined by whether the head is one-seventh, one-eighth, one-ninth or one-tenth of the body's overall height. Book 2 offers eight additional types. These are based on an arithmetical system of measurements proposed by Alberti. The side view of the woman (187) is labelled from the crown of the head to the sole of the

187
*Side View of
a Female Figure*
Woodcut in
*Vier bücher von
menschlicher
proportion
(Four Books
of Human
Proportions;*
Nuremberg,
1528), folio
M1 verso;
22.6 × 7.7 cm
(8⅞ × 3 in)

foot.[89] A series of horizontal lines intersect with the central vertical
axis. These lines are marked with numbers and symbols that
are absolute dimensions tied to the overall height. For example,
assuming the height was 180 cm (70⅞ in), the basic unit of
measurement (a *meßstab*) equals one-sixth or 30 cm (11¾ in).
This is further divided into a *zall*, equalling one-sixtieth or 3 cm
(1⅛ in), a *teil* of ¹⁄₆₀₀ or 3 mm (⅛ in), and a *trümlein* of ¹⁄₁₈₀₀ or
1 mm (¹⁄₃₂ in). An accompanying table lists all of the relative
distances. From the crown to the base of the throat is 1 *meßstab*
and 1 *zall*, or the equivalent of 33 cm (13 in) for a figure that
is 180 cm tall. This system is rather unwieldy to use. Book 3
introduces methods for changing the figures, and especially the
heads, through mathematical projection. Dürer's fascination with
distorted physiognomies may have been influenced by Leonardo's
grotesques and figure studies. Book 4 explores human movement
by curving, twisting or bending the body. It concludes with
remarks on using geometric faceting to understand movement.
Amid this somewhat arid scientific exposition, Dürer includes an
aesthetic excursus (folios T1 recto–T4 verso) at the end of Book
3.[90] This textual interlude extols the skilled master who labours
honourably in his art. Dürer recognizes that not all artists are
equally talented:

For this reason a man may often draw something with his pen on a half-sheet of paper in one day or engrave it with his tool on a small block of wood, and it shall be fuller of art and better than another's great work whereon he hath spent a whole year's careful labour. And this gift is wonderful. For God sometimes granteth unto a man to learn and know how to make a thing the like whereof, in his day, no other can contrive; and perhaps for a long time none hath been before him, and after him another cometh not soon.[91]

Presumably Dürer saw himself as just such an artist. He returns again to the issue of beauty. Late in his career, having measured two hundred to three hundred living people, Dürer recognized that beauty was a relative and varied concept for humans. God alone fully comprehends absolute beauty. Guided by the study of nature ('depart not from nature'), one should avoid extremes, such as the deformities included among the book's physiognomic studies. Rather, Dürer stresses the rules of decorum, specifically the importance of the harmony of the parts or *vergleichlichkeit*. 'As everything must be appropriate and right in itself, so the entire ensemble must harmonize; thus the throat must well rhyme with the head and shall be neither too short nor too long, neither too thick nor too thin.'[92] An old man should not be given a young man's hands. Only the well-practised artist has 'no need to copy each particular figure from the life. For it sufficeth him to pour forth that which he hath for a long time gathered unto him from without: and he hath whereof to make good things in his work. Howbeit very few come unto this understanding, though many there be who with greater toil … produce much that is faulty.'[93] A mature, knowledgeable artist is capable of 'painting out of [his] head' to achieve an inward and intuitive synthesis.

Dürer's dedication of the *Four Books of Human Proportions* to Pirckheimer includes the disclaimer, 'No one need blindly

follow this theory of mine, as though it were quite perfect, for human nature has not yet so far degenerated, that another man cannot discover something better.'[94] This raises the issue of the reception of this and his other treatises in a land with no theoretical tradition. In a draft introduction Dürer wrote, 'If I can spark something towards the increase and improvement of art, in time it may become a great beacon that will illumine the entire world.'[95] The most immediate response was a negative one. Pirckheimer sent a copy of the *Instruction in Measurement* to his sister Eufemia, abbess of the convent at Bergen, near Eichstätt. She responded, 'We enjoyed it, but our paintress thinks that she does not need it; she can practise her art just as well without it.'[96] Most artists probably felt the same way. Nevertheless, new editions and translations demonstrate the writings' continued success. Dürer inspired other artists, including Erhard Schön and Sebald Beham within his circle, to create their own treatises; however, these consist primarily of images with little explanatory text.[97] Or, as Schön states in his *Manual of Proportion and the Positioning of Jointed Mannequins* (Nuremberg, 1538): '[Because] my apprentices have many times begged me to make it easier for them to understand the art of proportion and measurement, based on Dürer, Vitruvius and other books, I have ventured to write this little book for my apprentices in the simplest and easiest manner. It is not intended for those who already know art.'[98] In 1604, in his biography of Dürer, Van Mander praised 'that Daedalian work on Analogy or Proportion' as well as his other writings, which had earned the Nuremberg master the 'admiration by ordinary people, … by the learned and those knowledgeable in art, but also by great lords'.[99] His much later readership embraced scholars and artists, including Nicolas Poussin (1594–1665) and Rembrandt.[100] Dürer's treatises stimulated others to reflect critically about art, creativity and knowledge.

On 6 April 1528 Albrecht Dürer the Younger died in Nuremberg.

188
Attributed to
Erhard Schön
Portrait of
Albrecht
Dürer, c.1528
Woodcut;
31.8 × 25.2 cm
(12¹/₂ × 9⁷/₈ in)

To the Memory of Albrecht Dürer. Whatever is mortal in
Albrecht Dürer, reposes under this stone. He departed on
6 April 1528.[1]

Willibald Pirckheimer composed these words for the brass plaque
adorning the artist's tomb (see 197) in the Saint Johannis cemetery
outside the western walls of Nuremberg.[2] In spite of his poor
health, Dürer's death stunned his family and friends. His passage
from mortality to immortality remains an unfinished story. As
his myth has grown, so over time have the uses and abuses of his
person and his legacy. Although much of this account is beyond
the scope of our text, I wish briefly to address the initial responses
to his death, the collecting of his art up until the early seventeenth
century, the Dürer jubilees, and a few artistic homages to Dürer.[3]

Erhard Schön's attributed woodcut (c.1528; 188) is the earliest
celebrity portrait of Dürer.[4] Efforts to honour and, in some cases,
to profit from his memory began immediately after his death.
The profile likeness with short hair is based on a medal of the
artist from 1527 by Mathes Gebel (c.1500–1574). His shield with
its open door, a play on his family name, appears in the upper
left corner. The text above reads: 'Albrecht Dürer represented in
his fifty-sixth year.' Following Schön's own death in 1542, the
woodblock was reprinted at least seven times by other Nuremberg
publishers. Some later impressions include a separate text by Hans
Sachs, Nuremberg's famous Meistersinger, who remarks that
Dürer had 'far surpassed all other masters of his time', and was
honoured by lords and gentlemen, near and far, as well as by all
artistic workers.[5]

A group of Dürer's friends opened his grave the day after he was

buried.[6] They desired a tangible memento once the living artist
was taken from their midst. Writing in 1542, Christoph Scheurl
reports they made a cast of his face. Commemorative death masks,
whether of wax or clay, were then rare, but more common in Italy
than in Germany. Thus his friends' action was quite extraordinary.
The fate of Dürer's cast is unclear, although either the original or a
copy of the face and a separate cast of the artist's right hand were
owned by the painter Frederick van Valckenborch (1566–1623)
in Frankfurt in the early seventeenth century and, after passing
into the collection of Elector Maximilian I of Bavaria, are thought
to have been destroyed, along with other works by Dürer, in the
devastating fire in Munich's Residenz palace in 1729. A separate
wax impression of the artist's hand, reportedly rendered quite
naturalistically, was recorded in Christoph Weickmann's collection
in Ulm in 1659.

These were not the only relics. A lock of Dürer's blond-brown
hair was cut off on this same occasion and sent to Hans Baldung
Grien in Strasbourg.[7] It is unclear whether this was done as
a token of friendship, perhaps at Baldung's earlier request, or
whether it signified that Dürer's mantle as Germany's leading
artist was being passed to the Strasbourg master. In any event,
the subsequent provenance of the hair can be documented fully
through various private collections until it was sold to Vienna's
Akademie der Bildenden Künste in 1873. Encased between two
sheets of glass and framed in silver, the lock of hair is occasionally
displayed to the faithful.

Reactions to Dürer's death came quickly.[8] Pirckheimer and other
Nuremberg humanists informed their correspondents of the news
and their bereavement. Erasmus, Luther, Melanchthon and Georg
Spalatin, among other notables outside the city, commented on
his passing. Sabina Pirckheimer, a nun at Kloster Bergen, tried to
console her brother Willibald, who was 'robbed' of his old and dear
friend. Published eulogies by Erasmus, Christoph Scheurl, Helius

Eobanus Hessus, the mathematician Thomas Venatorius and the theologian Sebastian Franck soon followed. Pirckheimer's elegy is in the first edition of Dürer's *Four Books on Human Proportions*, published on 31 October 1528. For the 1532 Latin translation of this treatise Camerarius composed an extensive introduction that is part biographical panegyric and part glorification of the art of painting.[9] He describes Dürer's appearance, his praiseworthy character, the skill of his hand and various anecdotes, such as Bellini and Mantegna's admiration for the Nuremberg master. Besides the brief account of Dürer's career in Neudörfer's unpublished lives of Nuremberg artists (1547), his biography appears in the influential texts of Giorgio Vasari (1550 and 1568), Karel van Mander (1604) and Joachim von Sandrart (1675). A book devoted solely to Dürer was published in 1728.[10]

Philipp Melanchthon (see 176) knew Dürer well from his stay in Nuremberg in 1525–6. He admired his art and native intellect. On several later occasions Melanchthon offered insights into Dürer's aesthetic aspirations. In his book *Elementa rhetorices* (Wittenberg, 1531), he wrote: 'You can see a similar thing to these three levels of style in pictures. Dürer depicted everything more grand, and diversified his pictures with very many and closely spaced lines. Lucas [Cranach]'s pictures on the other hand are simple, and though attractive, comparison shows how different they are from Dürer. Matthias [Grünewald] kept a middle between Dürer and Cranach.'[11] Melanchthon uses the artists to illustrate comparatively three Classical Greek rhetorical styles, with Dürer's art embodying the grandest manner. He assumes that his readers are familiar with and could distinguish between their works. In 1546 Melanchthon remarked:

> I recall that the painter Albrecht Dürer, a man of the highest talent and skill, once said that in his youth he loved paintings with lively and sparkling colours, and he enchanted an admirer of his works with the marvellous variety of his palette. Later, as an old man, he began to

look closely at nature, and attempted to convey its actual appearance; in the process he realized that it was precisely this same simplicity which was the greatest achievement of art. Since he could not reach it he had, as he said, ceased to admire his own work but often sighed, when he looked at his paintings, and thought of his own weaknesses.[12]

In Melanchthon's telling, Dürer astutely recognized that the style of an artist evolves over time. Youthful pyrotechnics (see 44) yield later to a simpler yet deeper understanding of form. The *Four Apostles* (see 169, 170) exhibits Dürer's mature stylistic distillation.

Dürer himself became an artistic subject. The artist as protagonist first appears in Hans Daucher's *Allegory with Albrecht Dürer* (189), dated 1522.[13] Daucher's monogram, designed in emulation of Dürer's, adorns a small tablet at right. The likeness of Dürer is based on Hans Schwarz's medal of the artist from 1520, a copy of which must have been in Augsburg, where Daucher worked.[14] The precise meaning of the relief remains elusive. As Emperor Maximilian I and others, including perhaps Johann Stabius, his court historian, look on, Dürer fiercely battles an armoured foe. Both men have their blades drawn. Is Dürer fighting with a personification, such as Envy, or with a historical figure? Suggestions that the opponent is Lazarus Spengler, his neighbour and friend, or that Dürer, as the embodiment of burgher virtues, is grappling with a noble in a symbolic feudal conflict are unconvincing. Thomas Eser reads this relief as a historical panegyric honouring both Maximilian and Dürer for advancing Germany's art. He wonders whether the opponent, who is dressed in old-fashioned armour, might be Apelles. If so, then Dürer struggles, seemingly successfully, to despatch and displace Apelles as the true paragon of artists. Maximilian, as a modern Alexander the Great, stands as the German master's patron, mentor and advocate. The date of 1522 may tie this carving with four additional reliefs by Daucher honouring the emperor, who died in 1519, and his successor, Charles V.[15] Regardless of the precise

meaning of the Berlin image, which Dürer probably never
knew, it is fascinating and, for the time, a rare glorification of a
living artist.[16]

In 1553 Hans Lautensack (c.1520–1564/6) painted a view of the
mills on the River Pegnitz with the western skyline of Nuremberg
(190) looming in the distance.[17] The landscape is the setting but
not the main subject. A portrait of Dürer holding a large *cartellino*
('ALBERTVS DVRERVS NORICVS'), his features derived from the
Landauer Altarpiece (see 102), dominates the foreground. The
text records the dates of his birth, incorrectly given as 1472, and
death. The cityscape, while reminiscent of Dürer's watercolour
(see 4), relates to Lautensack's exquisite landscape etchings of
Nuremberg of 1552. Was the painting commissioned by one of
the deceased artist's friends to commemorate the twenty-fifth
anniversary of his death? The picture proudly celebrates Dürer

as a Nuremberger. This link between artist and city, specifically
with Dürer personifying Nuremberg's artistic heritage, became a
popular theme (see 2).[18]

In 1541 Camerarius described Dürer as 'the most accomplished
artist, from whose divine hand many immortal works still exist'.[19]
Paracelsus (d. 1541), the famed medical theorist, called the
Nuremberg master a prophet and, along with Erasmus, a heavenly
constellation.[20] Since his death Dürer's artistic divinity and his
place among the firmament of art's greatest masters have never
been seriously challenged.[21] These two remarks, typical of the
florid posthumous praise, raise the interesting issue of possession.
Many of his woodblocks and copper plates continued to be printed
well into the seventeenth century and beyond. Aided by Endres,
Albrecht's brother, and assistants, Agnes replicated her husband's
prints until her own death in 1539. Some of Dürer's print matrices
reappeared nearly a century later. When the estate of Gommer
Spranger, nephew and heir of Bartholomäus Spranger (1546–
1611), was auctioned in Amsterdam in 1638, it included over 3,500
prints, thirty-three woodblocks, and three engraved plates by

Dürer.[22] The collection contained eighty-five complete impressions of the *Life of the Virgin* (107, 108, 196) plus all of the woodblocks. Among other works, Spranger possessed 220 impressions and the woodblock of the *Trinity* (see 117) and 140 impressions of the *Last Supper* (see 171). Yet other than prints, only a limited number of original works by Dürer existed. Demand gradually exceeded supply.

Initially Nuremberg possessed the best collections of Dürer's art.[23] It was therefore possible for Ferdinand Columbus, son of the explorer, to purchase Dürer's *Three Books*, the *Small Woodcut Passion* and about thirty single prints during a visit to Nuremberg in December 1521–January 1522.[24] Through inheritance and acquisition, Willibald Imhoff (1519–1580), Willibald Pirckheimer's grandson, owned ten paintings, including *Johann (Hans) Kleberger* (see 180) and the artist's parents (see 10, 11), numerous watercolours, twenty-nine albums filled with drawings and a complete set of his prints, and much of Dürer's literary remains. Melchior Ayrer (1520–1579), a physician, possessed most of the prints. Before his death, Paulus Praun (1548–1616) shipped his renowned collection of art and natural wonders from Bologna to his native city. Although comprising just a fraction of his overall holdings, his Dürers included a complete set of prints in original impressions that he obtained from the estate of Wenzel Jamnitzer (1508–1585), the famed Nuremberg goldsmith, who had served as one of his artistic advisers. Praun acquired the estate of Endres Dürer, which included *Michael Wolgemut* (see 13) and at least nine other paintings. Praun's collection remained intact until 1797. Most of the others were sold off much earlier, or as Thomas Howard, earl of Arundel, remarked when he stopped in Nuremberg in May 1636: 'Heere in this towne being not one scra[t]ch of Alb. Duers paints in oyle to be sold, though it were his countrye.'[25] The famous English collector, however, did not leave empty-handed since he purchased much of Pirckheimer's library, including Dürer's literary archives, from Imhoff's heirs.

Emperor Rudolf II and Elector Maximilian I of Bavaria aggressively pursued Dürer's art. Rudolf scoured Nuremberg and other towns first. He purchased the *Landauer Altarpiece* (see 102) in 1585, two more paintings including the *Adam* and *Eve* (see 93) in 1587, and numerous items, such as *Johann Kleberger*, from Willibald Imhoff's estate in 1588.[26] Many of the Dürer paintings, prints, watercolours and drawings today in Vienna (Albertina and Kunsthistorisches Museum) once belonged to Rudolf. Through purchases and gifts numerous paintings gravitated from across Germany and even from France to the emperor's palace in Prague. The *Adoration of the Magi* (see 99), a present from Elector Christian II of Saxony in 1603, was among six paintings that Van Mander saw during his visit to Prague that year.[27] After lengthy negotiations Rudolf obtained the *Feast of the Rose Garlands* (see 82) from Venice in 1606. According to Von Sandrart, Rudolf was so concerned about the painting's fragile condition that he ordered it to be wrapped in cloth and carried, rather than carted, by porters to Prague.[28] During the Thirty Years' War (1618–48), much of Rudolf's famed collection was shipped to Vienna while other items disappeared. Swedish troops transported *Adam and Eve* as war booty to Stockholm. Its stay there was brief since Queen Christina moved to Rome, converted to Catholicism and divested herself of works by most Northern artists. Around the time of her abdication in 1654 she gave the picture to Philip IV, king of Spain (r. 1621–65).

In 1627 Maximilian instructed his agents to pay particular attention to 'anything by Albrecht Dürer's hand' or with the AD monogram.[29] He probably inherited *Lucretia* (191), Dürer's last monumental nude, from his father, Wilhelm V, duke of Bavaria (r. 1579–97), who abdicated.[30] Documented in the Munich Kunstkammer in 1598, *Lucretia* soon hung in the new picture gallery added to the Residenz palace in 1607. Maximilian, known for his sober propriety, covered Dürer's most sensuous painting with *Cato the Younger* by Peter Candid (1548–1628), depicting

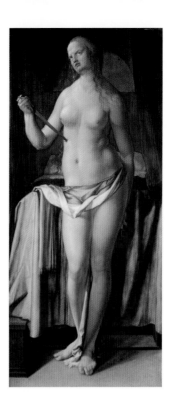

the highly moral Roman politician (95–46 BC). Candid's now lost
painting was replaced in 1627/30 with Lucas Cranach the Elder's
Lucretia. Both *Lucretias* were over-painted to heighten their
modesty. Cranach's nude was given a dress, while Dürer's figure
received only an additional swatch of cloth (the darker upper part)
across her mid-section. Maximilian altered other works to suit his
tastes. He modified the *Paumgartner Altarpiece* (see 7) by effacing
the patrons and embellishing the wings. At his command the text
on the bottom of the *Four Apostles* (see 169, 170) was sawn off and
returned to Nuremberg when he acquired the painting in 1627.
To his credit, he did commission replicas of the latter two pictures
and, in 1614, the central panel of the *Heller Altarpiece* (96). Jobst
Harrich's copy of this picture offers a precious record since the
original was burned in 1674 or 1729. Maximilian owned at least
seven and perhaps as many as nine paintings by Dürer, as well as
the sections of the *Prayer Book of Emperor Maximilian I* (see 136,
137, 138) illustrated by Dürer and Cranach.

**192
Hans
Hoffmann**,
*Dead Blue
Roller*, c.1583–4
Watercolour
and gouache
on parchment;
28.1 × 17.9 cm
(11 × 7 in)
British
Museum,
London

The taste for Dürer at these highest levels of society stimulated
demand. In addition to the quest to find originals, 'new' Dürers
were made through misattributions or by adding the artist's
monogram to other early sixteenth-century masters' creations,
including sculptures, or by intentional forgery. Willibald Imhoff's
heirs, who sold off the family's once great collection of Dürers,
admitted adding the artist's name to another master's work.[31] Still
other works replicated his art or were made in conscious imitation.
This fascination with the Nuremberg master around 1600, dubbed
the Dürer-Renaissance, is a phenomenon largely localized in
Nuremberg, Prague and Munich, a fact that underscores the tastes
of Rudolf and Maximilian.[32] Hans Hoffmann, active in Nuremberg
and at both courts, skilfully duplicated Dürer's watercolours of
animals and plants. His *Dead Blue Roller* (192) is one of at least
four copies that he made after Dürer's watercolour (see 73).[33]
Hoffmann even added Dürer's monogram and the date 1521

perhaps in an effort to pass off his replica as an original work by the earlier artist. In 1583, the date of another version (British Museum) signed by Hoffmann, Dürer's *Dead Blue Roller* and *Wing of a Blue Roller* (see 74) were in the Imhoff collection. In 1585 Hoffmann entered the service of Rudolf II in Prague. He was instrumental in the emperor's acquisition of Dürer's two bird studies as well as *The Hare* (see 65) in 1588.

Daniel Fröschel (1573–1613), Georg (Joris) Hoefnagel (1542–1600), Georg Gärtner the Younger (c.1575–1654), Frederick van Valckenborch and Paul Juvenel the Elder (1579–1643), among others, copied and/or made works in the style of Dürer. Aegidius Sadeler (c.1568–1628) engraved several drawings of Rudolf II by Dürer. His *Head of the Twelve-Year-Old Christ* (194) transforms Dürer's study from 1506 for *Christ among the Doctors* (see 84) into an independent image complete with a back wall and shadow.[34] The inscription tablet emulates the form Dürer used in his engraved portraits of the 1520s (see 174, 176). Given the interest in Dürer's art in Prague, Bartholomäus Spranger, Rudolf's court painter, amassed his own collection of prints, woodblocks and engraving plates by the Nuremberg master. The most unusual adaptation is Georg Vischer's *Christ and the Woman Taken in Adultery* (193), in which Jesus is based on Dürer's *Self-Portrait* of 1500 (see 75).[35] Vischer perceived the artist's image as an appropriate model both for its underlying iconography and for the fame, indeed the divinity, of Dürer. Vischer, one of Elector Maximilian's Munich court painters, must have seen the portrait in Nuremberg, since it entered the Munich collection only in 1805.

These and many other later masters are in dialogue with Dürer's art and myth. Their association with him is a matter of prestige and, at times, clear logic since there was a receptive market for copies after and pastiches of his art. Sometimes rivalry was the objective. In 1593–4, the Dutch artist Hendrick Goltzius (1558–1617) created six prints, often known as the *Master Engravings,*

illustrating the early life of the Virgin Mary. Each engraving emulates the style of a different master. The *Circumcision* (195) mimics Dürer.[36] Many poses, including the grouping of figures, recall Dürer's *Circumcision* (196) from the *Life of the Virgin*.[37] The candleholder with his tall cap and the man seated on the stool trimming Christ's foreskin both reappear, although wholly transformed, in Goltzius's scene. The amplitude of the architectural space, the partial exposure of the floor, the varied glances and even the shape of the *cartellino* hark back to Dürer's print. Goltzius, of course, made an engraving rather than a woodcut. He carefully studied Dürer's use of the burin, his complex drapery patterns and the varied lighting effects of his engravings. The window at the upper left of Goltzius's print quotes Dürer's *Saint Jerome in His Study* (see 121).

In the series' dedication to Wilhelm V, Goltzius, 'the admirable
engraver and inventor', compares his ability to emulate six
different styles with Proteus, the Classical sea god, who could
change his shape out of love for Pomona. One might say that
Goltzius could do the same out of his love for Dürer, who
represents the highest standard of excellence in Northern
European printmaking. He was justifiably proud of his skill at
matching and perhaps surpassing their prints. In the *Circumcision*
Goltzius included his self-portrait staring at the viewer from
beneath the arch. Van Mander tells how some unsigned
impressions without Goltzius's likeness fooled the connoisseurs
who thought they had discovered a new engraving by Dürer.[38]
When they learned the truth, they 'were horrified and ashamed,
or even angry'. In the artistic theory of Goltzius and Van Mander's
Haarlem, as in Prague and Munich, emulation (*aemulatio*) 'was
regarded as the highest degree of living up to classical paragons'.[39]
This level was achieved after the artist had learned the art of
copying (*translatio*) and next of imitating (*imitatio*) a master's
style. Only then was it possible to improve on the prototype.

Even as artistic styles changed drastically over the succeeding centuries, Dürer the artist and Dürer's art continued to command respectful attention that periodically bordered on adulation.[40] Celebrations peaked during 1828, 1871, 1928 and 1971, years commemorating anniversaries of his birth and death. Events associated with the first three were largely limited to the German-speaking lands, but 1971 witnessed exhibitions and publications across Europe and North America.[41] Let us consider two images that provide insights into the nineteenth century's veneration of the artist.

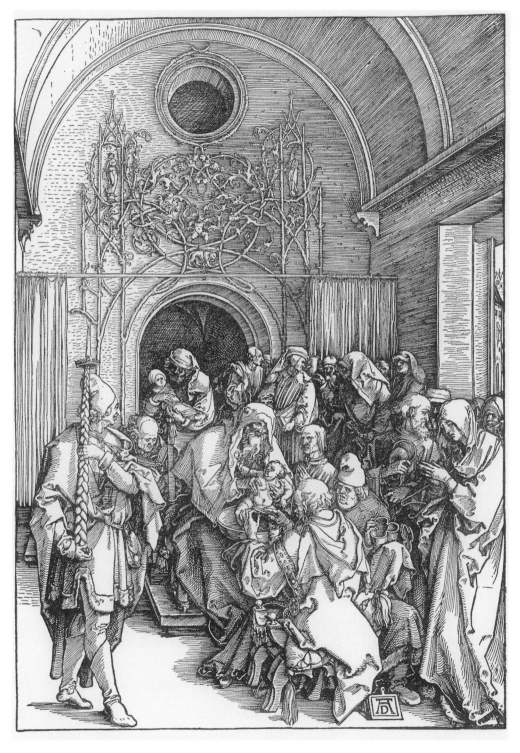

Heinrich Grünewald's memorial sheet for the 1871 jubilee in Nuremberg (197) depicts a central statue of Dürer, views of his grave and house, and eight 'portraits' of his contemporaries.[42] At the apex two angels trumpet the fame of Dürer and Nuremberg, whose coat of arms is set within a laurel wreath. Putti hold the Frey and Dürer coats of arms while the tools for architecture, sculpture, painting and printmaking are scattered below. This watercolour highlights Nuremberg's three primary pilgrimage sites visited by artists and art lovers. Here the tomb, renovated by Von Sandrart in 1681, is bathed evocatively in moonlight. The grave was the locus of annual commemorative ceremonies from at least 1820 on. On 6 April 1828, when the anniversary of his death coincided with Easter Sunday, about two hundred German artists processed from the city to the Saint Johannis cemetery, where they held a sunrise service at the wreath-bedecked tomb. Ludwig Emil Grimm (1790–1863), who later engraved the scene, recounted that 'a solemn silence had fallen. Suddenly it was broken by the mighty sounds of tubas reverberating around us, sublime and deeply moving, as they announced the high solemnity of the hour and the day. The wind abated, the clouds parted and the sun in all its glory rose over the old castle, illuminating the lovely churchyard and our large solemn gathering.'[43] The participants broke into a song written for the occasion. Then they returned to town for Easter service in Saint Sebaldus, Dürer's parish church, and a banquet in the Rathaus that night.

The city purchased Dürer's house in 1825.[44] The following year it was restored in a Gothic Revival style by Karl Alexander Heideloff and rented to a local art society (later known as the Albrecht-Dürer-Verein). In 1871 the house, refurbished and taken over by a new foundation, opened as one of Europe's first public museums dedicated to a single artist. The house has subsequently been restored several times, especially after World War II.

The bronze statue of Dürer (see 1) was erected in 1840 in the Milk

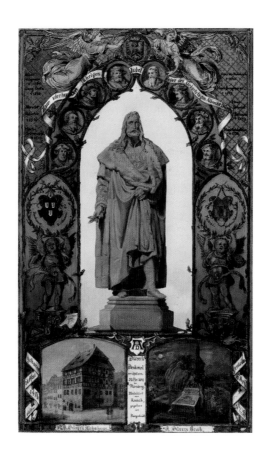

197
**Heinrich
Grünewald**,
*Memorial
Sheet for the
400th Birthday
of Albrecht
Dürer*, 1871
Drawing with
watercolour
and pasted
etchings by
unknown
artists;
38.8 × 23.3 cm
(15¼ × 9⅛ in)
Private
collection,
Germany

Market, renamed the Albrecht-Dürer-Platz. King Ludwig I of
Bavaria suggested the idea to Nuremberg's councillors in 1826 as
they planned for the 1828 jubilee. Members of the Albrecht-Dürer-
Verein, led by the councillor Friedrich Campe, and the Munich
Academy, directed by Peter Cornelius (1783–1867), commissioned
the noted Berlin sculptor Christian Daniel Rauch, King Ludwig's
choice. Participants in the 1828 celebrations had to content
themselves with the memorial's foundation stone, ceremoniously
laid on 7 April 1828, Rauch's model and various prints of the
statue.[45] Dürer's likeness derives from his self-portraits, notably
that in the *Landauer Altarpiece* (102). Rauch presents him holding
brushes in his right hand. Originally the base, designed by
Heideloff, was to include personifications such as *Pictura*. Funding
problems delayed the final casting by Jakob Daniel Burgschmiet
(1796–1858) of Nuremberg and the unveiling of the statue, now

with a simple stone base, until 1840. This was Europe's first public memorial honouring a past artist. News that Antwerp's statue of Peter Paul Rubens would be dedicated on 30 May that year spurred the completion of Dürer's commanding monument. Rembrandt's statue was erected in Amsterdam in 1847.

When the guests gathered in the Rathaus for the banquet that Easter night in 1828, they saw a temporary series of seven painted transparencies, each about two metres high, augmenting the Great Hall's existing decoration (see 143). Selecting biographical episodes from Dürer's recently published writings, Peter Cornelius's followers at the Munich academy framed the artist's life in Christological terms.[46] For instance, Ferdinand Fellner's *Dürer in the Storm on the River Scheldt* derived from Christ calming the storm. Another scene depicted Dürer and Raphael, who both died on 6 April, shaking hands before the throne of Art. Accompanied by popes Julius II and Leo X as well as Bramante and Perugino before Saint Peter's in Rome, Raphael embodies the Italian Renaissance. Backed by Nuremberg's skyline, Dürer, Germany's most illustrious artist, is joined by Emperor Maximilian I, Luther, Pirckheimer and Wolgemut. This spiritual and artistic sanctification of Dürer typifies the spirit of the 1828 jubilee.

Even this brief recounting of some of the events of 1828 hints at the unique status and, equally, historical burden accorded to Dürer. He was a source of pride and inspiration. His name was called out as a rallying cry for Germany's contemporary masters, who dreamed of restoring their land's artistic glory.[47] The inscription on the original base for Rauch's statue of Dürer reads: 'Father Dürer, give us thy blessing, that like thee we may truly cherish German art; be our guiding star until the grave!' Artists from other countries visited Nuremberg and its Dürer sites. William Bell Scott (1811–1890), the Scottish printmaker, painter and, in 1869, Dürer biographer, stayed in the city in 1853. A visit to the artist's house inspired one of his best-known paintings (198), showing

198
William Bell Scott,
Albrecht Dürer on the Balcony of his House, 1854
Oil on canvas; 60.4 × 73 cm (23¾ × 28¾ in)
National Gallery of Scotland, Edinburgh

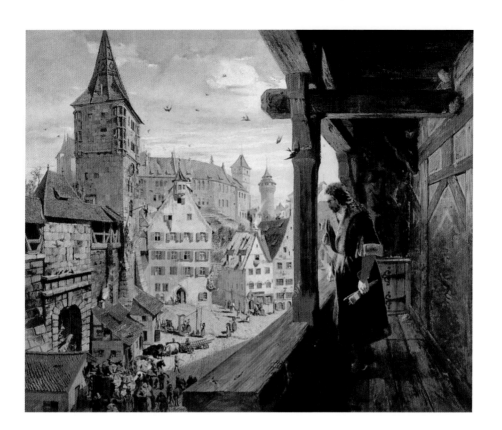

Dürer, brushes in hand, stepping on to the balcony and gazing at
the crowd gathered by the Tiergärtnertor.[48] The large residence
across the square is known as Pilate's house, because the annual
Passion plays were once staged there. The castle looms above.
Scott was just one of many artists whose scenes imaginatively
portrayed the Nuremberg master living and working in his
native city. Viewed differently, Scott's painting embodies Dürer's
elevated status within both Nuremberg and German art. Standing
alone, he is figuratively above all others. His familiar visage
personifies the best of German art and culture. Similarly Dürer's
sculpted portrait, signalling his permanent canonical authority,
will adorn the façades of some of the great new museums of the
nineteenth century, including the Alte Pinakothek in Munich,
the Kunsthistorisches Museum in Vienna and the Kunsthalle in
Karlsruhe.[49]

Dürer's legacy, like his art, continued to be used and abused throughout the late nineteenth and twentieth centuries. Some scholars questioned his German-ness because of his study of Italian art and theory. His often cool, analytical style was occasionally contrasted unfavourably with the expressive colours, explosive lines and intense pathos of Grünewald's best paintings.[50] Works such as *Knight, Death and the Devil* (119) were hijacked in the 1930s for ideological reasons by the National Socialists.[51] The German public's familiarity with Dürer's *oeuvre* and his fame made him a convenient target for political co-opting before, during and after World War II. More creatively, however, generations of artists have been inspired by his prints, drawings, paintings and even biography. Organizations such as the Albrecht-Dürer-Gesellschaft and the Albrecht-Dürer-Haus-Stiftung, both of Nuremberg, have sponsored exhibitions on the theme of contemporary artistic responses to Dürer's art.[52] A popular genre is the creation of self-portraits in the guise of or in the company of Dürer or images that playfully address biographical highlights, such as the artist's trip to Venice.[53]

Others offer a different sort of trans-historical meditation. In 1966 the poet and landscape designer Ian Hamilton Finlay (1925–2006) began Little Sparta, on an abandoned farm southwest of Edinburgh.[54] This garden combines nature with vestiges of Western culture. The latter assume the forms of inscriptions, statues, Classical capitals, battleships and various objects placed strategically around the twisting paths. These, more often than not, surprise the visitor. Albrecht Dürer lives on twice within this postmodern garden. A *cartellino* with his monogram hangs by a leather strap from a tree within the Woodland Garden section. Seeing this recalls *Adam and Eve* (63), but at a later moment in time. The first couple's expulsion leaves only this semiotic symbol of Dürer's immortal dwelling in paradise. Finlay was quite familiar with the eighteenth-century practice of constructing British garden landscapes in the style of artists such as Claude Lorrain.

He references Dürer's *Large Piece of Turf* (66) in the Temple
Pool (199) with the plantings, truly a micro-landscape, and with
the inclusion of the prominent monogram chiselled into stone
emerging from the water. In both instances Finlay pays homage to
Dürer's ability to make his viewers perceive and interpret nature.
This is a fitting tribute to an artist who looked so closely at the
world around him while constantly exploring new intellectual
directions for his art.

As Finlay shows, an actual work of art by Dürer is no longer
necessary to convey the artist's presence. His universally

199
Ian Hamilton
Finlay (with
Nicholas
Sloan),
Dürer's
Cartellino,
1980
Temple Pool
at Stonypath,
Little Sparta,
Scotland

recognized monogram works, as it had in the legal battles about
copyright in Venice and Nuremberg. It is a marker of the young
boy who centuries earlier first tentatively entered the studio
of Michael Wolgemut wanting to be an artist. Dürer would
have been flattered to know that he and his substantial *oeuvre*
remain part of each new period's discourse about art. He, the new
Apelles, remains an enduring standard of artistic excellence and
intellectual curiosity.

Introduction

1 *The New York Times*, 11 April 1997, B30;
 Stadt Nürnberg 2003; www.ottmarhoerl.de.
2 Panofsky 1943, II; Winkler 1936–9;
 Anzelewsky 1991; Meder 1932.
3 Rupprich 1956–69.
4 Hollar's *Plan of Nuremberg* was issued
 separately and as an illustration in Joannes
 Janssonius, *Urbium totius Germaniae
 Superioris ... tabulae* (Amsterdam, 1657).
 Pennington 1982, no. 874.
5 Mende 2000.
6 Winkler 1936–9, no. 116; Strauss 1974,
 no. 1496/1; Koschatzky 1973, no. 28.
7 Anzelewsky 1991, nos 50–4; Goldberg,
 Heimberg and Schawe 1998, pp. 166–235.
8 Goldberg, Heimberg and Schawe 1998,
 fig. 2.46, also 2.43–64 for other copies.
 Schauerte, Der Kardinal 2006, no. 50.
9 Goldberg, Heimberg and Schawe 1998,
 figs 2.51–4, pp. 57–8.
10 Goldberg, Heimberg and Schawe 1998,
 figs 2.41–2.
11 Neudörfer 1875, pp. 117–18; Buck and
 Messling with Brahms 2010, cat. no. 96–97.
12 Winkler 1936–9, no. 233; Strauss 1974,
 no. 1499/1; Rowlands 1993, no. 146 (with
 the descriptive texts by Frey(?) on the
 verso); Bartrum 2002, no. 62. On fountains,
 see Kohlhaussen 1968, pp. 255–65; Smith
 1994, pp. 199–215; Wiewelhove 2002, pp. 62–70;
 Schauerte, Der Kardinal 2006, no. 143.
13 Winkler 1936–9, no. 933; Strauss 1974,
 no. 1526/12; Schröder and Sternath 2003,
 no. 191.
14 Typing Albrecht Dürer into an internet
 search engine, such as Google, yielded
 1,800,000 sites in 2011; Hutchison 2000;
 Smith 2011b.
15 Panofsky 2005 with my historiographic
 introduction; Smith 2008.

Chapter 1

1 Philip 1978/9; Anzelewsky 1991, nos 2–4;
 Roth 2006, no. 3. Her portrait has been
 trimmed on the left side.
2 Rupprich 1956, pp. 27–34 (family chronicle),
 here p. 30; Conway 1958, p. 35.
3 Conway 1958, p. 34; Panofsky 1943, p. 4.
4 Schäfer 2006, p. 39.
5 Rupprich 1956, pp. 30–1; Conway 1958, p. 35.
6 On education in Nuremberg, see Leder 1971.
7 Kohlhaussen 1968; *Wenzel Jamnitzer
 und die Nürnberger Goldschmiedekunst
 1500–1700* 1985; Maué, Eser, Hauschke and
 Stolzenberger 2002; Smith 2006, pp. 25–40.
8 Schürer 1985, p. 108; Schmid 2003, p. 48.
9 Winkler 1936–9, no. 1; Strauss 1974,
 no. 1484/1; Koerner 1993, pp. 35–7, 42–51;
 Schröder and Sternath 2003, no. 1.
10 Woods-Marsden 1988; Calabrese 2006;
 Haag, Lange, Metzger and Schütz 2011.
11 The drawing has been attributed to Dürer
 rather than his father; however, the style
 is different and far more mature in its
 handling of space, line and light. Winkler
 1936–9, no. 3; Strauss 1974, no. 1484/4;
 Schröder and Sternath 2003, no. 2.

12 Koerner 1993, p. 37; Koerner 2006, p. 31
 dubbed this drawing 'opus one'.
13 Hoffmann's drawing is in London (British
 Museum). Koerner 1993, pp. 47–9, fig. 23;
 Bartrum 2002, no. 2; Smith 2011a, pp. 38,
 40–1.
14 Brandl 1986, pp. 51–3.
15 On Wolgemut, see Bauch 1932; Oettinger
 1954, pp. 153–68; Strieder 1993, pp. 65–85;
 Strieder 1994; Himmel 2000.
16 When the chapel was destroyed in 1564, the
 altarpiece was moved to the Heilig-Kreuz-
 Kirche and, in 1952, the Friedenskirche.
 Strieder 1993, p. 70, 72–6, figs 83–6;
 Himmel 2000, pp. 25–30.
17 Neudörfer 1875, p. 173; Wilson 1976,
 pp. 175–80; Schmid 2003, pp. 42, 44,
 46–7, 53.
18 Bellm 1962; Rucker 1973; Wilson 1976;
 Füssel 1994.
19 Anzelewsky 1991, no. 132; Löcher 1997,
 pp. 210–12; Smith 2011a, pp. 39–40.
20 Winkler, no. 17; Strauss, no. 1489/4;
 Ilatovskaya 1992, no. 15. Since 1945 the
 drawing has been in Russia and is now
 stored in Moscow.

Chapter 2

1 Schoch, Mende and Scherbaum 2004,
 no. 261 with illustrations of both sides
 of the woodblock, which is Öffentliche
 Kunstsammlung, Kupferstichkabinett, inv.
 no. 1662.169. The early part of Dürer's
 career, which is the least documented
 and most open to speculation, will be
 the theme of an exhibition in 2012 at
 the Germanisches Nationalmuseum in
 Nuremberg.
2 Rupprich 1956, p. 31; Hutchison 1990, p. 27.
3 Rupprich 1956, p. 290; Schmid 2003, pp. 54–5.
4 Christoph Scheurl's *Vita reverendi patris
 domini Antonii Kressen* (Nuremberg,
 24 July 1515), fol. 4 a–b; Rupprich 1956,
 pp. 294–5; Hutchison 1990, pp. 37–8; Schmid
 2003, p. 55.
5 Neudörfer 1875, p. 132; Rupprich 1956, p. 320;
 Schmid 2003, p. 55.
6 Béguerie 1991, no. 83.
7 British Museum, London. Bartrum 2002,
 no. 25; Smith 2011a, pp. 7–8.
8 Van Mander 1995–9, I: p. 82 (fol. 206r), II:
 p. 314; Von Sandrart 1675, I: p. 222–6, here
 p. 222; Panofsky 1943, pp. 23–4; Schmid,
 2003, pp. 58–9; and Aoyama-Shibuya 2005.
9 Braun and Grebe 2007.
10 On his activities for book publishers from
 1491 to 1494, see Rainer Schoch's comments
 in Schoch, Mende and Scherbaum 2004,
 pp. 23–9.
11 Rupprich 1956, p. 61; Conway 1958,
 pp. 74–5.
12 The blocks measure about 92 × 148 mm,
 with a thickness of 23 mm; Schoch, Mende
 and Scherbaum 2004, no. 262. Strauss 1974,
 nos 1492/5–128; *From Schongauer to
 Holbein* 1999, nos 45–8.
13 Schoch, Mende and Scherbaum 2004,

nos 263 (Der Ritter vom Turn) to 266
(Das Narrenschiff). Schoch (loc. cit., p. 25)
wonders whether the rigid regulations for
the guild that included painters, sculptors
and goldsmiths in Basel may have pushed
Dürer to associate himself instead with
the book publishers, who could better
accommodate temporary journeymen. Eser
and Grebe 2008, pp. 30–1.

14 Anzelewsky 1991, nos 7v–8v; Schmid 2003,
pp. 70–1, 74 on the Strasbourg stay.
15 While in Strasbourg, Dürer painted the
diminutive *Christ Child with the World
Orb* (oil on parchment, Albertina, Vienna),
monogrammed and dated 1493, and the
attributed *Man of Sorrows* (Staatliche
Kunsthalle, Karlsruhe); see Anzelewsky
1991, nos 11, 9 respectively.
16 Winkler 1936–9, no. 27; Strauss 1974,
no. 1493/6–7; *Gothic and Renaissance Art
in Nuremberg, 1300–1550* 1986, no. 102.
Whimsically, Dürer made some of the folds
resemble distorted human faces; see Koerner
1993, pp. 12–14, 27–8.
17 Universitäts-Bibliothek, Graphische
Sammlung. Winkler 1936–9, no. 26; Strauss
1974, no. 1491/9.
18 Panofsky 1943, pp. 6, 25; Rupprich 1956,
pp. 205, 211 (note 6); Anzelewsky 1991,
no. 10; Koerner 1993, pp. 31, 37; Wilson 1995.
19 Strieder 1993, pp. 85, 204.
20 Through her assessment of contemporary
herbals, Shira Brisman proposes a new
reading of this plant, which she will
explicate in a future article.
21 Strieder 1982, pp. 19–20.
22 Stumpel and Van Kregten 2002.
23 Rupprich 1956, p. 31; Hutchison 1990, p. 40.
24 Hutchison 1990, p. 40 paraphrasing
Neudörfer 1875, p. 117.
25 Winkler 1936–9, no. 151, who dates it
1494–7; Strauss 1974, no. 1494/7; Schröder
and Sternath 2003, no. 11. The inscription is
written in a different ink.
26 Panofsky 1943, pp. 6–7. Thausing 1882, vol.
1, pp. 131–66, gives a flattering description
of Agnes.
27 Rupprich 1956, pp. 283–8, esp. 284; and
Conway, 1958, pp. 38–9 for the 1530 letter.
Pirckheimer, who was himself sick, was
particularly vexed that Agnes would not
give him a set of antlers that he coveted.
The Italian letters and Netherlandish trip
are discussed in chapters 5 and 9.
28 Schleif 1999; Schleif 2010. On working
women such as Agnes, see Wiesner-Hanks
1986, pp. 149–85.
29 Rupprich 1956, p. 252.
30 Rupprich 1956, pp. 49–50.
31 Rupprich 1956, pp. 49–50; Conway 1958,
p. 52.
32 Rupprich 1956, p. 150; Goris and Marlier
1970, p. 55.
33 Rupprich 1969, p. 437.
34 Rupprich 1956, pp. 31 and 233–4.
35 Rupprich 1956, p. 31.
36 Rupprich 1956, p. 44; Conway 1958, p. 48;
Panofsky's comments in Wuttke 2006,
no. 1754.
37 Rupprich 1956, p. 290; Strieder 1982, p. 366.
38 Luber 2005, pp. 40–76.
39 Hutchison 1990, p. 42.
40 Grote 1954–9, 52ff.; Wilson 1976,
pp. 243–4 (the contract); on the models,

Levenson, Oberhuber and Sheehan 1973,
pp. 81–157; and on Dürer's possible role,
Winkler 1936–9, nos 122–41; Strauss 1974,
nos 1494/20–9.
41 Celtis may have suggested the theme of
Apollo and the Muses, which he encountered
earlier in Heidelberg. Hubach 2002.
42 Brown 1997; Roeck 2000; Matthews 2000;
Romanelli 2000.
43 Roeck 2000, p. 46.
44 Schulz 1978; Aikema and Brown 2000,
pp. 62–3.
45 Koschatzky 1973; Herrmann Fiore 1972;
Leber 1988.
46 Strieder 1993, figs 56, 59, 295a, 297
(for Pleydenwurff) and title page and
figs 428–9 (for the Master of the Krell
Altar). The closest comparison is a group
of six watercolour views of Bamberg
(Kupferstichkabinett, Berlin), made
c.1470–85. From Schongauer to Holbein
1999, no. 18; Suckale 2009, pp. 361–91; Buck
and Messling with Brahms 2010, cat. nos.
72v, 91–2, 95.
47 Neudörfer 1875, p. 132.
48 Kupferstichkabinett, Berlin. Winkler, no. 61;
Koschatzky 1973, no. 4; Strauss 1974,
no. 1494/3.
49 Winkler 1936–9, no. 66; Strauss 1974,
no. 1495/44; Koschatzky 1973, no. 7;
Schröder and Sternath 2003, no. 15. Grebe
2006, pp. 42–3; and Grossmann 2007 argue
that the drawing must date to 1496 or
1497 since the tower of the Wappenturm
burned in 1494 and was reconstructed in
1495–6. Both propose re-dating the entire
Venetian journey to 1496. For Dürer's two
watercolours of the palace's inner courtyard,
see Schröder and Sternath 2003, nos 16–17.
50 Winkler 1936–9, no. 99; Strauss 1974,
no. 1495/37; Koschatzky 1973, no. 11;
Strieder 1982, p. 103.
51 Winkler 1936–9, nos 91–2; Strauss 1974,
nos 1495/21–2.
52 Winkler 1936–9, no. 69; Strauss 1974, no.
1495/4; Schröder and Sternath 2003, no. 23.
53 Städel Museum, Frankfurt. Winkler 1936–9,
no. 75; Strauss 1974, no. 1495/6; Campbell
and Chong 2005, no. 37.
54 Campbell and Chong 2005.
55 Winkler 1936–9, nos 76–7, pp. 79–81;
Strauss 1974, nos 1495/13–16, 18–19.
56 Winkler 1936–9, no. 78; Strauss 1974,
no. 1495/12; Aikema and Brown 2000, no. 38.
57 Anzelewsky 1980, p. 48.
58 Winkler 1936–9, nos 59–60; Strauss 1974,
nos 1492/13–14; Panofsky 1943, p. 32;
Aikema and Brown 2000, nos 35–6;
Schröder and Sternath 2003, nos 13–14;
Herrmann Fiore 2007, nos II.37–8. On
Mantegna, see Levenson, Oberhuber and
Sheehan 1973, nos 74–6.
59 Conway 1958, p. 181; Rupprich 1966, p. 99.
60 Winkler 1936–9, no. 58; Strauss 1974,
no. 1494/11; Panofsky 1943, p. 32 and fig. 50
for its model; Panofsky 1955 on Dürer and
Classical antiquity; Schuster 1978; Rosasco
1984; Białostocki 1986, pp. 335–45 (citing
Aby Warburg).
61 Winkler 1936–9, no. 28; Strauss 1974,
no. 1493/3; Bonnet 2001, p. 62. One must be
careful about accepting all dates on Dürer's
drawings since some were added later by the
artist and some by subsequent owners.

62 Winkler 1936–9, nos 82–4, p. 87; Strauss 1974, nos 1494/16, 1495/1–3.

63 Winkler 1936–9, no. 85, p. 89; Strauss 1974, no. 1495/10–11; Fritz Koreny in Aikema and Brown 2000, pp. 242–3, notes the rarity of female life studies in contemporary Italian art; Bonnet 2001, pp. 73–5.

Chapter 3

1 First documented in Willibald Imhoff's collection in Nuremberg in 1573/4. Anzelewsky 1991, no. 49; Koerner 1993, pp. 37–9, 63–4, 67, 140–1; Manuth 2001; Schröder and Sternath 2003, no. 51 (Matthias Mende).

2 Panofsky 1943, p. 39. His claim (p. 42) that this is 'perhaps the first independent self-portrait ever produced' cannot be proven.

3 Hess 1998.

4 Białostocki 1970, pp. 173–4.

5 See Wolgemut's Levinus Memminger (c.1485) in Madrid (Thyssen-Bornemisza Collection). Buchner 1953, no. 140; Lübbeke 1991, no. 90; Strieder 1993, fig. 91, no. 54; Smith 2004, figs 60–2.

6 Buchner 1953, figs 31–5; Strieder 1993, figs 69 (1484, Master of the Landauer Altar), 91 (Wolgemut's Levinus Memminger), 552 (c.1506 – Schäufelein). See also Portrait of a Man (1487, Thyssen-Bornemisza Collection, Madrid) and Double Portrait (Städel Museum, Frankfurt) by Master W B (probably Wolfgang Beurer, active in Mainz or Frankfurt). Lübbeke 1991, no. 34; Brinkmann 2006, p. 15.

7 Berlin (Gemäldegalerie) and Weimar (Kunstsammlungen) respectively. Anzelewsky, 1991, nos 46, 59 (the problematic attributed Portrait of a Man in Accademia Carrara, Bergamo), 60–2; Brinkmann 2006, pp. 7, 13.

8 See Chapter 4 and his legal suit against Marcantonio Raimondi.

9 Knape 2003.

10 Smith 1983, no. 106.

11 Panofsky 1943, pp. 7–11, passim; esp. Rupprich 1971; Hutchison 1990, pp. 48–56; and Satzinger 2007.

12 Białostocki 1986, pp. 16–17, and on this topos, pp. 15–22.

13 Panofsky 1943, p. 7.

14 Pirckheimer married Crescentia Rieter on 13 October 1495.

15 Rupprich 1956, p. 59; Conway 1958, p. 58.

16 On the illuminations in twelve of Pirckheimer's books by Dürer or to an assistant, see Rosenthal 1928; Albrecht Dürer 1471–1971 1971, no. 296, p. 1; Rupprich 1971, pp. 86–7; Strauss 1974, no. 1502/26; Turner 1987, pp. 138–40; and Grasselli 1995, no. 19.

17 Dürer's lost painting of Crescentia Pirckheimer on Her Deathbed exists in four copies, the best of which are in Bremen (Kunsthalle) and Berlin (Kupferstichkabinett). Anzelewsky 1991, no. 81; Roth 2006, no. 31; Satzinger 2007, pp. 238–40.

18 Winkler 1936–9, no. 152; Strauss 1974, no. 1493/4; Röver-Kann 2001, no. 1 and passim.

19 The man could be the bath master discreetly checking the room. Often, however, bath-houses had bad reputations because

of their association with prostitution. See Wiesner 1986, pp. 95–7. On Hans Baldung Grien's inclusion of a background viewer, see Koerner 1993, pp. 423–37.

20 In Master M Z's engraving The Embrace (1503) the young woman looks at the viewer as she is hugged by her lover. Schrader 1993, pp. 14–27, fig. 1.

21 Koerner 1993, pp. 292–306; Brinkmann and Hinz 2007, pp. 109–14, figs 119–20.

22 Röver-Kann 2001, figs 2–3.

23 Talbot 1971, no. 84; Röver-Kann 2001, pp. 28–32; Schoch, Mende and Scherbaum 2002, no. 107, and on p. 52 is illustrated a painting attributed to Hans Wertinger that copies parts of this print.

24 Compare Erhard Schön's The Fountain of Youth woodcut (c.1525/30), where the water flows from a fool's cock-headed penis. Röver-Kann 2001, fig. 21.

25 Schoch, Mende and Scherbaum 2002, p. 55, and no. 103 (Dürer's Syphilitic broadsheet of 1496).

26 Ulman Stromer established the mill in 1390.

27 Albrecht Dürer Master Printmaker 1971, xii; Landau and Parshall 1994, pp. 15–21. On watermarks, see Meder 1932, pp. 293–8.

28 Field 2005, pp. 19–35.

29 Schoch, Mende and Scherbaum 2002, no. 127.

30 Schoch, Mende and Scherbaum 2002, no. 127 with illustration.

31 Ivins 1929; Boorsch and Orenstein 1997, pp. 24–5; Smith 2010a, pp. 75–8.

32 Schoch, Mende and Scherbaum 2002, pp. 33, 394–5.

33 Schoch, Mende and Scherbaum 2002, no. 241, esp. pp. 420–1, 423.

34 Meder 1932, no. 107. Meder chronicles the history of Dürer's prints, including their changes over time. On his methods, see Albrecht Dürer Master Printmaker 1971, xxiii–xxiv.

35 Panofsky 1943, pp. 51–9; Schoch 1999; Schoch, Mende and Scherbaum 2001, pp. 15–21; Peter Krüger in Schoch, Mende and Scherbaum 2002, pp. 59–106, nos 109–26.

36 Béguerie 1991, no. K 103.

37 Cunningham and Grell 2000; Price 2003, pp. 39–53.

38 For the initial four-folio gathering, the following pages were printed together: 1 recto – 4 verso; 1 verso – 4 recto; 2 recto – 3 verso; and 2 verso – 3 recto.

39 Schoch, Mende and Scherbaum 2002, no. 118.

40 Blockbücher des Mittelalters 1991, pp. 81–118 (Elke Purpus), nos 58–70.

41 Schoch, Mende and Scherbaum 2002, no. 115.

42 Schoch, Mende and Scherbaum 2002, no. 120.

43 Vorbild Dürer 1978, nos 59, 61, 64, 68.

44 Schoch, Mende and Scherbaum 2002, no. 111.

45 Schoch, Mende and Scherbaum 2001, nos 1–25.

46 Schoch, Mende and Scherbaum 2001, no. 1.

47 Schoch, Mende and Scherbaum 2001, no. 20 and p. 21, fig. 6 (counterproof).

48 Winkler 1936–9, no. 115; Koschatzky 1973, no. 25; Strauss 1974, no. 1496/6; Rowlands 1993, no. 127; Bartrum 2002, no. 193.

49 Schoch, Mende and Scherbaum 2001, no. 21.

50 Talbot 1971, no. 15.

51 Rupprich 1956, 162.

52 Anzelewsky 1983, pp. 45–56, figs 22–5.
53 Schoch, Mende and Scherbaum 2001, no. 22. Anzelewsky 1983, pp. 66–89.
54 Winkler 1936–9, no. 71; Strauss 1974, no. 1494/30; Schröder and Sternath 2003, no. 24.
55 Rupprich 1956, p. 154. Rainer Schoch notes that since Dürer gave João Brandao his finest prints, the entry probably does not refer to the *Hercules* woodcut (c.1496). Schoch, Mende and Scherbaum 2001, p. 76; 2002, no. 105.
56 Panofsky 1943, pp. 73–6; Panofsky 1997, pp. 166–73.
57 Rupprich 1956, pp. 85–7, 95–6; Schoch, Mende and Scherbaum 2001, p. 17, nos 89, 97.
58 Schmid 1996, pp. 34–6; Schmid 2003, pp. 122–7.
59 Von Hase 1967, pp. 267–332. His major agents were in Paris, Lyon and Basel, with others from Breslau (Wrocław), Krakow, Vienna and Buda(pest) to Spain. He also employed itinerant agents.
60 Schmid 2003, pp. 124–5, estimates that Switzer's annual salary and expenses totaled 45 florins. Dürer likely earned at least twice that, around 100 florins, from Switzer's sales. Schmid concludes that the artist's annual income from prints alone early in his career was a minimum of 100 florins net.
61 Rupprich 1969, pp. 448–9; Hutchison 1990, p. 57.
62 Rupprich 1956, p. 244.
63 Rupprich 1956, pp. 36, 38.
64 Anzelewsky 1991, nos 43–4; Hand 1993, pp. 51–60; Anna Scherbaum in Schröder and Sternath 2003, no. 29; Herrmann Fiore 2007, no. IV.20.
65 Anzelewsky 1991, nos 16–18.
66 Tempestini 1999, p. 213, no. 65.
67 *The Village* (Kunsthalle, Bremen) is currently in Moscow. Winkler 1936–9, nos 117–18; Strauss 1974, nos 1500/9–10; Koschatzky 1973, nos 31–2; Ilatovskaya 1992, p. 96–7, no. 21.
68 *From Schongauer to Holbein* 1999, no. 53.
69 Anzelewsky 1980, p. 70.
70 Goldberg, Heimburg and Schawe 1998, no. 3.
71 Bruck 1903; Ludolphy 1984.
72 Rupprich 1956, pp. 244–5; Anzelewsky 1991, nos 20–38 (*Mary Altarpiece* in Dresden, Gemäldegalerie, and Munich, Alte Pinakothek), 39–40 (*Dresden Altarpiece*, Gemäldegalerie). The attribution of the central *Virgin and Child* panel of the latter is problematic. Goldberg, Heimberg and Schawe 1998, pp. 138–65.
73 Anzelewsky 1991, nos 82 (*Adoration of the Magi*; Florence, Uffizi), 105 (*Martyrdom of the Ten Thousand*; Vienna, Kunsthistorisches Museum). Hans Schäufelein painted the *Ober St Veit Passion Altarpiece* (1505–7; Vienna, Diözesanmuseum) after Dürer's designs for Friedrich and his brother Johann. *Meisters um Albrecht Dürer* 1961, no. 293.
74 Anzelewsky 1991, no. 19. The identification of the sitter is verified through comparison with the bronze bust of Friedrich made in 1498 by Adriano Fiorentino (Adrianus de Maestri) (Staatliche Kunstsammlungen, Dresden, but currently displayed at Schloss Torgau). Smith 1994, pp. 319–20, fig. 280; Silver 2010, pp. 131–2.
75 Anzelewsky 1991, no. 67; Löcher 1997,

pp. 198–202; Goldberg, Heimberg and Schawe 1998, pp. 366–81; Herrmann Fiore 2007, no. II.11.
76 Bierende 2002, figs 78–9, 87, 95.
77 The text was finished in 1507 and published in Leipzig in 1508. Strieder 2005, pp. 25–34.
78 Białostocki 1976, p. 29.

Chapter 4

1 Schoch, Mende and Scherbaum 2001, no. 39; Panofsky 1943, pp. 84–7; Koerner 1993, pp. 191–202; Bonnet 2001, pp. 156–70.
2 See Chapter 10. Fragments of different drafts survive; see Rupprich 1966, pp. 81–150; also Conway 1958, pp. 170–81; Strauss 1977, pp. 8–9.
3 Conway 1958, p. 171; Rupprich 1966, p. 91.
4 Panofsky 1943, p. 242; Strieder 1983, p. 19.
5 Bartrum 2002, no. 86. Particularly insightful are Parshall's comments in Landau and Parshall 1994, pp. 312–14. First state: Berlin (Kupferstichkabinett), London (British Museum) and Vienna (Albertina); second state: Vienna (Albertina).
6 Schröder and Sternath 2003, illustrated on p. 256.
7 Rupprich 1969, p. 295, lines 436–50; Panofsky 1943, p. 279; Koreny 1985, pp. 13–14.
8 Winkler 1936–9, nos 242, 244, 359, 366–7; Strauss 1974, nos 1501/1, pp. 10–11, 1502/1, p. 7; Bartrum 2002, nos 91–4.
9 Winkler 1936–9, no. 248; Strauss 1974, no. 1502/2; Koreny 1985, nos 43, 44–9 for copies; Schröder and Sternath 2003, no. 70; Stadt Nürnberg 2003. The date may have been added later according to Daniel Hess.
10 Winkler 1936–9, no. 346; Strauss 1974, no. 1503/29; Koreny 1985, pp. 176–7 and no. 61; Foister 2004. On the nature studies see Fritz Koreny's remarks in Koreny 1985.
11 Koreny 1985, p. 210; Koreny 1991, pp. 588–97.
12 Gombrich 1972, p. 77 for Ficino's comments about Apelles looking at a field. Hutchison 1990, pp. 72–3, on Scheurl's comments about mimesis and Apelles.
13 Given in a letter of 1523 written to Pirckheimer. Rupprich 1956, pp. 101–102; Conway 1958, p. 165; Hutchison 1990, p. 72, for these quotes from the unpublished draft dedication to the *Four Books of Human Proportion*. On De' Barbari, see Levenson, Oberhuber and Sheehan 1973, pp. 341–81, esp. p. 342; Ferrari 2006.
14 I wish to thank Andreas Kühne for this reference. Kühne and Kirschner 2007, p. 242.
15 Vitruvius 1999.
16 Winkler 1936–9, no. 421; Strauss 1974, no. 1504/11; Koschatzky and Strobl 1972, no. 49a; Schröder and Sternath 2003, no. 66 (recto). Vitruvius' text is quoted in Strauss 1974, no. 1504/9.
17 It first appears in the *Study of a Female Nude* in London (British Museum). Winkler 1936–9, nos 411–12; Strauss 1974, nos 1500/29–30; Bonnet 2001, pp. 120–7; Bartrum 2002, no. 70.
18 Winkler 1936–9, no. 422; Strauss 1974, no. 1504/12; Koschatzky and Strobl 1972, no. 49; Schröder and Sternath 2003, no. 66 (verso).
19 Winkler 1936–9, no. 336; Strauss 1974,

nos 1504/13–14 (the verso depicts Eve's arm); Bartrum 2002, no. 88.

20 Haskell and Penny 1981, pp. 148–51, 325–8; Bober and Rubinstein 1986, pp. 59–61, 71–2.

21 Levenson, Oberhuber and Sheehan 1973, nos 141, 73.

22 Winkler 1936–9, no. 261; Strauss 1974, no. 1501/7; Bartrum 2002, no. 84; Schröder and Sternath 2003, no. 62.

23 Rupprich 1966, p. 104; Price 2003, p. 66 (with translation).

24 Schoch, Mende and Scherbaum 2001, no. 33 with a good discussion of the iconographic sources, notably Angelo Poliziano's poem of 1482 dedicated to Lorenzo de' Medici; Koerner 1995.

25 Koreny 1985, nos 10, 22; Schröder and Sternath 2003, nos 72–3.

26 Panofsky 1943, p. 85; Filipczak 1997.

27 Eisler 1991, pp. 107, 200–206, 209, 268.

28 Dülberg 1990, p. 70; Satzinger 2007, p. 230.

29 The literature is vast. See Anzelewsky 1991, no. 66; Panofsky 1943, pp. 43–5; Hess 1990; Koerner 1993, esp. pp. 63–186; Goldberg, Heimberg and Schawe 1998, pp. 314–53; and Zitzlsperger 2008.

30 Goldberg, Heimberg and Schawe 1998, pp. 340–3 (on provenance).

31 Kemperdick 2004, pp. 63, 69–70.

32 Goldberg, Heimberg and Schawe 1998, pp. 332–4; Price, 2003, p. 94.

33 Parshall 1993. Wölfflin 1971, p. 36 remarks: 'It is certainly not a strong likeness but a self-confession which contains all the essential qualities of his nature.'

34 Kempis 1952, p. 85; A German translation, *Dy ware nachvolgung Cristi*, was published in Augsburg (1493) and Nuremberg (1494).

35 Koerner 1993, pp. 71–6.

36 Winzinger 1954, pp. 43–64; Koerner 1993, pp. 158–9, fig. 79.

37 Translation given in Strieder 1982, p. 366.

38 Koerner 1993, pp. 150–2, on Camerarius and Hessus; Koerner 2006.

39 Fols 2, 2v, 3, 3v, 4, 4v. Rücker 1973, figs 9–10; Koerner 1993, fig. 75.

40 *Libellus de laudibus Germaniae et ducum Saxoniae*, 2nd edn (Leipzig, 1508), fol. H5 (43ab); Rupprich 1956, p. 290; Hutchison 1990, p. 73; Koerner 1993, p. 163; Price 2003, pp. 92–3.

41 Wuttke 1967, pp. 323, 325; Rupprich 1969, p. 460; Białostocki 1986, p. 18; Land 2006.

42 Silver 1983, pp. 14–18.

43 Vienna (Kunsthistorisches Museum). Anzelewsky 1991, no. 105; Schütz 1994, no. 4. Wuttke 1996 argues for the importance of the year 1500 to Celtis and his circle.

44 Smith 1983, no. 10; Wiener and Drescher 2002; Schoch, Mende and Scherbaum 2004, no. 269; Schauerte 2004.

45 Rupprich 1969, p. 460, no. 71.

46 Winkler 1936–9, no. 267; Strauss 1974, no. 1503/18; Schröder and Sternath 2003, no. 52; Roth 2006, no. 35.

47 Winkler 1936–9, no. 272; Strauss 1974, no. 1503/16; Koerner 1993, p. 220, fig. 113; Bartrum 2002, no. 82.

48 Panofsky 1943, p. 90; Koerner 1993, p. 241.

49 On Dürer's ambiguous sexuality, see Bodo Brinkmann in Brinkmann and Hinz 2007, pp. 97–108.

50 Schoch, Mende and Scherbaum 2001, no. 28;

Eichberger and Zika 1998, pp. 118–40; Margaret Sullivan 2000, pp. 332–401; Linda Hults 2005, esp. pp. 73–5.

Chapter 5

1 Letter 2, 7 February 1506; Rupprich 1956, pp. 44–5; Conway 1958, p. 48.

2 In 1503 Dürer drew Pirckheimer twice. Winkler 1936–9, nos 268, 270; Strauss 1974, nos 1503/3, 4; Roth 2006, nos 88–9.

3 These date from 6 January to 12 October 1506. Eight letters (nos 1–5, 7–8, 10) were found in the chapel wall of the Imhoff family house on the Egidienplatz in Nuremberg in 1748. Letter 6 is on the verso of a note that Hans III Imhoff wrote to a friend in 1624. Letter 9, together with other Dürer texts, probably entered the collection of Thomas Howard, earl of Arundel, along with parts of Pirckheimer's library, in 1636. Rupprich 1956, pp. 10–11, 39–60; Conway 1958, pp. 44–60; Sahm 2002, pp. 60–84. See Grote 1956 for an excellent, if dated, overview of this trip.

4 Dürer had passed through Augsburg by mid-February 1507. Rupprich 1956, p. 253.

5 His copy of the book (Venice, 1505) is in Wolfenbüttel (Herzog Anton Ulrich-Bibliothek). Rupprich 1956, pp. 221–2.

6 Rupprich 1956, p. 252, for Albrecht the Elder's letter of 1492 to Barbara.

7 Letter 10, around 13 October 1506. Rupprich 1956, p. 59; Conway 1958, p. 58.

8 Letter 2. In 1861 Nuremberg's Stadtbibliothek acquired a photograph of his letter, the location of which is unknown. Rupprich 1956, p. 44; Conway 1958, p. 49. On Dürer's lost painting of *Crescentia Pirckheimer on her deathbed*, see Anzelewsky, 1991, no. 81.

9 Letter 10. Rupprich 1956, 58; Conway 1958, p. 57.

10 Letter 5, 2 April 1506; Rupprich 1956, p. 49; Conway 1958, p. 52.

11 Letter 8, 8 September 1506; Rupprich 1956, p. 55; Conway 1958, p. 55. The two items of clothing also sent their greetings in Letter 9, 23 September 1506; Rupprich, p. 57; Conway, p. 57.

12 Letter 7, 18 August 1506; Rupprich 1956, p. 53; Conway 1958, p. 54.

13 Letter 5; Rupprich 1956, p. 49; Conway 1958, p. 51.

14 Letter 2; Rupprich 1956, p. 44; Conway 1958, p. 48.

15 Fletcher 2004, pp. 19–21.

16 Rupprich 1956, p. 309; Conway 1958, pp. 138–9; Smith 1970; Białostocki, 1986, p. 21.

17 Letter 1; Rupprich 1956, p. 42; Conway 1958, p. 47.

18 Letters 3 and 5; Rupprich 1956, pp. 45, 49; Conway 1958, pp. 49, 51.

19 Letters 8–10, 8 and 23 September, around 13 October. See below.

20 Martin 2006, p. 55.

21 Strieder 1982, pp. 117–25; Anzelewsky 1991, no. 93; Aikema and Brown 2000, pp. 306–309, no. 57; Luber 2005, esp. pp. 78–125; Kotková 2006.

22 Anzelewsky, 1991, p. 192, fig. 74, charts the paint losses.

23 *500 Jahre Rosenkranz, 1475–1975* 1975;

Winston-Allen 1997, pp. 69–71, 75, 78, 116.

24 Anzelewsky, 1991, p. 193, fig. 75.

25 Anzelewsky, 1991, no. 97; Herrmann Fiore 2007, no. I.11.

26 Kupferstichkabinett. Winkler 1936–9, no. 380; Strauss 1974, no. 1506/29.

27 Dunkerton 2000, pp. 100–101; and esp. Luber 2005.

28 Winkler 1936–9, no. 385, p. 404; Strauss 1974, no. 1506/19, 34; Schröder and Sternath 2003, nos 104–105.

29 Goldberg, Heimberg and Schawe 1998, pp. 321, 323, figs 6.9, 6.11.

30 Luber 2005, pp. 110–15, fig. 58, pl. VI; Hermann Fiore 2007, no. IV.21.

31 Winkler 1936–9, no. 401; Strauss 1974, no. 1506/30; Schröder and Sternath 2003, no. 97.

32 Rupprich 1956, p. 55; Conway 1958, p. 55. On his colours, see Baumeister and Krekel 1998, pp. 54–101.

33 Rupprich 1956, p. 57; Conway 1958, p. 56; and esp. Luber 2005, p. 89, who challenges Conway's translation as 'nobler'.

34 Luber 2005, pp. 88–9, 177.

35 Price 2003, pp. 66–96; Luber 2005, pp. 115–18, notes that 'eristic imitation is the imitative relationship of an artist with other artists', such as the story of Apelles and Protogenes.

36 Rupprich 1956, pp. 206, 211; Anzelewsky 1991, p. 113; Aikema and Brown 2000, pp. 308–309 (Isolde Lübbeke).

37 This issue is often discussed, including recently in Luber 2005, pp. 118–24.

38 Dürer may have purchased his manuscript copy of Alberti's treatise (written in 1435–6; published Basel, 1540) while in Venice.

39 Rupprich 1969, p. 293; Koerner 1993, pp. 213–14.

40 Białostocki 1986, p. 20, fig. 5; Anzelewsky 1991, figs 82–3; esp. Konečný 2006.

41 Rupprich 1956, p. 55; Conway 1958, p. 56.

42 Rupprich 1956, p. 58; Conway 1958, p. 57.

43 Rupprich 1956, p. 57; Conway 1958, p. 56; Lübbeke 2001.

44 Anzelewsky 1991, no. 98; Lübbeke 1991, pp. 218–41, no. 50; Schröder and Sternath 2003, no. 106 (Martin Schawe); Herrmann Fiore 2007, no. VI.1; Schauerte 2009. Schauerte thinks it is a pastiche painted in Prague around 1600 and based on several of Dürer's drawings then in the collection of Rudolf II. Others posit that Dürer referred instead to his poorly preserved Madonna of the Siskin, in Berlin (Gemäldegalerie); see Anzelewsky 1991, no. 94.

45 Seven Sorrows of the Virgin painting (1496; Gemäldegalerie, Dresden) and the woodcut (c.1503) in the Life of the Virgin series. Anzelewsky 1991, no. 23; Schoch, Mende and Scherbaum 2002, no. 181.

46 Schröder and Sternath 2003, p. 340, fig. 4.

47 Winkler 1936–9, no. 407; Strauss 1974, no. 1506/35.

48 Forcione 2003.

49 Carroll 1995; Price 2003, pp. 169–93.

50 Lübbeke 1991, p. 223; and for a superb discussion of Dürer's painting techniques, see Heimberg 1998, esp. pp. 44–5.

51 Anzelewsky 1991, figs 86–8; Lübbeke 1991, pp. 230, 232.

52 Rupprich 1956, p. 59; Conway 1958, p. 58.

53 Schröder and Sternath 2003, p. 346 (Martin Schawe).

54 Dürer also paid off the mortgage on his father's house on 12 May 1507; see Rupprich 1956, p. 226. On the Venetian trip portraits, see Anzelewsky 1991, nos 92, 95–7, 99, 101–102.

55 Pon 2004, pp. 39–41.

56 Rupprich 1956, p. 52; Conway 1958, p. 53.

57 Rupprich 1956, pp. 59–60; Conway 1958, p. 58. Panofsky 1943, p. 9, translates the first sentence as 'How shall I long for the sun in the cold'.

58 Rupprich 1956, p. 110; Conway 1958, p. 132 (gives the salary as 220 ducats).

59 Mészáros 1983; Heimbürger 1999, who in her conclusion (pp. 230–6) wonders whether it is more accurate to speak of a 'movimento düreriano' or a 'mania düreriana'. Herrmann Fiore 2007 offers a broad discussion of Dürer's influence on Italian artists.

60 Rupprich 1956, p. 58; Conway 1958, p. 57.

Chapter 6

1 Winkler 1936–9, no. 272; Strauss 1974, no. 1503/16; Kantor 2000, I, pp. 13–48 (Jordan Kantor), here pp. 22–4; Bartrum 2002, no. 82.

2 British Museum, London, same size and material. Winkler 1936–9, no. 271; Strauss 1974, 1503/17; Bartrum 2002, no. 81.

3 The cardinal's hat watermark of the paper is the same found on the drawings for the Feast of the Rose Garlands. Winkler 1936–9, no. 477; Strauss 1974, no. 1506/56; Anzelewsky and Mielke 1984, no. 60.

4 Rupprich 1956, p. 172; Conway 1958, p. 120.

5 Anzelewsky 1991, nos 103–104; Schoen 2001, pp. 28–56; Smith 2009, pp. 7–10. On the Madonna, Rupprich 1956, p. 68; Conway 1958, p. 67; Schoen 2001, pp. 117–22.

6 Anzelewsky 1991, nos 107V–115K; Decker 1996.

7 The two female panels are in the Staatliche Kunsthalle, Karlsruhe. Decker 1996, pp. 56–75; Brinkmann and Kemperdick 2005, pp. 353–73.

8 Half are dated 1508. Winkler 1936–9, nos 448–65; Strauss 1974, nos 1508/1–19.

9 Winkler 1936–9, nos 452, 461; Strauss 1974, nos 1508/9–10; Schröder and Sternath 2003, nos 111–12.

10 Anzelewsky 1991, no. 82.

11 Rupprich 1956, pp. 61–74; Conway 1958, pp. 62–71; Schröder and Sternath 2003, nos 111–20.

12 Rupprich 1956, pp. 72–3; Conway 1958, p. 70, for this and the next quotations.

13 Panofsky 1943, pp. 125–31; Anzelewsky 1991, no. 118; Schütz 1994, pp. 14–47, 78–9.

14 The chapel was destroyed in 1945. The windows, attributed to Veit Hirsvogel the Elder's workshop, were sold in 1810 and at the time of their destruction in World War II were in the Schlossmuseum in Berlin. Butts and Hendrix 2000, no. 23.

15 Winkler 1936–9, no. 445; Strauss 1974, no. 1508/23

16 Luber 2005, pp. 133–40, describes the altar's under-drawing as being extremely finished, with extensive internal modelling. One exception is the portrait of Landauer, which has no under-drawing.

17 Meisters um Albrecht Dürer 1961; Smith 1983, pp. 45–52; Grebe 2007.

18 Neudörfer 1875, p. 144; Rupprich 1956, pp. 244–5.

19 Winkler 1936–9, no. 508; Strauss 1974, no. 1511/2; Anzelewsky and Mielke 1984, no. 65.

20 It measures 167 × 653 cm (65¾ × 257 in) *Meisters um Albrecht Dürer* 1961, no 162. It is uncertain that Kulmbach was Dürer's pupil; however, his art from about 1507 to the mid-1510s shows Dürer's influence. Butts 1985.

21 Schoch, Mende and Scherbaum 2001, no. 32.

22 Windsor Castle. Winkler 1936–9, no. 241; Strauss 1974, no. 1500/1.

23 Schoch, Mende and Scherbaum 2001, no. 37, and the illustration on p. 102 of the *Three Helmets* (Musée du Louvre, Paris; Winkler 1936–9, no. 177; Strauss 1974, no. 1495/49) drawing that served as the model.

24 She is based on Dürer's *Nuremberg Woman Dressed in Dance Clothes* drawing (c.1501; Kupferstichkabinett, Basel). Winkler 1936–9, no. 227; Strauss 1974, no. 1500/7. On wildmen, see Silver 1983.

25 Schoch, Mende and Scherbaum 2002, no. 111.

26 Besides the studies cited below, see Guenther 1995; Kantor 2000; Arnulf 2004.

27 *Albrecht Dürer Master Printmaker* 1971, nos 63–82, 161–5; Schoch, Mende and Scherbaum 2002, 214–79, nos 166–85; Shin 2003; Scherbaum with Wiener 2004; Wiener, Scherbaum and Drescher 2005.

28 Price 2003, pp. 133–65, esp. pp. 135–41.

29 Schoch, Mende and Scherbaum 2002, no. 180.

30 Chelidonius remarks that to support his family Joseph 'forged iron, worked cedar wood and cut ivory, he shaped life-like portraits in marble', and was a builder; he was a 'second Daedalus'. Krohm 2001; Scherbaum with Wiener 2004, p. 87.

31 Schoch, Mende and Scherbaum 2002, no. 184.

32 Shin 2003; Scherbaum with Wiener 2004, pp. 225–30; Scherbaum and Wiener 2006. Price 2003, p. 154, translates the dedication to the 'Tireless Abbess of the vigilant virgins'.

33 *Vorbild Dürer* 1978, pp. 22–3 (with a list of catalogue entries); Mészáros 1983, pp. 352–3, with a list copies; Pon 2004, pp. 39–48.

34 Pon 2004, pp. 40–1.

35 Oberhuber 1978, no. 633 (406).

36 Schultheiss 1971, pp. 241–3.

37 Rupprich 1956, p. 76; Koerner 1993, p. 213.

38 Koerner 1993, pp. 214–18. On copyright, see Koerner, pp. 203–14; Pon 2004; Witcombe 2004.

39 Schoch, Mende and Scherbaum 2002, no. 164.

40 *Albrecht Dürer Master Printmaker* 1971, nos 112–52; Schoch, Mende and Scherbaum 2002, nos 186–222. Thirty-five of the pearwood blocks are in London (British Museum).

41 Schoch, Mende and Scherbaum 2002, p. 281, nos 207–209.

42 Compare Adam Kraft's *Stations of the Cross* (c.1505), seven carved reliefs placed along the road to the Saint Johannis Cemetery west of town; see Schwemmer 1958, pp. 34–47, figs 56–65.

43 Winkler 1941, pp. 197–208; Münch 2005.

44 Pauli 1927; Fehl 1992.

45 Price 2003, pp. 138, 140. The text was originally composed for the Passio Jesu Christi (Strasbourg, 1507) with woodcuts by Johannes Wechtlin. Schoch, Mende and Scherbaum 2002, p. 282.

46 Price 2003, p. 133.

47 Rupprich 1956, p. 152; Goris and Marlier 1971, p. 58.

48 Kantor 2000, p. 27.

49 Schoch, Mende and Scherbaum 2001, nos 45–60.

50 Schoch, Mende and Scherbaum 2001, no. 46.

51 Schoch, Mende and Scherbaum 2001, no. 53.

Chapter 7

1 Erasmus, *Dialogus de recta latini graecique sermonis pronunciatione*; Panofsky 1951, pp. 34–41; Białostocki 1986, pp. 31–3.

2 Rupprich 1956, pp. 227–9; Mende 1989; Grossmann and Sonnenberger 2007, pp. 27–172.

3 Rupprich 1956, pp. 231–2.

4 Rupprich 1956, pp. 229–31.

5 Schoch, Mende and Scherbaum 2002, no. 230. On the theme, see Westfehling 1982.

6 Schoch, Mende and Scherbaum 2002, no. 231.

7 The print exists in two states, the first of which lacks Dürer's monogram. *Albrecht Dürer Master Printmaker* 1971, nos 175–6; Talbot 1971, no. 39; Schoch, Mende and Scherbaum 2001, no. 65; Bartrum 2002, no. 125 (first state).

8 On the three engravings together, see Schoch, Mende and Scherbaum 2001, pp. 166–8 (Matthias Mende); Grigg 1986.

9 *Albrecht Dürer Master Printmaker* 1971, nos 179–82; Talbot 1971, no. 58; Theissing 1978; Białostocki 1986, pp. 381–93; Schoch, Mende and Scherbaum 2001, no. 69; Cuneo 2010.

10 Winkler 1936–9, no. 176; Rupprich 1966, p. 353; Strauss 1974, no. 1495/48; Schröder and Sternath 2003, no. 137.

11 Contemporary with the engraving, Dürer prepared a two-sided drawing with the definitive form of the knight, horse and, on the verso only, dog (Biblioteca Ambrosiana, Milan). He still struggled with the horse's rear right leg. The verso has a square grid for proportion. Winkler 1936–9, nos 617–18; Strauss 1974, nos 1513/1–2.

12 Dürer's *Death on Horseback* (1505) drawing in London (British Museum) displays many of the same features. Winkler 1936–9, no. 377; Strauss 1974, no. 1505/24.

13 Panofsky 1943, pp. 151–4, champions the *Christian knight reading*. This presumes Dürer's familiarity with Erasmus's *Enchiridion militis Christiani* (*Handbook of the Christian Soldier*), published initially in a limited 1504 edition.

14 Cited in Białostocki 1986, pp. 384–7.

15 Winkler 1936–9, nos 360–1; Strauss 1974, nos 1503/27–8; Schoch, Mende and Scherbaum 2001, nos 42–3.

16 Conway 1958, pp. 170, 172; Rupprich 1966, pp. 55–7, 84, 94–5.

17 Rupprich 1956, pp. 310–12; Conway 1958, p. 140.

18 In 1528 Agnes Dürer asked the city council to suppress Beham's book on human proportions, claiming the ideas were her

deceased husband's. Beham's *Proporcin der Ross*, published in August 1528, was quickly censored by the council for the same reasons. Beham moved to Frankfurt and eventually published a thirteen-page section on horses in his *Das Kunst und Lere Büchlin* of 1546. Smith 1983, pp. 176, 196.

19 Rupprich 1966, 56; Eisler 1991, 218–49, esp. pp. 236–40. Mende attributes to Dürer a sheet containing three equine proportional drawings, made using Leonardo's method. Stadtbibliothek, Nuremberg, Cent.V.App. 34aa, fol. 81r; Strauss 1974, pp. 2422–3; Mende 2000, no. 110.

20 Kemp 1981, pp. 202–207.

21 Eisler 1991, figs 9.14–16; Brown 1997, pp. 50–1.

22 *Albrecht Dürer Master Printmaker* 1971, nos 186–7; Schoch, Mende and Scherbaum 2001, no. 70.

23 Lazarus Spengler's German translation of the *De morte Hieronymi* by Bishop Eusebius of Cremona (d. 420) was published in 1514. Hamm 1990.

24 Vasari greatly admired the naturalistic details and sunlight in this engraving. He remarked 'that nothing more and nothing better could be done in this field of art'. Bartrum 2002, p. 189.

25 Dackerman 2002, pp. 1–47 (Susan Dackerman), no. 51.

26 Talbot 1971, no. 59; Schoch, Mende and Scherbaum 2001, no. 71. A vast literature on this print includes several dozen texts in the past two decades alone. Panofsky and Saxl 1923; Panofsky 1943, pp. 156–71; Böhme 1989; Schuster 1991; Von Engelhardt 1993; Scheil 2007; Lassnig 2008, who explores the influence of the writings of Ulrich Pinder, Nuremberg city physician, on Dürer.

27 Rupprich 1956, pp. 319–20; Heckscher 1978, pp. 32–3.

28 Compare Sebald Beham's engravings of *Geometry*, *Astrology* (rather than *Astronomy*) and *Melancholy* (dated 1539); see Koch 1978, nos 126–7, p. 144.

29 British Museum, London. Strauss 1974, no. 1514/25.

30 Compare the *Man of Sorrows* on the title page of the *Small Passion*. Schoch, Mende and Scherbaum 2001, no. 186.

31 Panofsky 1943, pp. 168–9. On melancholy and the arts, see Wittkower 1963; Clair 2005.

32 Panofsky 1943, pp. 162, 171.

33 *Commentarius de anima* (Wittenberg, 1548), fols 76v, 82; Rupprich 1956, p. 319; Panofsky 1943, p. 171.

34 Winkler 1936–9, no. 482; Strauss 1974, no. 1519/2 (though he admits that he is uncertain about the dating); Strieder 1982, p. 24; Koerner 1993, pp. 176–7; Schröder and Sternath 2003, no. 53 (Matthias Mende suggests a dating of c.1516[?]).

35 Koerner 1993, p. 23.

36 Schröder and Sternath 2003, no. 142 (Matthias Mende); Parshall 2006, pp. 207–10; however, Panofsky (1943, pp. 170–1) discounts this reading.

37 Winkler 1936–9, no. 559; Strauss 1974, no. 1514/1; and esp. Roth 2006, no. 1 and passim; Smith 2010b, pp. 74–7.

38 On the elderly in contemporary German art, see Roth 2006, nos 51–81.

39 Pirsig 2006; Bushart 2006. p. 177, fig. 5,

compares Dürer's mother and the actress Sophia Loren at the age of sixty-three.

40 Anzelewsky, 1991, no. 132; Roth 2006, no. 4.

41 Rupprich 1956, pp. 36–7; Hutchison 1990, pp. 121–2; Parshall 2006, p. 207.

42 Talbot 1971, no. 63; Schoch, Mende and Scherbaum 2001, no. 73; and also see Herrmann Fiore 2007, no.VII.7.

43 Mende 2000, nos 10, 15, 16.

44 Pfeiffer and Schwemmer 1977, figs 4–10, 153; Smith 1983, p. 11 and no. 192 (Jost Amman's *The Display of Fireworks on the Castle of Nuremberg*, an etching of 1570: its view, taken from a field north of the city, confirms the ordering of these buildings).

45 Dackerman 2006.

46 Schoch, Mende and Scherbaum 2001, no. 82. On Dürer's drawing for the angel, now in London (British Museum), see Strauss 1974, no. 1515/73.

47 Schoch, Mende and Scherbaum 2001, no. 68.

48 Schoch, Mende and Scherbaum 2001, no. 77, and for his peasant prints see nos 13–15, 76, 88; and Müller 2011.

49 Raupp 1986, pp. 165–90; Moxey 1989, pp. 35–66.

50 Mende 1983, no. 81. Jürgen Müller suggested that their poses reflect Dürer's familiarity with the *Laocöon*, which had been discovered in Rome in 1506 Müller 2011.

51 Schoch, Mende and Scherbaum 2001, no. 8; Anzelewsky 1991, no. 186.

52 Dürer accidentally dated the text 1513, not 1515. Schoch, Mende and Scherbaum 2002, no. 241; Bartrum 2002, nos 242–4, also 245–53 (influence); Monson 2004. On the image and its afterlife, see also Clarke 1986; Eisler 1991, pp. 269–74.

53 Eisler 1991, p. 271, no. 10.43.

Chapter 8

1 Winkler 1936–9, no. 567; Strauss 1974, no. 1518/19; Schröder and Sternath 2003, no. 162. On Maximilian I, see Silver 2008.

2 Von Baldass 1913/14.

3 Anzelewsky 1991, nos 123–4; *Gothic and Renaissance Art in Nuremberg, 1300–1550* 1986, no. 128 (Kurt Löcher); Löcher 1997, pp. 203–10; Kammel 2006, pp. 480–6. For his initial design showing the two panels as a hinged diptych, now in London (Courtauld Institute), see Winkler 1936–9, no. 503; Strauss 1974, no. 1510/5.

4 Schnelbögl 1962; Smith 1983, pp. 28–9.

5 Bauer 1987, pp. 119–87; Kirchweger 2005, pp. 70–109. The relics, today in Vienna (Schatzkammer), include a fragment of the True Cross, a splinter from the manger, a piece of the tablecloth used at the Last Supper and part of the apron worn by Christ when washing the Apostles' feet. The best-known object is the Holy Lance, believed to be the lance of Saint Longinus or of Saint Mauritius. The central pin was venerated as one of the nails used to crucify Christ.

6 Winkler 1936–9, nos 504–507, II/26; Strauss 1974, nos 1510/6–10. Bauer 1987, nos 148, pp. 153–5, 161–2.

7 Nuremberg (Germanisches Nationalmuseum). Winkler 1936–9, no. 505; Strauss 1974, no. 1510/8.

8 Nuremberg's council did not approve

Maximilian's initial request, dated 12 December 1512, that Dürer be exempt from local taxes because of his service to the emperor. Rupprich 1956, pp. 77–80; Hutchison 1990, pp. 114–15.

9 On Maximilian's projects, see Silver 1985, pp. 7–21; Schoch, Mende and Scherbaum 2002, pp. 389–92 (Thomas Schauerte); Röver-Kann and Müller 2003; Müller 2003; Silver 2008.

10 *Albrecht Dürer Master Printmaker* 1971, no. 204; esp. Schauerte 2001; Bartrum 2002, no. 139; Schoch, Mende and Scherbaum, II, no. 238 (Thomas Schauerte); Schröder and Sternath 2003, no. 154.

11 Stabius states that seven hundred impressions, not two hundred as is often cited, were delivered to Maximilian in Augsburg. Maximilian's grandson Archduke (and future Emperor; r. 1556–64) Ferdinand of Austria ordered another three hundred copies of the arch to be printed in Vienna in 1526/8. Today there are 169 blocks in the Albertina and one in the Museum für Angewandte Kunst, both in Vienna. Schauerte 2001, pp. 451–8, 462–5.

12 Rupprich 1956, pp. 82–3.

13 On large-scale woodcuts, see Appuhn and Von Heusinger 1976.

14 Schauerte 2001, p. 245; Bartrum 2002, no. 139.

15 Schauerte 2001, pp. 245–8.

16 Österreiche Nationalbibliothek, Vienna, Cod. 3255. Eight of Dürer's drawings survive. Strauss 1974, nos 1513/9–15.

17 Strauss 1974, no. 1513/8 (copy after Dürer).

18 Panofsky 1943, p. 177.

19 See the prints of Nicoletto da Modena, Giovanni Antonio da Brescia and Zoan Andrea; Schröder and Sternath 2003, pp. 448, 450.

20 Giehlow 1907; Strauss 1974a; Strauss 1974, nos 1515/1–45; Sieveking 1987. The illustrations from Giehlow's edition are usually reproduced by later scholars. As he noted (p. 18), he replaced the hand-drawn initials with printed ones copied from Dürer's *Treatise on Measurement*. The Viennese firm of Albert Berger, which made the reproductions, darkened many of the lines, among other alterations. This becomes obvious when comparing Dürer's original and often quite faint drawings in Munich (Bayerische Staatsbibliothek, L. impr. Membr. 64, fols 1–56v, 63–8) with the facsimile.

21 Strauss 1974a, pp. 70–1.

22 Parshall 1997, pp. 5–8. Also Koerner 1993, pp. 224–31.

23 Strauss 1974a, p. 81; Massing 1991, pp. 515–16; Nickel 2001 (on Aztec weapons).

24 A second inscription in Dürer's hand reads: 'this image was found in Celeia [Cilli in Styria] carved in a stone in the year 1516.' Koreny 1989; and Wood 2005, pp. 1160–6, who addresses the drawing's relation to ancient sources. For his drawing of Count Otto of Habsburg in Liverpool (Walker Art Gallery), see Winkler 1936–9, nos 676–7; Strauss 1974, no. 1515/50.

25 Scheicher 1986; Smith 1994, pp. 185–92.

26 Scheicher 1986, p. 337 and, for Theoderich (also cast by the Vischers in 1513), p. 380; Hauschke 2006, pp. 69–70.

27 Vienna (Albertina). Winkler 1936–9, no. 671; Strauss 1974, no. 1512/13.

28 Schoch, Mende and Scherbaum 2002, no. 239 (Thomas Schauerte).

29 Winkler 1936–9, no. 685; Rupprich 1956, pp. 261–2, for Pirckheimer's correspondence with Maximilian about the image; Strauss 1974, no. 1518/1; Schröder and Sternath 2003, no. 160.

30 Dated and with the imperial privilege at the far right. Hans Guldenmund of Nuremberg issued a Latin text copy in 1529. *Albrecht Dürer Master Printmaker* 1971, no. 205; Smith 1983, no. 26; Schoch, Mende and Scherbaum 2002, no. 257 (Thomas Schauert); Schröder and Sternath 2003, no. 161.

31 Rupprich 1956, p. 242, for this and the two other documents cited below. Mende 1978, pp. 38–88, 192–409, figs 1–2, 5–6, which show the room before and after its destruction in World War II.

32 Mende 1978, no. 112; Tacke 1995, pp. 118–22.

33 Vienna (Albertina); Winkler 1936–9, no. 922; Strauss 1974, no. 1522/12; Mende 1978, pp. 192–211, no. 160; Schröder and Sternath 2003, no. 182.

34 Mende 1978, pp. 211–24.

35 New York (Pierpont Morgan Library). Winkler 1936–9, no. 921; Talbot 1971, no. XXIX; Strauss 1974, no. 1521/62; Mende 1978, pp. 245–7, no. 273.

36 Mende 1978, pp. 247–96.

37 In June 1520 the council commissioned Dürer to design an elaborate silver medal with the portrait of Charles V and many coats of arms. Hans Krafft the Elder (active by 1509–42/3) cast the medal in silver, and at least eleven copies were delivered to the new emperor in Worms. Maué 1987, pp. 227–44.

38 On technique, see Luber 1991; Luber 2005, pp. 149–68, esp. pp. 154, 157.

39 Some scholars suggested he painted this quickly while still in Augsburg. Anzelewsky 1991, no.145; *Gothic and Renaissance Art in Nuremberg, 1300–1550* 1986, no. 140 (Kurt Löcher); Löcher 1997, pp. 213–16.

40 Anzelewsky 1991, no. 146; Schütz 1994, no. 7.

41 Rupprich 1956, pp. 173, 176; Goris and Marlier 1971, pp. 95, 99.

42 Schoch, Mende and Scherbaum 2002, no. 252 (Dagmar Eichberger).

43 Strieder 1982, p. 78. He translated 'pius' as 'gentle' when here 'pious' or 'devout' is more the intended meaning.

44 Mende 2000, no. 73.

45 Kotková 2006, no. I./4. Kupferstichkabinett, Berlin. Anonymous Venetian artist, c.1500.

Chapter 9

1 Rupprich 1956, pp. 86–7; Conway 1958, pp. 89–90; Smith 2010b, pp. 86–90.

2 On the latter topic, see Held 1931.

3 The original text, although lost, exists in two copies that date from the late sixteenth to the early eighteenth centuries. Rupprich 1956, p. 13 (on von Murr), pp. 146–202, esp. 146–7, on the history and editions of the journal; Conway 1958, pp. 92–126; Sahm 2002, pp. 133–84. On the trip, see Veth and

Muller 1918; Goris and Marlier 1971; *Albert Dürer aux Pays-Bas* 1977; Unverfehrt 2007.

4 Rupprich 1956, p. 148; Goris and Marlier 1971, p. 50. A copy of the portrait is in Schloss Pommersfelden. Anzelewsky 1991, no. 134K.

5 Rupprich 1956, p. 179, no. 12.

6 Rupprich 1956, p. 150; Goris and Marlier 1971, p. 55.

7 Van der Stock 1993, including Van der Wee and Materné 1993; Vermeylen 2003, pp. 15–34; Harreld 2004.

8 Winkler 1936–9, no. 821; Strauss 1974, no. 1520/12; Van der Stock 1993, no. 19; Schröder and Sternath 2003, no. 170.

9 Rupprich 1956, pp. 153, 165, 172–3; Goris and Marlier 1971, pp. 61, 82, 94.

10 Rupprich 1956; Goris and Marlier 1971, pp. 57–8.

11 Winkler 1936–9, no. 774; Strauss 1974, no. 1520/35; *From Schongauer to Holbein* 1999, no. 72.

12 Rupprich 1956, p. 151; Goris and Marlier 1971, p. 57.

13 Rupprich 1956, p. 152; Goris and Marlier 1971, pp. 58–9.

14 Rupprich 1956, p. 162; Goris and Marlier 1971, p. 76.

15 Rupprich 1956, p. 181, no. 118.

16 Grigg 1986, pp. 405–406.

17 Grigg 1986, pp. 402–403 notes that Dürer referred his prints of Saint Jerome using various titles.

18 Panofsky, 2005, p. 156; Talbot 1971, no. 60 (Charles Talbot who disagrees with Panofsky); Grigg 1986.

19 Schoch, Mende and Scherbaum 2001, nos 86, 91, 92.

20 Schoch, Mende and Scherbaum 2001, no. 87.

21 Rupprich 1956, pp. 165, 167, 172, 175; Goris and Marlier 1971, pp. 83, 85, 94, 97.

22 Rupprich 1956, p. 173; Goris and Marlier 1971, p. 94.

23 Winkler 1936–9, no. 804; Strauss 1974, no. 1520/17; Anzelewsky and Mielke 1984, no. 103; *From Schongauer to Holbein* 1999, no. 71; Roth 2006, no. 99.

24 Winkler 1936–9, no. 805; Strauss 1974, no. 1520/16; Schröder and Sternath 2003, no. 173 (Matthias Mende).

25 Rupprich 1956, p. 272.

26 Rupprich 1956, p. 156; Goris and Marlier 1971, p. 65.

27 Rupprich 1956, p. 167; Goris and Marlier 1971, p. 85.

28 The man's portrait is in Vienna (Albertina). Winkler 1936–9, no. 431; Strauss 1974, no. 1508/24; Schröder and Sternath 2003, no. 127. On Katharina, Winkler 1936–9, no. 818; Strauss 1974, no. 1521/8.

29 Rupprich 1966, p. 459; Strauss 1974, no. 1521/8 with translation.

30 Winkler 1936–9, no. 813; Strauss 1974, no. 1521/9; Anzelewsky and Mielke 1984, no. 105; Roth 2006, no. 94. I find unconvincing the identification of a badly damaged painting in Boston (Isabella Stewart Gardner Museum) as Rodrigo based on its comparison with this drawing. Anzelewsky 1991, no. 164.

31 Anzelewsky 1991, no. 162. For this and four related drawings, see Winkler 1936–9, nos 788–92; Strauss 1974, nos 1521/2–4, 6–7; Schröder and Sternath 2003, pp. 503–11,

nos 177–81; Roth 2006, no. 95.

32 Rupprich 1956, p. 164; Goris and Marlier 1971, p. 80.

33 Winkler 1936–9, no. 788; Strauss 1974, no. 1521/3; Rupprich 1956, p. 166; Goris and Marlier 1971, p. 84.

34 Schröder and Sternath 2003, pp. 504, 506 (Matthias Mende).

35 He received payment of 3 florins. Rupprich 1956, pp. 166, 193 note 498; Goris and Marlier 1971, p. 84.

36 Rupprich 1956, p. 158; Goris and Marlier 1971, p. 68. See also Strauss 1974, nos 1506/1–4; Oakes 2002; Bartrum 2002, no. 100.

37 Rupprich 1956, p. 166; Goris and Marlier 1971, p. 84.

38 On their contacts, see Rupprich 1956, pp. 152, 167, 169, 172, 175; Goris and Marlier 1971, pp. 59, 85, 88–9, 93, 97.

39 Winkler 1936–9, no. 800; Strauss 1974, no. 1521/14; *From Schongauer to Holbein* 1999, no. 76. Drawings in London and Besançon may be related; Winkler 1936–9, nos 801–2.

40 Rupprich 1956, p. 168; Goris and Marlier 1971, p. 87.

41 Rupprich 1956, p. 168; Goris and Marlier 1971, pp. 87–8.

42 Rupprich 1956, p. 161; Goris and Marlier 1971, p. 75.

43 Rupprich 1956, p. 173; Goris and Marlier 1971, p. 95.

44 Rupprich 1956, pp. 154–5, 172, 174; Goris and Marlier 1971, pp. 62–3, 93, 96; Eikelmann 2006.

45 Dürer purchased an illuminated Salvator from Susanna for 1 florin and remarked: 'It is very wonderful that a woman can do so much.' Rupprich 1956, pp. 165, 172, 175; Goris and Marlier 1971, pp. 82–3, 94, 98.

46 Rupprich 1956, pp. 174–5; Goris and Marlier 1971, pp. 96, 98. Winkler 1936–9, no. 816; Strauss 1974, no. 1521/26. This drawing was the model for Van Leyden's portrait in Hieronymus Cock's *Pictorum aliquot celebrium Germaniae inferioris efficies* (Antwerp, 1572).

47 Van Mander 1994–9, I, p. 97 (fol. 209v).

48 Rupprich 1956, pp. 209, 212; Nesselrath 1993.

49 Dürer sketched Vincidor's portrait too. Rupprich 1956, pp. 158, 169, 177; Goris and Marlier 1971, pp. 68–9, 89, 100, 103.

50 Mende 2000, p. 217, no. 117. Held 1982, p. 39.

51 The pillars actually came from Theodoric's palace in Ravenna. Rupprich 1956, p. 159; Goris and Marlier 1971, p. 69.

52 Winkler 1936–9, no. 763; Strauss 1974, no. 1520/22; Bartrum 2002, no. 151.

53 Scholars use this brief reference to attribute the so-called *Dombild*, now in Cologne Cathedral, and related paintings to Stefan Lochner (fl. 1440–51/3). Rupprich 1956, p. 160; Goris and Marlier 1971, pp. 71–2.

54 Rupprich 1956, p. 155; Goris and Marlier 1971, pp. 64–5; De Vos 1999, 200–206, 345–54.

55 Veth and Muller 1918, II, pp. 100–108; Rupprich 1956, p. 155; Goris and Marlier 1971, p. 64; Levenson 1991, pp. 499–505 (Michael D. Coe), 515–28 (Jean Michel Massing); Nickel 2001.

56 Rupprich 1956, pp. 167–8; Goris and Marlier 1971, pp. 86–7.

57 Hibbard 1974, p. 73, fig. 39.

58 Rupprich 1956, p. 168; Goris and Marlier 1971, p. 87; Dhanens 1973; Smith 2011a, pp. 31–3.

59 Winkler 1936–9, no. 779; Strauss 1974, no. 1521/12. The sheet with the single drawing is in Vienna (Albertina); see Winkler 1936–9, no. 781; Strauss 1974, no. 1521/3; Schröder and Sternath 2003, no. 174 verso.

60 Rupprich 1956, pp. 162–3; Goris and Marlier 1971, pp. 78–9; Mensger 2002.

61 Conway 1958, p. 91; Rupprich 1956, pp. 88–92 (letters 33–6), p. 160; Goris and Marlier 1971, p. 72.

62 Rupprich 1956, p. 162; Goris and Marlier 1971, pp. 76–7. A fathom is 1.829 metres.

63 For the passages on this trip, see Rupprich 1956, p. 162–3; Goris and Marlier 1971, pp. 77–9.

64 Mende and Hebecker 1971, nos. 18–19.

65 Winkler 1936–9, no. 823; Strauss 1974, no. 1521/27; Bartrum 2002, no. 153.

66 Rupprich 1956, pp. 168–9, n. 585; Goris and Marlier 1971, p. 88.

67 Winkler 1936–9, no. 886; Strauss 1974, no. 1522/8; Ilatovskaya 1992, no. 40.

68 On the shipments, see Rupprich 1956, pp. 166, 169, 174; Goris and Marlier 1971, pp. 84, 88–9, 96.

69 Smith 1990/91, pp. 165, 22; Smith 2011a, pp. 24–31.

70 Rupprich 1956, p. 176; Goris and Marlier 1971, p. 100.

71 Rupprich 1956, p. 176; Goris and Marlier 1971, p. 99.

72 Rupprich 1956, pp. 155, 158, 173, 175–6; Goris and Marlier 1971, pp. 64, 68, 95–6, 99; Smith 2010b, pp. 85–6.

73 Rupprich 1956, pp. 109–10; Conway, 1958, pp. 131–2.

74 Rupprich 1956, pp. 176–7; Goris and Marlier 1971, pp. 99–100. Winkler 1936–9, no. 815; Strauss 1974, no. 1521/33; Anzelewsky 1991, no. 169v; Bartrum 2002, no. 154.

75 Above the girl is inscribed 'cölnisch gepend' ('Cologne ribbonry'). This is on the recto of the single drawing of the Ghent lion. Winkler 1936–9, no. 780; Strauss 1974, no. 1521/57; Schröder and Sternath 2003, no. 174. For *Agnes in Netherlandish Dress* (1521), done on grey-violet toned paper (Kupferstichkabinett, Berlin), see Winkler 1936–9, no. 814; Strauss 1974, no. 1521/1; Roth 2006, no. 93.

Chapter 10

1 Rupprich 1956, pp. 214–15; Conway 1958, p. 145. Winkler 1936–9, no. 944; Strauss 1974, no. 1525/4; Rosenthal 1936; Schütz 1994, pp. 89–101, esp. 99–101; Poeschke 1994.

2 Knape 2003, fig. 8, showing Sebastian Brant asleep on the frontispiece to *Doctor Sebastianus Brants traum Jn tütsch* (Pforzheim, 1502); Telle 2006. See also Dürer's *Dream of the Doctor* engraving (c.1498); Schoch, Mende and Scherbaum 2002, no. 18.

3 Janeck 1982; Anzelewsky 1991, no. 14, p. 186; Schoch, Mende and Scherbaum 2001, no. 8; Roth 2006, no. 2.

4 Rosenthal 1936.

5 Rupprich 1966, p. 115; Massing 1986.

6 Rosenthal 1936, p. 85; Rupprich 1956, p. 215.

7 Scribner 1976; Blickle 1981.

8 Schoch, Mende and Scherbaum 2004, nos 274.108–9; Mittig 1984; Rebel 1996, pp. 405–10; Price 2003, p. 270.

9 Price 2003 CD-ROM, fol. J1 recto.

10 Mittig 1984, pp. 32–42; Schoch, Mende and Scherbaum 2001, nos 13–15, 77 (1514), 88 (1519).

11 Martin Luther, *Admonition to Peace: A Reply to the Twelve Articles of the Peasants in Swabia* (late March–early April 1525); *Against the Robbing and Murdering Hordes of Peasants* (early May 1525). Whitford 2003, pp. 184–6. Also *Reformation in Nürnberg* 1979, pp. 177–84.

12 G. Strauss 1976, pp. 154–86; *Reformation in Nürnberg* 1979; Smith 1983, pp. 30–6.

13 *Reformation in Nürnberg* 1979, p. 78; Price 2003, p. 17.

14 Van Mander 1994–9, I: p. 198 (fol. 235r).

15 Rupprich 1956, pp. 85–7; Conway 1958, p. 89.

16 These are listed by titles. Rupprich 1956, pp. 221–2; Conway 1958, pp. 156–7.

17 Rupprich 1956, p. 160; Goris and Marlier, p. 71.

18 Rupprich 1956, p. 175; Goris and Marlier, p. 98.

19 Rupprich 1956, pp. 170–2; Goris and Marlier, pp. 90–3.

20 Rupprich 1956, p. 93; Pfeiffer 1992; Price 2003, pp. 253–4.

21 Rupprich 1956, pp. 106–107; Conway 1958, p. 129; *From Schongauer to Holbein* 1999, no. 77.

22 Rupprich 1956, p. 281; Conway 1958, p. 36.

23 The print is in the collection at Veste Coburg. Rupprich 1956, p. 210; Andersson and Talbot 1983, pp. 323–5.

24 The literature on the Reformation's challenge to art is immense. See Christensen 1979; L and P Parshall 1986; Michalski 1993; Smith 1994, pp. 10–94; Wandel 1995. On Dürer, see Seebass 1971; Schuster 1986.

25 Conway 1958, p. 212; Rupprich 1966, p. 115.

26 Anzelewsky 1991, no. 187. There are three surviving copies.

27 Winkler 1936–9, no. 839; Strauss 1974, no. 1521/91, also nos 1521/81–90, 92–6.

28 Winkler 1936–9, no. 846; Strauss 1974, no. 1521/93; *From Schongauer to Holbein* 1999, no. 74.

29 Strieder 1982, p. 133.

30 Schoch, Mende and Scherbaum 2002, no. 259, with an illustration of the very different preparatory drawing (1523; Albertina, Vienna; Winkler 1936–9, no. 889; Strauss 1974, no. 1523/14); Kantor 2000, pp. 34–41; Price 2003, pp. 250–8; Arndt and Moeller 2005.

31 Schoch, Mende and Scherbaum 2002, no. 157.

32 Arndt and Moeller 2005, pp. 187–93.

33 Price 2003, pp. 255–6; Arndt and Moeller 2005, pp. 199–201.

34 Christensen 1965, pp. 140–52; Strieder 1982, pp. 322–7; Anzelewsky, 1991, nos 183–4; Schmid 1996a, pp. 129–74; Goldberg, Heimberg and Schawe 1998, no. 14, pp. 478–559; Price 2003, pp. 258–75; Arndt and Moeller 2003. On related drawings and prints, on possible sources including Giovanni Bellini's altarpiece in the Frari church in Venice, on Johann Neudörfer's claim that the four men represent the four

temperaments, and on the conjectures that the figures are portraits of Dürer's contemporaries, a suggestion I find wrong for many reasons, see Goldberg, Heimberg and Schawe 1998, pp. 509–13, 532–6.

35 Arndt and Moeller 2003, pp. 59–60.

36 Conway 1958, p. 135.

37 *Reformation in Nürnberg* 1979, pp. 171–4; Goldberg, Heimberg and Schawe 1998, pp. 525–9; Price 2003, pp. 266–7; Arndt and Moeller 2003, p. 36, for what follows.

38 Rupprich 1956, p. 117; Conway 1958, p. 135.

39 Rupprich 1956, pp. 242–3, 246; Goldberg, Heimberg and Schawe 1998, pp. 519–21, 551.

40 Neudörfer 1875, pp. 132–3; Rupprich 1956, pp. 320–1.

41 Arndt and Moeller 2003, pp. 42–3. These authors (pp. 46–7, 66–9) raise the interesting but undeveloped suggestion that Dürer's panels were influenced by his discussions with Spengler, who anonymously authored *Eyn Christenlicher Ratschlag vnnd vnterrichtung* in September 1526. Using two of the same biblical quotations, Spengler set out the challenges for a Christian government.

42 Rupprich 1956, p. 243.

43 Schwemmer 1949, pp. 97–108, 194–203; Christensen 1965, pp. 151–2; Van Mander 1994–9, I: p. 94; Goldberg, Heimberg and Schawe 1998, pp. 340–1.

44 Goldberg, Heimberg and Schawe 1998, pp. 26–7, 542–9, 551–9, figs 14.51–2 (Georg[?] Vischer's 1627 replica).

45 Rupprich 1956, p. 285; G. Strauss 1976, p. 172.

46 Rupprich 1956, pp. 234–5, 289; Price 2003, pp. 7–9, 283.

47 In his *Speis der Malerknaben* (c.1512) Dürer describes the preservation of the 'likeness of men after their death' as one task of the art of painting. These sentiments echo those of Alberti. Conway 1958, p. 177; Schuster 1982; Schröder and Sternath 2003, p. 524.

48 Schoch, Mende and Scherbaum 2002, no. 256; Talbot 1971, nos 203–4; Smith, Guenter et al. 1995, no. 69; Schröder and Sternath 2003, nos 185–6. The two men had known each other since at least 1515; Rupprich 1956, p. 257.

49 For the print's text, see Dreher 1994.

50 Rupprich 1956, p. 124.

51 Hofmann 1983.

52 Schoch, Mende and Scherbaum 2001, nos 89, 97.

53 Schoch, Mende and Scherbaum 2001, no. 98; Talbot 1971, no. 76; *Gothic and Renaissance Art in Nuremberg, 1300–1550* 1986, no. 153; Schröder and Sternath 2003, no. 187. The silverpoint drawing is in Paris (École nationale supérieure des Beaux-Arts); Winkler 1936–9, no. 897; Strauss 1974, no. 1524/1.

54 His publications included *Inscriptiones vetustae Romanae et earum fragmenta in Augusta vindelicorum* (Mainz, 1520). Wood 1998, figs 5, 7; and Wood 2001, p. 14.

55 Schröder and Sternath 2003, no. 187 (Matthias Mende).

56 Schoch, Mende and Scherbaum 2001, no. 99; Talbot 1971, p. 77; *Gothic and Renaissance Art in Nuremberg, 1300–1550* 1986, no.

152; esp. Satzinger 2007.

57 Rupprich 1956, p. 306, no. 21.

58 Trusted 1990, p. 36.

59 Schoch, Mende and Scherbaum 2001, no. 101; Talbot 1971, no. 78; Mende 2000, no. 114.

60 Suckale 1977.

61 Schoch, Mende and Scherbaum 2001, no. 102; Talbot 1971, no. 79; *Gothic and Renaissance Art in Nuremberg, 1300–1550* 1986, no. 155; Schröder and Sternath 2003, no. 188. The copper plate, now lost, was once owned by Emperor Rudolf II in Prague.

62 8 January 1525. Rupprich 1956, p. 271; Strauss 1976, p. 290. Dürer borrowed the Greek inscription from the medal.

63 Silver 1984, pp. 243–5 (medal), no. 58, pl. 99 (painting in Rome, Galleria nazionale d'arte antica, and replica[?] in Hampton Court, Royal Collection).

64 Rupprich 1956, p. 276 (letter of 30 July 1526 to Pirckheimer) and p. 279 (letter of 29 March 1528 to Henricus Botteus).

65 Strauss 1974, nos 1523/8–9, 17, 19–20, 1524/2, 1525/1–3, 14–16; 1526/2, 11; 1527/1; Anzelewsky 1991, nos 171–9, 182.

66 Pirckheimer 2006, p. 84.

67 The background is slightly damaged from an earlier over-painting, since removed. Anzelewsky 1991, nos 179–80.

68 Dülberg 1990, pp. 190–1.

69 Anzelewsky 1991, no. 182; Rebel 1990; Schütz 1994, pp. 86–8; Smith 2010a, pp. 91–2.

70 Smith 2000, figs 10.1–2, 4, 7.

71 Mende 1983, nos 28–9; Rebel 1990, 32–3, 96, figs 3–4.

72 Talbot 1971, p. 194.

73 Also suggested by Rebel 1990, pp. 73–7.

74 Erwin Panofsky addressed Dürer's theoretical writings in numerous publications. The clearest discussion is Panofsky 1943, pp. 242–84. See Conway 1958, pp. 165–273; Rupprich 1966 and 1969 for the various unpublished and published texts.

75 Conway 1958, pp. 177–8; Rupprich 1966, pp. 100, 109.

76 Conway 1958, p. 178; Rupprich 1966, p. 100.

77 Shelby 1977.

78 Rupprich 1956, p. 59; Conway 1958, p. 58.

79 Rupprich 1956, p. 309, also p. 294; Conway 1958, p. 139.

80 Conway 1958, pp. 175–80; Rupprich 1966, esp. pp. 99–103, 129–33.

81 Schoch, Mende and Scherbaum 2004, no. 274, pp. 168–278; Conway 1958, pp. 207–26; Rupprich 1969, pp. 307–67; Strauss 1977); Price, 2003-CD-ROM.

82 'Then take a compass and transfer the thickness of the column from the profile of the straight column to all the horizontal distances of the twisted column and draw a circle around each. These will indicate the thickness of the column' [fol. H3r]. Schoch, Mende and Scherbaum 2004, nos 274.101–2.

83 Schoch, Mende and Scherbaum 2004, nos 274.215–16; Talbot 1971, no. 215. Kemp 1990, pp. 53–64, 171–3.

84 A Latin edition was published in Paris in 1535. Schoch, Mende and Scherbaum 2004, no. 276; Conway 1958, pp. 262–73; Rupprich 1969, pp. 369–433; Talbot 1971, no. 216; Von Reitzenstein 1971; Anzelewsky 1980, pp. 238–40.

85 Berlin (Kupferstichkabinett). Winkler 1936–9,

no. 626; Strauss 1974, no. 1519/10.

86 Schoch, Mende and Scherbaum 2002, no. 260.
 Zdanowicz 1994, no. 25.

87 A Latin edition, translated by Joachim
 Camerarius, was published in two parts in
 Nuremberg in 1532 and 1534. Several
 French, Italian and Spanish editions
 appeared before 1600. Schoch, Mende and
 Scherbaum 2004, pp. 319–474, no. 277;
 Panofsky 1943, pp. 261–70, 273–83; Conway
 1958, pp. 227–61; Rupprich 1966, pp. 397–499;
 Rupprich 1969, pp. 17–306; Talbot 1971, no.
 217; Strauss 1974, vol. 5; Anzelewsky 1980,
 pp. 241–3; Price 2003-CD-ROM (on the first
 two books).

88 Strauss 1972, no. 116; Strauss 1974,
 no. 1519/18.

89 Schoch, Mende and Scherbaum 2004, p. 367,
 no. 277.63.

90 Conway 1958, pp. 243–50 (English
 translation of the manuscript); Rupprich
 1969, pp. 267–306, esp. 290–9; Schoch,
 Mende and Scherbaum 2004, pp. 441–3.

91 Conway 1958, p. 244.

92 Panofsky 1943, pp. 276–7.

93 Conway 1958, pp. 247–8.

94 Conway 1958, p. 230.

95 Rupprich 1966, pp. 117–18, 120; Strauss
 1977, p. 32.

96 Rupprich 1956, p. 278; Strauss 1977, p. 31.

97 Smith 1983, nos 71, 95, 136; Keil 1985.

98 Strauss 1981, p. 140 (with translation);
 Smith 1983, no. 71.

99 Van Mander 1994–9, I: p. 93 (fol. 208v).
 In his Teutsche Academie Von Sandrart
 paraphrases Van Mander's remarks and
 stresses the sensible utility of Dürer's
 treatises. Von Sandrart 1675, I: p. 223.

100 Białostocki 1986, p. 64; Golahny 2003,
 pp. 88–95.

Chapter 11

1 Rupprich 1956, p. 304; Białostocki 1986, p. 35.

2 He is buried beneath the Frey family
 tombstone. The brass plaque is attributed
 to the Vischer family workshop. In 1681
 Joachim von Sandrart renovated the tomb
 and added the laudatory Latin and German
 text plaque. Mende 2000, pp. 29, 37.

3 Lüdecke and Heiland 1955; Mende 2000;
 and, most fully, Białostocki 1986.

4 Meder 1932, pp. 240–2; Smith 1983, nos 66–7;
 Mende 2000, no. 19, p. 299. The original
 woodblock, or an excellent copy, with the
 added monogram and 1527 date, inlaid at a
 later time, is in the Princeton University Art
 Museum. Another is in Vienna (Albertina).
 On Gebel's medal, see Mende 1983, pp.
 82–93, 211–31.

5 Rupprich 1956, p. 305.

6 Rupprich 1969, pp. 297–8; Roth 2001.

7 Lüdecke and Heiland 1955, pp. 66–8, 285–6;
 Koerner 1993, pp. 248–50; Mende 2000,
 no. 119; Schmitt 2003.

8 Rupprich 1956, pp. 279–88 (letters) and pp.
 296–320 (publications). See also Panofsky
 1951; Mende 1971, nos 266–324.

9 Pages A2R–A4R. Rupprich 1956, pp. 307–15;
 Price 2003 CD-ROM (with English
 translation). Parshall 1978, pp. 11–29.

10 Arend 1728.

11 Rupprich 1956, p. 306; partial translation in
 Baxandall 1983, p. 16; Marquard 1997.

12 Letter of 17 December 1546 written to
 Georg von Anhalt, the Lutheran bishop of
 Merseburg. Rupprich 1956, p. 289; Conway
 1958, p. 184; Strieder 1982, pp. 366–7.

13 Beck and Decker 1981, no. 47; Smith 1994,
 pp. 339–40; Eser 1996, no. 8; Mende 2000,
 no. 118. Dürer is a protagonist in Johannes
 Ludovicus Vives's rhetoric textbook
 Exercitatio linguae latinae (1538), over two
 hundred editions of which were published.
 In one of the twenty-five conversations he
 triumphs verbally over two pedantic
 scholars who criticize his fictive portrait of
 Scipio. Gombrich 1973.

14 Schwarz's boxwood model, now in
 Braunschweig (Herzog Anton Ulrich-
 Museum), was designed before Dürer
 departed for the Netherlands. In his journal
 Dürer records that he paid Schwarz 2 gold
 florins. For this project and its many copies,
 including Hans Petzoldt's 1628
 commemorative version, see Mende 1983,
 pp. 57–68, 187–200, 265–75.

15 Eser 1996, nos 5–7 (all dated 1522),
 15 (undated).

16 Raphael celebrated Michelangelo, among
 others, in his School of Athens fresco in
 the Vatican.

17 Wolfson 1992, no. 34; Mende 2000, p. 157.
 Also see Koschatzky 1973, nos 4, 28, 30;
 Smith 1983, no. 164.

18 Wenzel Hollar's etching includes a profile
 portrait of Dürer, based on Schwarz's medal,
 surrounded by laurel branches and placed
 on top of a tablet inscribed 'Civitatis
 Norimbergae Vera Descriptio geometrica'.
 Pennington 1982, no. 874; Smith 1983, p. 2.

19 Rupprich 1956, pp. 319–20; Białostocki
 1986, p. 29, citing Camerarius's Elementa
 rhetoricae (Basel, 1541); Koerner 2006.

20 Entwürfe und andere Bruchstücke zu
 Jahrespraktiken (c.1537–41); Rupprich 1956,
 pp. 321–2.

21 Vasari and others lamented that Dürer
 would have been even greater if only he had
 been Italian or had studied with the masters
 of Italy. Białostocki 1986, pp. 37–54.

22 Schauerte 2006.

23 Von Murr 1797; Hampe 1904; Schwemmer
 1949; Koreny 1985, pp. 261–6 (with inventory
 of the Imhoff Collection); Smith 1985a;
 Löcher 1994; Schoch, Mende and Scherbaum
 2001, pp. 19–21 (Rainer Schoch).

24 Parshall 2004.

25 Schütz 1994, p. 55.

26 On Rudolf's collecting, see Koschatzky and
 Strobl 1972, pp. 11–22; Schütz 1994,
 pp. 49–54; Kotková 2006, pp. 117–18.

27 Van Mander 1994–9, I: p. 94 (fol. 209r).

28 Von Sandrart 1675, I: Part 2, Book 3, p. 223;
 Kotková 2006, p. 67.

29 Goldberg 1980, p. 140.

30 Anzelewsky 1991, no. 137; Goldberg,
 Heimberg and Schawe 1998, no. 12.

31 Białostocki 1986, pp. 146–7.

32 Kauffmann 1940–53; Goldberg 1971;
 Goldberg 1980; Herbert and Decker 1981;
 Koreny 1985; Schütz 1994, pp. 55–7;
 Kotková 2006, pp. 121–3.

33 Koreny 1985, no. 12, also see nos 11, 13;
 Bartrum 2002, no. 227, see no. 228.

34 Kotková 2006, no. II./8.

35 The picture is a pastiche as Vischer borrows
 other figures from Titian and Robert

Walker. Goldberg 1980, pp. 142–3; Koerner 1993, pp. 71–6; Goldberg, Heimberg and Schawe 1998, pp. 28–9, 326–7.

36 Goltzius worked in the style of Lucas van Leyden, Jacopo Bassano and Cornelis Cort after Federico Barocci, among others. Melion 1991, pp. 45–6, 55, 102–104; Leeflang and Luijten 2003, pp. 203–15, nos 75.4, 81, Goltzius's Pietà (1596), which refers to Dürer and Michelangelo.

37 Schoch, Mende and Scherbaum 2002, no. 176.

38 Van Mander 1994–9, 1604, fols 284v–285r.

39 Kotková 2006, pp. 150–1 (Eliška Fučíková).

40 Hinz 1971; Mende and Hebecker 1971; Mende and Hebecker 1973; Pirsich 1983; Białostocki 1986, pp. 91–143, 219–42; Hutchison 1990, pp. 187–206; Blumenthal 2001; Kuhlemann 2002.

41 Levey 1971; Vaisse 1973; Bräutigam and Mende 1974.

42 Mende 2000, p. 458. The likenesses of Martin (sic for Matthias) Grünewald, Albrecht Altdorfer, Georg Pencz, Albrecht (sic for Heinrich) Aldegrever, Hans von Kulmbach, Hans Burgkmair, Sebald Beham and Hans Schäufelein, many with incorrect death dates, are based on illustrations in Von Sandrart, 1675.

43 Białostocki 1986, p. 117, fig. 47. For other symbolic scenes, including Dürer's apotheosis above the tomb, see Mende 2000, figs on pp. 456–7.

44 Mende 1991, pp. 11–50.

45 Von Simson 1996, nos 161–3. Included among the items placed beneath the cornerstone were Friedrich Campe's Dürer book (see bibliography), portrait medals of Dürer and Pirckheimer, a woodcut of the head of Christ by H Reuther, a glass painting of Ludwig I, two bottles of cherry brandy and three tubes of seeds. Goddard 1988, pp. 118–19.

46 Mende 1969; Goddard 1988.

47 On German Romanticism and Dürer, see the articles in Anzeiger des Germanischen Nationalmuseums (1998).

48 Christian 1973, pp. 57–8, 79; Białostocki 1986, p. 243; Mende 1991, p. 30; Seifert 2010a, pp. 31–2. Scott owned at least 121 prints by Dürer and he authored Scott 1869.

49 Białostocki 1986, p. 97; Goldberg, Heimberg, and Schawe 1998, p. 30, fig. II.9; Decker 1998.

50 Białostocki 1986, pp. 309–33; Hayum 1989, pp. 118–50. See also Allegory of German Art by Alexander Kips (1858–1910), which positions Dürer at the apex of German artists, made for the German Pavilion at the 1893 Chicago World's Fair; see Hinz 1981, p. 64.

51 Białostocki 1986, pp. 235–42.

52 Bongard and Mende 1971; Mende 1971; Mende 1980; Mende 1990.

53 Stölzl 1986, pp. 38–9, also 40–1 (Dürer in Antwerp), 84–121 (Dürer-Suite with text by Matthias Mende).

54 Bann 1981, pp. 113–44, esp. 122, 130–1; Abrioux 1992, pp. 50, 54.

Albrecht Altdorfer (c.1480–1538)

A prolific, wide-ranging painter and printmaker. He settled in Regensburg in 1505. He experimented with landscape etchings and used evocative vistas as settings for historic and mythic subjects. Altdorfer was leader of a group of artists, later termed the Danube School, who portrayed the wild landscape near Regensburg and Passau. From 1517 he often served on the city council and was appointed city architect in 1526. He collaborated with Dürer on the *Triumphal Arch of Emperor Maximilian I* (135).

Apelles (fl. before 336–after 301 B C)

According to ancient texts, he was painter to Philip of Macedon, Alexander the Great, and Ptolemy I. His portraits and paintings, none of which survives, were renowned for their grace and beauty. During the Renaissance, Apelles was celebrated as the greatest of ancient Greek and Roman painters.

Hans Baldung Grien (1484/5–1545)

Among the most novel of German painters and printmakers. Besides his more conventional subjects, he explored the superstitious, the erotic, and the irrational sides of human nature. His depictions of *Adam and Eve* or of witches are often charged with sexual tension. Baldung hailed from a noted family of lawyers and doctors. Trained in Strasbourg, he worked in Dürer's shop in Nuremberg from 1503 to late 1506 or early 1507. The two artists kept in contact, and Baldung received a lock of Dürer's hair in 1528. Except for stays in Halle (1507–9) and Freiburg im Breisgau (1512–17), Baldung worked in Strasbourg.

Jacopo de' Barbari (c.1460/70–1516)

One of the few Italian artists who spent most of his career in Northern Europe. The monumental woodcut *View of Venice* (24) is the most famous work attributed to the Venetian artist. Appointed court painter to Emperor Maximilian I, de' Barbari resided in Nuremberg in 1500–3 before moving to Elector Friedrich the Wise's court in Wittenberg. By 1508, he settled in the Netherlands where he worked for Philip of Burgundy, bishop of Utrecht, and Regent Margaret of Austria in Mechelen. De' Barbari's reluctance to teach Dürer how to make proportional or constructed figures prompted the latter's intensive theoretical studies.

Gentile Bellini (c.1435–1507) and Giovanni Bellini (1431/6–1516)

These brothers were Venice's leading painters of the later fifteenth and early sixteenth centuries. Gentile was noted for his narrative scenes and his portraits. His most famous paintings for the Sala del Maggior Consiglio in the Doge's Palace, commissioned in 1474, were destroyed by fire in 1577. The Venetian senate sent Gentile to the court of Sultan Mehmed II in Constantinople from 1479 to early 1481. His depictions of Ottomans appear often in later works and influenced Dürer. Giovanni and his prolific workshop specialized in devotional pictures of great naturalism including many altarpieces for local churches and numerous commissions for the Doge's Palace. He was among the first Italian painters to switch from tempera to oil paints. While in Venice in 1506, Dürer mentions Giovanni's kindness.

Hans Burgkmair (1473–1531)

Born in Augsburg, he was among the most influential painters and printmakers after 1500. He trained with his father and then in Colmar with Martin Schongauer. Even prior to his trip to northern Italy in 1507, Burgkmair incorporated classical themes and architectural elements into his art. His woodcuts were decisive transmitters of the Italian Renaissance decorative style into German art. In 1508 Burgkmair started experimenting with the chiaroscuro woodcut. He frequently collaborated with Jost de Negker (c.1485–c.1544), the talented woodblock carver. Burgkmair, like Dürer, worked extensively on graphic projects for Emperor Maximilian I during the 1510s. Dürer's portrait drawing of Burgkmair of 1508 is in Oxford (Ashmolean Museum).

Lucas Cranach the Elder (1472–1553)

He had an innovative career which first flourished in 1501–4 when he created evocative Danube landscapes and portraits for scholars in Vienna. In 1504 Friedrich the Wise, Elector of Saxony, called Cranach to Wittenberg where he spent most of his career as court artist. Cranach's large workshop, including sons Lucas the Younger (1515–1586) and Hans (c.1513–1537), efficiently produced hundreds of paintings and prints. He was the favourite portraitist for the nobility in Saxony and northern Germany. Cranach collaborated closely with his friend Martin Luther in devising a new Protestant iconography; however, he continued to work for Cardinal Albrecht von Brandenburg and other Catholic patrons. Dürer's portrait drawing of Cranach, made in Nuremberg in 1524, is in Bayonne (Musée Bonnat).

Jan van Eyck (c.1390–1441)

The first internationally famous Netherlandish painter. He served as court artist for the Count of Holland in The Hague from 1422–4 and for Philip the Good, Duke of Burgundy, from 1425 until his death. Van Eyck participated in several diplomatic missions including a trip to Portugal in 1428–9 before settling in Bruges in 1432. His pictures are characterized by their innovative designs, complex iconographies, jewel-like colours, attention to light playing across material surfaces, and detailed naturalism. Dürer admired Van Eyck's greatest painting, the *Adoration of the Mystic Lamb* (1432; Ghent, Saint Bavo's church) during his 1521 visit.

Hugo van der Goes (c.1440–1482)

After joining the Ghent Painters' Guild in 1467, he became the outstanding Netherlandish painter of the 1470s. Van der Goes's early work reveals Jan van Eyck's influence. His highly detailed altarpieces and naturalistic portraits attracted numerous clients, including Tommaso Portinari, the Medici Bank's agent in Bruges. Sometime between 1475 and 1478, Van der Goes left Ghent and became a lay brother at the Roode Klooster, a Windesheim monastery near Brussels. Although he continued to paint, his subsequent career was limited by bouts of insanity. Dürer records seeing his paintings in Brussels and Bruges.

Jan Gossart (Gossaert, Mabuse; 1478–1532)

He was an important transitional figure whose early paintings reveal the influence of Jan van Eyck's art and a delight in elaborate Gothic ornamentation. In 1508–9 Gossart travelled to Italy with Philip of Burgundy who instructed him to sketch classical sculptures and buildings, such as the Colosseum.

Later paintings and designs blend his Netherlandish tradition with classical and contemporary Roman art plus his familiarity with Dürer's prints. He often used dramatic lighting and energetic drapery to enliven his pictures. In December 1520, Dürer saw Gossart's *Descent from the Cross Altarpiece* (1518–20) in the abbey in Middleburg.

Matthias Grünewald (c.1475/80–1528)

From Würzburg(?), he was the most visually expressive of German Renaissance painters. His actual name, Matthias Gothart called Nithart, was forgotten shortly after his death. Joachim von Sandrart first referred to this painter as Grünewald in 1675. He apprenticed in Augsburg (1501–2) and Nuremberg (1503). Only a few paintings and about forty drawings can be attributed to him. Many of these were made for his most famous work, the *Isenheim Altarpiece* completed in 1515. From 1510 Grünewald worked as a painter and water engineer for the archbishops of Mainz, including Albrecht von Brandenburg. Grünewald's style with its bold coloration, dramatic gestures, and emotional pathos was rediscovered by artists, notably the German expressionists, around 1900. He contributed painted wings to Dürer's *Heller Altarpiece* (95–6) in Frankfurt.

Housebook Master (Master of the Amsterdam Cabinet; fl. c.1470–1500)

Active in the middle Rhineland, perhaps in Heidelberg and Mainz, he authored at least eighty-nine drypoint prints, some of which Dürer likely knew, and a compilation of drawings known as the *Medieval Housebook* (Schloss Wolfegg). Many of these depict chivalric court life and every day images, such as peasants and

children. Only a few of his paintings survive. Efforts to identify this inventive artist have not been convincing.

Lucas van Leyden (c.1494–1533)

A highly successful painter whose *oeuvre* included the monumental *Last Judgement Altarpiece* (1526–7) originally in Saint Pieter's Church in Leiden. The artist achieved greater fame as the first significant Dutch printmaker; he authored about two hundred prints. Van Leyden's early woodcuts and engravings were strongly influenced by Dürer's prints. Later Jan Gossart and the engravings of Marcantonio Raimondi after Raphael nurtured his interest in contemporary Italian art. Van Leyden's scenes often feature classicizing nudes, elaborate architectural spaces, and innovative stagings. He met Dürer in Antwerp in June 1521. They exchanged prints and Dürer drew Van Leyden's portrait (157).

Andrea Mantegna (1431–1506)

He was among the most renowned painters and printmaker of the fifteenth century. After working in Padua up to 1460, he settled in Mantua where he became court painter to the dukes of Gonzaga. Dürer copied two of Mantegna's prints (33–4) and was inspired by his antiquarian fascination with classical forms, mythological themes, and sculpturesque figures.

Master E. S. (fl. c.1450–67)

Active in the Upper Rhineland and in Switzerland, he was the most technically adept engraver before Martin Schongauer and Dürer. Some of his approximately three hundred prints transmitted Netherlandish artistic models, notably those of Rogier van der Weyden and sculptor Nicolaus Gerhaert van Leyden (fl. 1462–73), throughout Germany.

Israhel van Meckenem (c.1440/50–1503)

Active in Bocholt, near the Dutch border, he was Germany's most prolific engraver of the fifteenth century. His own designs or those made in collaboration with Hans Holbein the Elder (c.1460/5–1524) of Augsburg are highly inventive. Van Meckenem often replicated prints by Master E.S., with whom he may have trained, Martin Schongauer, and the young Dürer.

Conrat Meit (Konrad; 1470/85–1550/1)

The Worms native worked in Wittenberg for Friedrich the Wise before moving to the Netherlands. Between 1514 and 1530, Meit was in the service of Margaret of Austria in Mechelen. He carved small sculptures as well as the tombs for Margaret, Philibert of Savoy and Margaret of Bourbon in Brou. Dürer dined with Meit on several occasions in Antwerp and Mechelen in 1520–1. Dürer sketched Meit's portrait and gave him prints. The sculptor joined the guild in Antwerp in 1536.

Quentin Massys (Quinten Metsys; 1466–1530)

The son of a blacksmith, he joined Antwerp's Guild of Saint Luke in 1491 and became its first great painter. Although his initial pictures mimic the style of early Netherlandish art, Massys was strongly influenced by Leonardo da Vinci (1452–1519) in the 1510s. He integrated Leonardo's figural groups and caricatures into his other pictures. Massys excelled as a portraitist and religious painter, sometimes in collaboration with Joachim Patinir and other local artists. Dürer toured Massys's house soon after arriving in Antwerp in 1520 but he does not mention meeting the artist.

Bernard van Orley (c.1488–1541)

Despite never travelling to Italy, he was strongly affected by the art of Raphael and his followers. A prolific painter, Van Orley flourished designing tapestries for weavers in Brussels and stained glass windows for various churches. Van Orley, court painter to Regent Margaret of Austria since 1518, hosted a costly dinner in Dürer's honour during his visit to Brussels in late August 1520. Dürer sketched his portrait.

Joachim Patinir (c.1480–1524)

He specialized in painting panoramic landscapes, often in collaboration with Quentin Massys or Joos van Cleve (d. 1540/1), who added the figures. Little is known about his early career, though he may have worked in Bruges before joining Antwerp's guild in 1515. Patinir lent Dürer an assistant and colours soon after the Nuremberg artist arrived in Antwerp in August 1520. During his stay the men became friends. Dürer drew his portrait, gave him prints, and provided him with figural designs (138). Dürer was an honoured guest at Patinir's wedding on 5 May 1521. An Antwerp lawyer gave Patinir's *Lot and His Daughters* painting (Museum Boijmans Van Beuningen, Rotterdam) to Dürer.

Marcantonio Raimondi (c.1470/82–1527/34)

Following his training in Bologna, he lived in Venice c.1506–8 where he was best known for the engravings he made after Dürer's woodcuts and engravings. According to Giorgio Vasari, Dürer sued Raimondi in Venice in 1506. Moving to Rome in 1510–11, Raimondi became the city's leading printmaker and achieved renown for his prints after Raphael's designs.

Raphael (Raffaello Santi; 1483–1520)

After training in Urbino and working in Florence (1504–8), he became the painter to Popes Julius II and Leo X in Rome. Perhaps the most celebrated artist of the Italian Renaissance, Raphael was a prolific painter, including frescoes for the Vatican Stanzas, draughtsman and architect. Many of his drawings were engraved by Marcantonio Raimondi. He designed the *Acts of the Apostles* tapestries (1516–21) woven in Brussels. Raphael and Dürer exchanged gifts of art, including the latter's self-portrait on canvas (now lost) in 1515. The two were frequently linked from the mid-sixteenth century on as the embodiments of Italian and German artistic genius.

Martin Schongauer (c.1435/50–1491)

From a family of goldsmiths in Colmar, he was Europe's foremost engraver prior to Dürer. Over one hundred monogrammed engravings survive. These reveal his compositional inventiveness and his talent at blending the art of the Upper Rhine with strong Netherlandish influences. Artists in other media frequently borrowed his compositions. Schongauer was also a noted painter whose pictures include the *Madonna of the Rose Bower* (1473) in Colmar and the monumental *Last Judgment* mural (c.1489–91) in Breisach (Münster). Schongauer's brothers in Colmar and Basel aided Dürer during his *wanderjahre*.

Tommaso di Andrea Vincidor (fl. 1517–1534/6)

According to Giorgio Vasari, this Bolognese painter was a pupil of Raphael at the Vatican in Rome. In 1520, Pope Leo X sent Vincidor to Brussels to design cartoons for tapestries for the Sala di Costantino and Sala di Consistoro. He and Dürer met on several occasions, at which they exchanged gifts and made each other's portraits. Dürer gave a set of prints that Vincidor was to send to Rome in order to obtain works by Raphael. The Italian painter and architect remained in the Netherlands, where he later worked for the Count of Nassau in Breda.

Vitruvius (fl. late 1st century BC)

This Roman architect and engineer is best known for his treatise *De architectura (On Architecture)*, the oldest surviving classical text on the theory and practice of architecture. Over eighty medieval manuscript copies are known. The treatise was first printed in 1486–92 and, with illustrations, in Venice in 1511. It influenced Leon Battista Alberti (1404–1472), other early Renaissance architects, and Dürer, who was inspired by the chapter on human proportions.

Rogier van der Weyden (c.1399–1464)

He was one of Europe's most famous early Renaissance painters. After completing his training with Robert Campin (?Master of Flémalle; c.1375/9–1445) in Tournai in 1432, he is documented in Brussels in 1435 and was appointed city painter in 1436. His patrons included Philip the Good, Duke of Burgundy, and his courtiers, such as Nicolas Rolin. Van der Weyden's style, with its balanced compositions, clear figural poses, harmonious colours, and occasional displays of emotion, proved far easier for other artists to emulate than the more intricate manner of Jan van Eyck. Dürer saw his paintings in Brussels and Bruges.

Michael Wolgemut (1434/7–1519)

He was Dürer's teacher from 1486 to 1489/90, a role which often overshadows his own remarkable career as a painter and printmaker. He ran a huge workshop that produced elaborate painted and carved retables, such as those in

Zwickau (1477) and Schwabach
(1507–8), epitaphs, portraits and
designs for stained-glass windows.
Working with publisher Anton
Koberger, Wolgemut revolutionized
the printed book by introducing high
quality woodcut illustrations. The
Schatzbehalter (1491) and
Nuremberg Chronicle (1493),
created in conjunction with Wilhelm
Pleydenwurff (c.1460–1494), his
stepson, are among the most
beautiful incunabula. Dürer painted
his portrait in 1516 (13).

Significant Events in the Life of the Artist	Historical Events in the Life of the Artist
1427 Birth of Albrecht Dürer the Elder in Ajtós, Hungary.	
1451 Birth of Barbara Holper in Nuremberg.	
1455 Albrecht Dürer the Elder settles in Nuremberg.	
1467 Marriage of Albrecht Dürer the Elder and Barbara Holper.	
1468 Albrecht Dürer the Elder is a master goldsmith in Nuremberg.	
1471 21 May: birth of Albrecht the Younger. Publisher Anton Koberger is his godfather.	**1474** William Caxton prints first books in English at Bruges
1475 Albrecht the Elder acquires a house at Burgstrasse 27 (Unter der Veste). Birth of Agnes Frey.	
1484 Begins training with his father to be a goldsmith. First drawn self-portrait [18]. Birth of Endres Dürer (d. 1555).	**1477** Death of Charles the Bold, Duke of Burgundy (r. 1467–77), at the battle of Nancy. Marriage of Maximilian I, the future emperor, and Mary, Duchess of Burgundy (r. 1477–82).
1486 30 November. Albrecht begins training as a painter with Michael Wolgemut.	
Late 1489/early 1490 Albrecht finishes his training with Wolgemut.	
1490 Birth of Hans Dürer (d. 1534).	
April 1490–May 1494 Albrecht's *wanderjahre* in the Upper Rhine, Colmar, Basel and Strasbourg.	**1492** Christopher Columbus's first voyage to the Americas. Spanish conquest of Granada and expulsion of the Moors.

Significant Events in the Life of the Artist	Historical Events in the Life of the Artist
	1493 Maximilian I (r. 1493–1519) elected to succeed his father Emperor Friedrich III (r. 1440–93).
7 July 1494 Marries Agnes Frey [23].	
October 1494–May 1495 First trip to Italy, based in Venice.	Publication of Hartmann Schedel's *Nuremberg Chronicle*.
1496 Receives his first commission from Friedrich the Wise, Elector of Saxony (r. 1486–1525 [61]).	
1498 Publishes the *Apocalypse* [47–8, 50–1].	
1500 *Self-Portrait* (Munich [75]).	**1500** Jubilee year in Rome.
1502 Death of Albrecht Dürer the Elder.	**1502** Founding of the University of Wittenberg.
1504 *Adam and Eve* engraving [63].	
Autumn 1505–February 1507 Second trip to Italy, based in Venice. Travels to Bologna.	
1506 *Feast of the Rose Garlands* [82] for San Bartolomeo in Venice.	**1507** Margaret of Austria, daughter of Maximilian I and Mary of Burgundy, becomes Regent of the Netherlands (to 1530).
1509 Purchases large house by the Tiergärtnertor [115]. Appointed a member of the Greater City Council.	**1509** Henry VIII becomes King of England. Erasmus's *In Praise of Folly* published in Basel.
1511 Publishes the *Apocalypse* (2nd edition [47–8, 50–1], *Large Passion* [110, 172], *Life of the Virgin* [107–108], and *Small Passion* [111]. Completes the *Adoration of the Holy Trinity (Landauer Altarpiece* [102]).	
1512 Begins working for Emperor Maximilian I. Purchases a garden plot outside of the Tiergärtnertor.	

1513 Publishes *Engraved Passion*
[112, 113]; *Knight, Death, and
the Devil* [119].

1514 Death of Barbara Holper,
Dürer's mother [126].
Saint Jerome in his Study [121];
Melencolia I [122].

1515 Coronation of Francis I, King of
France.

1515 Emperor Maximilian I awards
him an annuity of 100 Rhenish
guilders.
Dürer and Raphael exchange art.

1516 Dürer and others begin meeting
in Nuremberg's Augustinian
monastery to discuss religious
issues. The group is known
as the Sodalitas Staupitziana
starting in 1517.

1516 Charles V becomes King of Spain.

1517 Travels to Bamberg in October.

1517 Martin Luther posts his 95
Theses on the Palace Church in
Wittenberg.
Ulrich Zwingli, the Protestant
Reformer, preaches in Zürich.

1518 Attends the imperial diet
in Augsburg.
Portrays Maximilian I [132].

1519 Death of Maximilian I.
Travels to Zürich with Willibald
Pirckheimer and Martin Tucher.

1519 Death of Maximilian I. His
grandson, Charles V, elected Holy
Roman Emperor (to 1556).
Ferdinand Magellan
circumnavigates the world
(to 1521).

1519–21 Designs mural decorations
for Nuremberg's city hall.

July 1520–July 1521 Trip to the
Netherlands. Based in Antwerp.
On 12 November, Emperor
Charles V renews Dürer's
annuity.

1521 Diet of Worms. Excommunication
of Luther.
Süleyman I the Magnificent,
Sultan of the Ottoman Empire
(r. 1520–66) captures Belgrade.

1522 Luther's German translation
of the New Testament.
Andreas Bodenstein von
Karlstadt's pamphlet calling
for the removal of religious
art from churches is published
in Wittenberg. First acts of
iconoclasm in Wittenberg and
elsewhere in Saxony.

1524–5 Peasants' War in Germany.

Significant Events in the Life of the Artist	Historical Events in the Life of the Artist
1525 Publishes *Instruction in Measurement* [166, 181, 182, 183].	**1525** Nuremberg embraces Lutheranism. Death of Friedrich the Wise, Elector of Saxony.
1526 *Four Apostles* [169, 170] given to Nuremberg's city council.	**1526** Süleyman I's victory at the Battle of Mohács gives the Ottomans long-term control of southeastern Europe even though his siege of Vienna (1529) was unsuccessful.
1527 Publishes *Treatise on Fortification* [184, 185].	**1527** Sack of Rome by imperial troops.
1528 6 April: the artist dies. Buried in the Saint Johannis cemetery outside Nuremberg. Agnes Frey arranges for the publication of his *Four Books of Human Proportions* [see 186, 187] by Hieronymus Andreae.	
1538 *Instruction in Measurement* (second German edition published).	
1539 Death of Agnes Frey.	

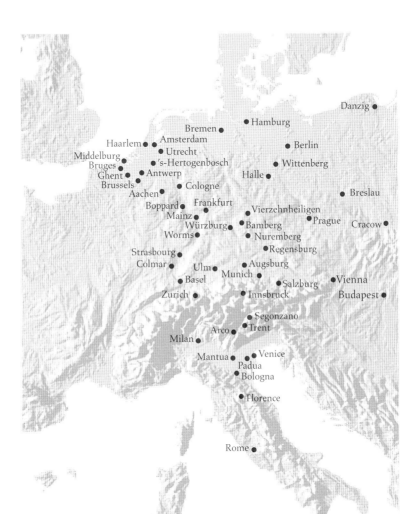

Altarpiece A religious image that stands on or behind the altar table (or *mensa*).

Briefmaler A German term for a specialist who colours prints.

Burin An engraver's tool with a lozenge-shaped tip. Used for cutting a copper or iron plate.

Carta azzurra A type of drawing, popular in Venice, using a blue-dyed paper on which ink and white highlights are applied with a brush.

Chiaroscuro An Italian word meaning light-dark. It is used to describe either the contrast of light and dark passages to create a sense of three dimensionality or modelling. Alternatively, it is a drawing or print using a colour ground.

Contrapposto The twisting of a body around its central vertical axis and often involving a weight shift.

Dendrochronology A method using the growth of annual hardwood rings of trees for dating the wood used in panel paintings. This establishes when the tree was cut but not necessarily when the panel was painted since oak and other woods were left to cure for at least two years.

Diptych Two equal-size adjoining images, usually hinged.

Drypoint An intaglio printmaking process using a sharp needle or knife to draw directly on a metal plate. This creates two burrs of metal, usually copper, on either side of the scratched line. The ink caught in these burrs, rather than in the slight furrow, prints. These burrs wear down quickly limiting the number of possible impressions.

Engraving An intaglio printmaking process using a burin to cut lines in a copper or metal plate. The plate is then inked, its surface wiped leaving ink only in the furrows, and then it is printed on paper using a press.

Epitaph (also *ex-voto*) A monument erected at a church as a remembrance of an individual or of a family. It is independent of a tomb and bears no strict funerary function.

Etching An intaglio printmaking process in which a metal plate, historically of copper or iron, is coated with an acid-resistant material, such as wax. Using an etching needle, lines are scratched through the coating to expose the metal. The plate is then bitten by being placed in a mild acid bath. The acid 'eats' into the exposed areas to cut lines. The coating is then removed and the plate is inked, wiped and printed.

Eucharist Christian sacrament instituted at the Last Supper in which Christ's sacrifice is consecrated in the communion wine (blood) and bread (body or host). It can refer also to the rite of communion at Mass.

Formschneider A German term for a professional woodblock carver.

Gesso A white preparatory ground, made of gypsum or chalk, pulverized into a fine powder, and glue that can be brushed onto a board creating a hard smooth surface for painting.

Grisaille Monochromatic painting, often in grey (*gris* in French). It is frequently used on the exterior of retables to imitate sculpture.

Humanism A cultural and intellectual movement that involved the study of the humanities (grammar, rhetoric, moral philosophy, poetry and history) using classical and contemporary texts. There was an emphasis on human accomplishment and dignity, often to complement religious devotion.

Iconoclasm The intentional destruction of art, most commonly religious art. Iconoclasts (image breakers) opposed the devotional use of art as idolatrous, specifically as forbidden by the second of God's Ten Commandments given to Moses (Exodus 20:3–5; 23), or as a misuse of financial resources.

Iconography The study of the subjects and symbols that provide meaning.

Infrared reflectography An imaging technique for viewing under-drawings and the invisible under-layers of paint. Drawings done in black chalk, charcoal or dark inks absorb infrared radiation. These lines may be detected with an infrared vidicon camera.

Intaglio A process in printmaking in which the lines to be printed are incised (or recessed) into the metal plate, as in drypoint, engraving and etching.

Liturgy The ceremonies of worship in the Christian Churches. Mass culminates in the celebration of the Eucharist. The liturgy also includes the Divine Office or the recitation of prayers for the eight canonical hours: Matins (before dawn), Lauds (daybreak), Prime (6 a.m.), Terce (9 a.m.), Sext (noon), None (3 p.m.), Vespers (sunset) and Compline (evening).

Perspective A means of suggesting depth to create the illusion of representing a three-dimensional space on a two-dimensional plane.

Polychrome/Polychromy Colouring applied to sculpture, metalwork, or architecture.

Polyptych A retable with more than three panels. Commonly employed for altarpieces with more than one pair of folding wings.

Predella The base of an altarpiece, often decorated with carvings or paintings.

Retable A winged altarpiece.

Rosary A Catholic devotion to the Virgin Mary in which ten Hail Marys (Ave Marias) and one Our Father (Paternoster or Lord's Prayer) are recited in sequence. The rosary refers, too, to a string of prayer beads used as a memory aid when reciting these prayers.

Silverpoint A metal drawing implement made from a hard alloy of silver and copper or brass. It must be used on a specially prepared, slightly roughened paper.

Tempera A painting technique in which ground pigments are mixed with egg, normally egg yolk.

Trompe l'oeil An illusionistic representation that deceives the eye into perceiving an object, such as a fly painted on a frame, as real.

Triptych An altarpiece with one pair of folding wings.

Under-drawing A preliminary drawing done on the prepared gesso ground of a panel or a canvas. Some artists permitted their under-drawings to show through the subsequent layers of paint.

Woodcut A printmaking process in which the surface of the woodblock is cut away, leaving only the lines to be printed still in relief. This surface is inked, covered with a sheet of paper and printed with or without a press.

Yves Abrioux, *Ian Hamilton Finlay: A Visual Primer*, revised edn (London, 1992)

Albrecht Dürer 1471–1971 (exh. cat., Germanisches Nationalmuseum, Nuremberg (Munich, 1971)

Albert Dürer aux Pays-Bas: son voyage (1520–1521), son influence (exh. cat., Palais des Beaux-Arts, Brussels, 1977)

Albrecht Dürer Master Printmaker (exh. cat., Museum of Fine Arts, Boston, 1971; reissued New York, 1988)

Bernard Aikema and Beverly Louise Brown (eds), *Renaissance Venice and the North: Crosscurrents in the Time of Bellini, Dürer, and Titian* (exh. cat., Palazzo Grassi, Venice, 2000)

Christiane Andersson and Charles Talbot, *From a Mighty Fortress: Prints, Drawings, and Books in the Age of Luther, 1483–1546* (exh. cat., Detroit Institute of Arts, Detroit, 1983)

Fedja Anzelewsky, *Albrecht Dürer: Das malerische Werk*, 2 vols, revised edn (Berlin, 1991)

—, *Dürer-Studien* (Berlin, 1983)

—, *Dürer: His Art and Life*, trans. Heide Grieve (New York, 1980)

Fedja Anzelewsky and Hans Mielke, *Albrecht Dürer. Die Zeichnungen im Kupferstichkabinett* (Berlin, 1984)

Aika Aoyama-Shibuya, 'Ein bisher unbekanntes Vorbild für Dürers "Thronender Greis und kniender Jüngling": Zum Entstehungsprozess der Werke Dürers aus dem Wanderjahren', in *Anzeiger des Germanischen Nationalmuseums* (2005), pp. 7–24

Horst Appuhn and Christian von Heusinger, *Riesenholzschnitte und Papiertapeten der Renaissance* (Unterschneidheim, 1976)

Heinrich Conrad Arend, *Das Gedechtniss der ehren … Albrecht Dürers …* (Goslar, 1728; facsimile reprint, intro. Matthias Mende, Unterschneidheim, 1978)

Karl Arndt and Bernd Moeller, *Albrecht Dürer im Spannungsfeld der frühen Reformation: Seine Darstellungen des Abendmahls Christi von 1523* (Göttingen, 2005)

—, *Albrecht Dürer's 'Vier Apostel'* (Gütersloh, 2003)

Arwed Arnulf, 'Dürers Buchprojekte von 1511: Andachtsbücher für Humanisten', *Marburger Jahrbuch für Kunstwissenschaft*, 31 (2004), pp. 145–74

Ludwig von Baldass, 'Die Bildnisse Kaiser Maximilians I.', *Jahrbuch der Kunsthistorischen Sammlungen des Allerhöchsten Kaiserhauses*, 31 (1913/14), pp. 247–334

Stephen Bann, 'A Description of Stonypath', *Journal of Garden History*, 1 (1981), pp. 113–44

Giulia Bartrum (ed.), *Albrecht Dürer and His Legacy* (exh. cat., British Museum, London, 2002)

Kurt Bauch, 'Dürers Lehrjahre', *Städel Jahrbuch*, 7/8 (1932), pp. 80–115

Rotraud Bauer *et al.*, *Kunsthistorisches Museum Wien – Weltliche und Geistliche Schatzkammer: Bildführer* (Vienna, 1987)

Andreas Baumeister and Christoph Krekel, 'Von Dürers Farben' in Gisela Goldberg, Bruno Heimberg

and Martin Schawe (eds), *Albrecht Dürer: Die Gemälde der Alten Pinakothek* (Munich, 1998), pp. 54–101

Michael Baxandall, 'Hand and Mind', *London Review of Books*, vol. 5, no. 5 (17–31 March, 1983), pp. 16–17

—, *The Limewood Sculptors of Renaissance Germany* (New Haven, 1980)

Herbert Beck and Bernhard Decker (eds), *Dürers Verwandlung in der Skulptur zwischen Renaissance und Barock* (exh. cat., Liebieghaus Museum alter Plastik, Frankfurt, 1982)

Pantxika Béguerie (ed.), *Der hübsche Martin: Kupferstiche und Zeichnungen von Martin Schongauer (c. 1450–1491)* (exh. cat., Unterlinden Museum, Colmar, 1991)

Richard Bellm, *Der Schatzbehalter: Ein Andachts- und Erbauungsbuch aus dem Jahre 1491*, 2 vols (Wiesbaden, 1962)

Jan Białostocki, *Dürer and His Critics* (Baden-Baden, 1986)

—, 'Myth and Allegory in Dürer's Etchings and Engravings', *Print Review*, 5 (1976), pp. 24–34

—, 'The Eye and the Window: Realism and Symbolism of Light-Reflection in the Art of Albrecht Dürer and His Predecessors', in Horst Keller *et al.* (eds), *Festschrift für Gert von der Osten* (Cologne, 1970), pp. 159–76

Edgar Bierende, *Lucas Cranach d. Ä. und der deutsche Humanismus* (Munich, 2002)

Peter Blickle, *The Revolution of 1525* (Baltimore, 1981)

Blockbücher des Mittelalters: Bilderfolgen als Lektüre (exh. cat., Gutenberg-Museum, Mainz, 1991)

Margot Blumenthal, *Die Dürer-Feiern 1828* (Egelsbach, 2001)

Phyllis Pray Bober and Ruth Rubinstein, *Renaissance Artists & Antique Sculpture: A Handbook of Sources* (London, 1986)

Hartmut Böhme, *Albrecht Dürer, Melencolia I: Im Labyrinth der Deutung* (Frankfurt, 1989)

Willi Bongard and Matthias Mende, *Dürer Heute* (Munich, 1971)

Anne-Marie Bonnet, *'Akt' bei Dürer* (Cologne, 2001)

Suzanne Boorsch and Nadine M. Orenstein, *The Print in the North: The Age of Albrecht Dürer and Lucas van Leyden* (exh. cat., Metropolitan Museum of Art, New York, 1997)

Till-Holger Borchert, *Rondom Dürer / Dürer and His Time* (exh. cat., Bonnefantenmuseum, Maastricht, 2000)

Rainer Brandl, 'Art or Craft? Art and the Artist in Medieval Nuremberg', in *Gothic and Renaissance Art in Nuremberg, 1300–1550* (exh. cat., New York, Nuremberg, Munich, 1986), pp. 51–60

Sebastian Brant, *The Ship of Fools*, trans. and intro. Edwin H Zeydel (New York, 1944; reissued 1962)

Ramona Braun and Anja Grebe, '"Albrecht Dürer von nörmergk" Zur Frage von Dürers Basler Buchholzschnitten', in G Ulrich Grossmann and Franz Sonnenberger (eds), *Das Dürerhaus. Neue Ergebnisse des Forschung* (Nuremberg, 2007), pp. 193–226

Günther Bräutigam and Matthias Mende, '"Mähen mit Dürer", Literatur und Ereignisse im Umkreis des Dürer-Jahres 1971', *Mitteilungen des Vereins für*

Geschichte der Stadt Nürnberg, 61 (1974), pp. 204–82

Bodo Brinkmann, Albrecht Dürer: Zwei Schwestern / Albrecht Dürer: Two Sisters (exh. cat., Städel Museum, Frankfurt, 2006)

Bodo Brinkmann and Berthold Hinz, 'Hexenlust und Sündenfall. Die seltsamen Phantasien des Hans Baldung Grien / Witches' Lust and the Fall of Man. The Strange Fantasies of Hans Baldung Grien (exh. cat., Städel Museum, Frankfurt, 2007)

Bodo Brinkmann and Stephan Kemperdick, Deutsche Gemälde im Städel 1500–1550 (Mainz, 2005)

Bodo Brinkmann, Hartmut Krohm and Michael Roth (eds), Aus Albrecht Dürers Welt: Festschrift für Fedja Anzelewsky (Turnhout, 2001)

Patricia Fortini Brown, Art and Life in Renaissance Venice (New Jersey, 1997)

Robert Bruck, Friedrich der Weise als Förderer der Kunst (Strasbourg, 1903)

Ernst Buchner, Das deutsche Bildniss der Spätgotik und der frühen Dürerzeit (Berlin, 1953)

Stephanie Buck and Guido Messling with Iris Brahms, Zeichnen vor Dürer. Die Zeichnungen des 14. und 15. Jahrhunderts in der Universitätsbibliothek Erlangen, Hans Dickel (ed.) (Petersberg, 2009)

Magdalena Bushart, '"Dürers Mutter" im 19. und 20 Jahrhundert', in Michael Roth (ed.), Dürers Mutter: Schönheit, Alter und Tod im Bild der Renaissance (exh. cat., Kupferstichkabinett, Berlin, 2006), pp. 173–8

Barbara Rosalyn Butts, "Dürerschuler" Hans Suss von Kulmbach', (unpublished Ph.D. diss., Harvard University, 1985)

Barbara Butts and Lee Hendrix, Painting on Light: Drawings and Stained Glass in the Age of Dürer and Holbein (exh. cat., J Paul Getty Museum, Los Angeles, 2000)

Omar Calabrese, Artists's Self-Portraits, trans. Marguerite Shore (New York, 2006)

Caroline Campbell and Alan Chong, Bellini and The East (exh. cat., Isabella Stewart Gardner Museum, Boston, 2005)

Friedrich Campe (ed.), Reliquien von Albrecht Dürer seinen Verehrern geweiht (Nuremberg, 1828)

Margaret Carroll, 'Dürer's Christ among the Doctors Re-examined', in Cynthia P Schneider, William W Robinson and Alice I Davies (eds), Shop Talk: Studies in Honor of Seymour Slive (Cambridge, MA, 1995), pp. 49–54

Fernando Checa (ed.), Durero y Cranach: Arte y Humanismo en la Alemania del Renacimiento (exh. cat., Museo Thyssen-Bornemisza, Madrid, 2007)

Carl C. Christensen, Art and the Reformation in Germany (Athens, OH, 1979)

—, 'The Nurenberg City Council as a Patron of the Fine Arts, 1500–1550' (unpublished Ph.D. diss., Ohio State University, 1965)

John Christian, 'Early German Sources for Pre-Raphaelite Designs', Art Quarterly, 36 (1973), pp. 56–83

Jean Clair (ed.), Mélancholie: Génie et folie en Occident (exh. cat., Galeries Nationales du Grand Palais, Paris, 2005)

T H Clarke, The Rhinoceros from Dürer to Stubbs, 1515–1799 (London, 1986)

Martin Conway (ed.), The Writings of Albrecht Dürer (New York, 1958; originally Literary Remains of

Albrecht Dürer, Cambridge, 1889)

Pia Cuneo, 'The Artist, His Horse, a Print, and its Audience: Producing and Viewing the Ideal in Dürer's *Knight, Death and the Devil* (1513)', in Larry Silver and Jeffrey Chipps Smith (eds), *The Essential Dürer* (Philadelphia, 2010, pp. 115–29, 248–52.

Andrew Cunningham and Ole Peter Grell, *The Four Horsemen of the Apocalypse: Religion, War, Famine and Death in Reformation Europe* (Cambridge, 2000)

Susan Dackerman, 'Dürer's Etchings: Printed Drawings?' in Michael Cole (ed.), *The Early Modern Painter-Etcher* (exh. cat., Baltimore, 2006), pp. 37–51

— (ed.), *Painted Prints: The Revelation of Color in Northern Renaissance and Baroque Engravings, Etchings and Woodcuts* (exh. cat., Museum of Art, University Park, Baltimore, PA, 2002)

Bernhard Decker, 'Dürer und Raphael in Marmor: Die Museums-Büsten in Frankfurt am Main und Karlsruhe', *Anzeiger des Germanischen Nationalmuseums* (1998), pp. 79–87

—, *Dürer und Grünewald. Der Frankfurter Heller-Altar: Rahmenbedingungen der Altarmalerei* (Frankfurt, 1996)

Dirk De Vos, *Rogier van der Weyden* (New York, 1999)

Elisabeth Dhanens, *Van Eyck: The Ghent Altarpiece* (New York, 1973)

C. R. Dodwell (ed.), *Essays on Dürer* (Manchester, 1973)

Derick F. W. Dreher, 'Dürer's Portrait of Varnbüler: The Monumental Woodcut and "Gedechtnus" in the German Renaissance', in Stephan Füssel *et al.* (eds), *ARTIBVS:*

Kulturwissenschaft und deutsche Philologie des Mittelalters und der frühen Neuzeit: Festschrift für Dieter Wuttke zum 65. Geburtstag (Wiesbaden, 1994), pp. 275–92

Angelica Dülberg, *Privatporträts: Geschichte und Ikonologie einer Gattung im 15. und 16. Jahrhundert* (Berlin, 1990)

Jill Dunkerton, 'North and South: Painting Techniques in Venice', in Bernard Aikema and Beverly Louise Brown (eds), *Renaissance Venice and the North: Crosscurrents in the Time of Bellini, Dürer, and Titian* (exh. cat., Palazzo Grassi, Venice, 2000), pp. 93–103

Dagmar Eichberger and Charles Zika (eds), *Dürer and His Culture* (Cambridge, 1998)

Renate Eikelmann (ed.), *Conrat Meit: Bildhauer der Renaissance* (exh. cat., Bayerisches Nationalmuseum, Munich, 2006)

Colin Eisler, *Dürer's Animals* (Washington, 1991)

Wolf von Engelhardt, 'Dürers Kupferstich *Melencolia I*', *Städel-Jahrbuch*, 14 (1993), pp. 173–98

Thomas Eser, *Hans Daucher: Augsburger Kleinplastik der Renaissance* (Munich, 1996)

Thomas Eser and Anja Grebe, *Heilige und Hasen: Bücherschätze der Dürerzeit* (exh. cat., Germanishes Nationalmuseum, Nuremberg, 2008)

Philipp P. Fehl, 'Dürer's Literal Presence in his Pictures: Reflections on his Signatures in the *Small Woodcut Passion*', in Matthias Winner (ed.), *Der Künstler über sich in seinem Werk* (Weinheim, 1992) pp. 191–244

Simone Ferrari, *Jacopo de' Barbari* (Milan, 2006)

Richard S. Field, 'Early Woodcuts: The Known and the Unknown', in Peter Parshall and Rainer Schoch (eds), *Origins of European Printmaking: Fifteenth-Century Woodcuts and Their Public* (exh. cat., National Gallery of Art, Washington, DC, 2005), pp. 19–35

Zirka Filipczak, *Hot Dry Men, Cold Wet Women: The Theory of the Humors and Western European Art, 1575–1700* (exh. cat., Joslyn Art Museum, Omaha, 1997)

Jennifer M. Fletcher, 'Bellini's Social World', in Peter Humfrey (ed.), *The Cambridge Companion to Giovanni Bellini* (Cambridge, 2004), pp. 13–47

Susan Foister, *Dürer and the Virgin in the Garden* (exh. cat., National Gallery, London, 2004)

Varena Forcione, 'Leonardo's Grotesques: Originals and Copies', in Carmen C. Bambach (ed.), *Leonardo da Vinci, Master Draftsman* (exh. cat., Metropolitan Museum of Art, New York, 2003), pp. 202–24

From Schongauer to Holbein: Master Drawings from Basel and Berlin (exh. cat., National Gallery of Art, Washington, DC, 1999)

Stephan Füssel (ed.), *500 Jahre Schedelesche Weltchronik* (Nuremberg, 1994)

Karl Giehlow (ed.), *Kaiser Maximilians I. Gebetbuch* (Vienna, 1907)

Stephen Goddard, 'Ernst Förster Drawing *Dürer at His Mother's Deathbed* and Its Role in the 1828 Dürer Festival in Nuremberg', *Pantheon*, 46 (1988), pp. 117–20

Amy Golahny, *Rembrandt's Reading* (Amsterdam, 2003)

Gisela Goldberg, 'Zur Ausprägung der Dürer-Renaissance in München', *Münchner Jahrbuch der bildenden Kunst*, 31 (1980), pp. 129–75

—, *Dürer-Renaissance* (exh. cat., Alte Pinakothek, Munich, 1971)

Gisela Goldberg, Bruno Heimberg and Martin Schawe (eds.), *Albrecht Dürer. Die Gemälde der Alten Pinakothek* (Munich, 1998)

Ernst H. Gombrich, 'Dürer, Vives and Bruegel', in J Bruyn *et al* (eds), *Album Amicorum J G van Gelder* (The Hague, 1973), pp. 132–4

—, *Symbolic Images* (London, 1972)

Jan-Albert Goris and Georges Marlier, *Albrecht Dürer. Diary of His Journey to the Netherlands 1520–1521*, trans. Martin Conway (Greenwich, CT, 1971)

Gothic and Renaissance Art in Nuremberg, 1300–1550 (exh. cat., New York, Nuremberg, Munich, 1986)

Margaret Morgan Grasselli (ed.), *The Touch of the Artist: Master Drawings from the Woodner Collection* (exh. cat., National Gallery of Art, Washington, DC, 1995)

Anja Grebe, 'Meister nach Dürer. Überlegungen zur Dürerwerkstatt', in G Ulrich Grossmann and Franz Sonnenberger (eds), *Das Dürerhaus. Neue Ergebnisse des Forschung* (Nuremberg, 2007), pp. 121–40

—, *Albrecht Dürer. Künstler, Werk und Zeit* (Darmstadt, 2006)

Robert Grigg, 'Studies on Dürer's Diary of his Journey to the Netherlands: The Distribution of the Melencolia I', *Zeitschrift für Kunstgeschichte*, 49 (1986), pp. 398–409

G. Ulrich Grossmann, 'Albrecht Dürer in Innsbruck. Zur Datierung der ersten italienischen Reise', in G. Ulrich Grossmann and Franz Sonnenberger (eds), *Das Dürerhaus. Neue Ergebnisse des Forschung* (Nuremberg, 2007), pp. 227–40

G Ulrich Grossmann and Franz Sonnenberger (eds), *Das Dürerhaus. Neue Ergebnisse des Forschung* (Nuremberg, 2007)

Ludwig Grote, *Albrecht Dürer – Reisen nach Venedig* (originally 1956; Munich, 1998)\

—, 'Die 'Vorderstube' des Sebald Schreyer – Ein Beitrag zur Rezeption der Renaissance in Nürnberg', *Anzeiger des Germanischen Nationalmuseums* (1954–9), pp. 43–67

Liz Guenther, 'Dürer's Narrative Style', in David Smith, Liz Guenther *et al.*, *Realism and Invention in the Prints of Albrecht Dürer* (exh. cat., Art Gallery, University of New Hampshire, Durham, NH, 1995), pp. 8–14

Sabine Haag, Christiane Lange, Christof Metzger, and Karl Schütz (eds), *Dürer, Cranach, Holbein – Die Entdeckung des Menschen: Das deutsche Porträt um 1500* (exh. cat., Kunsthistorisches Museum, Vienna, 2011)

Berndt Hamm, 'Hieronymus-Begeisterung und Augustinismus vor der Reformation: Beobachtungen zur Beziehung zwischen Humanismus und Frömmigkeitstheologie (am Beispiel Nürnbergs)', in Kenneth Hagen (ed.), *Augustine, the Harvest and Theology (1300–1650)* (Leiden, 1990), pp. 127–230

Theodor Hampe, 'Kunstfreunde im alten Nürnberg und ihre Sammlungen', *Mitteilungen des Vereins für Geschichte der Stadt Nürnberg*, 16 (1904), pp. 57–124

John Oliver Hand assisted by Sally E. Mansfield, *German Paintings of the Fifteenth through Seventeenth Centuries: The Collections of the National Gallery of Art Systematic Catalogue* (Cambridge, 1993)

Donald J Harreld, *High Germans in the Low Countries: German Merchants and Commerce in Golden Age Antwerp* (Leiden, 2004)

Oskar von Hase, *Die Koberger* (Leipzig, 1869; reprint of 2nd revised edn, Amsterdam, 1967)

Francis Haskell and Nicholas Penny, *Taste and the Antique: The Lure of Classical Sculpture 1500–1900* (New Haven, 1981)

Sven Hauschke, *Die Grabdenkmäler der Nürnberger Vischer-Werkstatt (1453–1544)* (Petersberg, 2006)

Andrée Hayum, *The Isenheim Altarpiece: God's Medicine and the Painter's Vision* (Princeton, 1989)

William S. Heckscher, '*Melancholia* (1541): An Essay in the Rhetoric of Description by Joachim Camerarius', in Frank Baron (ed.), *Joachim Camerarius (1500–1574)* (Munich, 1978), pp. 32–120

Bruno Heimberg, 'Zur Maltechnik Albrecht Dürers', in Gisela Goldberg, Bruno Heimberg and Martin Schawe (eds), *Albrecht Dürer: Die Gemälde der Alten Pinakothek* (Munich, 1998), pp. 32–53

Minna Heimbürger, *Dürer e Venezia: Influssi di Albrecht Dürer sulla pittura veneziana del primo Cinquecento* (Rome, 1999)

Julius Held, 'Artis Pictoriae Amator: An Antwerp Art Patron and His Collection', in Anne W Lowenthal, David Rosand and John Walsh Jr (eds), *Rubens and His Circle: Studies by Julius S. Held,* (Princeton, 1982), pp. 35–64

Kristina Herrmann Fiore, *Dürers Landschaftsaquarelle* (Frankfurt, 1972)

Kristina Herrmann Fiore (ed.), *Dürer e l'Italia* (exh. cat., Scuderie del Quirinale, Rome, 2007)

Daniel Hess, 'Das Gothaer Liebespaar oder die gesellschaftliche Absicherung einer gräflichen Konkubine', in Allmuth Schuttwolf (ed.), *Jahreszeiten der Gefühle: Das Gothaer Liebespaar und die Minne im Spätmittelalter* (Ostfildern-Ruit, 1998), pp. 14–20

—, 'Dürers Selbstbilnis von 1500. "Alter Deus" oder Neuer Apelles?', *Mitteilungen des Vereins für Geschichte der Stadt Nürnberg*, 77 (1990), pp. 63–90

Howard Hibbard, *Michelangelo* (New York, 1974)

Amelie Himmel, *Michael Wolgemut* (Nuremberg, 2000)

Berthold Hinz, *Dürers Gloria: Kunst, Kult, Konsum* (exh. cat., Kunstbibliothek, Berlin, 1971)

Werner Hofmann (ed.), *Köpfe der Dürerzeit* (exh. cat., Kunsthalle, Hamburg, 1983)

Hanns Hubach, 'Parnassus Palatinus: Der Heidelberger Schlossberg als neuer Parnass und Musenhort', in Hans Gerke (ed.), *Der Berg* (Heidelberg, 2002), pp. 84–101

Linda Hults, *The Witch as Muse* (Philadelphia, 2005)

Jane Campbell Hutchison, *Albrecht Dürer: A Guide to Research* (New York, 2000)

—, *Albrecht Dürer – A Biography* (Princeton, 1990)

T. A. Ilatovskaya, *West European Drawing of XVI–XX Centuries Kunsthalle Collection in Bremen Catalogue* (Moscow, 1992)

William M. Ivins Jr, 'Notes on Three Dürer Woodblocks', *Metropolitan Museum Studies*, 2 (1929), pp. 102–11

Axel Janeck, *Zeichen am Himmel: Flugblätter des 16. Jahrhunderts* (exh. cat., Germanisches Nationalmuseum, Nuremberg, 1982)

Frank Matthias Kammel, 'Kaiser Sigismund und die Reichsstadt Nürnberg', in Imre Takács (ed.), *Sigismundus Rex et Imperator: Kunst und Kultur zur Zeit Sigismunds von Luxemburg 1387–1437* (exh. cat., Szépmüvészeti Múzeum, Budapest, 2006), pp. 480–6

Jordan Kantor, *Dürer's Passions*, 2 vols (exh. cat., Harvard University Art Museums, Cambridge, MA, 2000)

Hans Kauffmann, 'Dürer in der Kunst und im Kunsturteil um 1600', *Anzeiger des Germanisches National-Museum* (1940–53), pp. 18–60

Thomas DaCosta Kaufmann, 'Hermeneutics in the History of Art: Remarks on the Reception of Dürer in the Sixteenth and Early Seventeenth Centuries', in Jeffrey Chipps Smith (ed.), *New Perspectives on the Art of Renaissance Nuremberg: Five Essays* (Austin, 1985), pp. 23–39

Robert Keil, 'Die Rezeption Dürers in der deutschen Kunstbuchliteratur des 16. Jahrhunderts', *Wiener Jahrbuch für Kunstgeschichte*, 38 (1985), pp. 133–50

Martin Kemp, *The Science of Art* (New Haven, 1990)

—, *Leonardo da Vinci: The Marvelous Works of Nature and Man* (Cambridge, MA, 1981)

Stephan Kemperdick, *Martin Schongauer* (Petersberg, 2004)

Thomas à Kempis, *The Imitation of Christ*, trans. Leo Sherley-Price (Harmondsworth, 1952)

Franz Kirchweger (ed.), *Die Heilige Lanze in Wien: Insignie, Reliquie, "Schicksalsspeer"* (Vienna, 2005)

Joachim Knape, 'Autopräsenz: Sebastian Brants Selbsinszenierung in der Oratorrolle im "Traum"-Gedicht von 1502', in Rudolf Suntrup and Jan R Veenstra (eds) *Self-Fashioning / Personen(selbst)darstellung* (Frankfurt, 2003), pp. 79–108

Robert A Koch (ed.), *The Illustrated Bartsch, 15 Early German Masters. Barthel Beham and Hans Sebald Beham* (New York, 1978)

Joseph Leo Koerner, *Dürer's Hands* (New York, 2006)

—, 'The Fortune of Dürer's *Nemesis*', in Walter Haug and Burghart Wachinger (eds), *Fortuna* (Tübingen, 1995), pp. 239–94

—, *The Moment of Self-Portraiture in German Renaissance Art* (Chicago, 1993)

Heinrich Kohlhaussen, *Nürnberger Goldschmiedekunst des Mittelalters und der Dürerzeit 1240 bis 1540* (Berlin, 1968)

Lubomír Konečný, 'Catching an Absent Fly', in Olga Kotková (ed.), *Albrecht Dürer: The Feast of the Rose Garlands, 1506–2006* (exh. cat., Národní Galerie v Praze, Prague, 2006), pp. 41–51

Fritz Koreny, 'A Coloured Flower Study by Martin Schonguaer and the Development of the Depiction of Nature from van der Weyden to Dürer', *The Burlington Magazine*, 133 (1991), pp. 588–97

—, 'Ottoprecht Fürscht: Eine unbekannte Zeichnung von Albrecht Dürer – Kaiser Maximilian I. und sein Grabmal in the Hofkirche zu Innsbruck', *Jahrbuch der Berliner Museen* 31 (1989), pp. 127–48

—, *Albrecht Dürer and the Animal and Plant Studies of the Renaissance* (exh. cat., Sammlung Albertina, Vienna, 1985), trans. Pamela Marwood and Yehuda Shapiro (Boston, 1988)

Walter Koschatzky, *Albrecht Dürer – The Landscape Water-Colours* (New York, 1973)

Walter Koschatzky and Alice Strobl, *Dürer Drawings in the Albertina* (Greenwich, CT, 1972)

Olga Kotková (ed.), *Albrecht Dürer: The Feast of the Rose Garlands, 1506–2006* (exh. cat., Národní Galerie v Praze, Prague, 2006)

Hartmut Krohm, 'ALTER DAEDALUS – zum Begriff künstlerischer Tätigkeit im Dürers "Marienleben"', in Bodo Brinkmann, Hartmut Krohm and Michael Roth (eds), *Aus Albrecht Dürers Welt: Festschrift für Fedja Anzelewsky* (Turnhout, 2001), pp. 77–90

Ute Kuhlemann, 'The Celebration of Dürer in Germany during the Nineteenth and Twentieth Centuries', in Giulia Bartrum (ed.), *Albrecht Dürer and His Legacy* (exh. cat., British Museum, London, 2002), pp. 39–60

Andreas Kühne and Stefan Kirschner, 'Die Kunst der Arithmetik', in Gudrun Wolfschmidt (ed.), *'Es gibt für Könige keinen besonderen Weg zur Geometrie': Festschrift für Karin Reich* (Augsburg, 2007), pp. 241–58

Norman E. Land, 'Apelles and Self-Portrayal', *Source*, 25 (2006), pp. 1–2

David Landau and Peter Parshall, *The Renaissance Print, 1470–1550* (New Haven, 1994)

Ewald Lassnig, 'Dürers Melencolia I und die Erkenntnistheorie bei Ulrich Pinder', *Wiener Jahrbuch für Kunstgeschichte* 57 (2008), pp. 51–95.

Hermann Leber, *Albrecht Dürers Landschaftsaquarelle. Topographie und Genese* (Hildesheim, 1988)

Klaus Leder, 'Nürnbergs Schulwesen an der Wende vom Mittelalter zur Neuzeit', in Verein für Geschichte der Stadt Nürnberg (ed.), *Albrecht Dürers Umwelt*, (Nuremberg, 1971), pp. 29–34

Huigen Leeflang and Ger Luijten (eds), *Hendrick Goltzius (1558–1617)* (exh. cat., Rijksmuseum, Amsterdam, 2003)

Jay A. Levenson (ed.), *Circa 1492: Art in the Age of Exploration* (exh. cat., National Gallery of Art, Washington, DC, 1991)

Jay A. Levenson, Konrad Oberhuber, and Jacquelyn L. Sheehan, *Early Italian Engravings from the National Gallery of Art* (exh. cat., National Gallery of Art, Washington, DC, 1973)

Michael Levey, '"To Honour Albrecht Dürer": Some 1971 Manifestations', *The Burlington Magazine*, 114 (1972), pp. 63–71

Kurt Löcher, *Die Gemälde des 16. Jahrhunderts – Germanisches Nationalmuseum Nürnberg* (Ostfildern-Ruit, 1997)

— (ed.), *Kunst des Sammelns: Das Praunsche Kabinett, Meisterwerke von Dürer bis Carracci* (exh. cat, Germanisches Nationalmuseum, Nuremberg, 1994)

Isolde Lübbeke, '… des gleichen jch noch nie gemacht hab.', in Bodo Brinkmann, Hartmut Krohm and Michael Roth (eds), *Aus Albrecht Dürers Welt: Festschrift für Fedja Anzelewsky* (Turnhout, 2001), pp. 99–101

—, *The Thyssen-Bornemisza Collection. Early German Painting 1350–1550*, trans. Margaret Thomas Will (London, 1991)

Katherine Crawford Luber, *Albrecht Dürer and the Venetian Renaissance* (Cambridge, 2005)

—, 'Albrecht Dürer's Maximilian Portraits: An Investigation of Versions', *Master Drawings*, 29 (1991), pp. 30–47

Heinz Lüdecke, *Albrecht Dürer's Wanderjahre* (Dresden, 1959)

Heinz Lüdecke and Susanne Heiland (eds), *Dürer und die Nachwelt* (Berlin, 1955)

Ingetraut Ludolphy, *Friedrich der Weise. Kurfürst von Sachsen. 1463–1525* (Göttingen, 1984)

Karel van Mander, *The Lives of the Illustrious Netherlandish and German Painters from the first Edition of the Schilder-boeck (1603–1604)*, ed. by Hessel Miedema, 6 vols (Doornspijk, 1994–9)

Volker Manuth, 'Dürer ein Dandy? Beobachtungen zum Kostüm des Künstlers', in Bodo Brinkmann, Hartmut Krohm and Michael Roth (eds), *Aus Albrecht Dürers Welt: Festschrift für Fedja Anzelewsky* (Turnhout, 2001), pp. 165–71

Reiner Marquard, 'Philipp Melanchthon und Mathias Grünewald', *Zeitschrift für Kirchengeschichte*, 108 (1997), pp. 295–308

Andrew John Martin, '"Dan hat sich ain quater befunden, in vnserer Capeln, von der Hand des Albrecht Dürers." The Feast of the Rose Garlands in San Bartolomeo di Rialto (1506–1606)', in Olga

Kotková (ed.), *Albrecht Dürer: The Feast of the Rose Garlands, 1506–2006* (exh. cat., Národní Galerie v Praze, Prague, 2006), pp. 53–67

Jean Michel Massing, 'Early European Images of America: The Ethnographic Approach', in Jay A Levenson (ed.), *Circa 1492: Art in the Age of Exploration* (exh. cat., National Gallery of Art, Washington, DC, 1991), pp. 515–20

—, 'Dürer's Dreams', *Journal of the Warburg and Courtauld Institutes*, 49 (1986), pp. 238–44

Louisa C Matthews, 'Working Abroad: Northern Artists in the Venetian Ambient', in Bernard Aikema and Beverly Louise Brown (eds), *Renaissance Venice and the North: Crosscurrents in the Time of Bellini, Dürer, and Titian* (exh. cat., Palazzo Grassi, Venice, 2000), pp. 61–9

Hermann Maué, 'Die Dedikationsmedaille der Stadt Nürnberg für Kaiser Karl V von 1521', *Anzeiger de Germanischen Nationalmuseums* (1987), pp. 227–44

Hermann Maué, Thomas Eser, Sven Hauschke and Jana Stolzenberger (eds), *Quasi Centrum Europae. Europa kauft in Nürnberg 1400–1800* (exh. cat., Germanisches Nationalmuseum, Nuremberg, 2002)

Joseph Meder, *Dürer-Katalog* (Vienna, 1932)

Meisters um Albrecht Dürer (exh. cat., Germanisches Nationalmuseum, Nuremberg, 1961)

Walter S. Melion, *Shaping the Netherlandish Canon: Karel van Mander's Schilder-Boeck* (Chicago, 1991)

Matthias Mende, *Albrecht Dürer – ein Künstler in seiner Stadt* (exh. cat., Museen der Stadt, Nuremberg, 2000)

—, *Das Dürerhaus in Nürnberg* (Nuremberg, 1991)

—, *Düreriana* (exh. cat., Albrecht-Dürer-Haus, Nuremberg, 1990)

—, *Nürnberg: Albrecht-Dürer-Haus*, 2nd revised edn (Munich, 1989)

—, *Dürer in Dublin: Kupferstiche und Holzschnitte Albrecht Dürers aus der Chester Beatty Library* (exh. cat., Chester Beatty Library, Dublin and Dürer-Haus, Nuremberg, 1983)

—, *Dürer-Medaillen* (Nuremberg, 1983)

—, *Dürer A–Z: Zeitgenössische Dürer-Variationen von Anderle bis Zimmermann* (Nuremberg, 1980)

—, *Das alte Nürnberger Rathaus* (exh. cat., Stadtgeschichtliche Museen, Nuremberg, 1978)

—, *Dürer-Bibliographie* (Wiesbaden, 1971)

—, *Mit Dürer unterwegs* (exh. cat., Germanisches Nationalmuseum, Nuremberg, 1971)

—, 'Die Transparente der Nürnberger Dürer-Feier von 1828', *Anzeiger des Germanischen Nationalmuseums* (1969), pp. 177–209

Matthias Mende and Inge Hebecker, *Nürnberg zur Zeit Ludwigs I. Zeichnungen von Georg Christoph Wilder* (exh. cat., Stadtmuseum Fembohaus, Nuremberg, 1986)

—, *Das Dürer-Stammbuch von 1828* (exh. cat., Dürerhaus, Nuremberg, 1973)

—, *Nürnberger Dürerfeiern 1828–1928* (exh. cat., Dürerhaus, Nuremberg, 1971)

Ralf Mennekes, *Die Renaissance der deutschen Renaissance* (Petersberg, 2005)

Ariane Mensger, *Jan Gossaert* (Berlin, 2002)

László Mészáros, *Italien sieht Dürer* (Erlangen, 1983)

Sergiusz Michalski, *The Reformation and the Visual Arts* (London, 1993)

Hans-Ernst Mittig, *Dürers Bauernsäule: Ein Monument des Widerspruchs* (Frankfurt, 1984)

Jim Monson, 'The Source for the *Rhinoceros*', *Print Quarterly*, 21 (2004), pp. 50–3

Keith Moxey, 'Impossible Distance: Past and Present in the Study of Dürer and Grünewald', *Art Bulletin*, 86 (2004), pp. 750–63

—, *Peasants, Warriors, and Wives: Popular Imagery in the Reformation* (Chicago, 1989)

Jürgen Müller, 'Albrecht Dürer's Peasant Engravings. A Different Laocöon, or the Birth of Aesthetic Subversion in the Spirit of the Reformation', *Journal of the Historians of Netherlandish Art* 3.1 (2011) [www.jhna.org]

Mathias F. Müller, 'Albrecht Dürer und das Kunstleben am Kaiserhof Maximilians I.', in Klaus Albrecht Schröder and Maria Luise Sternath (eds), *Albrecht Dürer* (exh. cat., Albertina, Ostfildern-Ruit, Vienna, 2003), pp. 89–101

Birgit Ulrike Münch, 'Cum figures magistralibus: Das *Speculum Passionis* des Ulrich Pinder (Nürnberg 1507) im Rahmen der spätmittelalterlichen Erbauungsliteratur', *Mitteilungen des Vereins für Geschichte der Stadt Nürnberg*, 92 (2005), pp. 1–91

Christoph Gottlieb von Murr, *Description du Cabinet de Monsieur Paul de Praun à Nuremberg* (Nuremberg, 1797)

Arnold Nesselrath, 'Raphael's Gift to Dürer', *Master Drawings*, 31 (1993), pp. 376–89

Johann Neudörfer, Georg Wolfgang Karl Lochner (ed.), *Nachrichten von Künstlern und Werkleuten daselbst aus dem Jahr 1547 nebst der Fortsetzung des Andreas Gulden* (Vienna, 1875)

Helmut Nickel, '"Wunderbarlich Wehr aus dem Neuen Gulden Land". Waffenkundliche Bemerkungen zu Dürers Tagebucheintrag über den Aztekenschatz', in Bodo Brinkmann, Hartmut Krohm and Michael Roth (eds), *Aus Albrecht Dürers Welt: Festschrift für Fedja Anzelewsky* (Turnhout, 2001), pp. 173–81

Simon Oakes, 'A New Proposal for Dürer's Drawing of *A House in Venice*', *Apollo* (March 2002), pp. 3–10

Konrad Oberhuber (ed.), *The Illustrated Bartsch*, vol. 27, *The Works of Marcantonio Raimondi and of His School* (New York, 1978)

Karl Oettinger, 'Zu Dürers Beginn', *Zeitschrift für Kunstgeschichte*, 8 (1954), pp. 153–68

Erwin Panofsky, *Hercules am Scheidewege und andere antike Bildstoffe in der neueren Kunst* (Berlin, 1930; new edition, afterword Dieter Wuttke, Berlin, 1997)

—, *Meaning in the Visual Arts* (Garden City, NY, 1955)

—, '"Nebulae in Pariete": Notes on Erasmus' Eulogy on Dürer', *Journal of the Warburg and Courtauld Institutes*, 14 (1951), pp. 34–41

—, *The Life and Art of Albrecht Dürer*, 2 vols (Princeton, 1943; 1 vol. edn, 1955)

Erwin Panofsky, intro. Jeffrey Chipps Smith, *The Life and Art of Albrecht Dürer* (Princeton, 2005)

Erwin Panofsky and Fritz Saxl, *Dürer's 'Melencolia I.'* (Berlin, 1923)

Linda and Peter Parshall, *Art and the Reformation: An Annotated Bibliography* (Boston, 1986)

Peter Parshall and Rainer Schoch (eds), *Origins of European Printmaking: Fifteenth-Century Woodcuts and Their Public* (exh. cat., National Gallery of Art, Washington, DC, 2005)

Peter Parshall, 'Albrecht Dürer's *Gedenckbuch* and the Rain of Crosses', *Word & Image*, 22 (2006), pp. 202–10

—, 'Ferdinand Columbus's Prints after 1500 from the German-Speaking Regions', in Mark P McDonald (ed.), *The Print Collection of Ferdinand Columbus (1488–1539): A Renaissance Collector in Seville*, 3 vols (London, 2004), 1, pp. 175–86

—, 'Albrecht Dürer and the Axis of Meaning', *Bulletin – Allen Memorial Art Museum, Oberlin College*, 50, no. 2 (1997), pp. 4–31

—, 'Art and the Theater of Knowledge: The Origins of Print Collecting in Northern Europe', *Harvard University Art Museums Bulletin*, 2 (Spring 1994), pp. 7–36

—, '*Imago contrafacta*: Images and Facts in the Northern Renaissance', *Art History*, 16 (1993), pp. 57–82

—, 'Camerarius on Dürer: Humanist Biography as Art Criticism', in Frank Baron (ed.), *Joachim Camerarius (1500–1574)* (Munich, 1978), pp. 11–29

Gustav Pauli, 'Dürers Monogramm', in *Festschrift für Max J. Friedländer zum 60 Geburtstag* (Leipzig, 1927), pp. 34–40

Richard Pennington, *A Descriptive Catalogue of the Etched Work of Wenceslaus Hollar 1607–1677* (Cambridge, 1982)

Alexander Perrig, *Albrecht Dürer oder Die Heimlichkeit der deutschen Ketzerei* (Weinheim, 1987)

Gerhard Pfeiffer, 'Andreas Karlstadt und Albrecht Dürer', *Jahrbuch für Fränkische Landesforschung*, 53 (1992), pp. 1–18

Gerhard Pfeiffer and Wilhelm Schwemmer, *Geschichte Nürnbergs in Bilddokumenten*, 3rd edn (Munich, 1977)

Lotte Brand Philip with comment by Fedja Anzelewsky, 'The Portrait Diptych of Dürer's Parents', *Simiolus*, 10 (1978/9), pp. 5–18

Caritas Pirckheimer, *A Journal of the Reformation Years 1524–1528*, trans. and intro. Paul A MacKenzie (Cambridge, 2006)

Volker Pirsch, 'Die Dürer-Rezeption in der Literatur des Beginnenden 19. Jahrhunderts', *Mitteilungen des Vereins für Geschichte der Stadt Nürnberg*, 70 (1983), pp. 304–33

Wolfgang Pirsig, '"Dürers Mutter" – aus ärztlicher Sicht', in Michael Roth (ed.), *Dürers Mutter: Schönheit, Alter und Tod im Bild der Renaissance* (exh. cat., Kupferstichkabinett, Berlin, 2006), pp. 17–22

Joachim Poeschke, 'Dürer's Traumgesicht', in Rudolf Hiestand (ed.), *Traum und Träumen* (Düsseldorf, 1994), pp. 187–206

Lisa Pon, *Raphael, Dürer and Marcantonio Raimondi: Copying and the Italian Renaissance Print* (New Haven, 2004)

David Price, *Albrecht Dürer's Renaissance: Humanism, Reformation and the Art of Faith* (Ann Arbor, MI, 2003)

—, *Albrecht Dürer, De Symmetria Partium in Rectis Formis Humanorum Corporum*

(Nuremberg, 1532) and
Underweysung der Messung
(Nuremberg, 1538) CD-ROM
(Oakland, CA, 2003)

Elke Purpus, 'Die Blockbücher der
Apokalypse', in Blockbücher des
Mittelalters: Bilderfolgen als
Lektüre (exh. cat., Gutenberg-
Museum, Mainz, 1991), pp. 81–118

Hans-Joachim Raupp, Bauernsatiren
(Niederzier, 1986)

Ernst Rebel, Albrecht Dürer. Maler
und Humanist (Munich, 1996)

—, Die Modellierung der Person.
Studien zu Dürer's Bildnis des Hans
Kleberger (Stuttgart, 1990)

Reformation in Nürnberg: Umbruch
und Bewahrung, 1490–1580 (exh.
cat., Germanisches Nationalmuseum,
Nuremberg, 1979)

Alexander von Reitzenstein, 'Etliche
Vnderricht / Zu Befestigung Der
Stett / Schlosz / Vnd flecken:
Albrecht Dürer's
Befestigungslehre', in Verein für
Geschichte der Stadt Nürnberg
(ed.), Albrecht Dürer's Umwelt
(Nuremberg, 1971), pp. 178–92

Bernd Roeck, 'Venice and Germany:
Commercial Contacts and Intellectual
Inspirations', in Bernard Aikema
and Beverly Louise Brown (eds),
Renaissance Venice and the North:
Crosscurrents in the Time of Bellini,
Dürer, and Titian (exh. cat., Palazzo
Grassi, Venice, 2000), pp. 44–55

Domenico Romanelli, 'The Fondaco
dei Tedeschi', in Bernard Aikema
and Beverly Louise Brown (eds),
Renaissance Venice and the North:
Crosscurrents in the Time of Bellini,
Dürer, and Titian (exh. cat., Palazzo
Grassi, Venice, 2000), pp. 77–81

Betsy Rosasco, 'Albrecht Dürer's
Death of Orpheus: Its Critical
Fortunes and a New Interpretation

of Its Meaning', Idea. Jahrbuch der
Hamburger Kunsthalle, 3 (1984),
pp. 19–40

A. Rosenthal, 'Dürer's Dream of
1525', The Burlington Magazine, 69
(August 1936), pp. 82–5

Erwin Rosenthal, 'Dürer's
Buchmalereien für Pirckheimer's
Bibliothek', Jahrbuch der
preussischen Kunstsammlungen,
49 (1928), Beiheft, pp. 1–54

Michael Roth (ed.), Dürer's Mutter:
Schönheit, Alter und Tod im Bild
der Renaissance (exh. cat.,
Kupferstichkabinett, Berlin, 2006)

—, 'Eine Dürerreliquie in Ulm?' in
Bodo Brinkmann, Hartmut Krohm
and Michael Roth (eds), Aus
Albrecht Dürer's Welt: Festschrift
für Fedja Anzelewsky (Turnhout,
2001), pp. 189–98

Anne Röver-Kann, Albrecht Dürer:
Das Frauenbad von 1496 (exh. cat.,
Kunsthalle, Bremen, 2001)

Anne Röver-Kann and Mathias
F. Müller, Künstler und Kaiser:
Albrecht Dürer und Kaiser
Maximilian I – Der Triumph des
römisch-deutschen Kaiserhofes
(exh. cat., Kunsthalle, Bremen,
2003)

John Rowlands assisted by Giulia
Bartrum, Drawings by German
Artists and Artists from German-
speaking Regions of Europe in the
Department of Prints and Drawings
in the British Museum. The
Fifteenth Century, and the
Sixteenth Century by Artists born
before 1530, 2 vols (London, 1993)

Elisabeth Rücker, Die Schedelsche
Weltchronik (Munich, 1973)

Hans Rupprich (ed.), Dürer.
Schriftlicher Nachlass, 3 vols
(I, Berlin, 1956; II, Berlin, 1966;
III, Berlin, 1969)

—, 'Dürer und Pirckheimer. Geschichte einer Freundschaft', in Verein für Geschichte der Stadt Nürnberg (ed.), *Albrecht Dürer's Umwelt*, (Nuremberg, 1971), pp. 78–100

Heike Sahm, *Dürer's kleinere Texte: Konventionen als Spielraum für Individualität* (Tübingen, 2002)

Joachim von Sandrart, *Teutsche Academie der Bau-, Bild- und Mahlerey-Künste,* 3 vols (Nürnberg, 1675–80; reprint with intro. Christian Klemm, Nördlingen, 1994)

Georg Satzinger, 'Dürer's Bildnisse von Willibald Pirckheimer', in Gerald Kapfhammer, Wolf-Dietrich Löhr and Barbara Nitsche (eds), *Autorbilder: Zur Medialität literarischer Kommunikation in Mittelalter und Früher Neuzeit* (Münster, 2007), pp. 229–43

Daniel Schäfer, '"... eine ungeheuerliche Krankheit, die sich durch kein Heilmittel vertreiben lässt." Medizinische und nicht-medizinische Sichtweisen auf das Alter um 1500', in Michael Roth (ed.), *Dürer's Mutter: Schönheit, Alter und Tod im Bild der Renaissance* (exh. cat., Kupferstichkabinett, Berlin, 2006), pp. 45–50

Thomas Schauerte, ' ... so es der natur entgegen ist so is es böß': Das Madrider Gemälde Christus unter den Schriftgelehrten und seine Stellung zum Werk Albrecht Dürers', in G. Ulrich Grossmann (ed.), *Dürer-Forschungen*, vol. 2 (Nuremberg, 2009), pp. 227–58.

— (ed.), *Der Kardinal. Albrecht von Brandenburg – Renaissancefürst und Mäzen* (exh. cat., Stiftung Moritzburg, Halle, 2006)

—, 'Dürer und Spranger: Ein Autographenfund im Spiegel der europäischen Sammlungsgeschichte', *Mitteilungen des Vereins für Geschichte der Stadt Nürnberg*, 93 (2006), pp. 25–69

—, 'Von der *Philosophia* zur *Melencolia I.* Anmerkungen zu Dürer's Philosophie-Holzschnitt für Konrad Celtis', in Franz Fuchs (ed.), *Konrad Celtis und Nürnberg, Pirckheimer Jahrbuch für Renaissance- und Humanismusforschung* 19 (Wiesbaden, 2004), pp. 117–39

—, *Die Ehrenpforte für Kaiser Maximilian I. Dürer und Altdorfer im Dienst des Herrschers* (Berlin, 2001)

Thomas Schauerte assisted by Birgit Münch, *Albrecht Dürer: Das grosse Glück – Kunst im Zeichen des geistigen Aufbruchs* (exh. cat., Kulturgeschichtliches Museum, Bramsche, Osnabrück, 2003)

Elisabeth Scheicher, *Das Grabmal Kaiser Maximilians I. in der Innsbrucker Hofkirche* (Vienna, 1986)

Elfriede Scheil, 'Albrecht Dürer's 'Melencolia I.' und die Gerechtigkeit', *Zeitschrift für Kunstgeschichte,* 70 (2007), pp. 201–14

Anna Scherbaum with Claudia Wiener, *Albrecht Dürer's Marienleben. Form – Gehalt – Funktion und sozialhistorischer Ort* (Wiesbaden, 2004)

—, 'Caritas Pirckheimer und das Bild der heiligen Familie im 'Marienleben' von Albrecht Dürer und Benedictus Chelidonius', in Franz Fuchs (ed.), *Die Pirckheimer: Humanismus in einer Nürnberger Patrizierfamilie, Pirckheimer Jahrbuch für Renaissance- und Humanismusforschung*, 21 (Wiesbaden, 2006), pp. 119–59

Corine Schleif, 'Albrecht Dürer between Agnes Frey and Willinald Pirckheimer', in Larry Silver and Jeffrey Chipps Smith (eds), T*he Essential Dürer* (Philadelphia, 2010), pp. 185–205, 267–71.

— , 'Das Pos Weyb Agnes Frey Dürer: Geschichte ihrer Verleumdung und Versuche der Ehrenrettung', *Mitteilungen des Vereins für Geschichte der Stadt Nürnberg*, 86 (1999), pp. 3–47

Wolfgang Schmid, *Dürer als Unternehmer. Kunst, Humanismus und Ökonomie in Nürnberg um 1500* (Trier, 2003)

— , 'Dürer's Enterprise: Market Area, Market Potential, Product Range', in Michael North (ed.), *Economic History and the Arts* (Cologne, 1996), pp. 27–47

— , 'Warum schenkte Albrecht Dürer dem Nürnberger Rat die *vier Apostel?*', in *Pictura quasi fictura. Die Rolle des Bildes in der Erforschung von Alltag und Sachkultur des Mittelalters und der frühen Neuzeit* (Vienna, 1996), pp. 129–74 [Schmid 1996a]

Lothar Schmitt, 'Dürer's Locke', *Zeitschrift für Kunstgeschichte*, 66 (2003), pp. 261–73

Erich Schneider, Anna Spall and Georg Drescher (eds), *Dürer als Erzähler: Holzschnitte, Kupferstiche und Radierungen aus der Sammlung-Otto-Schäfer* (exh. cat., Bibliothek Otto Schäfer, Schweinfurt, 1996)

Julia Schnelbögl, 'Die Reichskleinodien in Nürnberg, 1423–1523', *Mitteilungen des Vereins für Geschichte der Stadt Nürnberg*, 51 (1962), pp. 78–159

Rainer Schoch, essay Ludwig Grote, *Albrecht Dürer. Die Apokalypse – The Apocalypse. Faksimile der deutschen Urausgabe von 1498 Die heimlich Offenbarung Johannis* (Munich, 1999)

Rainer Schoch, Matthias Mende and Anna Scherbaum (eds), *Dürer. Das druckgraphische Werk*, III. *Buchillustrationen* (Munich, 2004)

— , *Dürer. Das druckgraphische Werk*, II.

Holzschnitte und Holzschnittfolgen (Munich, 2002)

— , *Dürer. Das druckgraphische Werk*, I. *Kupferstiche, Eisenradierungen und Kaltnadelblätter* (Munich, 2001)

— , *Albrecht Dürer. Die drei Grossen Bücher Marienleben, Grosse Passion, Apokalypse – Faksimile der Originalausgaben Nürnberg 1511* (Nördlingen, 2001) [Schoch, Mende and Scherbaum 2001a]

Christian Schoen, *Albrecht Dürer: Adam und Eva. Die Gemälde, ihre Geschichte und Rezeption bei Lucas Cranach d. Ä. und Hans Baldung Grien* (Berlin, 2001)

Stephanie Schrader, 'Master M.Z.'s Embrace: The Construction of a Visual Dialogue', *Bulletin – Allen Memorial Art Museum*, 47 (1993), pp. 14–27

Klaus Albrecht Schröder and Maria Luise Sternath (eds), *Albrecht Dürer* (exh. cat., Albertina, Vienna, 2003)

Werner Schultheiss, 'Albrecht Dürer's Beziehungen zum Recht', in Verein für Geschichte der Stadt Nürnberg (ed.), *Albrecht Dürer's Umwelt* (Nuremberg, 1971), pp. 220–54

Juergen Schulz, 'Jacopo de'Barbari's View of Venice', *Art Bulletin*, 60 (1978), pp. 425–74

Ralf Schürer, 'Der Akeleypokal: Überlegungen zu einem Meisterstück', in *Wenzel Jamnitzer und die Nürnberger Goldschmiedekunst 1500–1700* (exh. cat., Germanisches Nationalmuseum, Nuremberg, 1985), pp. 107–22

Peter-Klaus Schuster, *Melencolia I. Dürer's Denkbild*, 2 vols (Berlin, 1991)

— , 'Bild gegen Wort: Dürer und Luther', *Anzeiger des Germanischen Nationalmuseums* (1986), pp. 35–50

—, 'Individuelle Ewigkeit: Hoffnungen und Ansprüche im Bildnis der Lutherzeit', in August Buck (ed.), *Biographie und Autobiographie in der Renaissance* (Wiesbaden, 1982), pp. 121–73

—, 'Zu Dürers Zeichnung *Der Tod des Orpheus* und verwandten Darstellungen', *Jahrbuch der Hamburger Kunstsammlungen*, 23 (1978), pp. 7–24

Karl Schütz (ed.), *Albrecht Dürer im Kunsthistorischen Museum* (Vienna, 1994)

Wilhelm Schwemmer, 'Aus der Geschichte der Kunstsammlungen der Stadt Nürnberg', *Mitteilungen des Vereins für Geschichte der Stadt Nürnberg*, 40 (1949), pp. 97–206

Wilhelm Schwemmer, *Adam Kraft* (Nuremberg, 1958)

William Bell Scott, *Albert Durer: His Life and Works* (London, 1869)

Robert Scribner, 'Images of the Peasant, 1514–1525', in János Bak (ed.), *The German Peasant War of 1525* (London, 1976), pp. 29–47

Gottfried Seebass, 'Dürer's Stellung in der reformatorischen Bewegung', in Verein für Geschichte der Stadt Nürnberg (ed.), *Albrecht Dürer's Umwelt* (Nuremberg, 1971), pp. 101–31

Christian Tico Seifert, *Dürer's Fame* (exh. cat., National Galleries of Scotland, Edinburgh, 2011)

Lon R. Shelby, *Gothic Design Techniques: The Fifteenth-Century Design Booklets of Mathes Roriczer and Hanns Schmuttermayer* (Carbondale, IL, 1977)

Junhyoung M. Shin, *Et in picturam et in sanctitatem: Operating Albrecht Dürer's Marienleben (1502–1511)* (Berlin, 2003)

Hinrich Sieveking, *Das Gebetbuch Kaiser Maximilians: Der Münchner Teil* (Munich, 1987)

Larry Silver, 'Civic Courtship: Albrecht Dürer, the Saxon Duke, and the Emperor', in Larry Silver and Jeffrey Chipps Smith (eds), *The Essential Dürer* (Philadelphia, 2010), pp. 130–48, 252–7.

—, *Marketing Maximilian: The Visual Ideology of a Holy Roman Emperor* (Princeton, 2008)

—, 'Prints for a Prince: Maximilian, Nuremberg, and the Woodcut', in Jeffrey Chipps Smith (ed.), *New Perspectives on the Art of Renaissance Nuremberg: Five Essays* (Austin, 1985), pp. 7–21

—, *The Paintings of Quinten Massys* (Montclair, 1984)

—, 'Forest Primeval: Albrecht Altdorfer and the German Wilderness Landscape', *Simiolus*, 13 (1983), pp. 4–43

Larry Silver and Jeffrey Chipps Smith (eds), *The Essential Dürer* (Philadelphia, 2010)

Jutta von Simson, *Christian Daniel Rauch: Oeuvre-Katalog* (Berlin, 1996)

Alistair Smith, 'Dürer and Bellini, Apelles and Protgenes', *The Burlington Magazine*, 114 (1970), pp. 326–9

David Smith, Liz Guenther *et al.*, *Realism and Invention in the Prints of Albrecht Dürer* (exh. cat., Art Gallery, University of New Hampshire, Durham, NH, 1995)

Jeffrey Chipps Smith, 'Dürer on Dürer: Thoughts on Intentionality and Self-Fashioning', in Barbara Schellwald, Olaf Peters, and Beate Boeckem (eds), *Die Biographie – Mode und Universalie?* (forthcoming 2012)

—, 'Albrecht Dürer as Collector', *Renaissance Quarterly* 64.1 (2011) [2011a], pp.1–49.

—, 'Albrecht Dürer', in Margaret L. King (ed.), *Oxford Bibliographies Online – Renaissance and Reformation* (Oxford, 2011) [2011b]

—, 'Dürer and Sculpture', in Larry Silver and Jeffrey Chipps Smith (eds), *The Essential Dürer* (Philadelphia, 2010) [2010a], pp. 74–98, 238–243.

—, 'Dürer's Losses and the Dilemmas of Being', in Lynne Tatlock (ed.), *Enduring Loss in Early Modern Germany: Cross Disciplinary Perspectives* (Leiden, 2010) [2010b], pp. 71–100.

—, 'The "Invention" of Dürer as a Renaissance Artist', in Alex Lee, Harry Schnitker, and Pit Peporte (eds), *Renaissance? Perceptions of Continuity and Discontinuity in Europe, c.1300–c.1550* (Leiden, 2010) [2010c], pp. 331–348.

—, 'Dürer and Eastern Europe', *ARS – Journal of the Institute of Art History of Slovak Academy of Sciences* (Bratislava), 42 (2009), pp. 5–22.

—, 'La configuración de Alberto Durero a través de la Historia del Arte: de Wölfflin a Panofsky / The Art Historical Shaping of Albrecht Dürer: From Wölfflin to Panofsky', in Mar Borobia (ed.), *El siglo de Durero: Problemas historiográficos* (Madrid, 2008), pp. 83–108, 286–301.

—, *The Art of the Goldsmith in Late Fifteenth-Century Germany: The Kimbell Virgin and Her Bishop* (New Haven, 2006)

—, *The Northern Renaissance* (London, 2004)

—, 'A Creative Moment: Thoughts on the Genesis of the German Portrait Medal', in Stephen K. Scher (ed.), *Perspectives on the Renaissance Medal* (New York, 2000), pp. 177–99

—, *German Sculpture of the Later Renaissance, c.1520–1580: Art in an Age of Uncertainty* (Princeton, 1994)

—, 'Netherlandish Artists and Art in Renaissance Nuremberg', *Simiolus*, 20 (1990/1), pp. 153–67

— (ed.), *New Perspectives on the Art of Renaissance Nuremberg: Five Essays* (Austin, TX, 1985)

—, 'The Transformations of Patrician Tastes in Renaissance Nuremberg', in Jeffrey Chipps Smith (ed.), *New Perspectives on the Art of Renaissance Nuremberg: Five Essays* (Austin, TX, 1985), pp. 82–100 [1985a]

—, *Nuremberg, A Renaissance City, 1500–1618* (exh. cat., Huntington Art Gallery, University of Texas, Austin, TX, 1983)

Stadt Nürnberg, Kulturreferat/Kulturprofile (ed.), *Der Rasen wird 500. 1503–2003 – Beiträge zu Albrecht Dürer und seinem Rasenstück* (Nuremberg, 2003)

Wolfgang Stechow, *Dürer and America* (exh. cat., National Gallery of Art, Washington, DC, 1971)

Felix J. F. Steinraths, *Albrecht Dürer's Memorialtafeln aus der Zeit um 1500* (Frankfurt, 2000)

Jan Van der Stock (ed.), *Antwerp: Story of a Metropolis, 16th–17th Century* (exh. cat., Hessenhuis, Antwerp, 1993)

Christoph Stölzl (ed.), *Michael Mathias Prechtl Denkmalerei* (exh. cat., Stadtmuseum, Munich, 1986)

Gerald Strauss, *Nuremberg in the Sixteenth Century*, revised edn (Bloomington, IN, 1976)

Walter L. Strauss, *The Painter's Manual by Albrecht Dürer* (New York, 1977)

—, *The Intaglio Prints of Albrecht Dürer* (New York, 1976)

—, *The Complete Drawings of Albrecht Dürer*, 6 vols (New York, 1974)

—, *The Book of Hours of Emperor Maximilian the First* (New York, 1974) [1974a]

—, *Albrecht Dürer – The Human Figure: The Complete 'Dresden Sketchbook'* (New York, 1972)

Walter L. Strauss (ed.), *The Illustrated Bartsch*, vol. 13, *Sixteenth Century Artists* (New York, 1981)

Peter Strieder, 'Ein Traum von Göttern und Heroen: Andreas Meinhardis Dialog über die Schönheit und den Ruhm der hochberühmten Stadt Albioris, gemeinhin Wittenberg genannt', *Anzeiger des Germanischen Nationalmuseums* (2005), pp. 25–34

—, 'Michael Wolgemut – Leiter einer "Grosswerkstatt" in Nürnberg', in Claus Grimm, Johannes Erichsen, and Evamaria Brockhoff (eds), *Lucas Cranach: Ein Maler-Unternehmer aus Franken* (Regensburg, 1994), pp. 116–23

—, *Tafelmalerei in Nürnberg 1350–1550* (Königstein im Taunus, 1993)

—, '"Schri. Kunst. Schri. Vnd. Klag. Dich. Ser" – Kunst und Künstler an der Wende vom Mittelalter zur Renaissance', *Anzeiger des Germanischen Nationalmuseums* (1983), pp. 19–26

—, *Albrecht Dürer. Paintings, Prints, Drawings*, trans. Nancy M. Gordon and Walter L. Strauss (New York, 1982)

Jeroen Stumpel and Jolein van Kregten, 'In the Name of the Thistle: Albrecht Dürer's *Self-Portrait* of 1493', *The Burlington Magazine*, 144 (2002), pp. 14–18

Robert Suckale, *Die Erneuerung der Malkunst vor Dürer*, 2 vols. (Petersberg, 2009)

—, 'Haben die physiognomischen Theorien für das Schaffen von Dürer und Baldung eine Bedeutung?', in Friedrich Piel and Jörg Traeger (eds), *Festschrift Wolfgang Braunfels* (Tübingen, 1977), pp. 357–69

Margaret Sullivan, 'The Witches of Dürer and Hans Baldung Grien', *Renaissance Quarterly* 53 (2000), pp. 332–401

Andreas Tacke, *Die Gemälde des 17. Jahrhunderts im Germanischen Nationalmuseum – Bestandskatalog* (Mainz, 1995)

Charles W. Talbot (ed.), *Dürer in America: His Graphic Work* (exh. cat., National Gallery of Art, Washington, DC, 1971)

Joachim Telle, 'Ein Traumgesicht von Hieronymus Brunschwig (1512)', *Geschichte der Pharmazie*, 58, nos 2–3 (21 September 2006), pp. 20–2

Anchise Tempestini, *Giovanni Bellini* (New York, 1999)

Moriz Thausing, *Albert Dürer. His Life and Works*, trans. Frederick Alexis Eaton, 2 vols (London, 1882)

Heinrich Theissing, *Dürer's Ritter, Tod und Teufel: Sinnbild und Bildsinn* (Berlin, 1978)

Marjorie Trusted, *German Renaissance Medals: A Catalogue of the Collection in the Victoria and Albert Museum* (London, 1990)

Jane Shoaf Turner (ed.), *Master Drawings: The Woodner Collection* (exh. cat., Royal Academy of Arts, London, 1987)

Gerd Unverfehrt, *Da sah ich viel köstliche Dinge. Albrecht Dürer's Reise in die Niederlande* (Göttingen, 2007)

Pierre Vaisse, 'Albrecht Dürer – Écrits récents et états des questions', *Revue de l'art*, 19 (1973), pp. 116–24

Filip Vermeylen, *Painting for the Market: Commercialization of Art in Antwerp's Golden Age* (Turnhout, 2003)

Jan Veth and Samuel Muller, *Dürers niederländische Reise*, 2 vols (Berlin, 1918)

Vitruvius, *Ten Books on Architecture*, trans. Ingrid D Rowland, commentary Thomas Noble Howe (New York, 1999)

Christine Vogt, *Das druckgraphische Bild nach Vorlagen Albrecht Dürer (1471–1528)* (Munich, 2008)

Vorbild Dürer. Kupferstiche und Holzschnitte Albrecht Dürer's im Spiegel der europäischen Druckgraphik des 16. Jahrhundert (exh. cat., Germanisches Nationalmuseum, Nuremberg, 1978)

Lee Palmer Wandel, *Voracious Idols & Violent Hands* (Cambridge, 1995)

Herman van der Wee and Jan Materné, 'Antwerp as a World Market in the Sixteenth and Seventeenth Centuries', in Jan Van der Stock (ed.), *Antwerp: Story of a Metropolis, 16th–17th Century* (exh. cat., Hessenhuis, Antwerp, 1993), pp. 19–31

Uwe Westfehling, *Die Messe Gregor des Grossen. Vision, Kunst. Realität* (exh. cat., Schnütgen Museum, Cologne, 1982)

Wenzel Jamnitzer und die Nürnberger Goldschmiedekunst 1500–1700 (exh. cat., Germanisches Nationalmuseum, Nuremberg, 1985)

David M. Whitford, 'Luther's Political Encounters', in Donald K. McKim (ed.), *The Cambridge Companion to Martin Luther* (Cambridge, 2003), pp. 179–91

Claudia Wiener and Georg Drescher (eds), *Amor als Topograph. 500 Jahre Amores des Conrad Celtis: Ein Manifest des deutschen Humanismus* (exh. cat., Bibliothek Otto Schäfer, Schweinfurt, 2002)

Claudia Wiener, Anna Scherbaum and Georg Drescher (eds), *Andachtsliteratur als Künstlerbuch. Dürers Marienleben* (exh. cat., Bibliothek Otto Schäfer, Schweinfurt, 2005)

Merry E. Wiesner, *Working Women in Renaissance Germany* (New Brunswick, 1986)

Hildegard Wiewelhove, *Tischbrunnen: Forschungen zur europäischen Tafelkultur* (Berlin, 2002)

Adrian Wilson, *The Making of the Nuremberg Chronicle* (Amsterdam, 1976)

Jean C. Wilson, 'Enframing Aspirations: Albrecht Dürer's *Self-Portrait* of 1493 in the Musée du Louvre', *Gazette des Beaux-Arts*, 127 (1995), pp. 149–58

Friedrich Winkler, 'Dürer's kleine Holzschnittpassion und Schäufeleins *Speculum* Holzschnitte', *Zeitschrift des deutschen Vereins für Kunstwissenschaft*, 8 (1941), pp. 197–208

—, *Die Zeichnungen Albrecht Dürer's*, 4 vols (Berlin, 1936–9)

Anne Winston-Allen, *Stories of the Rose: The Making of the Rosary in the Middle Ages* (University Park, PA, 1997)

Franz Winzinger, 'Albrecht Dürer's Münchener Selbstbildnis', *Zeitschrift des deutschen Vereins*

für Kunstwissenschaft, 8 (1954),
pp. 43–64

Christopher Witcombe, Copyright in
the Renaissance: Prints and the
Privilegio in Sixteenth-Century
Venice and Rome (Leiden, 2004)

Rudolf and Margot Wittkower, Born
under Saturn: The Character and
Conduct of Artists (New York,
1963)

Norbert Wolf, Dürer (Munich, 2010)

Heinrich Wölfflin, The Art of Albrecht
Dürer, trans. Alastair and Heide
Grieve (London, 1971; originally
Vienna, 1905)

Michael Wolfson, Die deutschen und
niederländischen Gemälde bis 1550:
Kritischer Katalog (exh. cat.,
Niedersächsisches Landesmuseum,
Hannover, 1992)

Christopher S. Wood, 'Maximilian I as
Archeologist', Renaissance
Quarterly, 58 (2005), pp. 1128–74

—, 'Notation of Visual Information in
the Earliest Archeological
Scholarship', Word and Image, 17
(2001), pp. 94–118

—, 'Early Archaeology and the Book
Trade: The Case of Peutinger's
Romanae vetustatis fragmenta
(1505)', Journal of Medieval and
Early Modern Studies, 28 (1998),
pp. 83–118

Joanna Woods-Marsden, Renaissance
Self-Portraiture (Princeton, 1988)

Dieter Wuttke, 'Dürer und Celtis: Von
der Bedeutung des Jahres 1500 für
den deutschen Humanismus.
"Jahrhundertfeier als symbolische
Form"', in Dieter Wuttke,
Daszwischen: Kulturwissenschaft
auf Warburgs Spuren, vol. I (Baden,
1996; originally published in 1980),
pp. 313–88

—, 'Unbekannte Celtis-Epigramme
zum Lobe Dürers', Zeitschrift für
Kunstgeschichte, 30 (1967),
pp. 321–5

Dieter Wuttke (ed.), Erwin Panofsky.
Korrespondenz 1950 bis 1956
(Wiesbaden, 2006)

Irena Zdanowicz (ed.), Albrecht Dürer
in the Collection of the National
Gallery of Victoria, (exh. cat.,
National Gallery of Victoria,
Melbourne, 1994)

Charles Zika, 'Dürer's Witch, Riding
Women and Moral Order', in
Dagmar Eichberger and Charles
Zika (eds), Dürer and His Culture
(Cambridge, 1998), pp. 118–40

Philipp Zitzlsperger, Dürers Pelz und
das Recht im Bild: Kleiderkunde als
Methode der Kunstgeschichte
(Berlin, 2008)

Index

Numbers in **bold** refer to illustrations

Acknowledgments

I have been dancing with and around Albrecht Dürer for over a quarter century. He has been the subject of numerous classes, lectures and publications of mine during the interim years. I never planned, however, to author a monograph on the Nuremberg master. This changed when in 2004 I was asked to write the present book and a new introduction to Erwin Panofsky's classic monograph on Dürer (1943), which was being reissued in 2005 as part of the centenary of Princeton University Press. The latter resulted additionally in a series of lectures in Bristol, Rome, Berlin, Edinburgh and Madrid and forthcoming articles on the historiography of Dürer scholarship, a topic not included in the current book. By good fortune between 2003 and 2007 major exhibitions in Vienna, Rome and Madrid provided opportunities to see Dürer's art again, as did visits to important museums and libraries in Europe, Australia and North America. With instinctive good timing, Evelin Wetter invited me to be a visiting scholar in residence at the Geisteswissenschaftliches Zentrum Geschichte und Kultur Ostmitteleuropas e. V. at the University of Leipzig in June and July 2006. There I benefited from my interactions with Agnieszka Madej-Anderson, Maria Deiters and Kai Wenzel as well as Christoph Brachmann and Evelin, my hosts in Berlin. This permitted me to reacquaint myself with much of the nineteenth- and early twentieth-century Dürer literature. I happily acknowledge the fellowships and research funding that I received from the National Endowment for the Humanities, the University of Texas at Austin and, above all, the Kimbell Art Foundation of Fort Worth.

This study is the product of many conversations with and kindnesses provided by a host of colleagues. I wish to thank the following: in Australia, Irena Zdanowicz; in Austria, Fritz Koreny and Karl Schütz; in Czech Republic, Olga Kotková; in Germany, Anne-Marie Bonnet, Magdalena Bushart, Hans Dickel, Thomas Döring, Dagmar Eichberger, Thomas Eser, Tilman Falk, Anja Grebe, Ulrich Grossmann, Daniel Hess, Frank Matthias Kammel, Hans-Ulrich Kessler, Katharina Krause, Hartmut Krohm, Andreas Kühne, Iris Lauterbach, Konrad and Else Liebmann, Bernd Lindemann, Hermann Maué, Matthias Mende, Jürgen Müller, Birgit Münch, Christian Ring, Michael Roth, Anne Röver-Kann, Georg Satzinger, Willibald Sauerländer, Thomas Schauerte, Anna Scherbaum, Wolfgang Schmid, Rainer Schoch, Wolf Tegethoff, Elke Werner and Dieter Wuttke; in Great Britain, Giulia Bartrum, Ulinka Rublack and Christian Tico Seifert; in Italy, Sybille Ebert-Schifferer and Kristina Herrmann Fiore; in Slovakia, Ingrid Ciulisová; in Spain, Mar Borobia, Fernando Checa and Dolores Delgado; in Switzerland, Beate Boeckem, Hanns Hubach and Barbara Schellwald; in the US, Derick Dreher, Laura Giles, Stephen Goddard, Thomas DaCosta Kaufmann, Miriam (Lisa) Kirch who was my resourceful research assistant early in this project, Katherine Luber, Andrew Morrall, Peter Parshall, David Price, Corine Schleif, Larry Silver, Tania String, Margaret Sullivan, Charles Talbot and Christopher Wood; and at the University of Texas at Austin, Michael Charlesworth, Douglas Dempster, Ken Hale, Joan Holladay, Catharine Ingersoll, Josh McConnell, Glenn Peers, Irene Roderick, Louis Waldman and John Yancey. I learned much from Jonathan Bober, now in Washington, when we taught print seminars together. I am grateful to David Anfam at Phaidon Press for the invitation to write this book and to Helen Miles for her expertise in bringing it to fruition. My daughter, Abby, skillfully mastered measurement conversions and other thankless tasks. This book, which mercifully is only half as long as my initial draft, is lovingly dedicated to Paul Smith, my father, and to Sandy, my wonderful wife.

Phaidon Press Limited
Regent's Wharf
All Saints Street
London N1 9PA

Phaidon Press Inc.
180 Varick Street
New York, NY 10014

www.phaidon.com

Text typeset in Aldus, chapter titles and
page numbers in Palatino

Printed in Singapore

Cover illustration *The Hare* (detail),
1502 (65)